Material masculinities

Manchester University Press

GENDER IN HISTORY

Series editors:
Lynn Abrams, Cordelia Beattie, Julie Hardwick

The expansion of research into the history of women and gender since the 1970s has changed the face of history. Using the insights of feminist theory and of historians of women, gender historians have explored the configuration in the past of gender identities and relations between the sexes. They have also investigated the history of sexuality and family relations, and analysed ideas and ideals of masculinity and femininity. Yet gender history has not abandoned the original, inspirational project of women's history: to recover and reveal the lived experience of women in the past and the present.

The series Gender in History provides a forum for these developments. Its historical coverage extends from the medieval to the modern periods, and its geographical scope encompasses not only Europe and North America but all corners of the globe. The series aims to investigate the social and cultural constructions of gender in historical sources, as well as the gendering of historical discourse itself. It embraces both detailed case studies of specific regions or periods, and broader treatments of major themes. Gender in History titles are designed to meet the needs of both scholars and students working in this dynamic area of historical research.

To buy or to find out more about the books currently available in this series, please go to: https://manchesteruniversitypress.co.uk/series/gender-in-history/

Material masculinities

Men and goods in eighteenth-century England

Ben Jackson

MANCHESTER UNIVERSITY PRESS

Copyright © Ben Jackson 2025

The right of Ben Jackson to be identified as the author of this work has been asserted in accordance with the Copyright, Designs and Patents Act 1988.

Published by Manchester University Press
Oxford Road, Manchester, M13 9PL

www.manchesteruniversitypress.co.uk

British Library Cataloguing-in-Publication Data
A catalogue record for this book is available from the British Library

ISBN 978 1 5261 8060 5 hardback

First published 2025

The publisher has no responsibility for the persistence or accuracy of URLs for any external or third-party internet websites referred to in this book, and does not guarantee that any content on such websites is, or will remain, accurate or appropriate.

EU authorised representative for GPSR:
Easy Access System Europe, Mustamäe tee 50, 10621 Tallinn, Estonia
gpsr.requests@easproject.com

Typeset
by New Best-set Typesetters Ltd

For Colleen and Brian Jackson

Contents

List of figures	*page* viii
List of tables	x
Acknowledgements	xii
List of abbreviations	xv
Introduction: masculinities and materialities	1
1 Boyhood: playing at manhood	32
2 Householder: furnishing the home	80
3 Mobile man: travelling in style	126
4 Discerning consumer: possessing the self	165
5 Gentleman sportsman: collecting trophies	206
Conclusion: making men	245
Select bibliography	257
Index	280

Figures

1.1 Joseph Highmore, Mrs Sharpe and Her Child, 1731. Oil on canvas, 127 × 101 cm. Yale Center for British Art, New Haven, Connecticut. Museum Number B1981.25.339. Reproduced courtesy of the Yale Center for British Art. *page* 39
1.2 John James Halls, The Four Eldest Children of Sir Richard Croft, c.1803. Oil on Canvas, 127 × 101 cm. Croft Castle, Herefordshire, National Trust. Museum Number: NT537593. © National Trust Images 41
1.3 Allan Ramsay, Thomas, 2nd Baron Mansel of Margam with his Blackwood Half-Brothers and Sister, 1742. Oil on Canvas, 124 × x100 cm. Tate Britain, London. Museum Number: T05494. © Tate 44
1.4 John Michael Wright, Portrait of Mrs Salesbury with her Grandchildren Edward and Elizabeth Bagot, 1675–1676. Oil on Canvas, 130 × 133 cm. Tate Britain, London. Museum Number: T06750. © Tate 46
1.5 Johann Zoffany, The Blunt Children, c.1766–1770. Oil on Canvas, 77 × 123 cm. Birmingham Museums Trust, Birmingham. Museum Number: 1934P397. Reproduced by Birmingham Museums Trust, licensed under CC0. 47
1.6 William Hogarth, A Children's Tea Party, 1730. Oil on Canvas, 64 × 76 cm. National Museum Wales, National Museum Cardiff. Museum

List of figures

	Number: NMW A 94. © National Museum, Wales	49
1.7	William Hogarth, The Graham Children, 1742. Oil on Canvas, 160 × 181 cm. National Gallery, London. Museum Number: NG4756. Reproduced courtesy of the National Gallery, London, licensed by CC. BY.	50
1.8	'Lady Clapham', 1690–1700. Gesso and Painted Wood, 56 cm. Victoria and Albert Museum, London. Museum Number: T.846-1974. © Victoria and Albert Museum, London	61
1.9	'Doll', c.1700–1800. Wood. Young V&A, London. Museum Number: MISC.33-1967. © Victoria and Albert Museum, London	62
1.10	Isaac Cruickshank, 'The Cradle Hymn; New Version, Eighth Edition', 1820. Etching on Paper, 36.6 × 22.6 cm. British Museum, London. Museum Number: 1868,0612.1273. © The Trustees of the British Museum, London	67
4.1	BM. Battersea-Enamel Snuffbox, 1759. 7.4 × 5.3 × 3.4 cm. Museum Number: 1895,0521.11. © The Trustees of the British Museum, London	173
4.2	'Battersea-Enamel Snuffbox', c.1700–1800, 8.8 × 6.5 × 3.8 cm. The British Museum, London. Museum Number: 1895,0521.7. © The Trustees of the British Museum, London	174
5.1	Thomas Gainsborough, Mr and Mrs Andrews, c.1750. Oil on Canvas, 70 × 120 cm. The National Gallery, London. Museum Number: NG6301. Reproduced courtesy of the National Gallery, London, licensed by CC. BY.	207
5.2	BM. 'Draft Trade Card of John Burgon, Gunsmith', c.1790. Banks,69.11. © The Trustees of the British Museum, London	219
5.3	William Simpson, 'Flintlock Sporting Gun', 1738. Royal Armouries, Leeds. Object Number: xii.5843. © Royal Armouries	222

Tables

2.1	Occupations listed in the Brown sample by gender and average order size	page 86
2.2	New items of furniture purchased in relation to the average total items in the order and the average total spend in the order in the Williams sample by gender	90
2.3	Percentage of men and women ordering new goods in the Williams sample	90
2.4	New items of furniture purchased in the Brown sample by gender	91
2.5	Percentage of men and women ordering new goods in the Brown sample	92
2.6	Orders for different types of tables in the Williams Sample by gender	92
2.7	Orders for different types of tables in the Brown sample by gender	93
2.8	The variety of Pembroke tables in the Brown sample by gender	95
2.9	Furniture prefixed with 'Gentleman's' or 'Lady's' in eighteenth-century furniture manuals	96
2.10	The quantity of differing types and styles of chairs in the Williams sample by gender	97
2.11	The number of new mahogany goods in the Williams sample by gender	101
2.12	The consumption of different types of materials in the Williams sample by gender	101
2.13	The consumption of different types of materials in the Brown sample by gender	105

2.14	The different finishes to goods in the Brown sample by gender	106
2.15	Furniture with a specified shape in the Brown sample by gender	106
2.16	The number of repairs listed in the Williams ledger by gender	109
2.17	The different types of repaired objects in the Williams Sample by gender	110
2.18	Repairs in the Brown sample by order size, spend, and gender	113
2.19	The different types of repaired objects in the Williams sample by gender	114
2.20	The number of second-hand goods in the Williams sample by gender	116
2.21	The number of second-hand goods in the Brown sample by gender	116
3.1	The receipted coach-related bills of John and Sarah Churchill	150

Acknowledgements

The writing of this book has been possible due to the generosity of my mentors, colleagues, friends, and family. Firstly, Amanda Vickery, and her unique ability to breathe life into even the driest of historical sources, inspired me to pursue a PhD in eighteenth-century history. Her commentary on this work, in its many stages, was always insightful, robust, and forensic and she continues to provide me with a significant amount of personal and professional support for which I am hugely grateful. She, like her research, remains a constant inspiration. Second, support from Helen Berry and Karen Harvey has been instrumental in shaping this research for publication. As a mentor and a colleague at the University of Birmingham, Karen's considerable expertise and generous support has undoubtedly shaped both this work and my practice as a historian. Third, I am also incredibly grateful to the unerringly patient Meredith Carroll, Siobhan Poole, and Kate Hawkins at Manchester University Press, and the manuscript's two external reviewers' insightful and encouraging feedback.

My MA at York's Centre for Eighteenth Century Studies and its staff, past and present, first ignited my interest in the social and cultural history of eighteenth-century gender. At CECS, I met Jenny Buckley and Montana Davies-Shuck who are a constant source of knowledge, encouragement, and solidarity. I am particularly grateful to the School of History at Queen Mary, University of London's historians, past and present, who have supported me and my research: Nick Beech, Jo Cohen, Markman Ellis, James Ellison, Christina von Hodenberg, Miri Rubin, Claire Trenery, Matthew Walker, and Jen Wallis. A university studentship funded the three years of research and enabled me to attend conferences and visit archives. I am also

Acknowledgements xiii

incredibly grateful to my QMUL PhD peers, now many great historians, including Steve Bentel, Hillary Burlock, Ed Caddy, Amanda Langley, Hannah Lee, Evelien Lemmens, Ellie Lowe, Hannah Maudsley, Rebecca Morrison, Colm Murphy, Dave Saunders, and Emily Vine. I am especially indebted to Evelien, my 'Daily Achievable Goal' buddy for helping me and this work survive the many 2020/21 lockdowns.

Much of the writing of this book was undertaken during a teaching fellowship at the University of Birmingham. It was a lucky first post-PhD job, and my research has been hugely shaped by its intellectual community. I am grateful to Nathan Cardon, Anna Dearden, Noah Millstone, Imogen Peck, William Purkis, the late Marga Small, and Jonathan Willis. Jamie Doherty, Thomas Ellis, and the utterly wonderful and generous Sarah Kenny were great friends during my time there. Special thanks must go to Tom Cutterham, Sarah Fox, Tara Hamling, Matt Houlbrook, Kate Smith, and Emily Vine who read much of this work and provided their ever-insightful feedback on it – and special thanks to Sarah and Emily for our writing group in the final stages of completing the book manuscript. I am also grateful to staff at the University of Manchester, especially Hannah Barker, for her support and strong encouragement as I finished the manuscript during my postdoctoral fellowship.

Thanks to the generosity of the W. M. Keck Foundation at The Huntington Library, San Marino I completed archival research for this book in a 'historian's paradise'. It is true that historians' work is impossible without the guidance and expertise of archivists and librarians. I am particularly grateful to those at the Bedfordshire Archives and Record Service, British Library, East Riding Archives, Essex Record Office, The Huntington, Kent History and Library Centre, The London Archives, and the National Archives, Kew. Equally, digitised databases were invaluable in producing this work. The figures throughout the book were reproduced with the generous assistance of a grant from the Isobel Thornley's Bequest to the University of London.

Outside of the academy, I am thankful to my old school friends Niamh Hanlon and Lorna Turnbull who have provided me with enduring friendship. Thanks too to Gareth Harrington for his support during my doctoral studies. Ashleigh James, Alyssa Paynter, and Alice Tuck give me a life beyond research and picked me up at my

very lowest ebbs. To the two other members of the Funky Trio, my sisters Eleanor and Louisa Jackson, thank you both for your constant love, support, and generosity. I am also very grateful to the Hudsons and Jacksons who will never see this book, Ben and Winnie and Betty and Stan.

Completing this book coincided with meeting Adam Carver whose bountiful talent and joy and unerring enthusiasm and love has indescribably changed my life for the better. It is no exaggeration that their belief in me has made finishing this book possible. Thank you. Finally, and most importantly, my greatest thanks and acknowledgement goes to my incomparable parents, Colleen and Brian Jackson. My considerable debt to, admiration of, and gratitude and love for you both could fill all the pages in this book and many more. This book is, of course, for you.

Abbreviations

BA	Bedfordshire Archives
BL	British Library
BM	The British Museum
ERO	Essex Record Office
ESRO	East Sussex Record Office
HL	The Huntington Library, San Marino CA
LA	Lancashire Archives
LLRRO	Leicestershire, Leicester and Rutland Record Office
LWL	Lewis Walpole Library, Yale
OBO	Old Bailey Online
RA	The Royal Archives, Windsor
RCT	Royal Collections Trust
TLA	The London Archives
TNA	The National Archives, Kew
VAM	Victoria and Albert Museum, London
WCRO	Warwickshire Country Record Office
WSRO	West Sussex Record Office

Introduction: masculinities and materialities

In 1782 a probate inventory of the recently deceased Robert Child, a wealthy banker with connections to the East India Company, was drawn up to calculate the value of his estate at Osterley Park, Middlesex. The inventory of Child's material possessions recorded the contents of his circular closet, a small private room on the northeast front. It held a Wilton carpet, a mahogany shaving stand, a gold-and-silver-mounted hunting gun, an Indian sabre, fishing rods, and a Dollond telescope. The adjoining dressing room, of his wife Sarah Child, contained a mahogany sofa, an escritoire, Wedgwood vases, and watercolours of flowers and landscapes.[1] The two rooms are a perfect materialisation of late eighteenth-century gender difference, elite lifestyles, and elite identities. Child's telescope signals a polite interest in scientific instruments and his consumer discernment; the Dollands were renowned opticians and held the Royal Warrant. The gun, made by Edward Bate, a famous gunsmith, and fishing rods speak to his country pursuits of shooting and fishing – the preserve of a wealthy, male landowner with time to spare. The mahogany shaving stand suggests Child's dutiful maintenance of a well-shaven face, as well as his taste for luxury, exotic materials. The mahogany furniture and, more obviously, the Indian sabre point to the Child family's imperial connections and the global, and violent, origins of their significant wealth as an East India Company family. But these objects had lives before the Osterley closet, on plantations, at colonial frontiers, in dirty workshops, and glittering shops. The closet's objectscape therefore connected Child to fashion, cultivation, mobility, power, production, and labour – key issues that animated the eighteenth-century world.

Child's closet is a revealing site to us of an eighteenth-century elite man's material world and was itself a carefully curated space populated with the requisite objects to construct and express Child's social power, worldly wealth, elite status, refined taste, rational discernment, and dynastic lineage, as well as his manly pastimes and his masculine interests. The display, material upkeep, and material qualities and properties of these things as well as the mere ownership or possession of them worked together to materialise Child's masculinity. The materiality of this, very private, room illustrates that Child fostered central tenets of his masculine selfhood and his social identities through goods; Child knew who he was through these things and communicated his material self to others. Not all men in eighteenth-century Britain possessed such a house or populated it with such luxuries. The Childs were an upwardly mobile family whose rise from an obscure London goldsmith family in the mid-seventeenth century to a powerful landed and titled banking dynasty by the mid-eighteenth century was made possible by the mercantilist capitalism underpinning imperial expansion. The Childs were both actors in and exemplary of the commercialisation of eighteenth-century Britain, which unsettled early modern social, economic, and gendered hierarchies and distinctions.

Material Masculinities explores these issues of gender, materiality, and commercialisation during this period of rapid social and economic change. It provides the first systematic study to examine the processes, dynamics, and motivations of middling and elite men's material engagement and consumer participation in this burgeoning consumer society. More so than previous works, this book explores the consequences of this material engagement for both men and goods. In doing so, it demonstrates how men's material practices and interactions with their possessions informed the materiality of masculine selfhood and social identities. The book highlights the significant power dynamics of gendered materiality and, rather than surveying the often-repeated cultural anxieties surrounding masculine material engagement, seeks out the ways in which eighteenth-century men wielded their gender power and navigated social distinctions when designing, altering, repairing, purchasing, reselling, and gifting their possessions. Masculine materiality – these material practices, interactions, and experiences – therefore transformed eighteenth-century material and consumer culture. Men and things had a

reciprocal relationship in the eighteenth century; consumer goods shaped, and were shaped by, eighteenth-century men's lives.

Surveying over 1,000 material lives in an abundance of historical evidence ranging from personal testimony, administrative and financial documents, and court records to objects, portraiture, and buildings, this book unearths the significance of masculine materiality to eighteenth-century gendered and social power. Since the 1990s, eighteenth-century women's material selfhoods and consumer behaviours have, rightly, been excavated to show the rich materiality of femininities and womanhood.[2] Eighteenth-century women were eager, active, and skilled consumers and producers of material things – and women's material knowledges and literacies formed a significant part of female agency in the period. Since 2000, scholarship has unquestionably shown that men were active participants in a consumer society buying for their persons, their families, and their communities.[3] Yet the history of eighteenth-century men's material and consumer culture, focusing mostly on masculine dress and men's domestic consumption, is largely a response to scholarship on women's consumerism.[4] Instead, *Material Masculinities* surveys both a diversity of objects – in terms of production, cost, scale, material, ornamentation, and finish – and men, in terms of their position in the household, life course, locale, social rank, and profession.[5] Taking a more systematic and holistic view than previous studies, this book reveals not only the complexities of eighteenth-century masculine material experience but also the centrality of it to men's lives. In doing so, it also positions men as drivers of commercial, aesthetic, and material change in the period.

Masculine materiality had diverse dynamics and motivations, but my investigation of middling and elite eighteenth-century men finds that regardless of these men's age, position in the social hierarchy, pursuits, and location material things were necessary for the successful operation of a masculine identity. The book examines five 'material masculinities': boyhood, householder, mobile man, discerning consumer, and gentleman sportsman. These masculinities encompass a diversity of masculine experience from old and young, middling and elite, landed and moneyed, urban and rural, married and unmarried, and nationalistic and cosmopolitan men. While the 'gentleman sportsman' and 'mobile man' are certainly masculinities more pertinent for men at the upper echelons of society, the generality

of these material masculinities enables a comparison of how these masculinities were formed differently between social groups and across the life course. My material masculinities are concerned with masculine duties such as providing for and managing the household, while others explore masculine leisure and sociability. They are not limited to men of certain occupations, professions, or locales and are not masculinities born out of cultural anxieties over male fashionability, but masculinities that could be long-standing, such as the householder and boyhood that, in the eighteenth century, saw a particularly material development in their construction and operation. Others are new to the eighteenth century, such as the gentleman sportsman – emergent after the late seventeenth-century Game Laws – and the 'discerning consumer', who came under increased scrutiny in the eighteenth century. Historians have fruitfully studied the material lives of the bachelor, the sailor, and the militia man yet such figures are limited to a particular realm of masculine experience.[6] The 'material masculinities' under study here are purposefully broad in configuration to enable a more systematic and comprehensive study of masculine materiality than previously undertaken by scholars of masculinity and material culture. The goods that help construct these masculinities are equally wide ranging from the small and inexpensive to the luxurious and large-scale. I chart the emergence of these eighteenth-century 'material masculinities' and stress that, increasingly, identities had to have a material base in a burgeoning consumer society to remain meaningful. Yet not just a mere reflection or symbol of men's identities, eighteenth-century goods were helpful tools and props in identity formation and performance – how you proffered your snuffbox, held your cane, and drove your carriage all demonstrated to others your masculinity and helped set masculinities apart.

Approaching masculinities and materialities

In the 1990s, the history of masculinity emerged out of a growing dissatisfaction with women's and gender history's emphasis on public and private frameworks for understanding the operation of gender in historical contexts.[7] Gender historians in the 1980s eagerly adopted the 'separate spheres' paradigm to argue that the separation of men's

and women's work, space, religion, and education was central to their gender and class identities.[8] Leonore Davidoff and Catherine Hall's *Family Fortunes* (1987) made a concerted effort to shift discreet discussions of women's domesticity and men's public roles to an analysis of the roles and identities of nineteenth-century men and women in both domestic and public life.[9] Among a host of criticisms of its chronology and applicability, Joan W. Scott famously warned against separate spheres' biological essentialism, which perpetuated a rigidly patriarchal, binary categorisation of gender dynamics and identity in historical analysis.[10] The history of masculinity aimed to deconstruct and reposition such biological essentialism; there is no eternal man, but men, made distinct by historically and spatially contingent constructions and experiences of class, race, sexual orientation, and geography that often intersect with one another.

But the history of masculinity, unlike women's history, the history of race, and LGBTQ+ histories, emerged as an intellectual project, as Matt Houlbrook, Katie Jones, and Ben Mechen observe, without an associated liberation movement underpinning its trajectory and politics.[11] Instead, it developed through an eager engagement with the existing field of the sociology of masculinity. Raewyn Connell's foundational *Masculinities* (1993) approached the masculine subject as a critical and social structure. In doing so, she argued that 'masculinity' and 'patriarchy' are not synonymous categories or structures, and not all men benefit in a patriarchal society. Connell's paradigmatic theory of 'hegemonic masculinity' espoused that historically contingent masculine ideals are asserted by a small elite of typically white, heterosexual, and economically successful men to maintain their social and political authority. However, hegemonic masculinity is always dependent on its complicit accomplices, and the subordination and marginalisation of other 'masculinities' – non-white, homosexual, and working class.[12]

It is hard to overstate the influence of Connell's theory on the field. The masculinities hierarchy provided historians with an analytical structure to destabilise and decentre the 'male standard' and to examine men's changing experience and representation over time.[13] Yet in application, social scientists criticised Connell's hierarchy of 'masculinities' as a static set of universalist, essentialist typologies that understated the importance of relations between genders in the formation of gendered experience, identity, and

power. Historians agreed – Alexandra Shepard argued for a more fluid interaction between these typologies in the context of early modern manhood.[14] Ben Griffin's 2018 appraisal and reframing of 'hegemonic masculinity' called for masculinities historians to think more critically about the 'cultural contestation of ideal types; individual attempts to identify with those cultural types; processes by which those attempts are accorded recognition by others; and processes by which individuals are positioned in relation to institutional practices, rewards and sanctions'.[15] This book joins such calls and argues that materiality was significant to the social practice of eighteenth-century masculinities; the processes Griffin outlines are, in the context of the commercialisation of eighteenth-century society, particularly material in dynamic and operation. Houlbrook, Jones, and Mechen's *Men and Masculinities in Modern Britain* (2024) informs much of my approach to masculinity in the late early modern period. They, and their contributors, build on much of Connell's defence of her theory outlined in 2005 by approaching masculinity not as a structure of static typologies but as a structure '*as* and *in* process'. In doing so, they assert that men do not find themselves within these structures but are themselves agential in their creation and maintenance, and such processes are historically and spatially specific.[16] Houlbrook, Jones, and Mechen's assertion that 'masculinities and men are made' rather than performed has proven more fruitful in examining eighteenth-century men's materiality than other gender theories such as gender-as-performance.[17] Certainly, the politics of display is present both in the operation of gender identities and material culture and it is useful to consider eighteenth-century goods as props in the performance of communicating material messages about gendered and social identities to materially literate audiences. Masculinities, historians have convincingly shown, can be embodied, materialised, and emoted as well as performed. Indeed, as Joanne Begiato's recent study of nineteenth-century British manliness reminds us, studying masculinity-as-performance often obscures from the historians' purview other important terms such as 'manhood' and 'manliness' as well as producing, as it did in the 1990s, a focus on the cultural construction and performance of masculine character types.[18]

The 'material masculinities' this book examines are intersectional identities rather than relational cultural characters; they are animated

by the lifecycle and age, social class and wealth, household position, geography, and mobility. It was possible for many men to invest in these different masculinities at the same time and move between them over the course of their lives. These six masculinities could be materially acquired, repaired, altered, and lost and were therefore fluid, overlapping, and often unstable identities. They were always contingent and in the process of becoming or maintaining rather than fixed relational categories. In *Material Masculinities*, masculine selfhoods were not merely fashioned but materialised, made, and produced in eighteenth-century England. My purpose here is to highlight the processes involved in 'masculine materiality' – the diverse forms of material engagement men undertook – and in doing so the book thinks more about materiality and materialisation than material culture and the making of masculinities rather than fixed gender identities which then find material expression. In approaching both 'masculinity' and 'materiality' in this way, the book argues that the processes of gender construction mirrored, and even relied on, the wider languages and processes of producing and making goods in the period.[19] Men used objects to acquire, assert, and exercise power, in its many forms, over women and over other men through their position in the household, life course, locale, social hierarchy, and profession.

Materiality, a concept that owes much to a Marxian and Latourian intellectual tradition, makes abstract power visual, tangible, and fundamentally knowable. Taking anthropologist Daniel Miller's definition of materiality as the 'interactional process between humans and things [that] works to order, shape, and transform the world,' *Material Masculinities* argues that men turned to things to understand or obtain their place in the world precisely because materiality was useful to them in acquiring, asserting, or exercising power.[20] Building on Scott's assertion that gender is a useful category of historical analysis, the history of masculinity has highlighted masculinity's utility for understanding wider historical phenomena and processes. The patriarchal social order of early modern England existed within 'a grid of power', Michael Braddick and John Walter argue, comprising intersecting social, economic, legal, and broadly defined, political hierarchies. Under this framework, access to power was determined by individuals' ranking within a wide number of social orders and position within their hierarchies.[21] A man's access to power was

determined, then, by his position in the household, occupation/ profession, birth right, education, social networks, religious belief, and enfranchisement. Patriarchal power was articulated through religious, moral, and political thought and medical, legal, and economic practice – all of which assumed male superiority while possessing inherent contradictions and complexities.[22] Penelope J. Corfield's study of the language of class in eighteenth-century Britain concludes: 'power was resynthesised into active terms, of acquisition, production, and display, rather than of inheritance, formal title, and ancient lineage'.[23] It is precisely this destabilisation of existing power structures that makes eighteenth-century masculinities such a rich and fruitful field of enquiry. This book situates masculinity within the rise of market economies in eighteenth-century Britain, a process which undeniably destabilised the traditional early modern grids of power. Simply put, in the eighteenth century, more men and women had more money to spend, their choices concerning that spending were motivated by a host of factors and practised through a variety of strategies. Such motivations and behaviours reveal the material nature of patriarchal power in the period. Particularly for this book, forms of men's economic power, social privileges and distinctions, and legal customs underpin the forms and contours of masculine materiality it explores.

Goods, in this book, are not mere symbols of masculine expression but tools in its production. Accordingly, the book approaches masculinity and materiality as interactional, entwined even, historical processes that worked together to order and shape the eighteenth century as it grappled with the social and cultural changes brought about by industrialisation and commercialisation. If 'hegemonic masculinity' must shift, innovate, and respond to 'threats' to retain its dominance, as Connell argues, then we can understand the reciprocal relationship between men and material objects as responding, innovating, and adapting to retain or acquire dominance.[24] Importantly, this is how a book on masculinity and materiality differs from one on women. Studies of the English Common Law coverture, the legal custom which limited a married woman's property to her *bona paraphernalia* (small moveable goods which she could keep about her person), have fruitfully examined eighteenth-century women's legal ownership of goods.[25] Scholars subsequently examined women's material experiences, practices, knowledges, and selfhoods to unearth

both women's subordination and their consumer agency and skill. Yet men's material knowledges and engagement were just as integral to early modern manhood and masculinity as the familiar tenets of honour, honesty, self-governance, independence, economy, and authority that have been explored by other historians.[26] In fact, the book highlights how materiality enabled the operation of such masculine attributes. Therefore, in surveying men's material lives, this book explores the materiality of eighteenth-century gender relations and power dynamics.

In an age before the centralised factory, mass-production, and mass-markets, eighteenth-century people had considerable knowledge of their possessions, in part, because they were more involved in their production, repair, and reuse than modern consumers. The surviving order and letter books of England's manufacturers examined in this book are filled with customers repairing their coaches, personalising their canes, buying second-hand card tables, and designing their tableware.[27] Scholars in recent years have become increasingly interested in eighteenth-century material literacies – amateur and professional makers' knowledge of producing things and consumers' understanding of manufacturing.[28] This book focuses mostly on consumers' material knowledge and the phrase is used throughout this work to denote the understanding of the material world formed through possessors' understanding of objects' physical properties or qualities, construction, design features, or aesthetics. I use 'material literacy' to mean the successful deployment of those material knowledges in social practice.[29] Consumption, in this book, is an ongoing material process before and beyond the moment of purchase. I join others in approaching eighteenth-century materiality through a variety of consumer engagement processes but situate gender as a motivating and organising principle of these diverse forms of material interaction.[30] Scholarship on material literacies and knowledges has rightly highlighted women's material, particularly textile, skills but little has been written on the gender differences of material literacies in the period. In doing so, *Material Masculinities* – particularly in Chapter 2 – seeks out where gender animated the formation of material knowledges and where it was absent or shared between both genders.

Middling and elite men's own investment in the material construction and performance of their gender identities materialised immaterial

and abstract gendered values in goods' material qualities (their design, shape, properties, size, aesthetics, and function). Middling men chose mahogany furniture for its exotic yet enduring respectability; the material delicacy of a tortoiseshell snuffbox, like those owned by tea dealer John Brown or gentleman Thomas Littleton, encouraged their owners' refined haptic interactions with them.[31] The owner-driven phaeton, designed with high-spring suspension, was 'feminised' in ladies' phaetons that hung closer to the wheels.[32] Men's choices, desires, preferences, and experiences often informed what goods were made from, how they were constructed, and their social meaning. The reciprocal and dialectical relationship between men and things exposes men's significant material knowledge and literacy of objects' production, design, material qualities, aesthetics, and use in the social choreographies of the nursery, the home, the street, polite society, and even the sporting field. Accordingly, the book positions men and masculinity as contributing to product innovation in eighteenth-century England.[33] Often histories detail what effect the commercialisation of society had on gender identity, *Material Masculinities* joins these works but also writes a history of the impact that gender identity had on commercialisation in a period of sustained commercial growth.

Histories of eighteenth-century gender and materiality

At the centre of this book is a question that historians have long grappled with: how and why did people respond to, and participate in, the commercialisation of eighteenth-century Britain as it developed into a materially oriented consumer society? *Material Masculinities* tells the story of middling and elite men's material lives in a pivotal period of English history. The material expression of gender identities or gendered selfhood was not new to the eighteenth century, but it was in this period that the relationship between people and things became more increasingly meaningful, more intensely debated, and certainly more possible for a greater number and variety of people than ever before. The ever-expanding cohort of middling men, ranging from respectable shopkeepers to wealthy merchants, drove Britain's commercialisation. This diverse social grouping benefitted hugely from the social changes that accompanied their contribution to the

nation's economic growth and cemented their steady accumulation of social capital and economic power. Men of the landed gentry and peerage were by no means absent from this process and were actively engaged in many commercial and industrial endeavours.

These transformations to the early modern social order produced significant tensions within and between eighteenth-century social ranks as many grappled for power and others clung to it.[34] Scholars since the 1980s have intensively explored material culture's significance in how eighteenth-century people responded to these changes and have identified the integrity of material taste and consumer behaviour to classed identities.[35] This book studies middling and elite men's materiality. Issues of preservation of documentary and material evidence make plebeians' material lives more difficult to incorporate into the book's schema. The bulk of this book's evidence draws from propertied, landed, and titled men's material lives, although through sources such as the *Proceedings of the Old Bailey* I seek out, where possible, the experiences and practices of more plebeian men and women. Historical work on eighteenth-century plebeian material culture, particularly by Joe Harley and John Styles, has done much to excavate everyday peoples' often overlooked material lives.[36] Historians of masculinities increasingly study masculine 'communication communities', communities of shared norms, who invest and engage in the mechanisms to produce those norms, which can exist across social classes, geographies, and races.[37] This book argues that eighteenth-century middling and elite men's materiality was particularly useful to them in marking out their participation and belonging in social groups. It argues that the motivations in carving out distinct social identities of middling, propertied, landed, and titled men's consumer behaviour was instrumental in orienting fashions, aesthetics, and product innovation.

In the eighteenth century, more people than ever before could participate in commercial activities as Britain became a manufacturing nation famed for its mechanical and technological innovation – partly the result of its imperial expansion and ruthless participation in global markets. Imported French furniture, Chinese porcelain, and Japanese cabinets populated the homes of the respectable, genteel, and titled. Raw commodities such as sugar, tobacco, and mahogany flowed into Britain from its plantations and colonies and, due to mid-century import substitution policies, were innovatively manufactured into

'British' products.[38] Accordingly, the eighteenth-century consumer was faced with a dazzling array of both domestically produced and internationally imported material goods compared to their early modern antecedents. Such a consumer abundance meant that the mere ownership of certain possessions was no longer itself a signifier of rank. What your breeches were made from, the cut of your coat, the style of your furniture, the quality of your snuff, and the delicacy of your teacups were all potent symbols of, and tools in constructing, who you were, how you saw yourself, and how you wished to portray yourself to others. As examinations of thefts in the *Proceedings of the Old Bailey* reveal, both a farmhand and an aristocrat could own a snuffbox in the eighteenth century and so it was those objects' material qualities that materialised social distinction, with gold chasing setting the upper crust apart from the wooden boxes of the labouring snuffer. Snuffboxes, then, had limited demotic potential themselves and throughout *Material Masculinities* the chapters tease out the tensions between the types of objects and their material forms and properties in the creation of identities and power. This distinctly *material* power explains why men were so invested in the design, construction, and maintenance of their possessions.

Objects were key indicators of both upward and downward social mobility. Newly moneyed men would busy themselves with commissioning the newest carriage model ornamented in the latest designs, and purchasing furniture in the most modish tastes. Newly ennobled men wasted no time in adorning their carriages, tableware, snuffboxes, and guns with their new heraldry upon their receipt of titles. So central were goods to social rank that often the material remnants of an elite lifestyle were all that remained when the creditors called in their debts. The Earl of Northampton mortgaged one of his estates for £7,000 in August 1762 to pay his debts, totalling £3,700 to his coach-maker and tailor.[39] Even the nobility privileged the material trappings of elite status over landownership, its traditional power base, when money was tight.

Commercialisation, industrialisation, and urbanisation destabilised social and gendered hierarchies that many previously thought immutable, and this produced significant cultural anxieties surrounding the moral consequences of Britain's increased wealth. The Anglican cleric John Brown famously wrote in 1757/8 that 'the exorbitant Trade and

Wealth of England sufficiently account[s] for its present Effeminacy'.[40] The increased entanglement of the personal with the material made many despair at the immorality of a society obsessed with things. Scottish philosopher Adam Ferguson wrote in 1767 that Britain had disastrously 'transferred the idea of perfection from the character to the equipage; and that excellence itself is, in our esteem, a mere pageant, adorned at a great expense'.[41] Contemporaries, and many historians, viewed women's supposedly innate weakness for things as driving the 'consumer revolution'.[42] This now-rejected 'Veblenesque' characterisation of women's perilous luxurious consumption has also made historians focus too much on the supposedly 'real threat' of elite men's effeminate, luxurious consumption. Immortalised in the confected stereotypes of the beau, fop, macaroni, and dandy, men's luxurious tastes endangered the nation's economic, political, social, and cultural existence. Historians' examination of eighteenth-century politeness, a dominant eighteenth-century cultural paradigm that emerged out of a European courtly civility emphasising men's learned conversation and refined deportment, focused on the 'polite gentlemen'.[43] Politeness, Laurence Klein argues, emolliated sociability in Britain's urbanising and commercialising society. Authority over correct conversation, learning, behaviour, manners, and taste now lay with the whiggish, learned, and refined gentlemen in London's coffeehouses and on the pages of their periodicals rather than emanating from the royal court.[44] Many perceived the polite man's refined manners and magnificent tastes to be a corrosively effeminising continental import. These anxieties peaked at key moments in national life: the burst of the South Sea bubble (1720), the Jacobite Uprising (1745), the Seven Years' War (1756–1763), the loss of Minorca (1756) and the Americas in the 1770s. Many commentators considered the early Tory economic ideology of 'private vices for public benefit' had, by the mid-eighteenth century, produced an effeminate ruling elite and a feeble fighting force.[45]

Studies of men's dress have particularly engaged with these issues of effeminacy, social status, politeness, and luxury. Since psychologist J. C. Flügel's 1930 argument that the eighteenth century witnessed the 'Great Male Renunciation' of magnificent, luxurious dress, fashion historians have plotted the chronology of men's sartorial expression.[46] In the late 1770s, the exhibition of superior rank through affected manners and magnificent dress was considered

un-gentlemanly, foppish, effeminate, and, worst of all, foreign. The story goes that from the ostentatious and magnificent Restoration fashions emerged the sober, modest taste of the middle-class Victorian man. Flügel has had a long legacy in histories of masculine dress but his characterisation of a 'renunciation' has been significantly revised, if not somewhat exploded, most notably in Christopher Breward's 1999 book on fashionable, urban Victorian masculinities.[47] Yet it is truly surprising why no historian has yet applied the 'Great Male Renunciation' to men's wider material practices beyond clothing. *Material Masculinities* expands the remit of this simplification process to a wider material base. Snuffboxes, guns, carriages, and fob watches, for example, underwent a significant material evolution over the period, from rich and luxurious ornamentation to simpler, plainer designs. This was matched with an aesthetic shift from the florid baroque and rococo styles of the early eighteenth century to neoclassicism's geometric purity. Men's own consumer desires and material literacy were significant drivers of this process. Their letters to manufacturers demonstrate significant knowledge of products' design, construction, and decoration. In correspondence to others, men shared news of latest fashions, recommended particularly good makers, and would complain bitterly if tradesmen did not realise their visions.

But why, in this increasingly anxious climate surrounding the moral degeneracy of luxurious consumption, did so many eighteenth-century men engage in the consumption of material goods with such eagerness? Recently historians of masculinity have highlighted the materiality of masculine identity formation to justify the importance of material goods for a host of masculine identities and experiences. This shift has moved the conversation past the long shadow that potent eighteenth-century polemics on effeminate masculinity have cast on the history of men's material lives.[48] This effort was part of a wider historiographical shift, in the 2000s, away from the cultural constructions of polite, sentimental, or effeminate masculinity in printed materials to men's social experience in their life-writing.[49] *Material Masculinities* similarly finds little 'crisis of masculinity' in the men's material lives under study. Certainly, there were anxieties, concerns, and aspirations present in men's material choices, but often the new and ascendant middling social order animated the consumer choices and material practices of the gentry and aristocracy

and vice versa.[50] After many fruitful examinations of women's domestic responsibilities and experiences, historians resituated men, and their power, in the eighteenth-century home and domestic life.[51] Men's domestic consumption was particularly helpful in providing a more assuredly social history of early modern manhood and eighteenth-century masculinity. *Material Masculinities* further examines masculine materiality both within and beyond the home. In doing so it thinks about both the social dynamics and cultural constructions of men's material lives in both public and private contexts – and, indeed, the slippage of the public and the private worlds in the making of masculine identities.

Material Masculinities focuses forms and experiences of masculine power and powerlessness in eighteenth-century material and consumer history. It is not a history of 'pretty things' and 'pretty gentlemen' but about power, regarding both powerful things and the forms of power men wielded through and with them. Rather than focusing solely on identity formation, I instead ask: how did material goods aid boys and men in the construction and operation of social and gendered power beyond dress and the home? To investigate 'manly' experiences rather than 'masculine' cultural identities, a recent cluster of historians have examined 'embodied' masculinity, the sensory experience of the material body, and its implications within wider cultural, social, political, and national debates. Importantly, this focus on emotive and embodied manliness examined the body's interaction with material things.[52] While identity formation and social power are integral to this book's survey of masculine materiality, it also explores men's emotional and embodied responses to feelings of power and powerlessness that material objects could spark.

Themes in *Material Masculinities*

Five key themes emerge from this survey, which represent the nature and complexities of men's material lives from the late seventeenth to the early nineteenth century. The first is *gendered power*. All five chapters engage with the ways in which gender difference and patriarchal masculinity were materially demarcated and enacted. Over the course of the eighteenth century, children's material culture, the focus of Chapter 1, increasingly re-enforced gender difference.

Dolls were the stuff of many girls' dreams and were the replica of an idealised female form. While boys envisaged riding out on their rocking horse, girls were kept busy with the dress and wigs of their dolls. The male clientele in the furniture-maker order books examined in Chapter 2 were keen and skilled consumers who prudently furnished their homes, a key site of their masculine power. In Chapter 3, men of the upper middling sorts, gentry, and aristocracy lavished time, money, and emotional investment in their mobility. Under English Common Law coverture, husbands, not wives, owned carriages and women's mobility and the requisite finances to commission and keep a coach was the preserve of only the wealthiest of widows – few frugal spinsters could afford the luxury and dignity of a private coach of their own. As such, men's mobility – a key indicator of manly independence – was privileged and protected by men in the period. Together these chapters reveal the centrality of material goods throughout the life course and at key moments in men's lives. They informed key experiences of becoming and being a man and the acquisition of manly power.

The second theme is *social distinction*. Eighteenth-century commercialisation and industrialisation unsettled the early modern social order, and social mobility was both made possible by, and evident through, new material expressions of wealth acquisition. As domestic manufacturing boomed, eighteenth-century Britons became more knowledgeable of, and involved in, the production of their possessions.[53] In this unique climate of domestic production, goods' design was a potent tool in acquiring or policing social distinctions. The material qualities of objects, from furniture and carriages to accessories and guns (explored in Chapters 2, 3, 4, and 5) were often determined by their consumers, and these material properties worked to enforce social distinctions. The mere ownership of some goods, such as the prohibitively expensive carriages of Chapter 3 and legally prohibited guns in Chapter 5, helped retain material exclusivity. Where ownership was commonplace, such as domestic furniture or accessories, the material qualities of these objects informed and expressed social rank. In Chapter 2, the prudent middling clientele of upholsterer Robert Williams invested in durable, solid mahogany furniture but the more elite clients of James Brown, cabinet-maker of St Paul's Churchyard, splurged on fashionable Chippendale designs in a variety of *á la mode* colours, styles, and fabrics. Chiding the

elite's extravagance, many middling manufacturers, such as the Anti-Gallican Society founded c.1745, produced creamware and enamelware to cater to more sombre tastes of patriotic, middling consumers.

The third theme is *material interaction*. My focus on materiality – rather than material culture – enables the book to chart practices and experiences rather than approaching men's things as merely symbols or projections of their masculinity. Goods' material qualities also informed their use in eighteenth-century social choreographies. Proffering your snuffbox had a gestural language attached to it depending on whether you were interacting with a friend, a lover, or a stranger. In 1711, one satirical advert by famed perfumer Charles Lillie in *The Spectator* explained the 'the Careless, the Scornful, the Politick, and the Surly Pinch, and the Gestures proper to each of them'.[54] The 'discerning consumer' did not just own a refined and elegant snuffbox, but used it deftly in a more codified society of polite manners. The material refinement of these goods – their fine metalwork, delicate ceramics, or fragile tortoiseshell – encouraged the snuffer's slick haptic interactions with them. Chapter 5 thinks through the politeness of hunting and shooting in eighteenth-century England. Treatises on shooting, such as George Edie's *The Art of English Shooting* (1775), instructed gentlemen sportsmen to call upon polite forms of bodily movement to remain calm, composed, and, importantly, genteel when deploying their guns.[55] In a culture that often privileged 'polite' and elegant forms of social interaction, goods' material qualities informed polite distinctions across and within social ranks, and polite material culture was key to materialise social and classed gendered divisions. Goods, such as snuffboxes, canes, guns, and carriages, were deemed polite or impolite, and the same type of object could be both in different contexts, through men's and women's interaction and use of these objects. Abstract cultural ideas of polite refinement were materialised in the design of objects and practised in their use in the social choreographies of polite society. Together these chapters illustrate that goods were not just markers, or symbols, of masculine politeness and social distinction, but were actors in the creation and maintenance of these identities.[56]

Material Masculinities both centres materiality in masculine power and examines men's *material experiences* through and of their

possessions. As goods became more integral to selfhood and identity, eighteenth-century people invested significant emotion in their possessions and had emotional responses to owning, repairing, and most importantly, gifting goods. The chapters in *Material Masculinities* explore how objects informed men's emotional and embodied experiences of material culture. The final theme is *material change*. All chapters in *Material Masculinities* engage with the changing design of objects across the period. As carriage ownership increased over the course of the century, coach design changed. The ornate rococo carriages of the early eighteenth century were simplified, by the century's close, into plainly varnished coaches. By 1800 only a cipher, crest, or coronate denoted the owner's status – a middling merchant's cipher could not compete with the prestige of noble heraldry. Guns, too, became less ornate with plainer decorative metalwork; snuffboxes were simply chased in gold and silver rather than the florid designs of Meissen and Sevres. This revisiting of the 'Great Male Renunciation' highlights its continued utility for understanding masculine expression in the period.

Sources and methodologies

Object-studies of specific instances of men's material culture have often used objects as methodological tools to understanding eighteenth-century masculinities, and have paid less attention to the meanings behind men's interaction with their material worlds as a discrete subject of historical investigation.[57] To borrow Giorgio Riello's terminology, historians have mostly adopted a 'History *from* Things' rather than a 'History *of* Things' approach.[58] *Material Masculinities* combines these approaches and adopts an object-driven approach to material goods – considering objects' meaning as evidence of social relationships as well as their materiality – by detailing what it was about commodities themselves that appealed to men and what this suggests about men and masculinities in the period.[59] This focus on material goods' physicality moves beyond the limiting categories or descriptors of 'old', 'new', 'luxury', and 'novelty' goods, that are most often found in studies of early modern inventories, which do not fully reveal the complexities of eighteenth-century materiality.[60] Materiality fundamentally concerns modes of interaction between

matter; I approach the goods studied here not just as material symbols but think about their haptic qualities, their relationship to the body, their ability to evoke emotion, as well as the sorts of social and cultural messages they communicate.

While scholarship on men's consumption often relies on personal testimony, *Material Masculinities* surveys a host of historical evidence, from extant objects themselves to documentary and visual evidence ranging from portraits, trade cards, account books, manufacturer order books, bills and receipts, inventories, and court records.[61] Such a multi-source, 'object-driven' approach enables the book to unearth what an object meant to its owner (using life-writing) and the accessibility of that object type to different occupations (using quantitative data from court records or manufacturers accounts). Material things, from the handheld to the horse-drawn, the bespoke to the mass-produced, the new and the second-hand, and the strategies by which they were acquired, and the diversity of their meanings animated eighteenth-century men's lives from infancy to old age. In this work, fixed and moveable property, such as country houses and guns, and small and large commodities, such as snuffboxes and carriages, are all examined to reveal the materiality of masculine identities and experience in the period. Some objects cost tuppence and others thousands of pounds, while others were inherited, gifted, loaned, repaired, or repurposed. Such diverse men and objects under study in *Material Masculinities* makes it the first book dedicated to men's material culture, their material literacy, preferences and practices, and consumer behaviours throughout the course of the long eighteenth century through a variety of goods.

Most goods discussed in the documentary sources of this book – such as coachman John Forstesque's chased silver snuffbox stolen in 1747 and merchant Peter Cox's mahogany and silk armchairs bought in 1784 – do not fill the stores of the British Museum or Victoria and Albert Museum; this material absence is compounded by the very nature of eighteenth-century goods ownership as reselling, repairing, and repurposing goods were commonplace and everyday material practices.[62] While extant toys, furniture, carriages, accessories, and guns are examined here, they sit alongside documentary evidence. Through this abundance of sources, this book pieces together the fragmentary picture we have of masculine materiality, which often appears as chapters or articles, to provide a broader and

more systematic picture of masculine materiality than the existing object-studies of men's things. In doing so, it approaches objects as eighteenth-century men would have done as part of their everyday experiences, their emotional lives, their construction of masculine identities, and their acquisition and exercise of social and gendered power.

Summary

Chapter 1 examines 'boyhood' as a material masculinity and explores the ways in which gender difference was instilled materially in childhood and adolescence. Material things, it argues, helped inform childhood as a distinct stage in the life course, marked boys' and girls' progression and maturation through it, and, importantly, worked to inculcate and reproduce gendered and social expectations. The emergence of boys' things was a response to boyhood becoming a more definable and recognisable life phase during this period. Chapter 2 surveys the consumer behaviour of middling and elite 'householders' in three London furniture-makers' order books (Robert Williams of Bow Street, James Brown of St Paul's Churchyard, and Gillows of Oxford Street). It combines the qualitative and quantitative approaches of previous studies of household consumption to reveal men's significant investment in the furnishing of their homes as a key site of masculine identity and power. The chapter details what motivated men's and women's consumer and material engagement in the furnishing of their homes and explores when gender did and did not motivate consumer tastes. The chapter analyses men's and women's consumer strategies of furniture and furnishings – looking at order size, total spend, repeat custom, and whether they bought new, second-hand, or repaired goods. Exploring the position of the householder as a material masculinity, not just as a position in the life course, demonstrates how his power, authority, discernment, and provision was materialised in specific and classed ways in the domestic interior. Chapter 3 explores patterns of carriage consumption, ownership, use and decoration to study elites' investment in the carriage, inordinately costly to buy and maintain, as a tool and symbol of mobility which was

increasingly privileged by elites during the eighteenth-century transport revolution. It finds that manly mobility was dependant on material things in eighteenth-century Britain. The coach, then, is important for considerations not just of a commercialising, manufacturing modern society but is a keen example of the materiality of modern masculinity.

Chapter 4 turns to men's accessories and examines the 'discerning consumer'. The chapter stresses the importance of the small, the ingenious, and the delicate for men. Examining cases of stolen toothpick cases, snuffboxes, and canes in the Proceedings of the Old Bailey, the chapter reveals the ubiquity of these accessories across the social hierarchy. Yet how do we square this ubiquitous ownership of 'trifling baubles' with wider issues of material, aesthetic, and technological discernment which became increasingly prized in a period of burgeoning mass consumption? The manufacturing and demand for 'superfluities', such as snuffboxes, canes, and toothpicks supposedly drove the consumer revolution. In this climate, conservative moralists vociferously attacked the effeminacy of men's consumption of trifling things. Yet these novel goods' aesthetic innovation, manufacturing ingenuity, consumer novelty, and ability to denote sophistication enabled consumers to display their consumer discernment and material knowledge. Chapter 5 examines the 'gentleman sportsman' as a consumer and material identity in the eighteenth century. The sporting field, it reveals, was not an escape from the confines of polite society. The chapter studies elite men's gun consumer behaviour, and their material preferences in gun decoration, over the course of the eighteenth century to demonstrate how elite men used luxury objects to construct both a polite and sporting gentlemanly identity that combined to make the 'Gentleman Sportsman'. This chapter uses gunsmith bills and trade cards, extant guns, and household and probate inventories to examine the changing location and display of hunting equipment within the country house. Together, these themes and chapters reveal the reciprocity of masculinity and materiality in eighteenth-century England. Material goods were more than empty vessels of cultural meaning; they are not simply historical evidence with which we can unearth the dynamics of eighteenth-century masculinities, but important actors in the processes and strategies of becoming and being

a man in eighteenth-century England. In a period of rapid social, cultural, and economic transformation, material things gave often intangible masculine values, norms, and ideals tangible significance. The processes and skills of eighteenth-century men's, often everyday, engagement and interactions with material goods had important repercussions on objects' design, use, and meaning. Men were more than mere participants in eighteenth-century England's burgeoning consumer society, they were significant drivers in its dynamics and orientations.

Notes

1 Maurice Tomlin, 'The 1782 Inventory of Osterley Park', *Furniture History* 22 (1986), 117.
2 Notable works include: Amanda Vickery, 'Women and the World of Goods: A Lancashire Consumer and her Possessions, 1751–81', in John Brewer and Roy Porter (eds), *Consumption and the World of Goods* (London, 1993), 274–8; Elizabeth Kowaleski-Wallace, *Consuming Subjects: Women, Shopping, and Business in the Eighteenth Century* (New York, 1997); Jennie Batchelor and Cora Kaplan (eds), *Women and Material Culture, 1660–1830* (Basingstoke and New York, 2007); Maureen Daly Goggin and Beth Fowkes Tobin (eds), *Women and Things, 1750–1950: Gendered Material Strategies* (Farnham, 2009); Maureen Daly Goggin and Beth Fowkes Tobin (eds), *Material Women, 1750–1950: Consuming Desires and Collecting Practices* (Farnham, 2009); Maureen Daly Goggin and Beth Fowkes Tobin (eds), *Women and the Material Culture of Needlework, 1750–1950* (Farnham, 2009); Amanda Vickery, *Behind Closed Doors: At Home in Georgian England* (New Haven, CT and London, 2009); Barbara Burman and Ariane Fennetaux, *The Pocket: A Hidden History of Women's Lives, 1660–1900* (New Haven, CT, 2019); Rosie Dias and Kate Smith (eds), *British Women and the Cultural Practices of Empire, 1770–1940* (London, 2019); Serena Dyer, *Material Lives: Women Makers and Consumer Cultures in Eighteenth-Century England* (London, 2021); Freya Gowrley, *Domestic Space in Britain, 1750–1840: Materiality, Sociability and Emotion* (London, 2022), 101–39.
3 See Margot Finn, 'Men's Things: Masculine Possession in the Consumer Revolution', *Social History* 25.2 (2000), 134.
4 David Kuchta, *The Three-Piece Suit and Modern Masculinity: England, 1550–1850* (Berkeley, CA and London, 2002); Matthew McCormack,

'Boots, Material Culture and Georgian Masculinities', *Social History* 42.4 (2017), 461–79; Karen Harvey, 'Men of Parts: Masculine Embodiment and the Male Leg in Eighteenth-Century England', *Journal of British Studies* 54.4 (2015), 805–6; Beverly Lemire, 'A Question of Trousers: Seafarers, Masculinity and Empire in the Shaping of British Male Dress, c.1600–1800', *Cultural and Social History* 13.1 (2016), 1–22; Amy Miller, *Dressed to Kill: British Naval Uniform, Masculinity and Contemporary Fashions, 1748–1857* (London, 2007); Penelope J. Corfield, 'Dress for Deference and Dissent: Hats and the Decline of Hat Honour', *Costume* 23 (1989), 64–79. For early modern men's dress see Susan Vincent, *The Anatomy of Fashion: Dressing the Body from the Renaissance to Today* (London, 2009); Ulinka Rublack, *Dressing Up: Cultural Identity in Renaissance Europe* (Oxford, 2011); John Styles, *The Dress of the People: Everyday Fashion in Eighteenth-Century England* (New Haven, CT, 2013); Maria Hayward, *Stuart Style: Monarchy, Dress and the Scottish Male Elite* (New Haven, CT, 2020). For nineteenth-century men's dress see Anne Hollander, *Sex and Suits: The Evolution of Modern Dress* (New York, 1994); Anna Clark, *Struggle for Breeches: Gender and the Making of the British Working Class* (Berkeley, CA, 1995), 71; Tim Edward, *Men in the Mirror: Men's Fashion, Masculinity and Consumer Society* (London, 1997); Brent Shannon, *The Cut of His Coat: Men, Dress, and Consumer Culture in Britain, 1860–1914* (Athens, OH, 2006); Laura Ugolini, *Men and Menswear: Sartorial Consumption in Britain, 1880–1939* (Aldershot, 2007).

5 Recent publications tend to focus on masculine subgroups, for example see Karen Harvey, *The Little Republic: Masculinity and Domestic Authority in Eighteenth-Century Britain* (Oxford, 2012); Matthew McCormack, *Embodying the Militia in Georgian England* (Oxford, 2015); Rory Muir, *Gentlemen of Uncertain Fate: How Younger Sons Made Their Way in Jane Austen's England* (New Haven, CT, 2019), Henry French and Mark Rothery, 'Male Anxiety and Younger Sons of the Gentry', *Historical Journal* 62.4 (2019), 967–96; Henry French and Mark Rothery, *Man's Estate: Landed Gentry Masculinities, 1660–1900* (Oxford, 2012); Jon Stobart and Mark Rothery, *Consumption and the Country House* (Oxford and New York, 2019); Sarah Goldsmith, *Masculinity and Danger on the Eighteenth-Century Grand Tour* (London, 2020); Joanne Begiato, *Manliness in Britain, 1760–1900: Bodies, Emotion and Material Culture* (Manchester, 2020).

6 For work on bachelors see Vickery, *Behind Closed Doors*, 56–79; Helen Metcalfe, 'Moving House: Comfort Disrupted in the Domestic and Emotional Life of an Eighteenth-Century Bachelor', in Jon Stobart (ed.),

The Comforts of Home in Western Europe, c.1700–1900 (London, 2020), 181–6. For work on sailors see Miller, *Dressed to Kill*; Begiato, *Manliness in Britain*. For militia men see McCormack, *Embodying the Militia*.

7 John Tosh, 'The History of Masculinity: An Outdated Concept?', in John Arnold and Sean Brady (eds), *What is Masculinity? Historical Dynamics from Antiquity to the Contemporary World* (Basingstoke, 2013), 20–2. Early women's historians examined women's economic lives, see Alice Clark, *Working Life of Women in the Seventeenth Century*, new edition (London and New York, 1992); Ivy Pinchbeck, *Women Workers and the Industrial Revolution, 1750–1850* (London, 1969). For criticisms of this work, see Bridget Hill, 'Women's History: A Study in Change, Continuity or Standing Still?', *Women's History Review* 2.1 (1993), 5–22; Maxine Berg, 'The First Women Economic Historians', *Economic History Review* 45.2 (1992), 308–29; Amanda Vickery, 'Golden Age to Separate Spheres? A Review of the Categories and Chronology of English Women's History', *Historical Journal* 36.2 (1993), 403.

8 Barbara Welter, 'The Cult of True Womanhood: 1820–1860', *American Quarterly* 18.2 (1966), 151–74; Nancy F. Cott, *The Bonds of Womanhood: 'Woman's Sphere' in New England, 1780–1835* (New Haven, CT, 1997).

9 Leonore Davidoff and Catherine Hall, *Family Fortunes: Men and Women of the English Middle Class, 1780–1850* (Chicago, IL, 1987).

10 Joan W. Scott, 'Gender: A Useful Category of Historical Analysis', *American Historical Review* 91.5 (1986), 1057. For further critiques see Hill, 'Women's History', 19; Vickery, 'Golden Age', 385.

11 Matt Houlbrook, Katie Jones, and Ben Mechen, 'Histories of the Present', in Matt Houlbrook, Katie Jones, and Ben Mechen (eds), *Men and Masculinities in Modern Britain: A History for the Present* (Manchester, 2024), 4–5.

12 R. W. Connell, *Masculinities* (Berkeley, CA, 1993).

13 Tim Hitchcock and Michèle Cohen (eds), *English Masculinities, 1660–1800* (New York, 1999), 1; Karen Harvey and Alexandra Shepard, 'What Have Historians Done with Masculinity? Reflections on Five Centuries of British History, circa 1500–1950', *Journal of British Studies* 44.2 (2005), 274–80.

14 Alexandra Shepard, 'From Anxious Patriarchs to Refined Gentlemen? Manhood in Britain, circa 1500–1700', *Journal of British Studies* 44.2 (2005), 281–95. For critiques see Harry Brod, 'Some Thoughts on some Histories of some Masculinities: Jews and Other Others', in D. S. David and R. Brannon (eds), *Theorizing Masculinities* (Thousand

Oaks, CA, 1994). For R. W. Connell and James W. Messerschmidt's rebuttal see 'Hegemonic Masculinity: Rethinking the Concept', *Gender and Society* 19.6 (2005), 836.
15 Ben Griffin, 'Hegemonic Masculinity as a Historical Problem', *Gender & History* 30.2 (2018), 377–400.
16 See Susan D. Amussen, 'The Contradictions of Patriarchy in Early Modern England', *Gender & History* 30.2 (2018), 343–53.
17 Judith Butler, *Gender Trouble: Feminism and the Subversion of Identity* (New York, 1990).
18 Begiato, *Manliness in Britain*, 6.
19 See Ben Jackson, 'To Make a Figure in the World: Identity and Material Literacy in the 1770s Coach Consumption of British Ambassador, Lord Grantham', *Gender & History* (2022), 1–22.
20 Daniel Miller, 'Materiality: An Introduction', in Daniel Miller (ed.), *Materiality* (Durham, NC and London, 2005), 4.
21 Michael Braddick and John Walter, 'Introduction. Grids of Power: Order, Hierarchy, and Subordination in Early Modern Society', in Michael Braddick and John Walter (eds), *Negotiating Power in Early Modern Society: Order, Hierarchy and Subordination in Britain and Ireland* (Cambridge, 2001), 1–42, esp. 38–9.
22 See Alexandra Shepard, *Meanings of Manhood in Early Modern England* (Oxford, 2003); Amussen, 'Contradictions of Patriarchy', 345.
23 Penelope J. Corfield, 'Class by Name and Number in Eighteenth-Century England', *History* 72 (1987), 61.
24 Connell, *Masculinities*, 67–86.
25 Coverture has a detailed history: for eighteenth-century specific studies, see Margot Finn, 'Women, Consumption and Coverture, c.1760–1860', *Historical Journal*, 39.3 (1996), 707–10; Maxine Berg, 'Women's Consumption and the Industrial Classes of Eighteenth-Century England', *Journal of Social History* 30.2 (1996), 415–34; Sandra Cavallo, 'What Did Women Transmit? Ownership and Control of Household Goods and Personal Effects in Early Modern Italy', in Moira Donald and Linda Hurcombe (eds), *Gender and Material Culture in Historical Perspective* (London, 2000), 38–53; Joanne Bailey (Begiato), 'Favoured or Oppressed? Married Women, Property and "Coverture" in England, 1660–1800', *Continuity and Change* 17.3 (2002), 351–72; For how men and women circumvented coverture see Hannah Barker, *Women of Business: Female Enterprise and Urban Development in Northern England 1760–1830* (Oxford, 2006), 134–51; Jan de Vries, *The Industrious Revolution: Consumer Behaviour and the Household Economy, 1650 to the Present* (Cambridge, 2008); Alexandra Shepard, 'Crediting Women in the Early Modern English Economy', *History Workshop Journal* 79.1 (2015),

1–24. For a discussion of the influence of coverture practices on middling men see Harvey, *Little Republic*, 64–98.
26 See early studies of masculinity: Anthony Fletcher, *Gender, Sex, and Subordination in England, 1500–1800* (New Haven, CT, 1995); Elizabeth A. Foyster, *Manhood in Early Modern England: Honour, Sex and Marriage* (Harlow, 1999); Shepard, *Meanings of Manhood*; Harvey, *Little Republic*.
27 See TLA. ACC/0426/001; TNA. C107/109; TNA. C105/5; The National Art Library. VAM 7.
28 Chloe Wigston Smith and Serena Dyer, *Material Literacy in Eighteenth-Century Britain* (Oxford, 2021).
29 For an example of this approach see Jackson, 'To Make a Figure', 1–22.
30 For work on the materiality of consumption see Frank Trentmann, 'Materiality in the Future of History: Things, Practices, and Politics', *Journal of British Studies* 48.2 (2009), 283–307; Maxine Berg, *Luxury and Pleasure in Eighteenth-Century England* (Oxford, 2006); Helen Clifford, *Silver in London: The Parker and Wakelin Partnership, 1760–1776* (New Haven, CT, 2004); Kate Smith, *Material Goods, Moving Hands: Perceiving Production in England, 1700–1830* (Manchester, 2014). For an early and influential example of this approach to alternative consumer practices see Beverly Lemire, *Dress, Culture and Commerce: The English Clothing Trade before the Factory, 1660–1800* (Basingstoke, 1997), 95–120. Laurence Fontaine (ed.), *Alternative Exchanges: Second-Hand Circulations from the Sixteenth Century to the Present* (New York, 2008), 8; Clive Edwards and Margaret Ponsonby, 'Desirable Commodity or Practical Necessity? The Sale and Consumption of Second-Hand Furniture 1750–1900', in David Hussey and Margaret Ponsonby (eds), *Buying for Home: Shopping for the Domestic from the Seventeenth-Century to the Present* (Abingdon, 2008), 117–38; Margaret Ponsonby, *Stories from Home: English Domestic Interiors, 1750–1850* (Farnham, 2007), esp. Chapter 3; Bruno Blonde et al. (eds), *Fashioning Old and New: Changing Consumer Patterns in Western Europe (1650–1900)* (Turnhout, 2009); Jon Stobart and Ilya Van Damme, *Modernity and the Second-Hand Trade: European Consumption Culture and Practices, 1700–1900* (Basingstoke, 2010); Ariane Fennetaux, Amelie Junqua, and Sophia Vasset (eds), *The Afterlife of Used Things: Recycling in the Long Eighteenth Century* (Basingstoke, 2014).
31 TLA. ACC/0426/001; *Old Bailey Proceedings Online* (www.oldbaileyonline.org, version 8.0, accessed 16 June 2023), March 1721, trial of Robert Johnson (t17210301-60).
32 See Ben Jackson, 'The Thrill of the Chaise: Gendering the Phaeton in Eighteenth-Century Literary and Satirical Culture, c.1760–1820',

in Jennifer Buckley and Montana Davies-Shuck (eds), *Character and Caricature, 1660–1820* (London, 2024), 170–97.
33 John Styles, 'Product Innovation in Early Modern London', *Past & Present* 168 (2000), 124–69; Maxine Berg, 'Imitation to Invention: Creating Commodities in Eighteenth-Century Britain', *Economic History Review* 55.1 (2002), 1–30.
34 The transformation of the eighteenth-century social order with the formation and consolidation of middling and commercial sorts has too long and influential a historiography to examine here, for key examples see: Roy Porter, *English Society in the Eighteenth Century* (Harmondsworth, 1990), 1982; J. C. D. Clark, *English Society, 1688–1832: Ideology, Social Structure, and Political Practice During the Ancien Regime* (Cambridge, 1985); Paul Langford, *A Polite and Commercial People: England 1727–1783* (Oxford, 1989); Peter Borsay, *The English Urban Renaissance: Culture and Society in the Provincial Town, 1660–1770* (Oxford, 1991); John Smail, *The Origins of Middle-Class Culture: Halifax, Yorkshire 1660–1780* (Ithaca and London, 1994); Margaret R. Hunt, *The Middling Sort: Commerce, Gender, and the Family in England, 1680–1780* (Berkeley, CA, 1996); David Cannadine, *The Rise and Fall of Class in Britain* (New York, 1999); Keith Wrightson, *Earthly Necessities: Economic Lives in Early Modern Britain, 1470–1750* (London, 2002).
35 See Neil McKendrick, 'Introduction', in Neil McKendrick, John Brewer, and J. H. Plumb (eds), *The Birth of a Consumer Society: The Commercialisation of Eighteenth-Century Britain* (Bloomington, IN, 1982), 1; McKendrick built on the work of Thorstein Veblen, *The Theory of the Leisure Class*. Reprint (Boston, MA, 1973); H. J. Perkins, 'The Social Causes of the British Industrial Revolution', *Transactions of the Royal Historical Society*, 75 (1968), 123–43. For further influential studies see Colin Campbell, *The Romantic Ethic and the Spirit of Modern Consumerism* (Oxford, 1987); Carole Shammas, *The Pre-Industrial Consumer in England and America* (Oxford, 1990); Brewer and Porter, *World of Goods*; Daniel Roche, *A History of Everyday Things: The Birth of Consumption in France, 1600–1800* (Cambridge, 2004); Lorna Weatherill, *Consumer Behaviour and Material Culture in Britain, 1660–1760* (London, 1988), esp. 51–7, 195–7; Jan de Vries, 'Between Purchasing Power and the World of Goods: Understanding the Household Economy in Early Modern Europe', *Consumption and the World of Goods*, 85–133.
36 Styles, *Dress of the People*; Joseph Harley, *At Home with the Poor: Consumer Behaviour and Material Culture in England, c.1650–1850* (Manchester, 2024).
37 Griffin, 'Hegemonic Masculinity', 385.

28 *Material masculinities*

38 See particularly the work of Maxine Berg, 'From Imitation to Invention', 1–30; Maxine Berg, 'In Pursuit of Luxury: Global History and British Consumer Goods in the Eighteenth Century', *Past & Present* 182 (2004), 85–142.
39 Oxford Health Archive. W/D/129/3.
40 John Brown, *An Estimate of the Manners and Principles of the Times*, vol. 1 (London, 1757/8), 161.
41 Adam Ferguson, *An Essay on the History of Civil Society* (London and Edinburgh, 1767), 287.
42 See McKendrick 'Introduction', 1; Elizabeth Kowaleski-Wallace, *Consuming Subjects: Women, Shopping, and Business in the Eighteenth Century* (New York, 1997).
43 Lawrence E. Klein, *Shaftesbury and the Culture of Politeness: Moral Discourse and Cultural Politics in Early Eighteenth-Century England* (Cambridge, 1994), 3.
44 Klein, *Shaftesbury and the Culture of Politeness*, 121–94.
45 For key works on English masculinity and politeness see Michèle Cohen, *Fashioning Masculinity: National Identity and Language in the Eighteenth Century* (London, 1996), 42–3; Philip Carter, *Men and the Emergence of Polite Society: Britain, 1660–1800* (London, 2001); Paul Langford, 'The Uses of Eighteenth-Century Politeness', *Transactions of the Royal Historical Society*, 12 (2002), 311–31; Rosalind Carr, 'A Polite and Enlightened London?', *Historical Journal* 59.2 (2016), 623–34. For work on effeminacy see Linda Colley, *Britons: Forging the Nation, 1707–1837* (New Haven, CT, 1992), 85–98; Kathleen Wilson, *The Sense of the People: Politics, Culture and Imperialism, 1715–1785* (Cambridge, 1998), 185–204. Stephen Moore questions how far the nation actually perceived these events to be crises of national masculinity, and argues that the public were uninterested in questions of gender in time of national crises, see '"A Nation of Harlequins"? Politics and Masculinity in Mid-Eighteenth-Century England', *Journal of British Studies*, 49 (2010), 514–59.
46 J. C. Flügal, *The Psychology of Clothes* (New York, 1930); Anne Buck, *Dress in Eighteenth-Century England* (New York, 1979). Many works build on Flügel but see P. J. Corfield, 'Dress for Deference and Dissent: Hats and the Decline of Hat Honour', *Costume* 23 (1989); Langford, 'Uses of Eighteenth-Century Politeness'; Kuchta, *Three-Piece Suit*; Karen Harvey, 'Men of Parts: Masculine Embodiment and the Male Leg in Eighteenth-Century England', *Journal of British Studies* 54.4 (2015), 797–821.
47 Christopher Breward, *The Hidden Consumer: Masculinities, Fashion and City Life, 1860–1914* (Manchester, 1999).

48 Claire Walsh, 'Shops, Shopping and the Art of Decision Making in Eighteenth-Century England', in John Styles and Amanda Vickery (eds), *Gender, Taste, and Material Culture in Britain and America, 1700–1850* (New Haven, CT, 2005), 162–8; Berg, *Luxury and Pleasure*; Karen Harvey, 'Barbarity in a Teacup? Punch, Domesticity, and Gender in the Eighteenth Century', *Journal of Design History*, 21 (2008), pp. 205–21; David Hussey, 'Guns, Horses and Stylish Waistcoats? Male Consumer Activity in Late-Eighteenth- and Early-Nineteenth-Century England', in David Hussey and Margaret Ponsonby (eds), *Buying for the Home: Shopping for the Domestic from the Seventeenth Century to the Present* (Farnham, 2008), 47–72; Vickery, *Behind Closed Doors*, 166–83; Harvey, *Little Republic*, 99–133; Charles Ludington, *The Politics of Wine: A New Cultural History* (London, 2013); Kate Smith, *Material Goods, Moving Hands: Perceiving Production in England, 1700–1830* (Manchester, 2014); Alun Withey, *Technology, Self-Fashioning and Politeness in Eighteenth-Century Britain: Refined Bodies* (Basingstoke, 2016); Elizabeth A. Williams, 'A Gentleman's Pursuit: Eighteenth-Century Chinoiserie Silver in Britain', in Jennifer G. Germann and Heidi A. Strobel (eds), *Materializing Gender in Eighteenth Century Europe* (London, 2017), 105–19; McCormack, 'Boots', 461–79; Kate Smith, 'Manly Objects: Gendering Armorial Porcelain Wares', in Margot Finn and Kate Smith (eds), *The East India Company at Home, 1757–1857* (London, 2018), 113–30. For work on the earlier period, see Evelyn Welch, *Shopping in the Renaissance: Consumer Cultures in Italy, 1400–1600* (New Haven, CT, 2005), 212–44; Linda Levy Peck, *Consuming Splendour: Society and Culture in Seventeenth-Century England* (Cambridge, 2005).

49 Karen Harvey and Alexandra Shepard, 'What Have Historians Done with Masculinity? Reflections on Five Centuries of British History, circa 1500–1950', *Journal of British Studies*, 44.2 (2005), 275.

50 This is not to say that this was particularly driven by aspiration or emulation – characterisations made in the 'Consumer Revolution' thesis of the 1980s and 1990s – but rather that these social groups are responding to one another's consumer behaviour and class-formation.

51 Scholars were responding to the pioneering work of John Tosh on nineteenth-century masculine domesticity. See John Tosh, *A Man's Place: Masculinity and the Middle-Class Home in Victorian England* (New Haven, CT, 1999). For work on eighteenth-century men and private and public life see Matthew McCormack, *The Independent Man: Citizenship and Gender Politics in Georgian England* (Manchester, 2005), 27; Vickery, *Behind Closed Doors*, 49–82, 184–206, 207–30; Harvey, *Little Kingdom*; Henry French and Mark Rothery, *Man's*

Estate: Landed Gentry Masculinities, 1660–1900 (Oxford, 2012), 242–3

52 For work on masculine emotions see Thomas Dixon, *Weeping Britannia: Portrait of a Nation in Tears* (Oxford, 2015), 101. Historians have favoured the courtroom as a space in which a range of, sometimes conflicting, manly emotions were performed, see Thomas Dixon, 'The Tears of Mr Justice Willes', *Journal of Victorian Culture* 17.1 (2012), 1–23; Katie Barclay, *Men on Trial: Performing Emotion, Embodiment and Identity in Ireland, 1800–45* (Manchester, 2018). Joanne Begiato has detailed how, in naval contexts, men's emotions often undermined the manly ideal; Joanne Begiato (Bailey), 'Tears and the Manly Sailor in England, c.1760–1860', *Journal for Maritime Research* 17.2 (2015), 117–33. For key work on embodied manliness, see Matthew McCormack, *Embodying the Militia*; Begiato, *Manliness in Britain*; Harvey, 'Men of Parts', 815.

53 Wigston Smith and Dyer, *Material Literacy*.

54 Richard Steele, 'No. 138, Wednesday, August 8, 1711', in Donald F. Bond (ed.), *The Spectator*, vol. 2 (Oxford, 1987), 46–7.

55 George Edie, *The Art of English Shooting* (London, 1775).

56 My choice of the word 'actor' here bears further exposition. The work of Bruno Latour, *Reassembling the Social: An Introduction to Actor-Network Theory* (Oxford, 2005) and Jane Bennett, *Vibrant Matter: A Political Ecology of Things* (Durham, NC, 2010) has proved very influential for material culture studies in recent years. My approach here is historical and not the political or philosophical projects of new materialism scholars like Latour and Bennett. *Material Masculinities* stops short of making *sustained* materialist ontological arguments about historical 'thing-power' or 'objects-as-actants', but the book does consider the vitality and vibrancy of objects in the creation of historical social identities and interactions.

57 Harvey, 'Barbarity in a Teacup?', 205–21; Harvey, 'Men of Parts', 797–821; Karen Harvey, 'Craftsmen in Common: Skills, Objects and Masculinity in the Eighteenth and Nineteenth Centuries', in Hannah Greig, Jane Hamlet, and Leonie Hannah (eds), *Gender and Material Culture, c.1750–1950* (London, 2015), 68–89; Williams, 'A Gentleman's Pursuit', 105–19; McCormack, 'Boots', 461–79; Smith, 'Manly Objects', 113–30.

58 Giorgio Riello, 'Things that Shape History: Material Culture and Historical Narratives', in Karen Harvey (ed.), *History and Material Culture: A Student's Guide to Approaching Alternative Sources* (London, 2013), 28–9.

59 'Object-driven' is an approach to material culture coined by anthropologist Bernard Herman in *The Stolen House* (1992). For comprehensive overviews of material approach to history see Karen Harvey, 'Introduction: Practical Matters', in Harvey (ed.), *History and Material Culture*, 1–23.

60 For work on the possibilities and limitations of inventories as early modern sources see Giorgio Riello '"Things Seen and Unseen": The Material Culture of Early Modern Inventories and Their Representation of Domestic Interiors', in Paula Findlen (ed.), *Early Modern things: Objects and Their Histories, 1500–1800* (London, 2013), 120–50; Lena Cowen Orlin, 'Fictions of the Early Modern English Probate Inventory', in Henry S. Turner (ed.), *The Culture of Capital* (London, 2002), 51–83.

61 The focus on personal testimony was adopted due to Sara Pennell's call to put the 'consumer back in consumption' after years of approaching consumption through inventory studies. See Sara Pennell, 'Consumption and Consumerism in Early Modern England', *Historical Journal* 42 (1999), 549–64. Diaries form the source base of Finn, 'Men's Things', 1–34; Hussey, 'Guns, Horses and Stylish Waistcoats?', 47–72; Harvey, *Little Republic*, 7–8.

62 TNA. C107/109.

1

Boyhood: playing at manhood

Toys, and children's material culture more broadly, were important tools in the process of gender formation in eighteenth-century England.[1] Treatises on childhood and education often discussed the role toys played in the formation and inculcation of gendered attributes in children. Jean-Jacques Rousseau's 1762 educational treaty *Emile; Or, On Education* espoused an explicitly gendered observation of children's play and toys despite its influence in calling for childhood to be an unrestricted age of organic knowledge acquisition. Rousseau wrote:

> Boys seek movement and noise, drums, boots, little carriages; girls prefer what presents itself to sight and is useful for ornamentation ... The doll is the special entertainment of this sex ... She sees her doll and does not see herself. She can do nothing for herself. She is not yet formed; she has neither talent nor strength; she is still nothing. She is entirely in her doll, and she puts all her coquetry into it.[2]

For Rousseau, boys' instructive amusement was formed in, and enacted through, a productive and multi-sensory world of empirical play, whereas girls' materials of amusement and instruction were deemed passive and ornamental. Carriages, material markers of adult men's financial security, were important symbols of manly independence. Boots and toy drums were symbolic of a militaristic, worldly manliness. Dolls promoted female fashionable adornment that, as many invested in children's culture often commented, reduced women themselves into weak and talentless mannequins of fashion. Even the active tense is used to describe boys' play and the passive to describe girls'; boys seek entertainment, girls are entertained by dolls. This dichotomy epitomises the central question

of this chapter: how did differences in the availability, variety, and material qualities of girls' and boys' toys and material cultures work to shape and reinforce cultural and social codes of gender difference?

There are two main debates in the history of children's material culture. The first concerns whether toys and games functioned as objects of amusement or instruction.[3] The second, the 'commercialisation of childhood' theory, claims that eighteenth-century parents had a new emotional and economic investment in their children. Children became part of their parents' 'cultural capital' through their parents' conspicuous consumption.[4] However, children were often involuntary consumers and had little say in what was bought for them. This focus on consumerism has obscured these objects' materiality. The different variety of boys' and girls' toys, their material qualities – design, size, and medium – and boys' and girls' gendered interactions with them was central to the inculcation of values of genteel and elite masculinity and femininity. My focus here is to consider parent's consumption of children's goods but to pay particular attention to the prescriptions and values children's objects imbued and how, or if, they were played out in practice.[5] Studies of children's material culture rarely discuss the material qualities of girls' and boys' objects.[6] There are many detailed discussions of girls' material culture, and the history of adult men's material culture is flourishing, but boys' material lives remain obscure. Yet by examining the ways in which toys and other objects' design and use inculcated gendered behaviours, historians can better understand both the representational and experiential dynamics of eighteenth-century gendered childhood and the ways in which manly attributes and gendered distinctions were materially instilled and reinforced. The study of childhood, in any period, often reveals much about adults' fears and aspirations – this has often been an obstacle for historians of childhood to navigate. Toys and games were important tools in gender formation in childhood and reveal much about adult attitudes towards, behaviours concerning, and practices surrounding gender formation. That the material formation and expression of adult masculinity and femininity began in childhood and continued throughout eighteenth-century people's lives is indicative not only of the significance of materiality to gender-identity and expression but also to the materiality of the eighteenth-century gendered lifecycle.

Eighteenth-century gentry and aristocratic parents replicated adulthood gender difference by keeping their boys apart from their sisters and mothers, sending them away to school, encouraging their manly pursuits, and prioritising their education, as Michèle Cohen argues, to create and recreate gendered natures and minds. Girls' curriculum, most often delivered at home, mirrored boys' public education in its content but lacked its depth and ambition – setting entirely different lifegoals.[7] As a gender-age category, 'boyhood' made distinctions between both male and female children as well as between male children and adult men.[8] Historically, manhood was a stage in the life course and dependent on age (both young and old), maturity, economic independence, social position, and marital status. To fully achieve manhood, boys also had to acquire manly attributes such as honour, bravery, and authority, and continually display their manly values to others.[9] Embodied manhood was less performative, and the physical body was experienced through gender essentialism as well as being important in shaping modern gender ideals.

The early modern focus on manliness gave way, in conduct and educational literature, to a growing eighteenth-century emphasis on refined gentlemanly self-control. While boys were encouraged to be strong, active, and adventurous, boisterousness had to be tempered by prescriptions of polite, gentlemanly behaviour to ensure that boys turned into fully controlled men.[10] Toys were one method to channel boyish exuberance. In 1738, Elizabeth Robinson wrote to the Duchess of Portland that

> I think Lord T-'s education of his son is something particular, ... [He] is a very fine boy, but prodigiously rude; he came down to breakfast the other day when there was company, and his maid came with him, who instead of carrying a Dutch toy, or a little whirligig for his Lordship to play with, was lugging in a huge billet [wooden log] for his plaything; his diversions are all of the manly kind, which make him very strong, but that qualification seems more necessary for a porter than a man of quality.[11]

Boys' toys and play should be appropriate to their rank; unrefined toys, such as the billet, would produce unrefined adult gentlemen.[12] The perfect balance of strong but decorous behaviour was hard to achieve, and many thought boys should not attempt to be overly

manly in childhood. Lord Napier wrote to Mary Hamilton in 1780 that as a child it was deemed 'not manly to appear much affected by anything' and his childish attempts of manly reservation had made him cold in manhood.[13] Napier is just one example of the difficulty of successfully balancing these prescriptions. Examining boys' and young men's material culture elucidates how attributes of adult manhood were instilled, acquired, and displayed through a series of 'material firsts'; the first acquisition of breeches, wigs, and toys, as well as boys' first participation in activities such as field and blood sports, were moments in the life-stage of boyhood that prepared them for their roles as adult men. Adult masculine values were reproduced by parents in their children to maintain familial and social identities over time, as Henry French and Mark Rothery have shown, but material identities were also important and were created and reproduced over time.[14]

Seeking to think more about practice than prescription, the chapter moves discussions of children's gendered material culture away from prescriptive thinkers like Rousseau and instead examines diaries, correspondence, objects, and visual representations of children and their material world. It is possible to overstate Locke and Rousseau's influence on the changing attitudes towards and experiences of eighteenth-century children. Often, eighteenth-century parents executed many ideas from a variety of seventeenth- and eighteenth-century educational literature or, indeed, ignored them all together.[15] The chapter's analysis begins with an examination of teething toys, breeching, and boys' wigs, particularly focusing on the gendered body and 'authority'. Breeches are often seen by historians as the first ritual and material marker of gender distinction in childhood. I examine representations of children with gendered toys in portraiture across the long eighteenth century to argue that boys and girls were not 'genderless' before boys were breeched. It is well documented that portraiture's representational quality is a problematic historical source for determining practice. But artistic depictions, as Kate Retford's work has persuasively demonstrated, are useful to historians in providing a visual narrative of change. The rise of family and children's portraiture was itself a practice deployed by elite families to express their domestic and familial values.[16] By examining children's portraiture, extant toys, ego-documents, and toy-makers' bills, the chapter moves onto a discussion of boys' militaristic and equestrian

material culture and their participation in both field and blood sports. This will demonstrate how a variety of boys' toys, and their material meaning, worked to instil in them abstract manly attributes such as bravery, daring, and gallantry, and were props with which boys could display their manliness. The chapter concludes with a material analysis of the variety and size of boys' and girls' objects to demonstrate how material culture reinforced prescriptions of meek and mild femininity and worldly, dominant, and self-controlled masculinity.

There is a wealth of documentary sources for, and extant objects of, middling and elite children. Children of less affluent families would have seen or bought toys at early modern charter fairs, the most famous being Bartholomew Fair with its puppet shows and toy stalls. Touring pedlars would travel from parish to parish selling wooden and paper toys, such as peg dolls and cup and balls.[17] By the mid-nineteenth century, toys were increasingly mass-produced and available to a wider demography of children. Eighteenth-century children across the social hierarchy played with an abundance of non-commercial toys such as sticks and stones, and played games that required no objects, such as hopscotch. Imaginative and physical games, as well as the appropriation of non-toys, like spoons and pots, for play obviously predated the so called 'commercialisation of childhood'. Children's creativity unleashed an abundance of possible uses and meanings for toys both in historical and contemporary contexts. There was an abundance of eighteenth-century toys, games, and children's objects that did not have a specific gendered association. Boys and girls played with commercial games such as spinning tops, cup and balls, skittles, whirligigs, marbles, and 'Battledore and Shuttlecock', an early form of badminton. Board games such as the 'Fox and Goose' game and card games such as Newmarket amused boys and girls alike.[18] Whereas, dominoes, spelling cards, and alphabet blocks aided children's numeracy and literacy.[19] Geographical board games became popular from the mid-eighteenth century onwards. Engraver John Spilsbury began producing 'dissections' or jigsaws of maps in the 1760s, and the Royal governess Lady Charlotte Finch obtained two for her mahogany puzzle cabinet in the royal nursery. George III's children could choose from a variety of engraved cut-out maps of Britain, Europe, Africa, the Americas, and Asia. Some of

these wooden dissected maps had the English and French name on reverse sides to also aid language learning.[20] Educational toys and games were intended to make learning about abstract and difficult concepts a concrete and engaging process for both boys and girls.

Other games and objects were concerned with instilling religious and moral virtue. The Bible, as well as other religious books, aimed to educate children in the scriptures and was the first book children learnt to read. Abridged and illustrated versions for younger children were widely available across the eighteenth century.[21] Religious toys such as Noah's Arks were sometimes the only toy played with on Sundays.[22] Elizabeth Newberry, publisher and wife of John Newberry, published the 'The New Game of Human Life' in 1790. The complicated game covered 84 years of a man's life arranged into periods of seven years: 'Infancy to Youth, Manhood, Prime of Life, Sedate Middle Age, Old Age, Decrepitude and Dotage'. The players, of both sexes, would progress through the male lifecycle and learn moral lessons on the way. If a player landed on the 'Studious Boy' aged seven they could jump to age 42, the 'Orator', if a player landed on the 'Negligent Boy' they would have to miss two rounds. Although 'The New Game of Human Life' was ostensibly concerned with male experience, it was played by both boys and girls, and this reminds us that even though children possessed 'gendered' toys it did not mean they always played with them as intended. It is unsurprising that the historical record does not detail if boys secretly coveted their sisters' dolls and dolls' houses or girls wished to abandon their needlework and pick up a fencing file – it is only in recent years that heterosexual and patriarchal gender inculcation has come under more intense scrutiny by parents. A variety of toys existed then with non-gendered associations as did toys which did not necessarily mirror expectations of an elite identity. Children in the Prince Regent's household in the early nineteenth century had toy wagons, a toy grocer shop, toy kitchens, a toy windmill, a toy wheelbarrow, cart, and farm animals including a donkey, a lamb, a cow, and horses.[23] Even these most exalted of children had toys that were associated with mercantile or rural life, something that these young children would have little experience of in adulthood. Perhaps these farm toys were to do with an idyllic childhood, akin to the one prescribed by Rousseau, that was divorced from adult

roles and responsibilities. In more practical terms, they would have taught the royal children to understand the country they were to govern.[24]

Material firsts: breeching, shaving, and wigs

Breeching was the initial male rite of passage in boyhood and was the first step on the journey from childhood to boyhood and, eventually, manhood.[25] Historians view this rite of passage for young boys as the first time gender was outwardly imposed onto male, and therefore by exclusion also female, children.[26] Significantly, this first marker of gender-differentiation between children was material; in infancy children were differentiated, historians argue, by age and the breeching ceremony was the moment they began to be perceived in binary gendered terms. Paul Griffith's study of early modern court records demonstrated that children of both genders were titled as 'child' until around eight years old for male children who were then recorded as a 'boy' and 10 years old for female children then recorded as a 'girl'.[27] It is no coincidence that the recording of gendered age-titles occurred at the ages boys were typically breeched.[28] By the nineteenth century, boys, around the age of six, understood themselves as boys not children.[29] Breeching was a consistent, long-term practice and attitudes of when gender differentiation began in childhood persisted from the early modern period to the nineteenth century.[30] Early modern and eighteenth-century boys and girls did have a similar material culture before boys were breeched. Both boys and girls wore a similar costume of petticoats and a sash in early infancy. The colours of boys' and girls' sashes had no particularly gendered associations during this period. Boys and girls had leading strings attached to their petticoats to help when learning to walk and to aid their mobility. Typically, in early modern Europe, an elite child's first gift would be a silver rattle and a teething coral and were ungendered first 'toys' for infants. In Joseph Highmore's *Mrs. Sharpe and Her Child* (1731) her ungendered infant holds aloft their silver rattle and teething coral and the portrait contains no other iconographical clues to the child's gender (see Figure 1.1). Teething toys were made from silver and coral and were designed for sensory pleasure and medical relief. The bells and whistle created

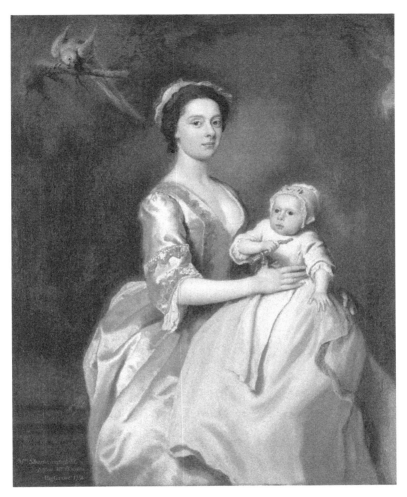

Figure 1.1 Joseph Highmore, *Mrs Sharpe and Her Child*, 1731. Oil on canvas, 127 × 101 cm. Yale Center for British Art, New Haven, Connecticut. Museum Number B1981.25.339. Reproduced courtesy of the Yale Center for British Art.

noise and the child would have chewed on the coral to ease teething pain and inflammation. By the late decades of the eighteenth century, teething corals became less popular as medical treatises warned against using coral during teething and instead recommended liquorice

root.[31] This infant material culture suggests a long-standing focus on developing elite children's bodies rather than carving out gender differentiation between boys and girls.

Despite this material culture, it is questionable whether, in practice, parents perceived and treated their infant children as genderless. The custom of primogeniture must have encouraged a uniquely English preference for boys from conception – although some argue that this preference has been overstated.[32] Letters between the landed elite were full of wishes for forthcoming sons and celebrations upon their arrival.[33] To conclude that male and female children were treated alike because they were dressed alike is a considerable assumption, and many historians agree that boys and girls were treated differently from birth.[34]

Typically, eighteenth-century boys were breeched between three and five, although this was subject to significant variation; some boys as young as two were breeched, while others were as late as seven or eight.[35] By the middle of the nineteenth century, the breeching age had decreased to between three and four years old. Tosh argued that this long-term slow change was driven by a shift in understandings of sex and gender.[36] The eighteenth-century shift from a one-sex to two-sex model of gender meant that gender difference became rooted in biological sex difference from birth rather than a gender identity accrued over time.[37] Anthony Fletcher writes that from the 1780s onwards boys wore skeleton suits that ascribed to Rousseau's prescriptions that boys who had outgrown their petticoats should be liberated from miniature versions of their fathers' suits and wear loose-fitting, ankle-length linen trousers and cambric smock shirts.[38] The introduction of the skeleton suit, historians argue, became another material stage in boys' development into men, but it also extended the period that boys were perceived as children, rather than young men.[39]

The nineteenth-century emergence of adolescence is no more obvious than in *The Four Eldest Children of Sir Richard Croft* by John James Halls (c.1803) (see Figure 1.2). The piece depicts Archer (2) in his petticoats, sitting in front of his sister Frances (3), reaching out to his elder brother Thomas (5) in his skeleton suit blowing bubbles and holding a delicate china cup. Their elder brother Herbert (10), in long trousers fashionable at the turn of the century, forlornly reclines with a book in his hand. The boys'

Boyhood: playing at manhood 41

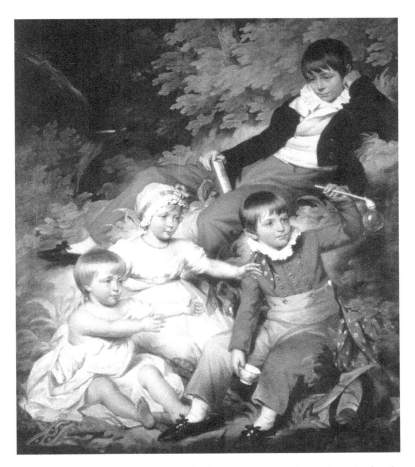

Figure 1.2 John James Halls, *The Four Eldest Children of Sir Richard Croft*, c.1803. Oil on Canvas, 127 × 101 cm. Croft Castle, Herefordshire, National Trust. Museum Number: NT537593. © National Trust Images

development is symbolised in their clothing and their possessions, the clay pipe and cup in Thomas's hand are objects of childhood play and Herbert's book suggests that he was at school. The bubble that Thomas blows from his clay pipe and the delicate cup he holds in his hand hint to the fragile and fleeting nature of childhood as a life-stage.[40] As a greater number of stages within boys' development

into men emerged, clothing was continually used to mark out differences in boys' progress.[41]

Many historians have characterised breeching as the symbolic moment when the care of boys transferred from mothers to fathers, and often occurred around the time that boys left for school.[42] In more practical terms, breeching often occurred when boys had become masters of their bowels, signalling their bodily autonomy and thus began acquiring and displaying attributes of manhood; breeches were a material symbol of their self-control and manly authority and thus the beginnings of their independence from the feminine world of the home and maternal care.[43] So powerful was this symbolic significance that, as Karin Calvert observed, some early American parents would threaten any breeched boys with a return to their infant petticoats if they displayed any childish temperament.[44]

Throughout its long history from the early modern period to the late nineteenth century, parents viewed the breeching ceremony with pride and they, along with relatives, filled their sons' pockets with coins and small tokens.[45] Amanda Vickery writes of boys running through Lancashire villages to collect coins on their breeching.[46] Anne North wrote to her son in 1678 of the pomp and ceremony of her grandson's new suit of clothes; 'never had any bride that was to dressed upon her wedding night more hands about her, ... he looks taller and prettier than in his coats'.[47] Over a century later, in November 1801, Samuel Taylor Coleridge, full of fatherly pride when his son Hartley was breeched, wrote to Robert Southey that Hartley

> looks far better than in his petticoats. He ran to & fro in a sort of dance to the Jingle of the Load of Money, that had been put in his breeches pockets; but he did [not] roll & tumble over and over in his old joyous way – No! it was an eager & solemn gladness, as if he felt it to be an awful aera in his Life. O bless him! Bless him! Bless him![48]

While many historians write that breeching marked, or symbolised, boy's development, here Coleridge perceives Hartley's breeches to themselves instruct a different behaviour; he is more sombre and restrained and displayed what Coleridge thought to be more manly attributes *because* of his breeches. Breeches, here, were agential in Hartley's transition into adolescent manhood. For elite boys, breeching might also coincide with the acquisition of heraldic goods that also

marked their growing maturity and acquisition of manly attributes. In 1780, the 7-year-old Thomas Parker wrote proudly to his uncle that his father had bought him some leather breeches and a seal for his letters, and boldly stamped the letter with it.[49]

But parents did not always decide when their sons cast off their petticoats. Five-year-old Charles Mordaunt, son of Sir John Mordaunt of Walton Hall, Warwickshire asked for new breeches and a periwigs ordered before he began school in 1701.[50] The breeches and periwig were a bone of contention between Charles's parents as his wig alone cost 30s and Sir John refused to pay for something 'so dear or too big'.[51] Thus, while parents' increased expenditure on children's possessions grew in the eighteenth century, children were not always lavished with gifts, and parents exercised prudent economy in their expenditure on their children.[52] It is questionable whether boys and girls were perceived, and treated, as genderless in infancy, but for boys from the early modern period to the nineteenth century breeches were the first material indicator of gendered difference. While the breeching age changed, and the introduction of the skeleton suit prolonged boyhood, breeching, as a rite a passage, remained a consistent practice that parents took great pride in. Boys also understood acquiring breeches as a transition from infancy to boyhood, as the first stage of acquisition and display of their gender.

While breeching was a longstanding social practice and material ritual throughout the long eighteenth century and beyond, other material firsts such as a boys' first shave and wig follow a less consistent pattern. Wigs were a popular male accoutrement from the later part of the seventeenth century well into the eighteenth, but fell out of fashion by the 1790s. By the turn of the nineteenth century, only elderly or men with traditional tastes wore wigs. Art and cultural historians all argue that hair, and false hair, signalled eighteenth-century men's manly attributes, social position, age, and profession. Wig-wearing was not so much a signifier of individual, personal identity but rather marked men's membership to a particular social, economic, occupational, and political group in an emerging public sphere. Indeed, the refusal to wear a wig, on moral or religious grounds, or the inability to purchase one, materially symbolised membership, or a rejection, of a certain group identity.[53] The practice of wigging a young man waxed and waned throughout the long eighteenth century according to their fashionability. It is therefore

difficult to find patterns of the age when boys began to wear wigs. Generally, boys in the later part of the seventeenth century, until the middle of eighteenth, began wearing a wig when they left home for school or at school before leaving for university. Visual evidence suggests that in the early eighteenth century some boys wore wigs as young as five or six – or at least they posed with them in portraits.

Young boys' uncovered heads signalled their lack of manly authority and autonomy.[54] The ceremony of the wig and hair-cutting was another material and bodily marker of boys' development. In 1659 seven-year-old Tom Pelham, son of wealthy Sussex baronet Sir John Pelham, was shaved and fitted for a wig. The wig and shooting rifle of 23-year-old Thomas Mansel, Baron Mansel in Alan Ramsey's 1742 portrait set him apart from his rosy-cheeked younger half-siblings (see Figure 1.3). This portrait shows Mansel as a gentleman, with

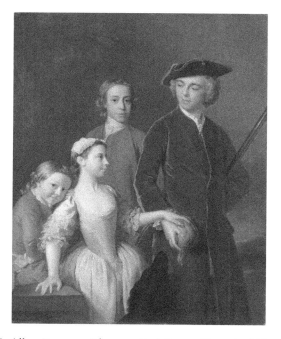

Figure 1.3 Allan Ramsay, *Thomas, 2nd Baron Mansel of Margam with his Blackwood Half-Brothers and Sister*, 1742. Oil on Canvas, 124 × 100 cm. Tate Britain, London. Museum Number: T05494. © Tate

velvet coat, shiny walnut rifle, and his shooting spoils. In 1701, Lady Mordaunt wrote to her husband that although a periwig had been ordered for their five-year-old son Charles, she would not cut his hair for the wig until Sir John returned home from London.[55] This makes the new wig for young Charles all the more meaningful as he soon set off for school after the purchase of new breeches and a suitable wig. As a symbol of age and maturity, Charles' wig marked his transition from the bare-headed world of home to the bewigged public sphere. But there is a more emotional bent to this familial scene, the first cutting of Charles's hair for his wig was also a poignant moment between parents and marked a moment in which Charles was no longer carefree but had to begin acquiring his manliness outside of the home. The donning of breeches and wigs were not just ceremonies of a confected boyhood that primed young elite boys for manly roles and behaviours, but moments of family memory ritualised and cherished by parents. Over the course of the eighteenth century, boys began to wear wigs later in boyhood, until the practice fell out of everyday adult fashion in the 1790s. Similarly, by the early nineteenth century, trousers, not breeches, were the staple of men's legwear. These changes in adult fashions for wigs and breeches explain why the breeching ceremony declined in practice by the mid-nineteenth century and suggests that these material firsts were often more meaningful to parents than to children themselves. John Tosh argues that the decline in breeching also maps onto changing understandings of gender identity and its formation by the nineteenth century. With a greater sense of biologically innate gender difference than their early modern antecedents, nineteenth-century parents ascribed less ceremonial and symbolic significance to breeching as they considered gender to be something a child was born with rather than an identity accrued over time.[56]

Yet it is possible to overemphasise the breeching's significance in eighteenth-century boyhood; breeching was not the first material marker of gender difference in childhood. Across the eighteenth century unbreeched boys were depicted with toys or games that had masculine associations. In John Michael Wright's 1675/6 portrait of a wealthy Welsh gentlewoman Mrs Salesbury, with her two grandchildren Edward and Elizabeth Bagot, the infants' gender was represented through material objects (see Figure 1.4). Although both infants wear petticoats, the rosy-cheeked Edward holds a toy

46 *Material masculinities*

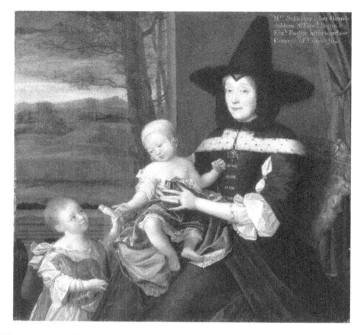

Figure 1.4 John Michael Wright, *Portrait of Mrs Salesbury with her Grandchildren Edward and Elizabeth Bagot*, 1675–1676. Oil on Canvas, 130 × 133 cm. Tate Britain, London. Museum Number: T06750. © Tate

horse and presents a small doll to his infant sister. Both these objects are iconographical markers of the adult gender roles they would later assume – him as landed gentleman, her as devoted mother. The use of toys to mark gender in portraiture continued across the long eighteenth century. Artistic depictions of young boys in their petticoats signalled the growing informality of the family conversation piece and an increasing investment in childhood and play. Johann Zoffany's *The Blunt Children* (c.1766–1770) depicts, most probably, the sons of Sir Henry Blunt, Robert and William, who would have been between four and five at the beginning of the portrait's creation in 1766 (see Figure 1.5). As with the Wright portrait, both boys are still in their petticoats and so it is the material culture depicted that genders the two boys. They are playing with a toy wagon to carry the hay from the wilderness of the forest to the ordered

Boyhood: playing at manhood

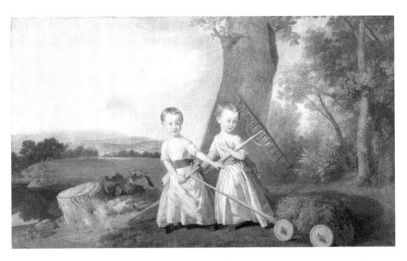

Figure 1.5 Johann Zoffany, *The Blunt Children*, c.1766-1770. Oil on Canvas, 77 × 123 cm. Birmingham Museums Trust, Birmingham. Museum Number: 1934P397. Reproduced by Birmingham Museums Trust, licensed under CC0.

and organised agricultural landscape of the estate one of them will one day inherit. It is a metaphor steeped in mid-eighteenth-century ideas of a natural childhood of untamed boyhood being shaped and refined into cultivated manhood. While Zoffany uses the natural setting, and the boys' comic play with an oversized rake, to create a scene of idyllic childhood play, two young girls would not have been depicted in this scene of land management.

This depiction of unbreeched boys with gendered objects continued into the nineteenth century. William Beechey's *William Ellis Gosling* (1800) depicts the fourth son of wealthy banker Sir Francis Gosling, similarly to the Zoffany picture, in a natural landscape setting wearing a petticoat and sash, and banging his toy drum. Again, a boy still in his petticoats is depicted alongside a material symbol of a masculine role he could pursue in adult life. The militaristic drum, although a multi-sensory toy typically associated with boys rather than girls, hints at the profession a younger son of a wealthy baronet would assume in manhood.[57] Although these are only three examples in a wealth of visual depictions of eighteenth-century children, these

portraits of young boys suggests a continued artistic convention of representing unbreeched boys with material markers of their gender, and of the future adult roles they would take on in manhood. While this visual evidence does not demonstrate that material gendering was widely practised, it does show that artists, and parents, used gendered toys to, at least symbolically, gender children in infancy. This would suggest that, while historians have fixated on the breeching ceremony as a moment when elite boys were perceived of, and understood themselves as, male children, their infant material culture was gendered.

When breeched, and in suits imitating those of their fathers, boys continued to have material markers of their boyhood status represented in portraiture. Hogarth's children's conversation pieces, produced throughout the 1730s and 1740s, are a good example of how portraiture used children's toys to gender them. Hogarth's earliest children's conversation pieces *A House of Cards* (1730) depicts four unidentified children, two boys and two girls, at play. One boy stands next to his sister to the right of the piece offering a basket of fruit. The other young boy on the left waves a flag. A companion piece to *A House of Cards, The Children's Tea Party* (1730) depicts four children playing in a landscaped parkland (see Figure 1.6). At first, this piece appears to depict a scene of happy, if chaotic, childhood play. But the urn with a garland of flowers hints at a recent death in the family, possibly the now missing other brother, and the central female figure holds a mirror up to the viewer, invoking the Classical symbol of vanity. The tea party is much more than an idyllic scene of childhood play. The only male figure, the suited boy playing a drum, stands separately to the left of his sisters, whose happy tea party, presided over by a fashion doll is being upturned by a wayward spaniel. Ronald Paulson observes that 'the child and dog are not disordering the scene as much as parodying the adult masquerade, revealing something about adulthood, without losing the animal, natural, instinctual truth they bring to it'.[58]

The picture is littered with material markers of a gendered childhood. The boy's drum, worn in a military style with a sash was a common toy for elite boys throughout the period. One of his sisters has leading strings still attached to her gown. Some girls wore leading

Boyhood: playing at manhood 49

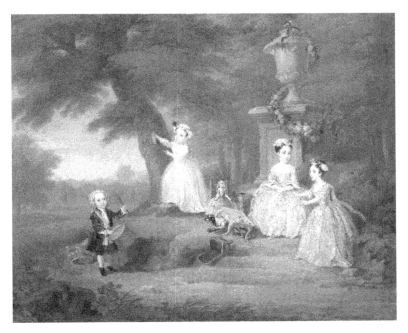

Figure 1.6 William Hogarth, *A Children's Tea Party*, 1730. Oil on Canvas, 64 × 76 cm. National Museum Wales, National Museum Cardiff. Museum Number: NMW A 94. ©National Museum, Wales

well into adolescence to signify that they were unmarried and still under the care of their fathers; the absence of an adult figure in this portrait suggests that they are used to show her age. Whilst their brother bangs a military tattoo on his drum, his sisters are playing with their doll and miniature tea set. As with the previous portraits, toys here are used to suggest the predestined adult gendered roles for these children; polite ladies taking tea and a worldly, military man.

Art historians have commented on Hogarth's ability to show how childhood innocence and play were tainted by death and pathos.[59] His 1742 conversation piece, *The Graham Children* is famed for its representation of childhood innocence and mortality (see Figure 1.7). The unbreeched Thomas sits in a richly upholstered, gilded

50 *Material masculinities*

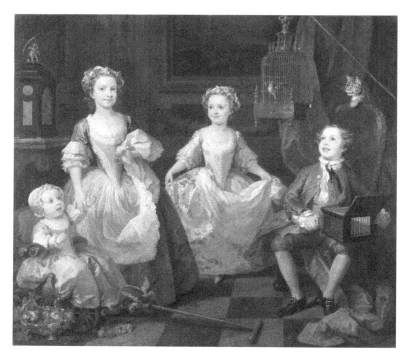

Figure 1.7 William Hogarth, *The Graham Children*, 1742. Oil on Canvas, 160 × 181 cm. National Gallery, London. Museum Number: NG4756. Reproduced courtesy of the National Gallery, London, licensed by CC. BY.

child's chariot with a flightless bird. Thomas died, aged two, in 1742 and Hogarth composed a study of him before he passed away. The portrait is littered with iconographical allusions to innocence, its loss, and death, but little has been said on its gendered iconography. Thomas's chariot hints at his gender, and perhaps at his illness; so too does his older brother Richard's bird-organ allude to his stage in boyhood. Elizabeth Einberg writes that the engraving of Orpheus on Richard's bird-organ hints that the harmony between man and nature, in this instance a Lockean idea of natural innocence, does not last and soon the seven-year-old Richard would have to leave his boyhood behind and become a man.[60] This is enforced by Richard's dress of breeches and wig. This series of visual sources represents

Boyhood: playing at manhood 51

a clear gendered material culture of boyhood and girlhood to which I will now turn.

Material boyhood: sporting, military, and equestrian toys

Hogarth's depictions and Rousseau's prescriptions of boys' material culture suggest that boys' toys had a particularly militaristic bent. Guns were used by boys, and more rarely girls, in early modern England. For example, middling boys between 9 and 17 used scaled-down weapons to practice shooting at the military academy in Artillery Gardens in seventeenth-century London. Toy firearms, and sometimes working, miniature firearms, were some of the most popular toys for elite seventeenth-century boys. Although extant toy guns from the seventeenth and early eighteenth century are hard to come by in museum collections, archaeological finds of metal toys suggest that they were widespread in early modern England.[61] Children in the royal household in the early nineteenth century had a variety of militaristic playthings including; a box of soldiers, toy drummers, a Sir Lancelot toy model, toy ships, toy drums, and toy cannons.[62] These toys were a precursor to the roles and responsibilities of elite boys in manhood, and are particularly pertinent for royal children, with its emphasis on military prowess.

Another militaristic masculine toy was the bow and arrow. By the 1780s, bows and arrows were less explicitly associated with militarism as archery became a popular leisure sport amongst eighteenth-century elites. Thomas Robinson, 3rd Baron Grantham, aged 9, was sent a set of bows and arrows at school in 1790.[63] For some, archery represented a romantic ideal of a preindustrial age, in which the elite's social power was stable and rooted in aristocratic tradition. This is certainly how children were portrayed with bows and arrows in late eighteenth-century portraiture.[64] Portraits commissioned in the 1780s, such as Daniel Gardner's *The Wife and Three Children of John Moore, Archbishop of Canterbury, 1783–1805* (1780) and William Beechey's *The Oddie Children* (1789), depicted boys with miniature bows and arrows. These depictions of children in nature reaffirmed late eighteenth-century cultural ideas of a carefree childhood informed by the natural world as well as the pastoral utopia of a preindustrial age.[65]

Militaristic toys in infancy encouraged boys to imagine themselves as adult men. By adolescence, boys discarded the military toys of their youth and partook in militaristic pastimes, particularly fencing. Locke advocated that fencing and riding were essential 'qualifications for the Breeding of a Gentleman'.[66] Lord Chesterfield was adamant that his 16-year-old son should put aside academic study and concentrate his efforts on riding, fencing, and dancing. He advised that these exercises 'will civilize and fashion your body and your limbs, and give you, if you will but take it, "l'air d'un honnete homme"'.[67] These accomplishments of refined masculinity also instilled embodied manliness in boys and emotional self-control. In a 1702 treatise *The English Fencing-Master*, the author cautioned to fight 'free from Passion; for if a Man be the best Swords-man in the Kingdom, and fights when in Passion, he disorders himself to that degree, that he cannot make use of all his Judgement'.[68] Thus more than mere accomplishments – often, as Michèle Cohen has shown, crudely and uncritically associated with a performative and ornamental feminine education – such activities were requisite for elite young men to embody gentlemanly qualities.[69] Fencing, however, was more than mere accomplishment and did have a more practical purpose. Writing in 1751, Chesterfield imparted that 'to fence well, may possibly save your life'.[70] While Chesterfield's prescriptions were criticised by many of his contemporaries when the letters were published in 1774 – Samuel Johnson famously said that the letters encouraged the manners of a dancing master – they were widely practised by elite young men at school, university, and on the Grand Tour. There is little evidence of boys learning to fence at home, rather they were taught at school, university, or at a fencing academy. Just as the dancing master trained young men in refined posture and codified gestures, fencing masters taught adolescent and young men the highly ceremonial sport of fencing.[71] Letters from boys at school, university, or on the Grand Tour boasted to their families or tutors of their fencing prowess.[72] Matthew McCormack's study of dance and drill in the Georgian militia finds that gentlemanly accomplishments and martial training often overlapped.[73] These masculine accomplishments instilled in young gentleman the values of martial masculinity, a central and longstanding pillar of idealised masculinity, while also providing informal training for the gentry and noble younger sons' potential military careers. Thus such bodily

activity was both culturally and practically significant in elite masculine identity formation.

The Grand Tour was the culminating rite of passage in young elite men's polite cultivation, intellectual refinement, and worldly education.[74] Fencing, dancing, and riding were practised before they undertook continental travel and were finessed in the fashionable centres of Paris, Geneva, Turin, Rome, and Lyon. Son of a wealthy, Catholic landowner, Edward Weld had Jesuit tutors as well as lessons in dancing and fencing, and bought a new wardrobe and wig before undertaking his scholastic Grand Tour in the 1760s.[75] In 1759, Thomas Robinson wrote to his old Cambridge tutor that, when in Turin on the Grand Tour, he practised dancing at seven in the morning, went riding at nine, then fenced from eleven o'clock to half past noon.[76] There were specialist fencing masters in London, the most famous of whom was the Italian Domenico Angelo, who set up exclusive fencing academies at Oxford Street and Bond Street. There were more generalist academies like Henri Foubert's Academy in Soho that offered young metropolitan men riding, fencing, dancing, and shooting lessons. Academies like Foubert's tutored elite young men in manly accomplishments as both an alternative to, and a preparation for, their European Grand Tour.[77]

Fencing masters and academies were perceived to be an important factor in civilising fencing, making it less a combative sport and more to do with 'swordsmanship' as an artful performance. In a later letter, Chesterfield advised his son to resume fencing 'to be adroit at it, but by no means for offense, only for defense in case of necessity'.[78] The rise of swordsmanship as an accomplishment has been credited with the decline of duelling from the mid-eighteenth century. Swordsmanship garnered a more superficial reputation thus many perceived it to be inferior compared to the academic studies of the Ancients that Chesterfield thought superfluous to a young gentleman's liberal education. These outer accomplishments were often perceived of as much more appealing to women than the 'inner accomplishments' taught at university. Sarah Goldsmith argues we should not necessarily see the accomplishments required for a successful Grand Tour simply in terms of overly refined politeness. Fencing, riding, and hunting were activities that instilled elite masculinity's long-held emphasis on martial, chivalric, and sporting identities. Danger and risk, she writes, formed an integral aspect of

the Grand Tour's culture, rationale and aims'.[79] Indeed, Cohen's recent work finds that boys and girls shared a core set of accomplishments, although fencing was exclusively for boys and needlework for girls.[80] Whether as childish play or polite refinement, for self-defence or as a sportsman-in-training, boys and young men's material culture and pastimes instilled and honed aspects of a martial masculinity.

It is unsurprising then that as well as militaristic toys, boys had a variety of equestrian toys ranging from toy horses, hobby horses, and rocking horses. Seventeenth- and eighteenth-century educational writers stressed the importance for walking, riding, and hunting to make young boys physically strong, and therefore manly, for adulthood and to purge any taint of effeminate manners or behaviours.[81] Equestrian toys prepared boys for manhood as a fascination with the kennel and coach and stable yard was as much the requirement of a gentleman as refined manners and good learning. These equestrian toys were a series of material transitions that both marked and aided physical and social development; things were discarded and acquired as a boy developed and matured. Younger boys, in art, were often depicted with a toy horse pulled by a rope. The hobby horse, a long stick with a carved horse's head, has a long history in English folklore cultures, but as a child's toy it would have been used by boys who were breeched and could place the hobby horse between their legs. There were other toys associated with equestrian transport available to elite families, such as children's wagons, chaises (scaled-down carriages), and mechanical carriages.[82]

The rocking horse was an increasingly popular toy by the close of the eighteenth century. One of the earliest existing examples of a rocking horse made for a child is believed to belong a young Charles I in 1610. The wooden rocking horse was reportedly designed to aid the disabled young prince's mobility and stability. However, the earliest documented rocking horse manufacturer was turner Charles Overing. His trade card (c.1757/8) advertised that he '[ma]kes and sells, all sorts of Children's Rocking and Wheel Horses, Coaches, Chariots, & Chaises' along with a plethora of other trinkets, playthings and household paraphernalia.[83] Rocking horses were expensive toys even for elite children; they were advertised as 'new', 'handsome', and 'modern', and were considered to be a useful and amusing gift for a young gentleman. In early nineteenth-century newspapers

auction notices, the local genteel and middling sort were listed as owners of rocking horses.[84] The children in the royal household had 'a very handsome Rocking Horse cover'd with Nat[ural] Skin, Elegantly decorated with double seat of red Morocco with bridle etc.' for £10 10s and 'A Large size Rocking Horse' with riding whip for £6 6s.[85]

Rocking horses were expensive objects, carved or turned from large quantities of polished or gesso-painted wood, or covered in a 'natural skin', with real horsehair, and furnished with a leather saddle, bridal, and metal stirrups. Thus rocking horses were a tool in creating the genteel young man. Just as dolls' dresses and wigs naturalised dolls, the equestrian accoutrements of saddles and bridles along with the real horse hair naturalised the rocking horse, imbuing it with imaginative possibilities; from the confines of a nursery, a young gentleman astride his rocking horse could imaginatively roam around his estate, ride out his with his hounds, or lead a cavalry charge into battle. Yet the rocking horse also had physical benefits: it helped to practise stability and develop core strength before boys were taught to ride real horses. In behavioural terms, rocking horses channelled boys' activeness and volatility, simultaneously reinforcing and controlling boisterous physicality within the safety of the nursery.

This childhood equestrian material culture encouraged a love of all things horse-related from a young age. Beyond toys, horse furniture and tackle were common gifts for eighteenth-century boys and young men. In 1707, Charles Mordaunt wrote from school to his mother, Lady Mordaunt, and thanking her for some new riding boots asked for a horse whip.[86] In 1772, upon reconciliation with his sister after her unwelcome marriage, Edward Parker of Browsholme, Clitheroe send his nephew and ward Thomas Parker a saddle.[87] Boys in the royal household regularly had child-sized horsewhips bought for them.[88] It is therefore unsurprising that elite adult men heavily invested their time and resources into equestrian pursuits in manhood, from riding and hunting to horse racing and carriage driving.

As the culmination of ideologies of manly militarism and equestrianism, elite boys and young men took part in blood sports, which were perceived to instil in them manly attributes of bravery, courage, and athleticism.[89] Boys and young men would hunt at home on their family's or friends' land. Thomas Parker appears in the 1772 diary of his mother, Elizabeth Parker Shackleton, aged 18 going

hunting alone.[90] The 17-year-old Lord Boringdon was away from his family foxhunting in Staffordshire in 1789.[91] His cousin, Thomas Robinson, later 3rd Baron Grantham, learnt to shoot at school aged 16 in 1797.[92] On his return from school the next year, and before going to Cambridge, he regularly went shooting on the Yorkshire Moors, near his estate in Ripon.[93] Young men also hunted when away at school. The 10-year-old Charles Mordaunt was congratulated by his uncle Robert Warburton in 1707 for pursuing his studies at school, which would stand him in 'good stead' for his adult responsibilities, but he was glad that Charles had begun to enjoy 'country diversions' such as hunting.[94] Sport-obsessed Stephen Terry's teenage diary was littered with accounts of hunting and shooting whilst at Eton in the 1780s.[95] Lighter sports, like fishing, were suitable for younger boys as they were less dangerous than the more violent and hazardous hunting and shooting. Thomas Robinson's childhood correspondence to relatives reveals his love of outdoor play. In 1790, aged 9, he wrote to his mother from his stay with his aunt, Lady Amabel Yorke, at Wrest Park in Bedfordshire, recanting tales of fishing, rowing, and camping, activities that he and his younger brother continued well into their teenage years.[96]

Blood sports were often activities that sons and fathers could participate in together. Viscount Torrington filled his teenage son's school holidays with fishing. He wrote in his 1794 diary 'to this pursuit [fishing] did John and I actively attach ourselves for one week and were then heartily sorry to quit our pastime, and the fine weather'.[97] Torrington also took his 9-year-old son Frederick out ferreting in Bedfordshire in 1794; 'F and I pursued our early thoughts of ferreting; ... he, dear fellow thus urging me to youthful sports, make me feel young again.'[98] These masculine homosocial pastimes enabled fathers and sons to bond and for fathers to instil in their sons enthusiasms that would benefit them in later life.

Other less violent sports, such as cricket, were equally popular amongst young elite men. By the close of the eighteenth century, cricket was the national sport of England.[99] Cricket players came from all social ranks. Frederick, Prince of Wales was famous for his love of cricket and sponsorship of the sport. Although 'gentleman players', mainly private gentlemen and younger sons of nobles, were common participants in provincial urban centres, there were also exclusive cricket clubs in London such as London Cricket

Club, White Conduit Club and Marylebone Cricket Club that held society dinners.[100] Despite the widespread participation in cricket, it became more associated with elite sporting culture by the end of the eighteenth century. It was perceived to require more agility and tactical skill than other ball or provincial sports.[101] In the 1790s, Torrington wrote in his diary that the provincial, often plebeian, game 'Prison Bars' was a 'a sport of mere agility, and speed and … In my opinion it is far inferior to cricket, cudgel-playing and many other provincial sports distinguished by skill, and gallantry'.[102] Men of all ages partook in cricket. Teenage Frederick and Thomas Robinson wrote to their mother in 1797 of filling their days visiting their aunt at Saltram House, Devon with the genteel pastimes of phaeton-driving, drawing, cricket, and fishing.[103] Throughout eighteenth- and nineteenth-century England, cricket was a common sport in English public schools. Team sports such as cricket, which became much more codified as the century progressed, taught more abstract values for the eighteenth-century gentleman.[104] Playing field sports would instil manly ideals of gallantry through sportsmanship and fair play, authority and leadership over tactics. In a tongue-in-cheek 1779 letter from a friend to John Thornhaugh Hewett, a Nottinghamshire landowner and MP, ball games were described as 'manly games'. Hewett's friend R. Morrison jokingly challenged Hewett's four-year-old grandson to

> play a game at foot ball, or at cricket, or any other manly game that he chooses; I don't choose to mention marbles, push pin or hop scotch or any such childish play because I don't care to depreciate his manhood. I therefore insist on it as a man of honour that he meet me at the place and day, to see who's the best man.[105]

Here cricket is manly, not childish, and is explicitly gendered as masculine. Sports that encouraged speed, tactics, skill, and gallantry were the sport of manly men in eighteenth-century England.

But while 'first-class' cricket, or cricket as a spectator and gambling sport, was mostly an exclusively male sport, women were involved in more informal games often known as village cricket.[106] Baroness Grantham wrote to her brother-in-law Frederick Robinson that she thought his wife 'may Row, play at Cricket and Ride with all her Gentlemen as often as she pleases without any criticism for being masculine'.[107] In portraiture, adolescent children of both

genders were often depicted playing cricket. In Hugh Barron's *The Children of George Bond of Ditchleys* (1768) the three older boys play cricket in the foreground with their sister umpiring behind them. In Wright of Derby's 1789 depiction of the Wood Children, Robert (8) hammers the stumps into the ground with his bat and John (13) leans nonchalantly on his cricket bat with their sister and Mary tossing the ball. In a similar composition, the children of Sir Thomas Pole, William (11), Mary Ann (10), and John (5) were painted by artist William Beach in the grounds of New Shute House with the boys holding the cricket bats and Mary Ann the ball. These portraits imply that although boys and girls played cricket together, in visual representations their roles of bowler and batsman were gendered.

Material girlhood: dolls, dolls' houses, and needlework

Toys and pastimes expressly designed for girls were limited to textiles and dolls, their clothes, and their houses. From a young age, girls were expected to be not only proficient but accomplished in needlework and embroidery and produce a range of textile media, from samplers to silkwork.[108] Sewing and handicrafts grounded girls in their domestic life and roles. While boys would leave home to become well-versed in Latin at school, their sisters would remain at home working away at their samplers. This was a practical preparation for girls' adult role as housewives, when the management of the household linens was a never-ending task.[109] Elite girls did not engage in more quotidian household textile tasks such as darning and repairing – a prerequisite of a middling girl's repertoire.[110] Sewing was both an obligation of domestic womanhood and a feminine genteel accomplishment. Plain sewing was a practical requirement of a dutiful housewife and itself an incredibly accomplished skill. Historians have argued that while needlework and embroidery presented women with a form of skilled expression and escape from the potential tedium of domestic life, textiles were fundamentally about female subservience. Vickery writes that embroidery had a 'longstanding appeal for conservative commentators because it was an indoor sedentary activity that enforced passive stillness and implied

patient service'.[111] Sewing was considered an expression of idealised feminine modesty, duty, and virtue combined with artistic flair and skill.[112] This was no truer than in women's embroidered courtship gifts that demonstrated to their future husbands their virtuous affection and a promise of wifely duty.[113] Needlework's inculcation of meek and mild femininity was not universally accepted. Mary Wollstonecraft wrote with some ire that girls should be 'taught to respect themselves as rational creatures, and not led to a have a passion for their own insipid persons. It moves my gall to hear a preacher descanting on dress and needlework'.[114] There was a plethora of sewing-related objects for girls. The most popular were workboxes, in which they could store their needlework and sewing paraphernalia, and work bags.[115]

Girls could also use their sewing skills to create dresses for their dolls. Eighteenth-century dolls were often called fashion dolls or babies and were passed down from mothers, who used them as early forms of mannequins for, particularly French, fashions to their daughters as playthings. As this practice became more commonplace, fashion dolls increasingly became marketed as toys for girls.[116] Neil McKendrick used this phenomenon to explain the commercialisation of eighteenth-century fashion and the indoctrination of women as rampant consumers. Historians have reframed McKendrick's theory of indoctrination into one of 'training' and in doing so have written a more feminist account of women's agency, consumer skill, and material literacy.[117]

Across the eighteenth century, dolls, and their accoutrements, modelled an idealised version of adult femininity for girls and women alike. There was widespread cultural criticism of dolls and their supposed indoctrination of women's consumption and hyperfeminine adornment. Rousseau's 1762 diatribe argued that a girl 'puts all her coquetry into it [her doll] ... she awaits the moment when she will be her own doll'.[118] Vicesimus Knox's conduct book *Essays Moral and Literary* (1778) observed that 'plain women' were the 'best' daughters, wives, and mothers, and that 'they who aim not at such characters, but live only to display a pretty face, can scarcely rank higher than a painted doll'.[119] Wollstonecraft in *A Vindication of the Rights of Woman* (1792) attacked Rousseau for perpetuating 'the absurdity ... of supposing that a girl is naturally a coquette'.[120]

She argued that Rousseau's description of girls' seemingly natural investment in dolls

> is certainly only an education of the body; but Rousseau is not the only man who has indirectly said that merely the person of a *young* woman, without any mind, ... is very pleasing. To render it weak, and what some may call beautiful, the understanding is neglected, and girls forced to sit still, play with dolls and listen to foolish conversations; —the effect of habit is insisted upon as an undoubted indication of nature.[121]

Wollstonecraft emphasises that girls' supposed passive play was the result of their subordinate education not a natural consequence of essentialised gendered difference.

These critiques were levelled at a specific material form of eighteenth-century fashion dolls. The material similarities between dolls made in 1690 (Figure 1.8) and in 1790 (Figure 1.9) are remarkable; despite a few variations in height and condition, these dolls both have jointed limbs and cinched waists. Most wooden dolls had, at least, a gesso-painted head with painted lips, rouge, eyebrows, and glass eyes. Elizabeth Kowaleski-Wallace argued that fashion dolls' 'connection to reality is still largely a function of their many outfits ... their clothing places them in different imaginative settings and allows them to come alive'.[122] Fashion dolls' human hair and fashionable wigs also humanised them and imbued them with imaginative impossibilities. Dolls' material form changed as culturally idealised adult femininity increasing valorised motherhood in the later part of the eighteenth century. By the turn of the nineteenth century, wax baby dolls, the material replica of a human infant, functioned to teach girls, through play, how to become successful, nurturing mothers.[123] As Kowaleski-Wallace writes the 'baby [wax] doll shifts the focus of the mimesis from the clothing to the baby's face'.[124] In the early nineteenth-century, girls in the royal household had both 'dressed dolls' and babies with toy cradles.[125]

Just as fathers and sons engaged in masculine activities together so, too, did women and girls participate in the feminine activities of doll-dressing and furnishing dolls' houses. As there was no written instructions, akin to Latin books, for sewing, girls acquired their knowledge from female members of the household.[126] Dolls continued to be pastimes for women throughout their lives – whether

Boyhood: playing at manhood 61

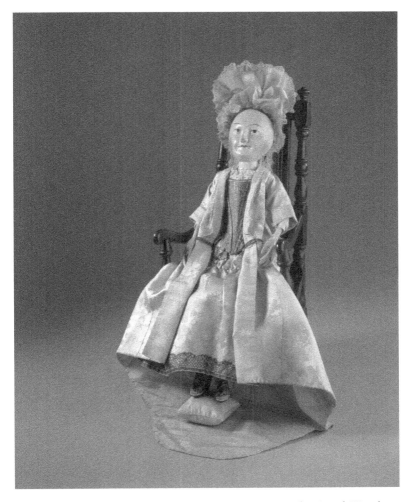

Figure 1.8 'Lady Clapham', 1690–1700. Gesso and Painted Wood, 56 cm. Victoria and Albert Museum, London. Museum Number: T.846-1974. © Victoria and Albert Museum, London

as daughters or as mothers. Laetitia Clark, born in 1741, dressed thirteen dolls in her lifetime beginning in her childhood. These dolls became a pastime for Laetitia's throughout her adult life – one doll even models her wedding dress in 1761.[127] Dolls provided

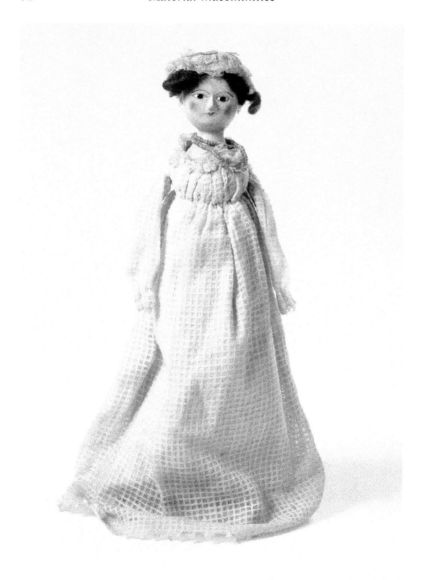

Figure 1.9 'Doll', c.1700–1800. Wood. Young V&A, London. Museum Number: MISC.33-1967. © Victoria and Albert Museum, London

an opportunity for women and girls to join together in play and education; Mary Delany wrote in 1775 that she was dressing a doll for her niece, and Jane Austen wrote to her sister that her mother was enjoying dressing a doll for a young relative.[128] Other women enjoyed dressing dolls as an entirely adult pastime. Elizabeth Carter wrote to Elizabeth Montagu in 1776 that 'I am just as ready to whimper if I cannot get all the dolls together who happen to be drest to my own fancy'.[129]

Dolls' houses originated from seventeenth-century Dutch *poppenhuis* and Nuremberg kitchens and were exceptionally expensive luxury cabinets that reflected the homes of wealthy Dutch merchants and their wives in miniature.[130] In England, the most famous examples include the Uppark Dolls' House owned by Sarah Featherstonehaugh and Susanna Winn's dolls' house that was a miniature version of her husband's newly built Yorkshire Palladian house Nostell Priory. These are examples of real houses in astonishingly accurate miniature, replete with miniature glassware, fireplaces, and paintings. These dolls' houses were designed for adult women but were passed down through the generations as both playthings and quasi-cabinets of curiosities. Elite girls, from young Penny Mordaunt, daughter of Sir John, in 1720s to the royal children in the 1820s had their own beloved dolls' houses.[131] These dolls' houses trained girls in consuming for and managing the home. Miniature tea sets, as seen in Hogarth's *The Children Tea Party* (Figure 1.6), were also toys with which girls could mimic their mothers and practise the delicate art of taking tea. Beyond needlework and doll-related paraphernalia, the other significant object of girlhood was the pocketbook diary. Popular from the mid-eighteenth century onwards, these commercial printed diaries were given to girls from the age of 10 onwards and were used to record small expenditures, gifts, visits, tea parties, and comments on their lessons.[132] As such, these pocket diaries were both a space within which the experience of genteel girlhood could be recorded and a tool in the inculcation of it.[133]

Towards a gendered material childhood

Leonore Davidoff and Catherine Hall's *Family Fortunes* (1987) noted that by the nineteenth century, middle-class boys had a wider variety

of toys, games, and pets than girls.[134] Of course, boys and girls did play ball and board games together, and it is important not to ignore that boys and girls shared toys and games that did not overtly work to impart gendered distinctions. By the early nineteenth century, rocking horses were advertised to both boys and girls, although it is unclear whether girls riding astride a rocking horse would be deemed a subversion of the idealised femininity promoted in other girlhood objects.[135] The portraits of children playing cricket in their youth suggests that, while they were perceived to instil traditional manly attributes of physical agility and gallant sportsmanship, gendered ideologies behind games and toys were not always played out. Nevertheless, the belief that toys played an important and necessary function in preparing children for their adult roles and responsibilities was consistently materialised in the gendered differences in boys' and girls' material culture across the eighteenth century. Boys' toys were associated with sporting cultures, militarism, and equestrianism, girls had relatively limited material culture beyond textiles and needlework, grounding them in the domestic and sedentary. Boys had a greater variety of toys to channel their boisterousness and, indeed, reflect their more diverse roles and responsibilities in adulthood.

Eighteenth-century educational writings espoused that boys' minds and bodies should be active and, to fulfil that requirement, a constant supply of stimulus, whether toys or games, should be made available. In 1747 the widely popular *The Young Gentleman and Lady Instructed* advocated that 'the child is diverted with the smallest trifle; if he be free from pain, and gratified in his change of toys ... The man devoted to the pursuit of wealth or ambition loves the hurry of an active life'.[136] This stress on boys' mental activity was thought to be heavily dependent on their physical well-being.[137] Exercise had long been considered beneficial to a young man's education. *The Young Gentleman and Lady Instructed* argued that physical activity was 'necessary for the proper exertion of our intellectual faculties, during the present laws of union between the body and the soul'.[138] In practice, variety and activity were essential to a boy's physical and educational development. Elizabeth Carter wrote to Catherine Talbot in 1749 that her little brother

is inexpressibly volatile. He skips and dances, and plays all manner of monkey tricks, while he is saying his lesson. ... He exercises my whole contrivance to prevent his running in the streets, and sure much contrivance is necessary to find employment for a lively boy. ... He is allowed the full use of looking over every picture-book in my closet, and to stun my head by playing over his tops and whips, &c. in my chamber; but of all this he is soon tired.[139]

Master Carter engaged in boisterous, active play and learning and Carter reflects how different he is compared to his 'docile' sister. He had a voracious appetite for active, sensory play and that had to be satisfied with a variety of material objects.

Not only did eighteenth-century boys have a wider range of toys than girls, they also had more material opportunities to acquire, display, and celebrate their development into adolescents and adults. While girls remained in their petticoats, and had leading strings sometimes until marriage, boys began wearing breaches. This chapter's discussion of wigs has expanded the material culture of 'authority' and also shown that boys and girls did play with gendered toys in infancy. Even before they were breeched, boys began acquiring talismans of their maleness. From wigs and watches to saddles and swords, boys had more material markers of their maturation and young men were expected to eschew material markers of their infancy. Indeed, adult women had the dolls, dolls' houses, and workboxes of their girlhood throughout their lives. Needlework was a female skill that was honed from youth to old age. Dolls' houses were both girls' toys and adult women's 'cabinets of curiosity'. Dolls were themselves objects that blurred the distinction between 'girl' and 'woman' as they were objects of both elite adult fashion and childhood play. These differences are suggestive of a distinctive life course of material childhood for boys and girls.

This distinction, that boys eschewed toys for more adult and rational pursuits as they developed into adolescents while girls could keep their childhood toys even in adulthood, had a particularly powerful charge in debates on adult toys' feminine and effeminate connotations.[140] Eighteenth-century commentators were quick to characterise adult toys and trinkets as the stuff of women's consumer and material desires. Chapter 4 examines in more detail the significant commentary on adult men's small accoutrements and fripperies,

perceived by many to weaken and effeminise men and make them servants of fashion. This effeminate charge, I would suggest, has its roots in the material culture of childhood. A preoccupation with toys, which followed women throughout their lives, was not an attribute of rational, adult men. Effeminacy was often not a sexual failing but a social one; men were not failing to be men necessarily but were failing to be men on the terms society dictated. As this chapter has shown, boys had a greater number of material opportunities to showcase their acquisition of manliness. But, as Locke thought, would boys that were overindulged in playthings in their infancy 'desire it, and contend for it still, when he is in Breeches? Indeed, as he grows more towards a Man, Age shews his Faults the more'.[141]

In visual culture, satirical cartoons used boys' toys as a visual metaphor for adult men's immaturity and their ill-preparation for the responsibilities of manhood. In Thomas Rowlandson's 1784 print 'Master Billy's Hobby-Horse, or his triumphal entry into Downing Street', the hobby horse, Fox's rod, and the 'Royal Primer' tucked under Pitt the Younger's arm are all markers of Pitt's ill-preparation for his role as Britain's youngest prime minister. As Anja Müller has noted, 'since a child is supposed to want judgement, Pitt as child suggests that he only emulates slavishly what his monitors have told him'.[142] Similarly, in Issac Cruickshank's 'The Cradle Hymn' (1820), toy soldiers, mounted lancers, and a canon are strewn around a grotesquely infantilised George IV brandishing a rattle in his pagoda-style cradle (see Figure 1.10). The positioning of these military toys alongside the sceptre and crown suggests how the notoriously petulant George IV treats kingship as a boy does his toys. 'Masculine' toys in these prints work to symbolise how the stuff of boyish immaturity emasculates men and how toys had a significant cultural and political valency to challenge whether men had fully achieved manly status. The comment in both prints is that if these men have not left behind their boyish toys and reached the basic requirements of manhood, how can they govern a nation? Boys' toys, unlike girls', had a dual function. They marked binary gendered distinctions and distinctions between boys and men based on age and maturity. The necessity of boys' material culture to their gender inculcation and parents' ritualisation and celebration of boys' material firsts sits awkwardly with this cultural discourse on the dangers of boyish talismans in manhood. Such a contradiction in

Boyhood: playing at manhood

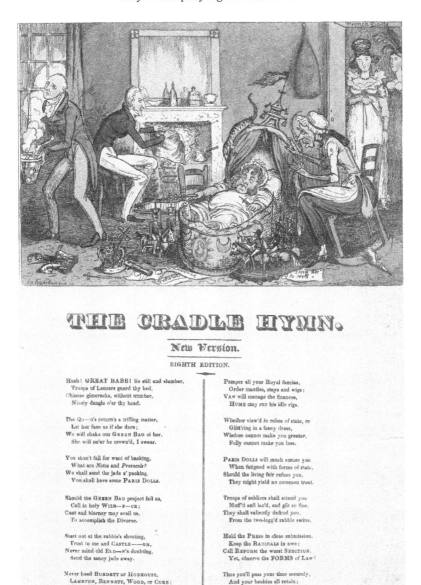

Figure 1.10 Isaac Cruickshank, 'The Cradle Hymn; New Version, Eighth Edition', 1820. Etching on Paper, 36.6 × 22.6 cm. British Museum, London. Museum Number: 1868,0612.1273. © The Trustees of the British Museum, London

attitudes speaks to Susan D. Amussen's reflection that patriarchy is an inherently contradictory system and suggests that such contradictions played out in material form.

While boys had a greater variety of toys and material markers of their acquisition of manhood, boys' toys were also often larger in terms of size and scale than girls. Chariots, carts, wagons, and rocking- and hobby- horses were all larger than girl's toys of dolls, dolls' houses and doll's furniture, and miniature workboxes. A selection of dolls from the Young Victoria and Albert Museum range from 40 cm to 60 cm in height. A rocking horse made between 1811 and 1820 at National Trust property Erddig measures 1.7 metres in height and 1.93 in width.[143] A child's carriage measured just over a metre in height, and over two metres in length.[144] Boys' toys would have taken up considerable room in the nursery and reinforced their dominance of the space. Another key contrast is that while wooden dolls were fragile due to their gesso paint and jointed limbs, boys' toys were bulkier, sturdier objects that could withstand the battering boys could inflict upon their toys. This materially reinforces feminine passivity and masculine virility and mirrored eighteenth-century gender-differentiated education and attitudes towards gendered bodies. Gendered toys produced a gendered kind of 'work'. Girls' dolls modelled idealised femininity and reflected it back to them, boys' toys actively, through interaction and use, formed, modelled and shaped embodied masculine attributes such as strength and self-control.

Boyhood and the progress into manhood was marked and enacted through a series of material firsts, rituals, and transitions that shaped, displayed, and celebrated boys' bodily and social development. Toys were agential in the process of gender-differentiated identity formation. This was a uniquely male material culture: breeches, wigs, drums, hobby horses, and swords. This chapter has established that gender difference was materialised in boys' and girls' material culture and this worked to produce materially expressed gendered identities. Eighteenth-century gendered childhood was understood through, and produced by, gendered interactions with gendered things. In one sense, the material culture, and the gendered values and attributes it instilled in boys and girls, explored here is unsurprising. But gendered socialisation began in infancy and material objects complimented and reproduced gendered cultural values alongside gendered-differentiated

curriculum and education. The inculcation and practise of abstract cultural values of feminine delicacy, virtue, and duty and masculine authority, independence, and bravery were materialised in the things of boyhood and girlhood and were tools in their social practice. The following chapters expand on the objects, and their meanings, explored in this chapter. They will detail how a variety of men's objects from guns to carriages, were central to the representation, formation, expression, and experience of eighteenth-century material masculinities.

Notes

1 For ease of reading, throughout the book, I use the term children's 'toy' instead of the eighteenth-century word 'plaything'. Eighteenth-century 'toys' were small curiosities, produced, designed for, and owned and used by adults, whereas 'plaything' denoted only objects used by children in play. 'Toyshops' often sold both by the end of the eighteenth century.
2 Jean Jacques Rousseau, *Emile, or, On Education: includes Emile and Sophie, or, The Solitaries*. ed. and trans. Christopher Kelly, trans. Allan Bloom (Hanover, NH, 2010), 542–3.
3 Lawrence Stone, *The Family, Sex and Marriage in England 1500–1800* (London, 1977), 259; J. H. Plumb, 'New World of Children', in Neil McKendrick, John Brewer, and J. H. Plumb (eds), *The Birth of a Consumer Society: The Commercialisation of Eighteenth-Century England* (Bloomington, IN, 1982), 287. Stone and Plumb were building upon Philippe Ariès' *longue durée* study of childhood, see Philippe Ariès', *Centuries of Childhood: A Social History of Family Life*, trans. Robert Baldick (London, 1962). For revisions of Ariès see Linda Pollock, *A Lasting Relationship: Parents and Children over Three Centuries* (London, 1987), 12; Adrian Wilson 'The Infancy of the History of Childhood: An Appraisal of Philippe Ariès', *History and Theory* 19.2 (1980), 132–53. For a discussion of more diverse parental attitudes to children see Alan Macfarlane, *Marriage and Love in England, 1300–1840* (Oxford, 1986), 51–78.
4 See Pierre Bourdieu, 'Forms of Capital', in *Handbook of Theory and Research in Education*, ed. John Richardson, trans. Richard Nice (New York, 1986), 46–58; Daniel Thomas Cook, 'Children as Consumers: History and Historiography', in Paula S. Fass (ed.), *The Routledge History of Childhood in the Western World* (Abingdon, 2013), 589.

5 For a particularly persuasive interdisciplinary example of this approach see Stuart Campbell, 'Work and Play: The Material Culture of Childhood in Early Modern Scotland', in Janay Nugent and Elizabeth Ewan (eds), *Children and Youth in Premodern Scotland* (Woodbridge, 2015), 65–86.

6 For a notable exception see Elizabeth Kowaleski-Wallace's study of waxy dolls, 'Recycling the Sacred: The Wax Votive Object and the Eighteenth-Century Wax Baby Doll', in Ariane Fennetaux, Amélie Junqua, and Sophie Vasset (eds), *The Afterlife of Used Things: Recycling in the Long Eighteenth Century* (New York, 2014).

7 Michèle Cohen, *Changing Pedagogies for Children in Eighteenth-Century England* (Suffolk, 2023); Michèle Cohen, '"A Little Learning"? The Curriculum and the Construction of Gender Difference in the Long Eighteenth Century', *Journal of Eighteenth-Century Studies* 29.3 (2006), 331–2; Jennifer Jordan, '"To Make a Man Without Reason": Examining Manhood and Manliness in Early Modern England', in John Arnold and Sean Brady (eds), *What is Masculinity? Historical Dynamics from Antiquity to the Contemporary World* (Basingstoke, 2013), 256.

8 John Tosh, 'What Should Historians do with Masculinity? Reflections on Nineteenth-Century Britain', *History Workshop Journal* 38 (1994), 183.

9 See Elizabeth Foyster, *Manhood in Early Modern England: Honour, Sex and* Marriage (London, 1999), 31.

10 Joanne Begiato 'Between Poise and Power: Embodied Manliness in Eighteenth- and Nineteenth-Century British Culture', *Transactions of the Royal Historical Society*, 26 (2016), 131.

11 Elizabeth Robinson Montagu, 'Letter from Elizabeth Robinson Montagu to Lady Margaret Cavendish-Harley Bentinck, Duchess of Portland, October 15, 1738', *The Letters of Mrs. E. Montagu, With Some of the Letters of Her Correspondence*, vol. 1 (London, 1809), 304.

12 This passage is indicative of politeness's foundation on decorum, the principle that everyone should behave according to their rank, age, and gender and according to different occasions.

13 JRRIL. GB 113 HAM/1/20/44. 'Letter from Francis Napier, 8th Lord Napier, to Mary Hamilton' (20 February 1780).

14 Henry French and Mark Rothery, *Man's Estate: Landed Gentry Masculinities, 1660–1900* (Oxford, 2012), 105–6.

15 Joanne Bailey 'Reassessing Parenting in Eighteenth-Century England', in Helen Berry and Elizabeth A. Foyster (eds), *The Family in Early Modern England* (Cambridge, 2007), 209–30.

16 Kate Retford, *The Art of Domestic Life: Family Portraiture in Eighteenth-Century England* (New Haven, CT, 2006), 187–214.

17 See Peter Borsay, *The English Urban Renaissance: Culture and Society in the Provincial Town, 1660–1770* (Oxford, 1991), 143; Dennis Denisoff, 'Small Change: The Consumerist Designs of the Nineteenth-Century Child', in Dennis Denisoff (ed.), *The Nineteenth-Century Child and Consumer Culture* (Aldershot, 2016), 1–28.
18 Fox and Geese dates to 1300 in northern Europe when it was called 'Fox-Chess'.
19 RA. GEO/MAIN/29100.
20 Finch herself is credited with designing more of these map 'dissections', see VAM. Lady Charlotte Finch, 'Puzzle', c.1760. Mahogany, 51 × 45 cm. Young V&A Museum, London. Museum Number: B.17-2011.
21 Ruth B. Bottigheimer, *The Bible for Children: From the Age of Guttenberg to the Present* (New Haven, CT, 1996), 43–5; Matthew O. Grenby, *The Child Reader, 1700–1840* (Cambridge, 2011), 99–101.
22 Antonia Fraser, *A History of Toys* (London, 1972), 90.
23 RA. GEO/MAIN/29104–29104a; RA. GEO/MAIN/29108–29108a; RA. GEO/MAIN/29111; RA. GEO/MAIN/29199; RA. GEO/MAIN/29201.
24 Another possibility is that these farm toys were bought for the royal household due to George III's (nicknamed 'Farmer George') own investment in agricultural reform.
25 Paul Griffiths, *Youth and Authority: Formative Experiences in England 1560–1640* (Oxford, 1996), 140. See also Anthony Fletcher, *Gender, Sex and Subordination in England, 1500–1800* (New Haven, CT, 1995), 87–8; David Cressy, *Birth, Marriage, and Death: Ritual, Religion, and the Life-Cycle in Tudor and Stuart England* (Oxford, 1997), 6; John Tosh, *A Man's Place: Masculinity and the Middle-Class Home in Victorian England* (New Haven, CT, 1999), 103–4; Laura Ugolini, *Men and Menswear: Sartorial Consumption in Britain, 1880–1939* (Aldershot, 2007), 23; Anthony Fletcher, *Growing Up in England: The Experience of Childhood, 1600–1914* (New Haven, CT, 2008), 14; Susan Vincent, 'From the Cradle to the Grave: Clothing the Early Modern Body', in Sarah Toulalan and Kate Fisher (eds), *The Routledge History of Sex and the Body: 1500 to the Present* (Abingdon, 2013), 169.
26 Jordon's study of manliness in early modern England does include parents who also celebrated girls' transition into adult clothes, but in a less ritualised way than for boys, see Jennifer Jordan, '"To Make a Man Without Reason": Examining Manhood and Manliness in Early Modern England', in John Arnold and Sean Brady (eds), *What is Masculinity? Historical Dynamics from Antiquity to the Contemporary World* (Basingstoke, 2013), 250–1; Laura Gowing, *Gender Relations in Early Modern England* (London, 2012), 11–13.

27 Griffiths, *Youth and Authority*, 23–6.
28 Vincent, 'From the Cradle', 169. Vincent used the breeching ages discussed in Phillis Cunnington and Anne Buck, *Children's Costume in England 1300–1900* (London, 1965), 69.
29 Tosh, *Man's Place*, 103.
30 Breeching had less ideological and ceremonial importance in the nineteenth century, as it was more to do with tradition rather than contemporary attitudes to gendered childhood, see Tosh, *Man's Place*, 103–4.
31 For an example, see Alexander Hamilton, *A Treatise on the Management of Female Complaints, and of Children in Early Infancy* (Edinburgh and London, 1792), 503.
32 Macfarlane, *Marriage and Love*, 53; For a long discussion of primogeniture and its effect on family structures, see Stone, *Family, Sex and Marriage*, 42–54, 87–91; Ingrid H. Tague, 'Aristocratic Women and Ideas of Family in the Early Eighteenth Century', in Berry and Foyster (eds), *The Family in Early Modern England*, 190–3.
33 For examples see WCRO. CR 1386 Vol. 3/5. 'From Sir Robert Walpole' (21 October 1700), CR 1386 Vol. 3/27. 'From Lord Willoughby to Sir John Mordaunt' (5 October 1701); JRRIL. GB 133 HAM/1/17/290. 'Letter from Lady Catherine Herries to Mary Hamilton' (10 September 1805).
34 See Robert B. Shoemaker, *Gender in English Society, 1650–1850: The Emergence of Separate Spheres?* (London, 1998), 87–144.
35 Stone, *Family, Sex and Marriage*, 409–10.
36 Tosh, *Man's Place*, 103; Ugolini, *Men and Menswear*, 23; Leonore Davidoff, *Thicker than Water: Siblings and their Relations, 1780–1920* (Oxford, 2012), 65–6.
37 Thomas Lacquer, *Making Sex: Body and Gender from the Greeks to Freud* (Cambridge, MA, 1990), 25–6.
38 Fletcher, *Growing Up in England*, xx. For specific details on the enduring popularity for skeleton suits from the 1780s to the 1830s, see Cunnington and Buck, *Children's Costume in England*, 172–7.
39 Fletcher, *Growing Up in England*, xx.
40 Herbert died at Eton before the picture was commissioned, and the bubble speaks to childhood mortality.
41 Griffiths, *Youth and Authority*, 22–34; Fletcher, *Growing Up in England*, 12–22.
42 See Fletcher, *Growing Up in England*, 38–9, 69–70; Tosh, *Man's Place*, 104.
43 Karen Harvey, 'Men of Parts: Masculine Embodiment and the Male Leg in Eighteenth-Century England', *Journal of British Studies* 54.4 (2015),

805–6. There is significant discussion in histories of early modern masculinity and manhood that an emasculating insult commonly used was that a husband's wife wore the breeches in the household, see Alexandra Shepard, *Meanings of Manhood in Early Modern England* (Cambridge, 2003), 80, 127.
44 Karin Calvert, *Children in the House: The Material Culture of Early Childhood, 1600–1900* (Boston, MA, 1992), 43, 46.
45 See Vincent, 'From the Cradle', 69.
46 Amanda Vickery, *The Gentleman's Daughter: Women's Lives in Georgian England* (New Haven, CT, 1998), 14.
47 Roger North, *The Autobiography of the Hon. Roger North*, (ed.) Augustus Jessop (London, 1887), 215.
48 Samuel T. Coleridge, 'Letter 421. To Robert Southey (9 November 1801)', in Samuel T. Coleridge, *Collected Letters of Samuel Taylor Coleridge*, vol. 2, (ed.) Earle L. Griggs (Oxford, 2000), 56.
49 BA. L 30/15/39/1. 'Boringdon to Robinson' (4 January 1780).
50 Fletcher, *Growing up in England*, 69–70.
51 WCRO. CR 1386 Vol. 1/16. 'From Sir John Mordaunt to his wife, Penelope, written from Walton' (22 September 1701).
52 For more for specific expenditure on children see Vickery, *Behind Closed Doors*, 115–19. This is a revision of Plumb's assertion laid out in 'New World of Children'.
53 Anne Buck, *Dress in Eighteenth-Century England* (New York, 1979), 29–30, 166–7. This was part of the male sartorial egalitarianism of the 1780s and 1790s, see Paul Langford, 'The Uses of Eighteenth-Century Politeness', *Transactions of the Royal Historical Society*, 12 (2002), 330. Margaret K. Powell and Joseph Roach, 'Big Hair', *Eighteenth-Century Studies* 38.1 (2004), 79–99; Michael Kwass, 'Big Hair: A Wig History of Consumption in Eighteenth-Century France', *The American Historical Review* 111.3 (2006), 631–59; Lynn Festa, 'Personal Effects: Wigs and Possessive Individualism in the Long Eighteenth Century', *Eighteenth-Century Life* 29.2 (2005), 59, 62.
54 P. J. Corfield, 'Dress for Deference and Dissent: Hats and the Decline of Hat Honour', *Costume* 23 (1989), 71.
55 WCRO. CR 1386 Vol. 1/41. 'H Mordaunt at Southlyn' (2 October 1701).
56 Tosh, *A Man's Place*, 103.
57 Henry French and Mark Rothery, 'Male Anxiety Among Younger Sons of the English Landed Gentry, 1700–1900', *Historical Journal* 62.4 (2019), 987–93.
58 Ronald Paulson, *Hogarth*, vol. 2 (Cambridge, 1992), 225.
59 Paulson, *Hogarth*, 178.

60 Elizabeth Einberg, *Hogarth the Painter* (London, 1997), 39.
61 Lois G. Schwoerer, *Gun Culture in Early Modern England* (Charlottesville, VA, 2016), 144–55. Toy cannons were also popular military toys. For an example see Royal Armouries, 'Miniature Cannon', c.1700–1799. Cast Iron, 3 × 1 cm. Museum Number: XIX.939.
62 RA. GEO/MAIN/29113–29113a; RA. GEO/MAIN/29199; RA. GEO/MAIN/29204.
63 Plymouth and West Devon Record Office. 1259/1/220. 'Letter from Thomas, 3rd Lord Grantham' (21 September 1790). Also see Martin Johnes, 'Romance and Elite Culture in England and Wales, c.1780–1840', *History* 89.2 (2004), 193–208.
64 Kate Retford, *The Conversation Piece: Making Modern Art in Eighteenth-Century Britain* (New Haven, CT, 2017), 164.
65 See Toshiharu Nakamura, *Images of Familial Intimacy in Eastern and Western Art* (Leiden, 2014), 129.
66 John Locke, *Some Thoughts Concerning Education*, eds John W. Yolton and Jean S. Yolton (Oxford, 1989), 253.
67 Philip Dormer Stanhope, Earl of Chesterfield, *Lord Chesterfield's Letters*, ed. David Roberts (Oxford, 1992), 230.
68 Henry Blackwell, *The English Fencing-Master* (London, 1702), 52.
69 Cohen, *Changing Pedagogies*, 121–49.
70 Stanhope, *Lord Chesterfield's Letters*, 230.
71 French and Rothery, *Man's Estate*, 66, 75.
72 BA. L 30/15/21. 'Glasse, Greenford [?] to Robinson' (29 September 1791); BA. L 30/15/39/87. 'Parker, Christchurch, Oxford to Robinson, Newby' (22 October 1789); BA. L 30/14/315/22. 'Robinson [Grantham after 1770], Turin to Porteus' (13 January 1759).
73 Matthew McCormack, 'Dance and Drill: Polite Accomplishments and Military Masculinities in Georgian Britain', *Social and Cultural History* 8.3 (2011), 315–30.
74 There is a wealth of historical research on the Grand Tour, in particular see John Stoye, *English Travellers Abroad, 1604–1667* (London, 1952); Rosemary Sweet, *Cities and the Grand Tour: The British in Italy, 1690–1820* (Cambridge, 2012); French and Rothery, *Man's Estate*, 137–84.
75 Dorset History Centre. D/WLC/C26. For more discussion of Weld's Grand Tour see French and Rothery, *Man's Estate*, 143–4.
76 BA. L 30/14/315/22. 'Robinson [Grantham after 1770], Turin to Porteus' (13 January 1759). This Turin academy was also mentioned in earlier letters sent by the Earl of Lincoln in 1739 and Horace Mann in 1747; BL. Add MS 33065. f. 342–3; Horace Walpole, 'From Mann 6 June 1747', *The Yale Edition of Horace Walpole's Correspondence*, vol. 19, (ed.) W. S. Lewis (New Haven, CT, 1977), 407.

77 Richard Ansell, 'Foubert's Academy: British and Irish Elite Formation in Seventeenth- and Eighteenth-Century Aristocratic Grand Tour', in Rosemary Sweet, Gerrit Verhoeven, and Sarah Goldsmith (eds), *Beyond the Grand Tour: Northern Metropolises and Early Modern Travel Behaviour* (Abingdon, 2017), 46–64.
78 Stanhope, *Lord Chesterfield's Letters*, 229.
79 Sarah Goldsmith, 'Dogs, Servants and Masculinities: Writing about Danger on the Grand Tour', *Journal for Eighteenth-Century Studies* 40.1 (2017), 7, 4–7. For more on fencing see Cohen, *Fashioning Masculinity*, 62; Robert B. Shoemaker, 'The Taming of the Duel: Masculinity, Honour and Ritual Violence in London, 1660–1800', *Historical Journal* 45.3 (2002), 529–30; French and Rothery, *Man's Estate*, 94–6, 140.
80 Cohen, *Changing Pedagogies*, 124.
81 Fletcher, *Growing Up in England*, 15.
82 See the nineteenth-century bills of the royal household, RA. GEO/MAIN/29108–29108a; RA. GEO/MAIN/29111.
83 LWL. Trade Tokens and Bookplates 1705–1799: 66 726 T675 Quarto.
84 *Ipswich Journal*, Saturday 8 May 1802; *Suffolk Chronicle; or Weekly General Advertiser & County Express*, Saturday 15 December 1810; *Hull Advertiser and Exchange Gazette*, Saturday 21 September 1811; *Hull Advertiser and Exchange Gazette*, Saturday 8 May 1813; *Norfolk Chronicle*, Saturday 12 February 1814; *Exeter Flying Post*, Thursday 11 May 1815.
85 RA. GEO/MAIN/29204; RA. GEO/MAIN/29116.
86 WCRO. CR 1386 Vol. 1/85. 'From Charles Mordaunt to his mother' (5 May 1707).
87 LA. DDB/81/17.
88 RA. GEO/MAIN/29204.
89 Linda Colley, *Britons: Forging a Nation, 1707–1837* (New Haven, CT, 1992), 174.
90 LA. DDB/81/17.
91 Plymouth and West Devon Record Office. 1259/1/106. 'Letter from John, 2nd Lord Boringdon' (7 October 1789).
92 Plymouth Archives. 1259/2/347.
93 Plymouth Archives. 1259/1/219; BA. L 30/11/240/78. 'Mary to Amabel' (17 August 1798); Plymouth Archives. 1259/2/408. 'Letter from Frederick J. Robinson' (25 September 1798).
94 WCRO. CR 1386 Vol. 1/87. 'From Robert Warburton, his uncle, to Charles' (1 October 1707). See earlier discussion of Mordaunt requesting riding equipment from his mother.
95 Stephen Terry, *The Diaries of Dummer: Reminisces of an Old Sportsman* (ed.) Anna Stirling (London, 1934).

76 Material masculinities

96 BA. L 30/16/16/65. 'Mary to Katherine' (1 October 1794).
97 John Byng, Viscount Torrington, *The Torrington Diaries* (ed.) C. B. Andrews (New York, 1938), 56.
98 Byng, *Torrington Diaries*, 69, also see 9–10, 36.
99 Foreign visitors such as César de Saussure wrote in the 1720s that the English were incredibly fond of cricket, and his clumsy description of the game, that players 'go into a large open field, and knock a small ball about with a piece of wood', reveals cricket to be uniquely English. RCT. RCIN 1128232. César-Francois de Saussure, *A Foreign View of England in the Reigns of George I and George II: The Letters of Monsier César de Saussure to his Family*, (ed. and trans.) Madame Van Muyden (London, 1902), 259.
100 Lucy Inglis, *Georgian London: Into the Streets* (London, 2013), 232–3.
101 Also see Christopher Christie, *The British Country House in the Eighteenth Century* (Manchester, 2000), 278; Emma Griffin, *England's Revelry: A History of Popular Sports and Pastimes, 1660–1830* (Oxford, 2005), 50–1. Even in his clumsy description of cricket de Saussure acknowledged the skill and agility required to play well, *A Foreign View of England*, 259.
102 Byng, *Torrington Diaries*, 17. Played particularly in the Northwest, 'Prison Bars' was a traditional running game played by large teams of men and is considered to be an early version of baseball, see Griffin, *England's Revelry*, 50–1.
103 Plymouth and West Devon Record Office. 1259/2/330. 'Letter from Frederick J. Robinson and Thomas, 3rd Lord Grantham' (3 August 1797).
104 The London Cricket Club published the *Laws of Cricket* in 1744.
105 Nottinghamshire Archives. DD/FJ/11/1/4/52. 'R. Morrison to John Hewett' (20 February 1779).
106 Borsay, *English Urban Renaissance*, 175–7.
107 BA. L 30/15/53/5. 'M. Grantham, Wrest [Bedfordshire] to F. Robinson' (6 August 1788).
108 Leonore Davidoff and Catherine Hall, *Family Fortunes: Men and Women of the English Middle Class, 1780–1850*, 3rd ed. (Abingdon, 2019), 377–8; Vickery, *Behind Closed Doors*, 238, 244–7.
109 Vickery, *Gentleman's Daughter*, 178–9.
110 Middling and genteel women would not be expected to manage heavy sewing and textile repairs, see Vickery, *Gentleman's Daughter*, 160–1. For elite women's household management of textiles see Ingrid Tague, *Women of Quality: Accepting and Contesting Ideals of Femininity in England, 1690–1760* (Woodbridge, 2002), 128–9.

111 Vickery, *Behind Closed Doors*, 238. Also see Rozsika Parker, *The Subversive Stitch: Embroidery and the Making of the Feminine* (London, 1984); Amanda Vickery, 'The Moral Negotiation of Fashion in Regency England', *Eighteenth-Century Life* 44.3 (2020), 172.
112 Many writers on accomplishments thought that women's accomplishments should be merely proficient rather than artistic, see Cohen, *Changing Pedagogies*, 127.
113 Vickery, *Behind Closed Doors*, 241; Sally Holloway, *The Game of Love in Georgian England: Courtship, Emotions, and Material* Culture (Oxford, 2019), 71.
114 Mary Wollstonecraft, *Wollstonecraft: A Vindication of the Rights of Man and a Vindication of the Rights of Woman and Hints*, (ed.) Sylvana Tomaselli (Cambridge, 1995), 175.
115 See the royal household's bills, RA GEO/MAIN/29121.
116 Neil McKendrick, 'The Commercialization of Fashion', in Neil McKendrick, John Brewer, and J. H. Plumb (eds), *The Birth of a Consumer Society: The Commercialisation of Eighteenth-Century Britain* (Bloomington, IN, 1982), 46.
117 Serena Dyer, 'Training the Child Consumer: Play, Toys, and Learning to Shop in Eighteenth-Century Britain', in Megan Brandow-Faller (ed.), *Childhood by Design: Toys and Material Culture of Childhood, 1700–Present* (London, 2018), 47–66; Ariane Fennetaux, 'Transitional Pandoras: Dolls in the Long Eighteenth Century', in Brandow-Faller (ed.), *Childhood by Design*, 47–66.
118 Rousseau, *Emile*, 543.
119 Vicesimus Knox, *Essays, Moral and Literary* (London, 1782), 162.
120 Wollstonecraft, *Wollstonecraft*, 160. Mary Astell, a century earlier, made a similar claim about women's education, see Mary Astell, *A Serious Proposal to the Ladies*, ed. Patricia Springboard (Peterborough, 2002).
121 Wollstonecraft, *Wollstonecraft*, 160. Cohen has demonstrated that female education and curriculum was designed to construct, rather than reflect, a certain kind of 'surface' femininity see Cohen, '"A Little Learning"', 331–2. Also see Michèle Cohen, '"To Think, to Compare, to Methodise": Girls' Education in Enlightenment Britain', in Sarah Knott and Barbara Taylor (eds), *Women, Gender and Enlightenment* (London, 2025), 228. For a more detailed discussion of Wollstonecraft's views on girls' education, see Claudia L. Johnson, *Equivocal Beings: Politics, Gender, and Sentimentality in the 1790s: Wollstonecraft, Radcliffe, Burney, Austen* (Chicago, IL, 1995), 30; Harriet Guest, *Small Change: Women, Learning and Patriotism, 1750–1810* (Chicago, IL, 2000), 210.

78 Material masculinities

122 Kowaleski-Wallace, 'Recycling the Sacred', 154.
123 See M. O. Grenby, *Children's Literature* (Edinburgh, 2008) on how nineteenth-century children's literature encouraged girls to mimic their mothers through dolls. There are earlier examples of wax baby dolls, but they are rare compared to their adult-doll counterparts. In 1699 Lady Penelope Mordaunt wrote to her husband of her daughter's 'wax beby in swadels', see WCRO. CR 1368 Vol. 1/21. 'From Lady Penelope to Sir John' (12 October 1699).
124 Kowaleski-Wallace, 'Recycling the Sacred', 160–1.
125 RA. GEO/MAIN/29104.
126 Cohen, *Changing Pedagogies*, 142.
127 VAM. 'Mrs Powell's Wedding Suit 1761', c.1761–1800. Wax, wood, and cloth. Young V&A, London. Museum Number: W.183:7–1919.
128 Mary Delany, 'Letter from Mary Granville Pendarves Delany to Mary Dewes Port, April 29, 1776', in *The Autobiography and Correspondence of Mrs. Delany*, vol. 2, (ed.) Sarah Chauncey Woolsey (Boston, MA, 1879), 285; Jane Austen, 'Letter 32, Sat 1 November 1800', in *Jane Austen's Letters*, (ed.) Deirdre Le Faye (Oxford, 1995), 81.
129 Elizabeth Carter, 'Letter from Elizabeth Carter to Elizabeth Robinson Montagu, May 15, 1776', in *Letters from Mrs. Elizabeth Carter to Mrs. Montagu between the Years 1755 and 1800*, vol. 2 (London, 1817), 355–6.
130 The most famous example of a Dutch dolls' houses is Petronella Oortman's Dolls' House in the Rijksmuseum; 'Dolls' House of Petronella Oortman', c.1686–1710. Various materials, 225 × 190 × 78 cm. Rijksmuseum, Amsterdam. Museum Number: BK-NM-1010
131 WCRO. CR 1368 Vol. 2/8. 'To Dowager Lady Mordaunt' (17 October 1726); RA. GEO/MAIN/29111.
132 They were also designed for men, but evidence of use by boys is scant, see Amanda Vickery, 'A Self off the Shelf: Packing Identity in Eighteenth-Century England', *Eighteenth-Century Studies* 54.3 (2021), 667–86.
133 See Jennie Batchelor, 'Fashion and Frugality: Eighteenth-Century Pocket Books for Women', *Studies in Eighteenth-Century Culture* 32 (2003), 1–18.
134 Davidoff and Hall, *Family Fortunes*, 344.
135 *Ipswich Journal*, Saturday 8 May 1802; *Ipswich Journal*, Saturday 20 November 1802; *Suffolk Chronicle; or Weekly General Advertiser & County Express*, Saturday 15 December 1810.
136 Anon., *The Young Gentleman and Lady Instructed in such Principles of Politeness, Prudence, and Virtue*, vol. 2 (London, 1747), 71.

Boyhood: playing at manhood 79

137 See Cohen, '"A Little Learning"', 331; Fletcher, *Growing up in England*, 12.
138 Anon., *Young Gentleman and Lady Instructed*, 109.
139 Elizabeth Carter, 'Letter from Elizabeth Carter to Catherine Talbot, May 05, 1749', in *A Series of Letters between Mrs. Elizabeth Carter and Miss Catherine Talbot from the Year 1741 to 1770*, vol. 1 (London, 1808), 308–9.
140 For girls' and women's toys see Fennetaux, 'Transitional Pandoras', 47–66. For boys' toys in visual representations see Anja Müller, *Framing Childhood in Eighteenth-Century English Periodicals and Prints, 1689–1789* (Abingdon 2009), 61–5.
141 Locke, *Some Thoughts Concerning Education*, 104.
142 Müller, *Framing Childhood*, 63.
143 National Trust Collections. 'Rocking Horse', 1811–1820. Wood, paint, horsehair, 107 × 198 cm. National Trust Erdigg, Wrexham. Museum Number: NT 1147231.
144 National Trust Collections. 'Child's Carriage', 1700–1799. Wood, metal, 86 × 215 cm. National Trust Cotehele, Cornwall. Museum Number: NT 348482.

2
Householder: furnishing the home

Upholsterers Robert Williams and James Brown, working out of Bow Street and St Paul's Churchyard respectively, built, repaired, and resold thousands of domestic furnishings in the second part of the eighteenth century. Their chairs, tables, chimney mirrors, and wall sconces furnished the homes of respectable Londoners, country gentry, and colonial officials. Williams' and Brown's extant order books groan with thousands of ordinary eighteenth-century men's and women's material choices and consumer strategies in furnishing their homes. Historians of the domestic have richly shown that household decoration was more than mere ornamentation. Since the 1970s, the early modern household has proven a rich and dynamic historical subject – particularly for historians of gender relations, the family, and the social order.[1] The household was the smallest, constituent unit of the early modern state at the local level. A well-ordered and well-governed state was constituted of well-administered parishes which, in turn, comprised well-managed and orderly households – such was the basis of the early modern social order and its political contract theory.[2] The early modern household was at once a set of hierarchies and a grouping of peoples; often for labouring and middling people it was a place of work as well as sociability and repose. The house, household, and home were thus political and closely aligned with stratifications of (social, gendered, aged, classed) power. Studies of the household as a physical entity with spatial and material dynamics has demonstrated how the home's materiality and spatiality were important to those that lived, and often worked, there as well as underpinning the household's power relations – making them meaningful and knowable.[3] Here, I examine men's and women's practices in the furnishing, decoration, and maintenance of their

Householder: furnishing the home 81

domestic space in Williams' and Brown's ledgers and order books. In doing so, I contend that the position of male householder was a 'material masculinity' – one comprised of material practices as well as already known social, cultural, and political practices.

Histories and sources of domestic consumption

The eighteenth-century home, unlike its early modern antecedent, was no longer essential for the maintenance of social and political order and became a space of private, family life. Historians have done much to counter the narrative that this 'rise of domesticity,' and the emergence of gendered separate spheres, was solely the product of men's absence and women's subsequent investment in the family, the household, and its furnishing. Longstanding theories of the early modern household as the state in miniature underpinned the household-patriarch as the mainstay of some men's possession of manhood and access to patriarchal authority – a long-term continuity that John Tosh observed of nineteenth-century masculine domesticity.[4] Patriarchs' position at the apex of the household hierarchy was the bedrock of their claims to manly authority within wider social relations, yet as historians of fatherhood remind us, eighteenth-century fathers could be both autocratic disciplinarians and affectionate parents.[5] Margot Finn, Margaret Ponsonby, Amanda Vickery, Karen Harvey, and Jon Stobart and Mark Rothery, among others, have unearthed men's significant emotional and financial investment in the materiality of domestic life, which was both important for masculine identity formation and formed part of men's domestic authority and responsibilities. In these studies, clear patterns of gendered domestic consumption appear – men tended to order bigger, bulkier, more expensive household items that often were part of a dynastic domestic material culture of the home, whereas women's domestic consumption was more quotidian, buying small items for themselves, servants, and children and focused particularly on clothing and household linens. Generally, this gendered consumption mapped onto spatial patterns, with women provisioning for the kitchen and linen cabinets and men for more 'public' domestic spaces.[6] Domestic household management, despite these gendered divisions, was often a joint enterprise, superintended by the householder and adeptly

deputised by the mistress – and many caution at overlooking the collaboration and partnership between masters and mistresses that evades the historical record. Vickery argues that historians need to analyse men's and women's consumer practices, behaviours, and preferences simultaneously despite the lack of historical sources that enable such a comparison.[7]

However, the body of literature specifically examining men's domestic consumption is slowly increasing. Harvey's *The Little Republic* (2012) studies eighteenth-century middling masculinity and the home and finds that middling men were keen recorders of their significant investment in the materiality of domestic life.[8] This still comparatively small field of the history of pre-modern masculinity is tentative about attributing men with similar levels of material literacy and consumer expertise as women. This is, in part, a problem of approach. Histories of consumption use, unsurprisingly, consumer, rather than material categories to analyse men's consumption of 'new', 'common', and 'old fashioned' goods, but rarely do they detail their material composition or style. This chapter examines the materiality of eighteenth-century consumption to probe deeper than just the quantities and types of objects men purchased or had repaired. In doing so, it elucidates men's attitudes to fashion, luxury goods, and the daily procurement and management of domestic furniture and furnishings. It will do this by centring the discussion on consumer categories of goods (new, repaired, altered, and second-hand) and examining their material qualities such as form, style, and material. In doing so, it asks what gendered patterns of consumption emerge and whether furniture's style, aesthetics, or material or structural form drove these patterns. It aims to debunk the myth about 'masculine' and 'feminine' material literacy, material preferences, and consumer practices. As a result, it characterises the manly status of householder as a manly status reliant on material goods to be meaningful and formed out of material and consumer practices.

A material history of men's domestic consumption can reveal much about wider practices concerning consumption and material culture. Theories of emulative conspicuous consumption have prioritised categories of goods (novel luxuries) and the consumer practices (buying new goods) that supposedly drove the consumer revolution.[9] Yet consumers adopted a variety of strategies in their procurement of goods and the maintenance of their domestic interiors.

Consumer historians have recently shown that a desire for quality and fashionable goods, as well as their relationship to elite material culture, drove consumers to repair, recycle, resell, and exchange goods; middling consumers used a variety of consumer practices to acquire goods in changing styles and fashions. Nonetheless, this approach to consumer history has yet to make the connection between alternative consumer strategies and gender. Historians have tended to characterise men as 'interested' consumers of goods specifically marketed for, and associated with, masculine attributes: equestrian and outdoor sports accoutrements, coaches, drinking paraphernalia, food stuffs, books, and dynastic pieces of furniture.[10] Men, I argue, were not merely interested in some aspects of the domestic interior, but active, knowledgeable, and skilled participants in its curation and maintenance.

The history of domestic consumption has been characterised by a broad use of source material: diaries, account books, letters, bills and receipts, order books and ledgers, and probate inventories and wills – not to mention visual and literary sources. Of these, inventories and diaries have received the most attention.[11] While inventory studies have been a foundational source of consumer history, historians have often ignored the material qualities of the objects they categorise and count. Equally, the work by historians of masculinity's source material has been characterised by John Tosh's call to move away from cultural histories of masculinity to analyse men's behaviour and agency through their personal testimony. As a result, diaries remain the *modus operandi* for examining the history of men and their consumption and material culture.[12] Yet, while men's diaries reveal their motivations behind consumption, they do not lend themselves to larger-scale quantitative analysis of consumer habits and material preferences between men, and between men and women. Commercial ledgers are more than just a list of orders for tables, chairs, beds, and their costs. As social and furniture historians have demonstrated, quantitative and qualitative analysis of upholsterers' ledgers can reveal consumers' habits, the variety of goods they consumed, what second-hand goods they procured, and what furniture was deemed too economically or emotionally valuable to simply throw away.[13] Unlike probate inventories, ledgers record objects at the moment of consumption but also show a glimpse into men's and women's existing domestic interiors, their budgets,

tastes, possessions, and their desires for domestic comfort and those precious items of luxury.

This chapter analyses the consumer habits and strategies and material preferences of men and women in cabinet-makers' and upholsterers' commercial ledgers between 1763 and 1786. The first sample is taken from Robert Williams, who had a shop in Bow Street, Covent Garden and kept a ledger, previously unstudied, between 1763 and 1772.[14] Typical amongst his profession, Williams was a jack-of-all-trades. He worked primarily as an upholsterer and cabinet-maker, but also as a coffin-maker, removal man, and supplier of wholesale and naval goods. The second sample is taken from upholsterer James Brown's order book in 1786. Brown had been working out of 29 St Paul's Churchyard between 1771 and 1795. Like Williams, he provided a plethora of services beyond upholstery and furniture-making such as furniture hire, bedbug extermination, and house removals.[15] These two samples are taken from sources made in London in the second half of the eighteenth century; there are no comparative sources for the earlier eighteenth century besides the account book of Leeds upholsterer Jonathon Hall.[16] As such, the samples in this chapter do not provide a national picture or a long-term narrative of change. But they do provide a snapshot of nearly 500 men's and women's consumer behaviour and material preferences. The chapter will now outline the characteristics of both samples' demographics in terms of gender, marital status, occupation, average order size, average spend, and address. It will also detail the location of Williams' and Brown's workshops and their businesses. Moving on from this discussion, it will compare the two samples' attitude to acquiring new goods in terms of order size and average spend, but also detail the 'types' of furniture bought, specifically tables and chairs. This section will also pay particular attention to the material qualities of these 'types' and examine the samples' attitudes to furnishings' materials, design, shape, and finish. To demonstrate the variety of consumer practices in the samples, the chapter will conclude by examining repaired furniture and furniture bought second-hand.

The first sample of 57 clients is taken from Robert Williams' ledger in 1763. The sample contained 48 men and 9 women. There was only one known married couple recorded in the sample, a Mr and Mrs Tipper, and only two women were recorded as 'Miss'. Of

the 48 men, 19 were listed as having an occupation. This is a clear indicator of social rank; there were apothecaries, barbers, lacemen, carpenters, joiners, and stay-makers, as well 11 sailors. Five men were listed as esquires. Only one woman had a recorded occupation. The mean average entry size was 14 orders. The mean average total spend was £50 12s 3d, but there was significant variation. The amount of money that customers spent on furniture could vary upon the same page of the ledger. For example, on page 12, a Captain Lewin spent £33 16s 6d on furniture while a Mr Gall spent five shillings to repair his mahogany chairs. The most expensive order was made by a Mr Cammron, who spent an eye-watering £263 13s 11d on decking out his new home.[17]

The second sample, taken from all entries made into Brown's order book in 1786, had 430 customers. Of these, 309 were men, 111 were women, and 10 were unnamed or listed with only a surname. Of the 111 women recorded, 23 are listed as 'Miss' and therefore presumably were unmarried. Two women are known widows (Mrs Bacon Foster and a Mrs Newsom).[18] 11 women in the sample were married and 4 of these women's husbands also placed orders in 1786. 74 women were listed as 'Mrs'; however, as 'Mrs' denoted women's social, rather than marital, status in the eighteenth century it is not known whether these women were married or widowed.[19] Of the 309 men, 11 are known to be married – 4 of these men's wives also placed orders in the sample and 2 men have a wife mentioned in their orders. Four men were bachelors. The remaining 294 are recorded as 'Mr' and therefore their marital status is unknown. There were four orders made by husbands and wives in the sample. The Brown sample had an average order size of four items and an average spend of £5 3s 9d.[20]

Occupation and address are two methods of tracing clients' social position. I have been able to trace the profession of 26% of Brown's clients in 1786 (117 in total). Of these, only five women are mentioned: a school-mistress, Miss Gregory; a Mrs Gray, a Cutler in St Paul's Churchyard; Lady Westmoreland; Lady Eleanor Dundas; and Lady Dudley. Notably of the four titled clients in the sample, three were women. As Table 2.1 shows, gentlemen made up the largest social group within the Brown sample's known social positions (28%) and the majority of these men come from professional, clerical, military, and mercantile ranks rather than metropolitan artisans and

Table 2.1 Occupations listed in the Brown sample by gender and average order size

Rank/ occupation	Percentage	Men	Average order size	Women	Average order size
Aristocrat	3	1	1	3	1
Gentlemen	28	32	9	0	0
Clergymen	11	13	8	0	0
Military	13	15	3	0	0
Professionals	12	13	10	1	3
Mercantile	15	17	3	0	0
Retailers	7	8	2	0	0
Artisans	11	13	2	1	1
Total		112		5	

retailers. Gentlemen, clergymen, and professional men had similar average order sizes, and all had larger average order sizes compared to mercantile men, artisans, and retailers.

From this description of the two samples' clients' gender, order size, order value, known occupation, and marital status, there are significant variations between the Williams and Brown sample. Natacha Coquery has observed that eighteenth-century Parisian upholsterers had a mixed clientele that varied from artisans and shopkeepers to the highest ranks of the nobility and court. This varied clientele, she argues, demonstrates the many nuances of consumer and material culture found within one source.[21] Both the samples reflect Coquery's French clientele coming from a variety of social groups, locales, and occupations. Williams' ledger bridges clients from the more modest middling sorts and its upper echelons as well as the lesser gentry, although his clientele is predominantly made up of metropolitan artisans and retailers. Compared to the sample taken from Williams' ledger, Brown's business served a more elite client base. This is a difficult comparison as Williams rarely recorded clients' occupation and address compared to Brown. While Brown was fastidious about noting clients' addresses and occupations, he was less so with recording the cost of items: 49 clients (11%) had no total spend noted, and many clients' orders had only one or two prices attached to items in orders of several goods.

Householder: furnishing the home 87

This makes a financial comparison between the two samples more difficult.

Of the known occupations of Brown's clientele, 81% came from the 'upper section' of the middling sorts, lesser gentry, and aristocracy: merchants, clergymen, gentleman, esquires and an Earl (see Table 2.1). A striking difference between the two samples is that Brown had 30 esquires, whereas Williams had only 5. Indeed, Brown could boast 4 aristocratic patrons in 1786 alone, including the Earl of Suffolk.[22] Another difference is the number of recorded clients in a year; Brown had 430 clients while Williams had only 57. This suggests that Brown was operating a larger business to cope with such demand. Business must have been booming as Brown was insured for £2,000 in 1779, with his stock and utensils valued at £1,400.[23] Another factor is the location of their shops. Williams' shop in Bow Street was less than illustrious compared to St Paul's Church Yard at the very heart of the London furniture trade.[24] In 1740 a Sir Thomas de Veil, a Justice for the Peace for Middlesex, acquired the lease of 4 Bow Street and converted it into a magistrates' court. At that time, he was the street's only private ratepayer, and Bow Street became a London crime hotspot.[25]

Therefore, both samples straddle the border between more modest artisans and retailers, wealthy London merchants, gentleman, and the lesser gentry. Nonetheless in terms of clients' occupation, address, and the upholsterers' locale and business size and location, the Brown sample was weighted more towards to upper section of middling, gentry, and nobility. Indeed, the fact that a newly minted esquire, with both a townhouse in the fashionable West End and a country seat, was buying furniture from the same upholsterer as the Earl of Suffolk must have carried significant social clout.

Moreover, while the known addresses of the Williams sample are predominantly metropolitan, those in the Brown sample included a much wider geographical area. He provided furniture for his clients' London and country houses. Orders by letter came to Brown from large country seats such as Norton Place in Lincolnshire, Aspenden Hall in Hertfordshire, and Woodcote Manor in Hampshire. He also supplied some of the most fashionable addresses of late eighteenth-century London such as St James's, St George's Hanover Square, Pall Mall, Bedford Square, Queen's Square, and Arlington Street as well as addresses in the City, the emerging East End, and outlying

suburban areas such as Hampstead, Kentish Town, Chelsea, and Clapham. The sample also included three clients from overseas in Greece, the Netherlands, and North America. The two samples differ in clientele, business size, and geographical scope and this is no more obvious than in the different tones of two makers' trade cards. A trade card for a T. Williams was most likely made for Robert's father and bares the rococo details typical of mid-century trade cards.[26] It stated that he sold from his carpet warehouse 'Wholesale and Retail at the Lowest Prices'. In much more flamboyant prose, Brown's trade card detailed the 'best and most fashionable' assortment of mahogany furniture, 'curiously painted' window blinds, and a 'good choice' of goods.[27]

Men made up most customers in both samples. It is no surprise that only 12 of the 350 customers listed in the index of Williams' ledger were women – although 5 more appear in the ledger in later years making a total of 17.[28] All but two are recorded as 'Mrs', suggesting that the majority were either married or widowed. The two women recorded as 'Miss' both had their orders paid by other parties. English Common Law coverture restricted women's economic activity, their ability to claim credit, and therefore consumer behaviour and material culture. Coverture has obscured married women's consumer habits and possessions in legal and commercial documents.[29] As Margot Finn has demonstrated, married women were able to use their husband's credit to purchase household necessities to circumvent coverture.[30] The problem that faces this chapter, and other studies that use legal and economic source material, is establishing who was responsible for buying what.[31]

Both Williams and Brown listed multiple separate orders for husbands and wives entered consecutively: Mr and Mrs Anthony Hayes Esq., who was the British Consul in Smyrna from 1762 to 1794, Mr and Mrs John Boldero Esq. (and their son), Mr and Mrs Gryse, and Mr and Mrs Gregory. The Bolderos had an interesting pattern of consumption as Mrs Boldero's orders came from their townhouse in Bedford Square, whereas Mr Boldero's came by letter from their Hertfordshire estate, Aspenden Hall, acquired earlier in the 1760s. This shows a clear dynamic of marital responsibility for maintaining different homes, with Mrs Boldero furnishing the prestigious London townhouse for entertaining and Mr Boldero establishing the dynastic seat. Both Williams and Brown noted if

someone other than the named client paid for the goods and often recorded if goods were paid for in cash. However, it is not only these details that demonstrate who is ordering and buying goods. The language of ownership in the ledgers, indicated by the use of 'your' – usually referring to items for repair – suggests that the named client was the one ordering. This is the same stylistic trope for both men's and women's orders. Moreover, Williams' ledger appears to be a transcript of the customers' orders. Orders for similar goods varied in the language used to describe them. Williams put question marks after pieces of furniture or styles that he was not familiar with such as Venetian window blinds. Combined, these factors lead to the conclusion that the named client on entries was the person ordering the goods themselves.

Buying new goods

Historians have emphasised the variety of consumer strategies used to acquire goods in the eighteenth century and both samples indicate that most customers' orders contained new goods. Of the 693 orders in Williams' ledger, 534 (77%) were for new goods. Women ordered smaller amounts of new furniture and had smaller orders in terms of quantity and expenditure than men.[32] This gendered pattern is typical of order sizes in upholsterer ledgers. Men typically made large orders for whole-house commissions for more substantial goods, whereas women tended to have smaller orders comprising of commissions for single pieces of furniture, although they occasionally, in Vickery's words, had the 'wherewithal for large orders'.[33] However, even in a small sample of 57 clients, the fact that one woman ordered more new furniture than 36 men confirms Vickery's claim that this gendered difference in order size does have its exceptions (see Table 2.2). By analysing the gendered difference of order sizes through the percentage of men (48) and of women (9) in the sample, there is a stark difference between men and women who ordered no new goods and those who ordered greater number of goods (16 or more). Women's orders were more likely than men's to contain no new goods. While 8% of men's orders comprised more than 15 new goods, no women in the sample ordered over 15 new goods. However, most men (85%) and women (78%) in the sample ordered

90 Material masculinities

Table 2.2 New items of furniture purchased in relation to the average total items in the order and the average total spend in the order in the Williams sample by gender

New goods	Total	Men	Women	Average total items	Average spend
0	6	4	2	2	£7 18s 12d
1–5	31	27	4	7	£14 5s
6–10	6	5	1	11	£37 2s 9d
11–15	10	9	1	18	£10 12s
16–20	1	1	0	20	£62 10s 12d
>21	3	3	0	85	£71 1s 6d

Table 2.3 Percentage of men and women ordering new goods in the Williams sample

New goods	Percentage men	Percentage women
0	8	22
1–5	56	56
6–10	10	11
11–15	18	11
16–20	2	0
>21	6	0

1–15 new goods. Therefore, the majority of Williams' male and female customers ordered similar, small quantities of new furniture. This would suggest that, in this sample, there was only a small, gendered distinction in order sizes for new goods at the top and bottom end of the scale. The similarities in order size indicate that it was less to do with gender and more to do with ability to spend. This supports Lorna Weatherill's view that probate inventories do not indicate a subculture of women's goods. She claims that men's and women's possessions were less to do with gender and more to do with household demographics, social status, occupation, and location.[34]

Householder: furnishing the home

Table 2.4 New items of furniture purchased in the Brown sample by gender

New goods	Total	Men	Men average order size	Women	Women average order size	Unknown
0	33	27	2	6	1	0
1	206	124	1	75	1	7
2	85	69	2	14	2	2
3	19	16	3	2	3	1
4	26	21	4	5	4	0
5	14	11	6	3	5	0
6–10	12	10	8	2	7	0
11–15	11	9	13	2	14	0
16–20	4	3	17	1	1	0
>21	11	10	35	1	39	0

In the Brown sample, of the 1,504 total goods ordered, 1,289 (86%) were newly purchased goods – 9% more than in the Williams sample. This suggests that, despite a vastly larger sample, both Williams' and Brown's customers purchased a similar percentage of new furnishings. As with Williams, most of Brown's customers' orders were small, with most orders for both men (65%) and women (80%) containing one or two new goods. But, unlike the Williams sample, the women in the Brown sample made larger orders, suggesting that order size was less to do with gender than with status and spending ability. Interestingly, of the three women who ordered over 10 new goods, two were both married to men in the ledger, a Mrs Gregory and Mrs Boldero. The third was a Miss Gregory who kept a school in Esher, Surrey. These, admittedly few, examples support historians' claims that married women had a greater degree of economic independence than their unmarried counterparts.[35]

However, quantitative analysis of order sizes is only one way to determine if there was a pattern of gendered consumption. Examining the different types of furniture that men and women bought can also reveal gendered attitudes to goods. Clients in both samples bought an abundance of different 'types' of furniture in a wide variety of styles, materials, and functions. There were 26 orders for

Table 2.5 Percentage of men and women ordering new goods in the Brown sample

New goods	Percentage men	Percentage women	Unknown
0	9	5	–
1	42	68	70
2	23	12	20
3	5	2	10
4	7	4	–
5	4	3	–
6–10	3	2	–
11–15	3	2	–
16–20	1	1	–
>21	3	1	–

Table 2.6 Orders for different types of tables in the Williams Sample by gender

Table type	Total	Men	Women
Table top	1	1	0
Tea table	1	1	0
Corner table	1	1	0
Night table	1	0	1
Dressing table	1	1	0
Kitchen table	1	1	0
Shaving table	1	1	0
Pillar & claw	3	0	3
Chamber table	4	4	0
Card table	4	4	0
Dining table	8	6	2
Total	26	20	6

tables in the Williams sample (see Table 2.6). Consumers bought tables for specific functions of sociability (tea drinking, dressing, card-playing, and dining) and specific rooms (bedrooms and dining rooms). The inclusion of a corner table in the Williams sample shows a penchant for French fashion. Matching corner tables were

Table 2.7 Orders for different types of tables in the Brown sample by gender

Table type	Total	Men	Women	Unknown
Kitchen table	1	0	1	0
Child's table	1	0	1	0
Loo table	1	1	0	0
Folding table	1	1	0	0
Toilet table	2	1	1	0
Writing table	2	2	0	0
Inlaid table	2	2	0	0
Work table	5	2	3	0
Backgammon table	5	5	0	0
Side board table	5	5	0	0
Chamber table	7	7	0	0
Dining table	8	7	1	0
Night table	10	8	2	0
Portable desk	13[a]	9	2	0
Dressing table	13	10	3	0
Card table	22	19	3	0
Pembroke table	26	19	6	1
Total	124	98	23	1

[a] Some orders contain multiple entries for an item, hence any apparent discrepancy in totals. This applies throughout.

typically placed in either corner of a long wall with a matching commode or side table in the middle. Three women bought pillar and claw tables, another fashionable table style in the 1760s. Six men bought dining tables, which were associated with masculine dynastic consumption of bulkier and expensive items.[36] The inclusion of a 'good mahogany shaving table with glass and folding top' bought by a James Gold Esq. shows an interest in a particularly masculine furniture type.[37]

There were 124 orders for tables in the Brown sample (see Table 2.7). Perhaps because of the sample' different sizes, there are a greater number of different types of tables in the Brown sample (17) than Williams' (11). The proliferation of furniture styles, types, and materials in the intervening years between the samples must

play a part in the greater variety of table types in the Brown sample. In both, tables associated with the practices of sociability were popular, although card tables were especially popular with Brown's more elite customers. Considerably more men ordered tables than women in both samples. In the Brown sample men placed 75% of the orders for tables. Interestingly, compared to the Williams sample, Brown's customers bought comparatively fewer dining tables.

Unsurprisingly, work tables were the only table type bought by more women than men, although an insurance broker Peter Cox of College Hill in Hertfordshire ordered 'a card table to elevate occasionally for a pin table' showing a need for multi-purpose furniture and furniture that combined different functions and different aspects of gendered leisure.[38] A similar requirement for multi-purpose furniture is mirrored in the presence of 13 portable desks. Of the 25 'gaming tables' (Loo, Backgammon, and Card), only three of the 22 card tables were purchased by women. There are considerably more dressing tables in the Brown sample (13) than in the Williams (1). Men and women, on the whole, bought furniture associated with established functions of gendered leisure. The description of the tables ordered is the most striking difference between the samples. For example, in the Brown sample, Pembroke tables, which became popular in the mid-eighteenth century and were commonly used as breakfast tables wheeled on casters to the bedside, varied greatly in terms of shape, finish, and material.[39] There were 10 different varieties of Pembroke table alone listed in the Brown sample (see Tables 2.7 and 2.8). Of the 26 Pembroke tables, 13 specified a shape, 3 tables specified a material (mahogany), and 1 specified a style of table (commode). The more elite men in the Brown sample bought a greater variety of furniture than those in the Williams sample.

A gendered language of furniture appears in both samples, but in a much smaller number than Vickery suggests.[40] As the gendered language of furniture was only emerging in the mid-eighteenth century, it is unsurprising that there was only one lady's commode dressing table in the 1763 sample; however, it was not significantly more prevalent in the 1786 sample, with only three items prefixed with 'Lady's' (a writing box and two dressing tables) and three items prefixed with 'Gentleman's' (two dressing cases and a dressing table).[41] Gendered furniture was therefore present but not prevalent in both samples. As Akiko Shimbo notes, references to gentleman's furniture

Table 2.8 The variety of Pembroke tables in the Brown sample by gender.

Variety of Pembroke table	Total	Men	Women	Unknown
Fine solid	1	0	1	0
Commode	1	1	0	0
Plain oval	1	0	1	0
Solid mahogany	1	1	0	0
Circular	1	1	0	0
Square inlaid	1	1	0	0
Square mahogany	1	1	0	0
Oval mahogany	1	0	1	0
Oval	5	4	0	1
Square	6	4	2	0
Pembroke table	7	6	1	0
Total	26	19	6	1

were less frequent in Sheraton's 1803 *The Cabinet Dictionary*.[42] This is also true of earlier furniture manuals (see Table 2.9) and Shimbo writes that the lack of gendered prefixes suggests that most furniture was designed for men as a default and then adapted to suit associations of women's use. But, as Vickery acknowledges, gendered language does not indicate gendered use or work.[43]

Chairs were the most varied item of furniture in the Williams sample, with 35 orders for chairs in 17 different styles, types, and materials. Men ordered a wider variety of chairs in terms of style, type, and material than women. French armchairs, the second most popular type in the sample, were a new and fashionable style of chair in the mid-eighteenth century and were purchased in equal numbers by men and women. The sample also included three orders for 'plain' and 'commonplace' chairs. Men ordered sets of chairs to match and numerous orders included loose seat covers.[44] These chairs remained in a 'semi-finished condition', with men thinking ahead by ordering chairs that could be easily altered to incorporate the changing fashions in upholstery without having to replace them – this also meant they were easier to clean and repair. Another pattern was the consumption of painted and stained wooden chairs;

Table 2.9 Furniture prefixed with 'Gentleman's' or 'Lady's' in eighteenth-century furniture manuals

Year	Manual	'Gentleman's'	'Lady's'
1762	Chippendale[a]	1	3
1762	Ince and Mayhew[b]	1	2
1788	Hepplewhite[c]	1	1
1791	Sheraton[d]	1	6
1803	Sheraton[e]	2	2

[a] Thomas Chippendale, *The Gentleman and Cabinet-Maker's Director* (London, 1762).
[b] William Ince and John Mayhew, *The Universal System of Household Furniture* (London, 1762).
[c] A. Hepplewhite, *The Cabinet-Maker and Upholsterer's Guide* (London, 1788).
[d] Thomas Sheraton, *The Cabinet-Makers and Upholsterer's Drawing Book* (London, 1791).
[e] Thomas Sheraton, *The Cabinet Dictionary* (London, 1803).

one client ordered chairs to be 'stain'd red' perhaps to mimic the reddish hues of mahogany without its associated cost. Six new mahogany chairs could cost upwards of five pounds in the ledger, whereas entries for six stained chairs show they could cost between 16s 6d and 19s 6d.[45]

The choice of stained wooden chairs over mahogany ones illustrates men's material literacy in negotiating the desire for fashionable and quality materials with the limitations of budget. There was a relative parity between orders that specified a type or style of chair (54%) and orders that specified a particular type of material (46%) – if orders that included a specific textile for upholstery were included the latter figure would rise considerably. Rarely in the sample were expensive mahogany chairs also upholstered in expensive textiles. Men would order chairs made of cheaper wood but with upholstery that is more expensive or cheaper upholstery and more expensive wood. This shows that materials rather than design was a significant material preference for Williams' male clients' consumption of furniture, as they were often on a budget.

In the Brown sample, there were 108 orders for chairs by 72 customers. Men placed the majority of orders (94) while women only made 15. There were over 60 different varieties of chairs in terms of style, material, shape, function, and colour – considerably

Householder: furnishing the home

Table 2.10 The quantity of differing types and styles of chairs in the Williams sample by gender

Style of chair	Total	Men	Women
Camp	1	1	0
Chair-back stool	1	1	0
Common chair	1	1	0
Painted	1	1	0
Kitchen	1	1	0
Stuffed-back	1	0	1
Bamboo	1	1	0
Elbow	1	1	0
Beech	1	1	0
Wooden bottom	1	1	0
Night	2	2	0
Child	2	2	0
Windsor	2	2	0
Plain chair	3	3	0
Stained	4	4	0
French armchair	4	2	2
Mahogany chairs	8	7	0
Total	35	31	3

more than in the Williams sample. As with tables, Brown's larger sample size than Williams could account for the greater variety of chairs. In both samples, mahogany chairs were the most popular; in the Brown sample, men placed 32 orders for mahogany chairs and women 5. The Brown sample contains more chairs with specific functions than in the earlier Williams sample; examples include 23 orders for children's chairs, nursing chairs, dressing stools, bedroom chairs, and hall chairs. While 39 chair orders specified a material such as mahogany or beech, 35 specified a particular finish such as staining, japanning or dyeing; 62 specified a style of chair such as vase back, flute back, oval back, bow top, round top, Southampton, Windsor, and French armchairs. Therefore, while mahogany was the most popular material, the finish and style of wooden furniture was more important to Brown's customers than Williams.

This examination of types of furniture – tables and chairs – reveals a gendered pattern in consumption. Typically, more men bought bulkier items such tables and chairs than women, although tables

with 'gendered' functions, such as shaving or needlework, did fall along expected gender distinctions. Both samples illustrate a rich variety of furniture in terms of style, material, and design, but Williams' customers were more concerned with the material these goods were made from rather than their design or finish and this appears to be the result of limitations of budget; customers ordered stained chairs or chose plain chairs with more expensive upholstery. The wider variety of styles and designs for Brown's more elite customers' can be attributed to a concern with furniture's aesthetics rather than materials. This chapter will now turn to a more detailed discussion of the materials and design of furniture in both samples.

Materials vs. design

A significant preoccupation for Williams' customers was the type of timber used in wood furniture. Of the 534 orders for new goods in the Williams sample, 111 (20%) specified a particular wood in their orders; 82% of these orders specified mahogany, meaning that mahogany furniture made up 17% of the total purchased goods. Eighteenth-century furniture manuals, upholsterers' trade cards, and printed auction sales catalogues espoused the suitability of certain woods for particular furniture types and pushed the desirability of walnut and mahogany furniture.[46] Mahogany was first imported to England in 1700 and, due to its comparatively cheap cost to deal (pine) and wainscot (oak), furniture-makers began to use it in significant quantities by the 1730s and 1740s. The increased popularity of mahogany goods raised the demand and imports of raw mahogany, from British slave plantations in the West Indies, in the 1750s and 1760s and resulted in the increased cost and desirability of mahogany goods.[47]

Historians have considered the, often contradictory, gendering of mahogany goods in Britain. Some have argued that mahogany was a new, exotic, and luxury material skilfully crafted into the furniture of polite sociability such as tea- and card- tables – furniture that the social imagination closely aligned with femininity.[48] Others characterise it as a material closely associated with 'masculine' spaces and objects – desks, bookcases, and study panelling – and was perceived to eschew the transient whims and extravagant tastes

of 'feminine' luxuries.[49] One answer to this contradiction would be, as Hannah Greig has posited, that for London's *beau monde*, objects' fashionable status was attached to the people who owned them, rather than an innate 'fashionable' quality of objects' design or material. Objects' meaning was derived from their position within social networks rather than which materials they were made from or their design.[50] Certainly the rise of furniture manuals can be attributed to consumers wishing to emulate the fashions of others by purchasing furniture with a specific Chippendale or Sheraton style.

We can certainly see this in the samples studied here. Brown's clients ordered furniture to match their neighbours, friends, and Brown's other customers. Richard Walker Esq. ordered 'a wilton carpet to fit the plan exactly the same as Mr. Tubs, Bedford Square' and 10 Cabriole Chairs and 2 cabriole sofas to be 'made of the same as Mr Tubbs'.[51] Richard Walker Esq. was listed in the parish rate books as living at 13, Bedford Square between 1782 and 1783, followed by a Mr Marchant Tubb Esq. in 1784–1791.[52] Mr Thomas Wittenoom, a proctor at Doctors' Commons, ordered striped cotton bed furniture to the 'pattern of Mr. Caslon's curtains'.[53] Mr Gryse, an anchor smith in Rotherhithe, asked Brown to mount his wife's satinwork into a 'neat oval French screen' for £1 11s 6d and, under a fortnight later, a Miss Crouch in the 'next house to Mr Gryse at Rotherhithe' ordered Brown to mount her sewing onto 'an oval French Skreen' for £2.[54] Three clients bought tea boards with scenes from Frances Brooke's 1783 opera *Rosina: A Comic Opera, in Two Acts* of the hero and heroine Captain Belville and Rosina, and two bought waiters japanned with the 'shipwreck of the centaur', possibly depicting John Harris' etching of HMS Centaur in 1783.[55] For these clients, clearly, goods' association with their owners informed their desirability, rather than an innate fashionability.[56] If we follow Greig's argument, for elite men and women the materials which goods were made from may have been unimportant, but for the aspiring and acquisitive middling sorts, raw materials such as mahogany were a prominent consideration of their furniture consumption due to limitations of budget. When a restricted budget met with a desire for fashionable or luxurious furniture, as demonstrated in the adaptability of chairs, the materials goods were made from was a key consideration for middling consumers, who had to decide

whether materials' status-displaying ability was matched by goods' design qualities.

Another possible explanation, made by Vickery, is that furniture's scale and size, not its material components, was a much stronger indicator of its gendered associations.[57] Mid-century furniture advertising pushed mahogany and walnut furniture without explicit reference to gender, and furniture such as desks and tables designed specifically for men and women was only an emerging phenomenon in the 1760s.[58] However, there was a subtle gendering of mahogany in furniture manuals, which espoused that furniture, in design, style, and material, should reflect the function and use of the room it populated.[59] Sheraton prescribed that dining rooms, spaces with 'masculine' domestic associations, should be furnished 'in substantial and useful things, avoiding trifling ornamentals and decorations ... The furniture, without exception, is of mahogany, as being the most suitable for such apartments'. He also specified for a gentleman's library table that 'mahogany is the most suitable wood, and the ornaments should be carved or inlaid, what little there is; japanned ornaments are not suitable as these tables frequently meet with a little harsh usage'. Nonetheless, mahogany was also suitable, according to Sheraton, for lady's drawing, writing, and dressing tables.[60] But neither Greig's nor Vickery's suggestions resolve the contradiction of gendered mahogany consumption, nor help answer why Williams' clients preferred mahogany to other woods and why men bought mahogany in comparative abundance to women. To answer this, I will now examine the prevalence of mahogany in customers' orders in relation to their gender, average spend, and total items.

Only three of the nine women in the Williams sample bought new mahogany furniture. They had comparatively larger orders and a higher expenditure on goods than the women who bought no mahogany goods at all. A Mrs Gilpin specified the 'best' mahogany in her order for a dining table, pillar and claw table, and a bedstead. She was one of just a handful of clients to order only mahogany goods.[61] To put this into greater perspective, Gilpin ordered more mahogany furniture than 48 clients, 40 of whom were men. As with the three women, men who bought more mahogany furniture had a greater average price and order size than those who did not purchase any at all. In plainer terms, the sample demonstrates that the more money spent on furniture, the more mahogany items a customer

Householder: furnishing the home 101

bought regardless of gender. Many entries requested 'strong', 'solid', 'best', and 'fine' wood, illustrating a desire for quality rather fashionable raw materials.[62] Customers wanted the latest fashions in furniture, made of quality materials and in the best 'taste', but without breaking the bank. Furniture-makers were responsive to their new market of middling consumers; upholsters' trade cards, including that of Williams' father, stressed their reasonable, or even sometimes low, prices for furniture.

Table 2.11 The number of new mahogany goods in the Williams sample by gender

Number of new mahogany goods	Total	Men	Women
0	24	18	6
1	15	13	2
2	9	9	0
3	5	4	1
4	3	3	0
5	1	1	0
9	1	1	0
18	1	1	0
Total		50	9

Table 2.12 The consumption of different types of materials in the Williams sample by gender

Material	Total number of orders	Men	Women
Deal	1	1	0
Beach	1	1	0
Bamboo	1	1	0
Ivory	1	1	0
Rosewood	2	2	0
Wainscot	4	3	0
Gilt	4	4	0
Stained wood	5	5	0
Mahogany	92	50	9

In Jennifer L. Anderson's history of mahogany in early America she argues that mahogany's reflective quality created a stronger sense of shared national identity for early Americans.[63] In Britain, mahogany furniture was highly polished and this created a unique, mirror-like sheen that reflected the possessor's acquisition of a signifier of respectability.[64] They could see themselves reflected in their status-displaying possessions. Men and women could not escape the exotic lustre of mahogany's ability to denote respectability and social status. Berg argues that raw materials, and the new commodities they were manufactured into, 'were not just the stuff of women's desires, of shopping for bargains or making style. They were just as much about men's acquisitiveness, of their passion for goods that marked out respectability and independence'.[65]

Therefore, while mahogany furniture evoked respectability no matter the gender of the consumer, moving beyond mahogany to examine the other woods men bought reveals a much greater investment in the material qualities of furniture. Despite mahogany's dominance in the sample, it does include men who bought goods made from a variety of materials, unlike female consumers.[66] Men were both traditional and adventurous consumers of wooden furniture. Deal (soft pinewood) had been commonly used in the cabinetry and furniture trades since the seventeenth century.[67] As Clive Edwards has observed, deal and wainscot (oak) were considered traditional woods, unfashionable even, compared to mahogany by the mid-eighteenth century.[68] In Williams' ledger four men ordered wainscot furniture. Sen. Chapereau ordered a 'large Wainscot table top, with strong ... hinges' for £1 10s.[69] In an order mainly for repairs, wainscot was a sensible choice to limit expenditure. It is nonetheless interesting that it was a wainscot table top and not a mahogany one. But Chapereau also bought a 'good mahogany tea borde' – perhaps mahogany could have been afforded in smaller items but not for larger pieces.[70] Mr Cammron, whose total order came to £263 13s 11d, ordered a wainscot table for 9s but this was clearly not for his own use as it was surrounded by orders for kitchen furniture and paraphernalia.[71]

Others ordered furniture that was made of a mixture of wainscot and mahogany. Captain Webber ordered a 'large 4 post'd Wainscot Lath bottom bedstead with neat mahogany carved postes compass rod & base slips on casters' for £6 6s.[72] Again, budget was a deciding

factor in choice of wood, with the cheaper wainscot base covered by the bed furniture and the neat mahogany carved posts on show. In Sheraton's *Drawing-Book* he had a similar approach to combining woods. When writing about a making a card table top, Sheraton suggested it was

> best to rip up dry deal, or faulty mahogany, into four inch widths, and joint them up. It matters not whether the pieces are whole lengths ... After the tops are dry, hard mahogany is tongued into the ends of the deal, then flips are glued on the front and back, the whole may appear solid mahogany.[73]

Sheraton applied the same technique to bed testers that were made up of deal or wainscot with thinner panels of mahogany glued to the surface.[74] Webber's combination of materials demonstrated a knowledge of the manufacturing process and how to use this to circumvent costs; he could have a bed that *appeared* to be made of solid mahogany without paying for it.

It was not only traditional items such as bedsteads and tables that were made of wainscot, as new and fashionable goods, such as girandoles and cellarets, were also made from this material. This use of wainscot suggests that the style or fashionability of furniture was more important than the material it was made from. While some men chose traditional or cheaper woods to suit their tastes and budget, others purchased exotic woods in foreign styles. A Mr Clavel purchased 'a neat rosewood Box inlaid with ivory &c.' for £3 3s and four 'neat bamboo chairs with arms and &c.' for £5 8s.[75] Captain Webber purchased a set of rosewood chairs and sold them through Williams.[76] Certain finishes to goods, like japanning and Chinese fretwork, demonstrated a taste for the exotic. In the Williams sample, men consumed more goods made from exotic materials than women. While mahogany had more to do with status-display than any noticeable gendered associations, men were keener to acquire furniture in exotic and luxurious materials and styles than women. Despite the virulent debates on luxury, the exotic, and effeminacy in the eighteenth-century print marketplace (examined further in Chapter 4), it is clear that men were keen consumers of luxurious furnishings as a sign of tasteful discernment and respectability.

In the Brown sample, 207 goods (16% of all new goods) were made with a specified wood. Mahogany dominated wooden furniture

in both samples (82% in Williams and 74% in Brown). Both samples included clients specifying quality materials and both contained orders for furniture made from a wide variety of materials. Like Captain Webber, who combined wainscot and mahogany in a bedstead, Brown's customers purchased goods made from a combination of woods to keep costs down. In the Brown sample, five men placed orders for bedsteads to be made of stained beech with mahogany pillars and feet. However, furniture made of a combination of luxury woods was more prevalent in the Brown sample than in the Williams. This can be attributed in part to the organisational developments of upholsterers and cabinet-makers that used a web of sub-contractors to produce products.[77] Another possibility is that mahogany's dominance in the furniture trade waned in the 1770s when satinwood and rosewood became more popular in England due to increased colonial territories in India and the Caribbean.[78] But there is a significant difference between combining luxury woods, such as satinwood and tulipwood, for inlaid work and marquetry to create elaborate decorative effects and combining stained beech with mahogany to reduce cost. Both samples included clients who specified items to be made of solid mahogany, potentially as a reaction against the combination of mahogany and cheaper woods. That customers specified which particular woods that that their furniture should be made from, suggests that the type of wood was important for customers in both samples. The reasons for their choice of wood varied from cost-cutting to status-claims by rejecting cheaper alternatives.

One notable difference between the samples is that when Williams' female clients specified a particular wood, it was always mahogany, whereas Brown's female clients bought a variety of wooden furniture. Again, this can be attributed, in part, to changes in fashion in the 1770s, with lighter woods such as tulipwood and satinwood becoming more popular. The same number of men as women bought satinwood furniture, supporting Vickery's argument that the materials that furniture was made from did not always evoke gendered associations.[79] Middling mahogany consumption had, as Jon Stobart and Mark Rothery have argued, compromised its elite consumer patina and Brown's clientele contained more elite customers.[80] In the Brown sample, though, as with Williams, the amount of mahogany furniture

Table 2.13 The consumption of different types of materials in the Brown sample by gender

Material	Total	Men	Women	Unknown
Airwood	1	1	0	0
Bamboo	1	1	0	0
Tulipwood	1	1	0	0
Rosewood	1	0	1	0
Kingswood	1	0	1	0
Deal	5	3	2	0
Wainscot	5	4	1	0
Satinwood	10	5	5	0
Grey wood	11	6	5	0
Beech	18	16	2	0
Mahogany	153	120	31	2

ordered correlated to the total spend on, and size of, orders regardless of gender.

The samples' different attitudes towards materials is the most striking difference between them. Williams' clients were more invested in the material furniture was made from, and especially if it was made of mahogany, and this was one of the sample's standout features. Though not entirely absent from the Brown sample, goods' material was increasingly over-shadowed by the clients' preoccupation with aesthetics and design. As demonstrated in the comparison between chairs and tables in both samples, the style (gothic ornaments or cabriole leg), type (Pembroke table or vase back chair), function (hall chairs, nursing chairs, and shaving tables), colour (puce or green), and finish (japanned, painted, stained or inlaid) were more important to Brown's customers than those of Williams (see Tables 2.12 and 2.13). This is echoed throughout the Brown sample beyond chairs and tables. Five men ordered secretary desks and bookcases with gothic doors and scroll pediments (possibly influenced by designs in Chippendale's *Gentleman and Cabinet-Maker's Director*). In fact, 10 orders were made to patterns from furniture plates. There was also a trend in the Brown sample of matching furniture or furniture in sets, with 44 orders specifying matching furniture either in colour,

Table 2.14 The different finishes to goods in the Brown sample by gender

Finish	Total	Men	Women	Unknown
Stained	12	10	2	0
Japanned	44	30	11	3

Table 2.15 Furniture with a specified shape in the Brown sample by gender

Shape	Total	Men	Women	Unknown
Hexagon	3	0	3	0
Shield	3	3	0	0
Octagon	4	3	1	0
Circular	8	6	2	0
Oval	87	63	21	3
Square	179	149	28	2

textile, or style.[81] Most noteworthy, however, was the recurring emphasis on the shape and colour of furniture in the Brown sample. There were 286 orders (19% of total ordered goods) that specified a shape, compared to 211 (14% of total ordered goods) that specified a material. In contrast, only three of the 534 orders for new goods in the Williams sample referenced a specific shape.[82] Furnishings' design or finish was more important to Brown's customers than the material it was made from.

There are a few possible reasons to account for the different attitudes to the furniture's composition, material, and design in the samples. Changing fashions in the 23 years between the samples could account for this; for example, the widespread popularity of japanned chairs began in the late 1770s.[83] But the emergence of other luxury woods within the Brown sample was not large enough to significantly affect the consumption of mahogany. When customers specified a certain wood, mahogany furniture dominated both samples, and both men and women were keen consumers of mahogany goods if their budget allowed. Despite this, there are notable differences

between the samples. Williams' customers were more concerned with materials than design, unlike Brown's who privileged design, colour, shape, and finish. It is curious that in the Williams sample, which richly details the materials of furniture orders, there is such a lack of focus on design and shape. Perhaps the differences in the craftsmanship and skill of the two cabinet-makers can account for this difference; Brown was certainly operating a larger business than Williams and had a more elite clientele. Another possible reason could be that Williams' more middling clientele prioritised the materials that furniture was made from as it denoted respectability, but for Brown's more elite customers, furniture's design signalled their fashionable tastes. Investing in solid mahogany furniture, which was unlikely to go out of fashion, was more practical than purchasing a set of oval-backed green chairs that would soon be *démodé*. This privileging of design over material was also matched with a greater concern for who owned goods in the Brown sample. Even though Brown's clients were mostly fashion-followers, rather than the fashion-leaders of Greig's *beau monde*, they emulated their neighbours' and friends' possessions. In more gendered terms, despite the commentary that luxury, exotic goods were the stuff of women's material desires, men were consumers of more exotic wooden furniture than women.

Repairing

While examining the newly made furniture in the Williams and the Brown samples reveals a snapshot of their clients' consumer desires and material preferences, the significant number of repaired and second-hand goods in the samples indicates that the ledgers can also unearth a significant amount of furniture already in customers' possession. The upkeep of furniture, whether replacing broken hinges, re-stitching snagged cushions, or the dusting and polishing of the best mahogany pieces, was a part of the everyday maintenance of the home and was demonstrative of good household management for both men and women.[84] Recently, historians of consumer and material cultures have stressed the centrality of recycling, repairing, and altering in the curation of the domestic interior. Shimbo has noted that London furniture-makers were keen to provide low-price

services such as repairs and maintenance to furnishings to encourage long-term patronage, early cash payments, and to build consumer trust for greater and more expensive commissions.[85] Furniture, as Margaret Ponsonby has demonstrated, was considered a lifelong investment to be passed on to – not always grateful – children.[86] Building on Grant McCracken's discussion of 'patina' – goods' material marks of age and use as a sign of social distinction – Ponsonby argued that people held strong emotional and familial attachment to household furnishings; although furniture's wear and tear could signify the owner's elite heritage, pieces also bore the hallmarks and memories of family life.[87] In both samples, clients stressed that new goods should be made of good quality, durable materials.[88] Ponsonby argues the middling sorts repaired furniture because their desire for fashionable and luxurious interior decoration was tempered by financial limitations as well as religious and economical prudence.[89] However, historians of recycled things have stressed that furniture repairs were common across social ranks.[90] Despite this, little has been done to examine the gendered narrative behind repairing and recycling goods.[91]

Both the Williams and the Brown samples contained orders for repairs to existing household furnishings. The Williams sample contained orders for repairs to 97 household objects (17% of the sample's total items) by 30 of the 57 clients (53%); 27 of these 30 customers requested between 1 and 5 repairs to furniture and furnishings. The Brown sample contained 206 repairs (14% of total orders) by 74 of the 410 clients (18%). In both samples, the repairing and 'recycling' of furniture was a noticeable consumer practice, although more prevalent amongst the more middling and artisanal Williams' customers. In Williams' ledger, repairing furniture was a common occurrence in women's orders. A third of Williams' female clients made requests for repairs (36% of the total repairs recorded). In comparison, women made up only 6% of the clients who ordered new goods. This difference between the percentages of women ordering new rather than repaired goods is more marked considering the relatively small number of women (9) compared to men (48) in the sample. Men's orders featured less repairs than women's. Half of the sample's men (24) made requests for repairs and commissioned 64% of the total repairs ordered. The 27 customers whose orders

Householder: furnishing the home

Table 2.16 The number of repairs listed in the Williams ledger by gender

Repairs	Total	Men	Women	Average total spend	Average total order
0	27	24	3	£53 3s 5d	18
1	10	9	1	£21 7s 10d	9
2	5	4	1	£25 17s 2d	10
3	6	5	1	£108[a]	11
4	5	4	1	£25 13 7d	15
5	3	2	1	£24 14s 10d	12
6	1	1	0	£24 2s 6d	17
8	1	0	1	£2 2s 9d	10
11	1	1	0	£5 18s	16

[a] The average order cost for clients with three repairs would be £24 0s 5d, if Captain Godfrey's order of £527 12s 9d is discounted.

comprised solely of new goods spent, on average, double those who repaired even one item. The clients whose orders contained mostly repaired goods ordered significantly fewer newly bought ones. This suggests that budget must have determined whether or not goods were replaced or repaired, and therefore whether customers deployed this consumer strategy to maintain their homes. Despite this, it is important to remember that customers' ability to spend was also determined by their gender, and particularly for women, their marital status.

The two highest numbers of repairs recorded were by a Miss Plaice (8) and a Mr Malby (11).[92] In Malby's case, 12 of the 16 entries were for repairs to items including easy chairs, a dining table, a pillar and claw table, and a bedstead. Plaice's order included eight repairs to mahogany and stained chairs, repairing and re-stuffing a French armchair, mending window curtains, and replacing the tripod base and fretwork around the top of her pillar and claw table – all for the sum of £2 2s 9d. Although Malby and Plaice's total spend on furniture was significantly lower than the average in the sample (£50 12s 3d), they were both able to maintain their domestic interiors under limited budgets. However, this frugality does not mean that

Table 2.17 The different types of repaired objects in the Williams sample by gender

Repaired object	Total	Men	Women
Side board	1	1	0
Fire screen	1	0	1
Desk	1	1	0
Curtains	1	1	0
Card table	2	2	0
Pillar & claw table	2	1	1
Dining table	3	3	0
Tea table	3	1	2
Tea chest	3	3	0
Tea tray	4	3	1
Bedstead	5	4	1
Window blinds	5	4	1
Re-stuffing & upholstering chairs	8	7	0
Mirrors	8	5	1
Chairs	14	3	4

their repaired possessions were a meagre assemblage of everyday necessities and essentials but were a plethora of good-quality objects in a variety of designs, materials, fashions, and functions.[93]

Repaired goods that were associated with practices of sociability made frequent appearances in the sample, especially paraphernalia associated with the quintessential polite pastime of tea drinking, such as tea tables, chests, caddies, and trays. This is unsurprising considering the effects of spilling hot tea on mahogany, although Williams does not go into detail on the type of repairs made to the tea paraphernalia. Other furniture associated with sociability, such as card tables, were also repaired. It would be a stretch to argue that the repairs were due to bad gamblers over-turning tables after losing a game of bridge, as the repairs listed were for more practical purposes such as mending hinges and the scratches on tables' surfaces.[94]

A variety of table styles and functions appeared in the ledger, making up 10 of the 97 items for repair. Five of these tables are listed as pillar and claw tables.[95] Pillar and claw tables typically had

a circular top with varying degrees of fretwork and ornamentation that rested on a central pillar with a tripod base and were used for eating, drinking wine, gaming and, most of all, tea drinking. Some more sophisticated pieces had lobed tip-up tops inlaid with brass and mother-of-pearl.[96] This new and fashionable table style was designed to facilitate unrestricted sociability and physical intimacy; replacing the corner legs with a central pillar meant that users were unrestricted by recurring material boundaries between them. However, this desire for the fashionable trappings of polite sociability was an impractical purchase. The central pillar and tripod-claw base meant that these tables could easily be overturned – especially when hooped petticoats were involved. Mimi Hellman's study of elite furniture in eighteenth-century Paris argues that the design of domestic objects had a regulatory influence on users' behaviours and manners. Applying this theory to the pillar and claw table, its precarious design required users to use more refined, slow, and delicate movements when interacting with it.[97] This took on a particular charge in visual and literary culture, most famously in William Hogarth's *The Harlot's Progress* (1728–1731), where the pillar and claw tea table, like the social-climbing mercantile family, could teeter at any moment into chaos and ruin.[98] In the Williams sample, the number of repairs, combined with only one entry specifying decorative alternations to the fretwork of a pillar and claw table, suggest that practicality motivated repairing furniture.[99]

Chairs were the most common item in need of repair in the sample – 22 out of the 97 items. They varied in material (mahogany and beech) and in style (easy chairs, dining chairs, Windsor chairs, and French armchairs). A similar number of men and women asked Williams to make structural repairs to chairs by bracing the corners or adding rods and backs. However, while seven men ordered chairs to be re-stuffed and re-upholstered no women in the sample did. Re-stuffing chairs shows a preference for comfort without great expense and these men were invested in the physical comfort of their homes. Five of the eight chairs were re-upholstered in leather. Leather's durability was a practical and traditional choice and eschewed the trends of mid-century furniture to be upholstered in damask, silk or chintz, which was associated with a 'feminine' taste.[100] Others preferred more fashionable textiles. Mr Marr, a slater, paid Williams 12s 6d to re-stuff and reupholster his chairs in sturdy

morine and added the expensive flourish of having them tacked with brass nails.[101] Captain Newton was the only man to request that his chairs be reupholstered in silk, at 3s 6d.[102] Marr and Newton's total spends came to £17 19s 2d and £18 12s 1d respectively. These examples illustrate how men would alter or 'upcycle' existing furniture with more expensive and fashionable fabrics. Despite a large budget, these repairs to the upholstery of men's chairs were driven by both practical necessity and a desire for comfort and material respectability. These men were invested in the material maintenance and comfort of their homes.

In the Brown sample, 74 customers made 206 orders (14% of total orders) for repairs – only slightly less than the 17% of the Williams sample. These repairs included 42 different types of furnishings, from cellarets to venetian blinds and bed furniture to urn stands – a more diverse and fashionable domestic material culture that reflects the higher social rank of Brown's clientele which perhaps explains the significant difference between the two samples' variety of repaired goods; the Brown sample had a much more diverse selection of repaired goods (42) than the Williams sample (15). In the Williams sample, customers who only ordered new goods had a considerably greater total expenditure and average order size than those who ordered even just one repair. However, in the Brown sample there was only 16s difference between the average spend of customers' orders that contained no repairs and those who ordered one, and an average difference of one good in their order sizes (see Table 2.18). The difference in sample sizes must be taken into account once again; the much larger group that ordered no repairs had a lowest spend of 1s 2d and a highest spend of £56 4s. Both samples included many orders that combined purchasing new items and repairing existing ones, and both had orders to repair furniture in a variety of fashions, functions, and styles. Similarly, to Mr Malby's 11 orders for repairs in the Williams sample, those who ordered more than 16 repairs in the Brown sample had smaller overall average spend. The majority of Williams' repairs can be characterised as low-cost maintenance, however this cannot be said for the majority of Brown's as there was little difference between those whose orders contained no repairs and those that did. Repairing was part of a set of consumer strategies for Brown's clients in maintaining their domestic interiors.

Table 2.18 Repairs in the Brown sample by order size, spend, and gender

Repairs	Total	Men	Women	Average order size	Average total spend
0	326	224	102	2	£5 3s 10d
1	38	33	5	3	£4 7s 10d
2	15	12	3	10	£8 11s 9d
3	10	9	1	9	£4 3s 6d
4	1	1	0	33	NA[a]
5	2	2	0	42	£7 15s
6–10	3	3	0	16	£3 2s 6d
11–15	4	4	0	27	£41 2s 7d
>16	1	1	0	23	£1 11s 11d

[a] No total spend was recorded for this entry.

Only 8% of Brown's female clients ordered repairs, compared to 66% of women in the Williams sample. Brown's female clients were predominantly one-off customers and ordered, on average, two new items in total. Men, in both samples, were repeat customers and responsible for larger and whole-house orders and this can account for the greater number of repairs. While women's maintenance of the domestic interior is often hidden from a source such as an upholsterer's ledger, we do know that the daily upkeep of furniture was one of the responsibilities of a dutiful housewife.[103] However, both samples demonstrate that men took an active role in the maintenance of the domestic interior which could not be managed within the household, such as structural repairs and decorative alterations. Similar to the Williams sample, furniture repairs were everyday, practical maintenance for Brown's clients. One of the most expensive recorded items in the entirety of the Brown sample was an alteration to a mirror ordered by John Moffatt Esq. to remove 'an ornament of wheat ears [to be] taken off and a plan of feathers introduced' to a mirror for £31 10s.[104]

Repairs to chairs made up 15% of the orders for repaired goods in the Brown sample. They were prevalent in both samples, in terms of structural repairs and also re-stuffing and re-upholstering. While tea drinking paraphernalia was prevalent in the Williams

Tables 2.19 The different types of repaired objects in the Williams sample by gender

Repaired object	Total	Men	Women
Tea chest	1	1	0
Dressing glass	1	1	0
Tea board	1	1	0
Pocket screen	1	1	0
Japanned cabinet	1	1	0
Chair cases	1	1	0
Urn stand	1	1	0
Gentleman's dressing case	1	1	0
Portable desk	1	1	0
Lamp	1	1	0
Desk	1	1	0
Curtain rod	1	1	0
Sofa cases	1	1	0
Cushion	1	1	0
Tassel bags	1	1	0
Slab	1	1	0
Waiter	1	1	0
Picture	1	1	0
Clothes' horse	1	1	0
Chest	1	1	0
Box	1	0	1
Ink stand	1	0	1
Sideboard	1	0	1
Sofa castor	1	0	1
Wardrobe	2	2	0
Tea caddy	2	2	0
Bookcase	2	2	0
Girandoles	2	2	0
Cupboard	2	1	0
Cellaret	2	2	0
Loose seat chairs	2	1	1
Bolster case	3	3	0
Mirror	5	4	0
Venetian blind	5	3	1
Carpet	6	5	0
Frame	6	4	2
Fire screen	8	8	0
Bedstead	11	9	0
Table	21	11	2
Curtains	25	17	1
Chairs	28	21	2
Bed & furniture	52	19	1

Householder: furnishing the home 115

sample, it featured much less in that of Brown, with only 4 total orders for tea chests, boards, and caddies. Repairs to bedsteads and bed furniture were the most frequent in the Brown sample, making up 32% of all repaired goods and were ordered overwhelmingly by men (19 orders from men, 1 from a woman).[105] Both samples illustrate that men had a characteristic consumer practice of both ordering new furniture and repairs to existing goods, but that they had different material preferences in what was being repaired.

Second-hand furniture

Unlike repairs, the consumption of second-hand furniture was not a prevalent feature of either sample. Nevertheless, the small quantity of second-hand goods in both samples demonstrates that men and women did deploy other consumer strategies to acquire the goods they desired. The five Williams customers who bought second-hand furniture had small orders, apart from Sen. Chapereau who had a comparatively large order that continued over a number of years.[106] Unlike those who ordered repairs to goods, which was driven by a range of motives including cost, orders containing second-hand items appear to be characterised by budget. Buying second-hand gave those who could not afford new luxury goods an opportunity to obtain them by other means. For example, a Mrs Gibison stressed quality materials when spending £2 5s on a 'Good second hand Mahogany dining table'.[107] Some of the mahogany dining tables Williams sold could cost double Gibison's second-hand one. The second-hand goods purchased were larger, more costly items such as dining tables, desks, and chests of drawers.[108] Although limited by budget, customers stressed that second-hand furniture be of good quality and made from luxurious material such as mahogany or cherry wood. The number of second-hand purchases in the sample is too small to make a clear gender comparison, but it is telling that 3 of the 9 women in the sample bought second-hand goods while only 3 of the 48 men did. Finally, although too small to be too conclusive, as with the consumption of new goods, customers stressed materials rather than styles in the second-hand goods they purchased through Williams.

Table 2.20 The number of second-hand goods in the Williams sample by gender

Second-hand goods	Total	Men	Women	Unknown
0	53	46	6	1
1	4	1	2	1
2	1	0	1	0

Table 2.21 The number of second-hand goods in the Brown sample by gender

Second-hand goods	Total	Men	Women	Unknown
0	415	302	111	2
1	5	5	0	0
2	2	2	0	0

As with the Williams sample, Brown's customers ordered only a small number of second-hand goods. The sample contains only nine orders (less than 1% of the total goods) for second-hand goods. The small number of second-hand goods in both samples may be because lots of second-hand furniture was bought at auctions or house sales.[109] No women bought second-hand furniture in the Brown sample unlike the Williams sample. While repairs to domestic furnishings in both samples was driven by a variety of motivations, the purchase of second-hand goods in both samples were more concerned with acquiring fashionable and quality goods without great expense. The second-hand consumption of goods mirrors the prevalence of mahogany and shaped furniture in the sample's new goods. John Philip Esq. purchased an oval mahogany tea board for 18s but in the same order spent £13 10s on a new mahogany commode cellaret side-board table; similarly a Mr Collett spend £47 on a new dispensary but only 16s on a second-hand square fire screen on claws. Equally Robert Bradley paid £13 16s for oval-back mahogany chairs and armchairs.[110] These examples from the Brown sample suggest that money was spent on larger or more costly items

such as tables, and customers bought more everyday good such as tea trays second-hand.

Conclusion

Whether customers ordered newly made or second-hand furniture or ordered repairs to furniture, they did so to keep up with the latest fashions in styles and quality raw material. If budget would allow, they furnished their homes with pieces that varied significantly in terms of type, style, colour, finish, and material. Unsurprisingly, budget determined middling men's and women's consumer habits and the material culture of their homes. However, financial constraints did not prevent men and women seeking out consumer and material strategies to keep up with the Joneses without breaking the bank. In doing so, both men *and* women displayed their material literacy of furniture. Both samples demonstrated that Williams' more modest clientele and Browns' more elite ones had similar consumer practices; in both samples the majority of men and women had small orders of new goods. Both samples had comparable percentages of repaired and second-hand goods in the total of ordered goods. If budget would allow, Williams' and Brown's customers furnished their homes with pieces that varied significantly in terms of type, style, colour, finish, and material. The samples had some similarities in material preferences, such as combining woods to negotiate cost, but the material that furniture was made from drove Williams' male and female clients' consumption of new goods. With a few exceptions, the type of wood and textile furniture was made from was more important and carried more social meaning that styles. The gendered material culture that emerges from this sample questions the gendering of certain materials such as mahogany and leather by previous historians. Objects' ability to denote respectability, rather than gender, had a greater influence upon the ways in which the men and women of the sample consumed new goods. Consideration and knowledge of the materials furniture was made from was a defining motivation of their domestic assemblages. Design and style drove the consumption of goods in the Brown sample. The style, finish, colour, and shape of furniture was more important to Brown's clients than the material than they were made from. In part, this difference

must be attributed to change over time in fashion and manufacturing techniques, but the different social positions of the samples' clientele must be a considerable factor in this difference. Material literacy defines a more modest, more respectable material culture, while a focus on aesthetics, design, and styles was about creating a more elite and grand assemblage of domestic furniture – as they could afford to replace or order these items if fashions changed.

This chapter has sought out middling and genteel men's and women's material preferences and literacies and consumer strategies, but what is revealing here is the material and consumer knowledges required to furnish the home as a site of masculine identity formation. Being a householder emerges from these ledgers and order books as a 'material masculinity' and materiality informed the duties and practices of householding. Not just merely maintaining the physical structure of the house and buying expensive legacy furniture, the men who bought and repaired furniture with Williams and Brown were engaged and literate consumers. In furnishing their little kingdoms, men expressed a desire for domestic comfort, for fashionable respectability, and discerning design and aesthetic choices. In these sources, social rank was often more deterministic of men's and women's consumer behaviour and material preferences than gender, reminding us that furnishing a home was an important process in maintaining a household as a wider expression of men's public and private lives.

Notes

1 See Lawrence Stone, *Family, Sex and Marriage in England, 1500–1800* (New York, 1977); Anthony Fletcher, *Gender, Sex and Subordination* (New Haven, CT, 1995); Naomi Tadmor, *Friends and Family in Eighteenth-Century England: Household, Kinship and Patronage* (Cambridge, 2001); Helen Berry and Elizabeth Foyster (eds), *The Family in Early Modern England* (Oxford, 2007); Tara Hamling and Catherine Richardson, *A Day at Home in Early Modern England: Material Culture and Domestic Life, 1500–1700* (New Haven, CT, 2017).
2 Susan Dwyer Amussen, *An Ordered Society: Gender and Class in Early Modern England* (New York, 1988).

Householder: furnishing the home 119

3 Amanda Flather, *Gender and Space in Early Modern England* (Woodbridge, 2007); Hamling and Richardson, *A Day at Home*; Amanda Vickery, *Behind Closed Doors: At Home in Georgian Britain* (New Haven, CT, 2009).
4 John Tosh, *A Man's Place: Masculinity and the Middle-Class Home in Victorian England* (New Haven, CT, 1999), 115–19.
5 Matthew McCormack argues that Georgian men enjoyed their public roles precisely because of their 'private' status as householders, husbands, and fathers, see *The Independent Man: Citizenship and Gender Politics in Georgian England* (Manchester, 2005), 27. For work on fatherhood and authority see Joanne Bailey (Begiato), *Unquiet Lives: Marriage and Marriage Breakdown in England, 1660–1800* (Cambridge, 2003); Elizabeth Foyster, *Marital Violence: An English Family History, 1660–1857* (Cambridge, 2005); Joanne Bailey (Begiato), *Parenting in England 1760–1830: Emotion, Identity, and Generation* (Oxford, 2012); Hannah Newton, *The Sick Child in Early Modern England, 1580–1720* (Oxford, 2012), 102–3.
6 Margot Finn, 'Men's Things: Masculine Possession in the Consumer Revolution', *Social History* 25.2 (2000), 133–55; David Hussey and Margaret Ponsonby (eds), *Buying for Home: Shopping for the Domestic from the Seventeenth Century to the Present* (Abingdon, 2008); David Hussey and Margaret Ponsonby, *The Single Homemaker and Material Culture in the Long Eighteenth Century* (Farnham, 2012); Vickery, *Behind Closed Doors*, 106–28, 257–90; Karen Harvey, *The Little Republic: Masculinity and Domestic Authority in Eighteenth-Century Britain* (Oxford, 2012); Jon Stobart and Mark Rothery, *Consumption and the Country House* (Oxford and New York, 2016), 109–40.
7 Vickery, *Behind Closed Doors*, 108, 106–28.
8 Harvey, *Little Republic*, 99.
9 John Styles made an early critique of historians' categorisation of goods such a 'mass produced' and 'non-luxury' and the critical terminology of consumption and manufacturing that has confined the debates surrounding design and consumer history particularly to elite material culture, see 'Manufacturing, Consumption and Design in Eighteenth-Century England', in John Brewer and Roy Porter (eds), *Consumption and the World of Goods* (London, 1993), 527–54.
10 Finn, 'Men's Things', 153–5; Maxine Berg, *Luxury and Pleasure in Eighteenth-Century England* (Oxford, 2006), 199–246; Vickery, *Behind Closed Doors*, 124–5; Karen Harvey, 'Ritual Encounters: Punch Parties and Masculinity in the Eighteenth Century', *Past & Present* 214 (2012), 165–203.

11 Lorna Weatherill, *Consumer Behaviour and Material Culture in Britain, 1660–1760* (London, 1988); Carol Shammas, *The Pre-Industrial Consumer in Britain in England and America* (Oxford, 1994); Mark Overton et al., *Production and Consumption in English Households, 1600–1750* (London, 2004).

12 Tosh, *A Man's Place*, 14. For examples see Finn, 'Men's Things'; Vickery, *Behind Closed Doors*; Berg, *Luxury and Pleasure*; Harvey, *Little Republic*; David Hussey, 'Guns, Horses and Stylish Waistcoats? Male Consumer Activity in Late-Eighteenth- and Early-Nineteenth-Century England', in David Hussey and Margaret Ponsonby (eds), *Buying for the Home: Shopping for the Domestic from the Seventeenth Century to the Present* (Farnham, 2008); Margaret Ponsonby, *Stories from Home: English Domestic Interiors, 1750–1850* (Farnham, 2007).

13 Amanda Vickery, 'Fashioning Difference in Georgian England: Furniture for Him and For Her', *Early Modern Things*, 342–59 (London); Natasha Coquery, 'Fashion, Business, Diffusion: An Upholsterer's Shop in Eighteenth-Century Paris', in Dena Goodman and Kathryn Norberg (eds), *Furnishing the Eighteenth Century: What Can Furniture Tell Us about the European and American Past* (New York and Abingdon, 2007), 63–77. Also see Geoffrey Beard, *Upholsterers and Interior Furnishing in England, 1530–1840* (New Haven, CT, 1997); Pat Kirkham, *The London Furniture Trade 1700–1870* (London, 1988).

14 Although the ledger does in fact not have an explicit reference to who kept it, The London Archives has accredited it to Williams.

15 For more discussion on the alternative services that upholsterers and furniture-makers provided see Akiko Shimbo, *Furniture-Makers and Consumers in England 1754–1850: Design as Interaction* (Abingdon, 2015), 153–94.

16 For Jonathan Hall's accounts for 1701–1732, see West Yorkshire Archives Service, Calderdale. SH:3/AB/8–15.

17 TLA. ACC/0426/001.

18 Mrs Bacon Foster's remarriage to William Bentham in 1789 was mentioned in *The Lady's Magazine; Or, Entertaining Companion for the Fair Sex, Appropriated solely to their Use and Amusement* (London, 1789), 503.

19 See Amy Louise Erickson, 'Mistresses and Marriage: Or, a Short History of the Mrs', *History Workshop Journal* 78 (2014), 39–57.

20 TNA. C107/109.

21 Coquery, 'Business, Fashion, Diffusion', 66.

22 He is also known to have made furniture for the Duke of Gordon in 1747 and the Earl of Coventry in 1781. See 'Brown, James', in

Geoffrey Beard and Christopher Gilbert (Eds), *Dictionary of English Furniture Makers 1660–1840* (Leeds, 1986), British History Online.
23 F. H. W. Sheppard (ed.), *Survey of London: Volume 36, Covent Garden* (London, 1970), 185–92, British History Online.
24 Vickery, 'Fashioning Difference', 350.
25 Sheppard, *Survey of London*, 185–92.
26 'Williams, Robert', in Beard and Gilbert, *Dictionary of English Furniture Makers*.
27 BM. Heal,28.236, 'Trade card of T Williams, cabinet maker', c.1763–1777; BM. Heal,125.11. 'DRAFT Trade card for James Brown, upholsterer'.
28 TLA. ACC/0426/001.
29 Coverture has a detailed history, see Susan Staves, *Married Women's Separate Property in England, 1660–1833* (Cambridge, MA, 1990); Amy Erickson, *Women and Property in Early Modern England* (London, 1993); For discussions of gendered consumer practice and coverture see Lorna Weatherill, 'A Possession of One's Own: Women and Consumer Behaviour in England, 1660–1740', *Journal of British Studies* 25.2 (1986), 131–56; Vickery 'Women and the World of Goods', 274–301; Margot Finn, 'Women, Consumption and Coverture, c.1760–1860', *Historical Journal*, 39.3 (1996), 707–10; Maxine Berg, 'Women's Consumption and the Industrial Classes of Eighteenth-Century England', *Journal of Social History* 30.2 (1996), 415–34; Sandra Cavallo, 'What Did Women Transmit? Ownership and Control of Household Goods and Personal Effects in Early Modern Italy', in Moira Donald and Linda Hurcombe (eds), *Gender and Material Culture in Historical Perspective* (London, 2000), 38–53; Joanne Bailey (Begiato), 'Favoured or Oppressed? Married Women, Property and "Coverture" in England, 1660–1800', *Continuity and Change* 17.3 (2002); 351–72; Margot Finn, *The Character of Credit: Personal Debt in English Culture, c.1740–1914* (Cambridge 2003). For how men and women circumvented coverture see Hannah Barker, *Women of Business: Female Enterprise and Urban Development in Northern England 1760–1830* (Oxford, 2006), 134–51; Alexandra Shepard, 'Crediting Women in the Early Modern English Economy', *History Workshop Journal* 79.1 (2015), 1–24. For a discussion of the influence of coverture practices on middling men see Harvey, *Little Republic*, 64–98.
30 Finn, 'Women, Consumption and Coverture', 772. Another suggest strategy is that men purchased goods via proxy for their wives, see Amanda Vickery, *The Gentleman's Daughter: Women's Lives in Georgian England* (New Haven, CT, 1998), 22–3.

31 Both Vickery and Coquery discuss this ad hoc recording of clients' details in upholsterers' ledgers, Vickery, 'Fashioning Difference', 350–2; Coquery, 'Fashion, Business, Diffusion', 65–6.
32 Vickery, *Behind Closed Doors*, 282. Also see Vickery's work on ledgers and the gendered language of furniture in 'Fashioning Difference', 342–61.
33 Vickery, *Behind Closed Doors*, 284.
34 See Weatherill, 'Possessions of One's Own', 156.
35 Vickery, *Gentleman's Daughter*, 244–9.
36 Vickery, *Behind Closed Doors*, 124–5.
37 TLA. ACC/0426/001. For more on shaving tables see Alun Withey, 'Shaving and Masculinity in Eighteenth-Century Britain', *Journal for Eighteenth-Century Studies* 36.2 (2012), 234–5.
38 TNA. C107/109. Peter Cox of College Hill is listed as an agent and insurance broker in *Wakefield's Merchant and Tradesman's General Directory for London, Westminster, Borough of Southwark* in 1794. The eighteenth century saw an increase in multi-purpose furniture to suit domestic spaces' multi-purpose functions, see Judith Flanders, *The Making of Home* (London, 2014), 126.
39 Thomas Sheraton, *The Cabinet-Makers and Upholsterer's Drawing Book* (London, 1791), 412. Also see Shimbo, *Furniture-Makers and Consumers*, 97.
40 Vickery, *Behind Closed Doors*, 280–7.
41 TLA. ACC/0426/001; TNA. C107/109.
42 Shimbo, *Furniture-Makers and Consumers*, 98–9.
43 Vickery, *Behind Closed Doors*, 280.
44 TLA. ACC/0426/001.
45 TLA. ACC/0426/001.
46 Vickery, 'Fashioning Difference', 350. Also see Kate Smith, *Material Goods, Moving Hands: Perceiving Production in England, 1700–1830* (Manchester, 2014).
47 See Adam Bowett, 'The English Mahogany Trade 1700–1793' (Unpublished PhD Thesis, Brunel University, 1996); James Walvin, *Slavery in the Small Things: Slavery and Modern Cultural Habits* (London, 2017), 85–91.
48 Maxine Berg and Elizabeth Eger, 'The Rise and Fall of the Luxury Debates', in Maxine Berg and Elizabeth Eger (eds), *Luxury in the Eighteenth Century: Debates, Desires and Delectable Goods* (Basingstoke, 2003), 1; Berg, *Luxury and Pleasure*, 40; Jon Stobart, 'Luxury and Country House Sales in England c.1760–1830', in Fennetaux, Junqua, and Vasset (eds), *Afterlife of Used Things*, 27.
49 Berg, *Luxury and Pleasure*, 196; Vickery, *Behind Closed Doors*, 288; Stobart and Rothery, *Consumption*, 24.

50 Hannah Greig, *The Beau Monde: Fashionable Society in Georgian London* (Oxford, 2012), 32–62.
51 TNA. C107/109.
52 'No. 13, Bedford Square', in W. Edward Riley and Laurence Gomme (eds), *Survey of London: Volume 5, St Giles-in-The-Fields*, ii (London, 1914), 163.
53 TNA. C107/109.
54 TNA. C107/109.
55 TNA. C107/109.
56 Greig, *Beau Monde*, 32–62.
57 Vickery, *Behind Closed Doors*, 280. Also see Jennifer L. Anderson, *Mahogany: The Cost of Luxury in Early America* (Cambridge, MA, 2012), 188.
58 Also see Clive D. Edwards, *Eighteenth-Century Furniture* (Manchester, 1996), 47.
59 Vickery, *Behind Closed Doors*, 137. Also see Karen Lipsedge, *Domestic Space in Eighteenth-Century British Novels* (Basingstoke, 2012), 74.
60 Sheraton, *The Cabinet-Makers and Upholsterer's Drawing Book*, 440, 372, 397, 437.
61 TLA. ACC/0426/001.
62 TLA. ACC/0426/001.
63 Anderson, *Mahogany*, 188. For more on mahogany and international and imperial trade see Chaela Pastore, 'Mahogany as Status Symbol: Race and Luxury in Saint Domingue at the End of the Eighteenth Century', in Goodman and Norberg (eds), *Furnishing the Eighteenth Century*, 37–48.
64 Walvin, *Slavery in the Small Things*, 85–91.
65 Berg, *Luxury and Pleasure*, 196.
66 It is worth a reminder that these figures do not include all references to wooden furniture in the ledger but only specific types of wood recorded. It was not only possible, but also likely, that a variety of wooden furniture was ordered without specific reference to which type it was.
67 Bowett, 'The English Mahogany Trade', 28.
68 Edwards, *Eighteenth-Century Furniture*, 171.
69 TLA. ACC/0426/001.
70 TLA. ACC/0426/001.
71 TLA. ACC/0426/001.
72 TLA. ACC/0426/001.
73 Thomas Sheraton, *Appendix to the Cabinet-Maker and Upholsterer's Drawing* Book (London, 1793), 17.
74 Sheraton, *Appendix*, 4.
75 TLA. ACC/0426/001.

76 TLA. ACC/0426/001.
77 Edwards, *Eighteenth-Century Furniture*, 25.
78 Edwards, *Eighteenth-Century Furniture*, 79.
79 Vickery, *Behind Closed Doors*, 280.
80 Stobart and Rothery, *Consumption*, 24.
81 Consistent upholstery schemes were deemed a key attribute of good interior design in eighteenth-century England, see John E. Crowley, *The Invention of Comfort: Sensibilities and Design in Early Modern Britain and Early America* (Baltimore, MD, 2003), 125.
82 The three orders were for mirrors (two oval and one square).
83 Edwards, *Eighteenth-Century Furniture*, 106.
84 See Harvey, *Little Republic*, 30; Vickery, *Behind Closed Doors*, 300.
85 Shimbo, *Furniture-Makers and Consumers*, 153–94.
86 Ponsonby, *Stories from Home*, 79. Also see Vickery, *Gentleman's Daughter*, 23.
87 Grant McCracken, *Culture and Consumption: New Approaches to the Symbolic Character of Consumer Goods and Activities* (Bloomington, IN, 1988), 31–42; Ponsonby, *Stories from Home*, 97–8.
88 Sara Pennell argues that goods, especially beds, were repaired because of their existing quality and durability, see 'Making Beds in Georgian England', in Jon Stobart and Bruno Blonde (eds), *Selling Textiles in the Long Eighteenth Century* (London, 2014), 31–3.
89 Ponsonby, *Stories from Home*, 79–102. Durability and quality were also important qualities, see Stobart and Van Damme, 'Introduction', 1–7.
90 Olivia Fryman, 'Renewing and Refashioning: Recycling Furniture in the Late Stuart Court (1689–1714)', in Fennetaux, Junqua, and Vasset (eds), *Afterlife of Used Things*, 89–107.
91 Harvey is a notable exception. Although her discussion of 'keeping house' centres mainly on middling men's structural and architecture repairs and alterations to the house, she observes how men's account books reveal that they were engaged in a combination of 'maintenance' expenditure, shelling out for both personal and domestic repairs and alterations to goods and furnishings of varying sizes and materials, see Harvey, *Little Republic*, 105–16.
92 TLA. ACC/0426/001.
93 TLA. ACC/0426/001. Malby's came to £5 18s and Plaice's came to £2 2s 6d.
94 TLA. ACC/0426/001.
95 Christopher Gilbert, *John Channon and Brass-Inlaid Furniture, 1730–1760* (New Haven and London, 1993), 113–14.
96 For an example see VAM. 'Tripod Tea Table', 1737–1738. Frederick Hintz. Mahogany, with inlaid brass and mother-of-pearl. W.3–1965.

97 See Mimi Hellman, 'Furniture, Sociability, and the Work of Leisure in Eighteenth-Century France', *Eighteenth-Century Studies* 32.4 (1999), 415–45.
98 For more on the cultural valency of the tea table see Ann Smart Martin, 'Tea Tables Overturned: Rituals of Power and Place in Colonial America', in Goodman and Norberg (eds), *Furnishing the Eighteenth Century*, 169–82.
99 TLA. ACC/0426/001.
100 Expensive textiles were, nonetheless, a prevalent feature of the ledger. On the gendered language of chintz, see Vickery, *Behind Closed Doors*, 20. For a more general study see David Porter, *The Chinese Taste in Eighteenth-Century England* (Cambridge 2014).
101 TLA. ACC/0426/001.
102 TLA. ACC/0426/001.
103 Vickery, *Gentleman's Daughter*, 154; Vickery, *Behind Closed Doors*, 158–61.
104 TNA. C107/109.
105 TNA. C107/109.
106 TLA. ACC/0426/001.
107 TLA. ACC/0426/001.
108 TLA. ACC/0426/001.
109 Stobart, 'Luxury and Country House Sales', 25–36.
110 TNA. C107/109.

3

Mobile man: travelling in style

Eighteenth-century people, goods, and information were on the move like never before. The century's transport and infrastructure revolution saw the development of turnpike roads, created an interconnected web of towns and destinations, and increased the use of public horse-drawn transport such as stage and mail coaches. In London and large towns, legislation was passed to protect the pedestrian from private carriages and hackney carriage; sedan chairs replaced the water boats as the key mode of urban transport – especially in London. Scholars characterise the subsequent large-scale and rapid movement of goods, people, and communications as the advent of a modern, enlightened, and commercial British nation-state with a thriving and dynamic public sphere.[1] But not everyone travelled equally in eighteenth-century Britain. Mobility, for all its modernising benefits, was closely tied to power. For Frederick Robinson, a young noble bachelor in the late eighteenth century, it was a 'prudent necessity' to buy a town-carriage that enabled him to 'partake of the amusements' of London.[2] To travel in style and dignity was important for the maintenance of rank in eighteenth-century society – to walk about the streets of polite London, full of mud and sewage, was beneath such men as Robinson. The town-carriage provided Robinson with a mode of dignified transport as well as fully enabling him to enjoy the city's sociable life. Such dignified and enjoyable mobility was not only important for Robinson, but essential. Beyond aristocratic London, the European Grand Tour was the culminating rite of passage in an elite young man's preparation for the world. Travel through unfamiliar and dangerous environs was thought to toughen up these young men and this was just as important to Grand Tourists as their cultivation of France and Italy's art and culture.[3] The sons of the

lesser gentry and mercantile classes engaged in domestic tourism of factories and resort towns, mimicking the cultivation of their social betters. After his ordination, gentry younger son Rev. John Mulso hired private carriages to visit a host of country estates in the 1740s in a quasi-Grand Tour of England's Italianate architecture.[4]

New and existing modes of mobility were important – though often understudied – ways in which eighteenth-century men desired, acquired, experienced, and displayed masculine autonomy. My purpose here is to explore what private carriage ownership afforded elite men, and some women, in an age of ever-increasing geographical mobility. In this context, elites increasingly privileged modes of, practices surrounding, and, crucially, the materiality of prestigious forms of private transport. Eighteenth-century men's coach consumption and materiality highlights mobility as an integral way elite men achieved, experienced, and displayed their status in mobile and public ways. Control over one's own movements was significant to the display and experience of patriarchal and elite privilege in eighteenth-century England. Horseback riding was integral to longstanding and traditional modes of chivalric and martial masculinity and this association is perhaps why many polemicists saw the significant increase in carriage ownership as an effeminising consequence of luxury upon the nation. With men no longer active riders but passive passengers, men's carriage travel could itself be seen as effeminate or overly refined. John Gay's *Trivia, Or The Art of Walking the Streets of London* (1716) chided fashionable male Londoners' mode of urban transport: 'In gilded chariots while thy loll at ease, / And lazily ensure a life's disease'. Of course, such complaints were levelled by pedestrians who had to now navigate the bustling streets of London filled with carriages and sedan chairs. Later in the poem, Gay envisages the lost glories of Roman London including: 'No carts, no coaches, shake the floating town! / Thus was, of old, Britannia's city bless'd, / Ere pride and luxury her sons possess'd; / Coaches and chariots yet unfashion'd lay, / Nor late-invented chairs perplex'd the way'. Clearly the modernising effects of increased mobility was not universally appealing.[5] Perhaps unsurprisingly, my survey of elite consumption and use of private carriages in eighteenth-century England finds little concern with the proud refinement and luxurious effeminacy that Gay highlights. Elite men were keen, materially literate consumers who deployed the design, construction, use, and

possession of their coaches to construct and defend their position at the apex of the social and gender hierarchy – a hierarchy that was particularly destabilised through the commercialisation of eighteenth-century society. Coaches were prohibitively expensive to commission and maintain, and their bespoke luxury nature aligned economic power with material magnificence. Yet to parade around Hyde Park in your coach, or to travel long distances at a fast pace, was not just symbolic of elite masculine power but was an important way these men *experienced* and understood it.

Consumer historians since the 1990s have cautioned against 'reading' goods as simply material markers of possessors' position in the social hierarchy. The successful integration of 'materiality' into consumer histories has complicated traditional narratives of conspicuous consumption. Scholarship on elite eighteenth-century consumption acutely focuses on coaches' ability to display the acquisition of high social rank and economic wealth but coaches were not just mere status-displaying possessions. To be able to travel in a richly decorated, private carriage was an important activity to the elites studied here. Men were able to exercise their autonomy of movement, and to determine the movements and mobility of their subordinates, thus the carriage was important in asserting and exercising masculine autonomy and forms of gendered power. Carriages were essential for genteel and elite women's polite sociability, particularly the gruelling rounds of visiting, which was integral to these women's accrual of social power, credit, and networks – men's withdrawal of prestigious mobility could be considered a cruel yet perfectly acceptable weapon of patriarchal dominion.[6]

Through examining the materiality of the changing participation and practices of masculine mobility in eighteenth-century England, this chapter uses letters, bills, receipts, probate documents, and personal testimony to investigate the gendered meanings and material practices of eighteenth-century carriage ownership and use. In doing so, the carriage emerges as an integral component in the materiality of elite masculine identify-formation and an important vehicle for the wielding and protection of elite social and gendered power. The chapter does not seek to question the carriage as the *pars pro toto* of elite masculine material culture; to do so would be to undermine its ability to reveal the variety of changing material expressions of elite masculinity. The chapter does, however, interrogate the

historiographical emphasis on coaches' 'magnificence' and conspicuous status display. It situates carriages in a variety of contexts such as newly ennobled or moneyed men, material literacies and product innovation, and in marriage and domestic authority to reveal its centrality for elite masculinity in the period.

The evolution of the eighteenth-century carriage

The evolution of carriage design, manufacturing, and consumption across the long eighteenth century is particularly important to understanding its ability to convey a host of social and gendered meanings. The bill for George III's Gold State Coach, which took over two years to complete, signals the complexity of coach design and construction. The bill contained payments for a coach-maker, carver, gilder, painter, laceman, chaser, harness-maker, mercer, bit-maker, milliner, saddler, tailor, and draper.[7] Notably, it did not include Sir William Chambers' input in designing the carriage itself. Although this bill is not a universal example of the trade, it was the complexity of carriages' design and the cost of their construction and components that enabled them to denote prestige and wealth. In bills, coach-makers stressed the use of the very best timber, leather, iron, upholstery, and workmanship to justify their astronomical costs. The specialised skills and processes required in manufacturing the many different coach components meant that the 'coach-maker' was in fact the central organising figure, and his workshop a central assembly space, in a wide-reaching network of specialised artisans.[8] While modern subcontracting practices are often a cost-cutting measure, subcontracting in the production of bespoke, luxury eighteenth-century goods ensured quality, artistry, and craftsmanship in the finished product.[9]

To regulate the rapidly expanding trade in the capital, Charles II granted the Worshipful Company of Coachmakers and Coach Harness Markers a royal charter in 1677. London led the way in coachbuilding across the eighteenth century and often customers outside the capital would order new carriages when visiting Town or send their coaches up to London for repair.[10] Long Acre, in Covent Garden, was the beating heart of England's coach-making trade, housing coach-spring makers, coach-makers, coach-harness

makers, and coach painters – akin to other metropolitan production clusters like Clerkenwell, renowned for its density of watchmakers. Long Acre enabled coach-makers to 'put out' work to the City's older trades such as ironmongers and saddlers while attracting wealthy customers from the developing West End. Over time, specialised trades associated with coachbuilding, such as gilders, coach-painters, coach heraldry-painters, coach-carvers, coach wheelwrights, and coach lamp, spring, and axletree makers emerged in close proximity to Long Acre.[11] Of the 44 London coach-makers insured by the Sun and Royal Exchange companies between 1777 and 1786, 13 were located on Long Acre, the rest were scattered in the newly developing West End and around the City of London.[12] One of the most famous and innovative coach-makers on Long Acre was John Hatchett. Coach-maker William Felton wrote that, since the 1770s, coach-makers were 'highly indebted' to Hatchett's innovative improvements to carriage design and that 'they seldom build without copying his designs: he stands justly distinguished'.[13]

The expansion of the coachbuilding trades across the century was, in part, due to the evolution of carriage design and the emergence of different carriage types beginning in the middle of the seventeenth century. Before the 1640s, European coaches were akin to a waggon, as the coach body was fixed directly onto the wheel-carriage. They were large, cumbersome, open-sided, door-less vehicles that could seat up to eight people inside. By the 1650s, glass panels filled the open-sides and doors replaced the leather screens covering the entrance. Hungary, Austria, and Prussia led the way in early carriage design with, unusually, England and France following suit: 'coach' itself is etymologically derived from the Hungarian 'Kotche'. In the 1660s, the Duke of Prussia commission a coach hung on two strong leather straps fixed to two parallel perches running between the front and back wheels. This decreased the risk of overturning and made coach travel more comfortable. The suspended coach body now had to be much lighter and smaller than previous models and it contained only one forward and one backward facing seat. European countries rapidly adopted his design innovation and, by the 1670s, steel coach springs were introduced in England.[14] Steel springs meant that coach bodies became heavier with more elaborate carving and widened to accommodate more passengers – although the use of leather straps continued well into the eighteenth century.[15] The 'Berlin'

marked a watershed in carriage design, as it was the first example of a variation in the type of coach body. A coach, until this moment, described one specific design of carriage. Hereafter an evolution of different carriage 'types' for different purposes and locations appeared on Europe's streets.

Probate documents and coach-makers' bills across the eighteenth century suggest that the ownership of a variety of travelling and pleasure carriages was a marker of social distinction. The ownership of just one carriage was not necessarily a marker of elite status but having a collection of different carriages for various purposes truly signalled wealth, taste, and high rank. Take Jane Austen's pompous parson Mr Collins' correction that 'her ladyship's carriage is regularly ordered for us. I should say, *one* of her ladyship's carriages, for she has several' in *Pride and Prejudice* (1813).[16] By the middle of the eighteenth century, coach-makers were building a greater variety of carriage bodies such as chariots, chaises, cabriolets, and calashes. The Duke and Duchess of Marlborough had nine different coaches between 1677 and 1708. Between 1791 and 1824, Thomas Noel-Hill, Baron Berwick purchased six different carriages.[17] Fashion scholars point to how fashions changed as a form of competition. In the eighteenth century, specific goods designed for specific functions emerged to carve out new forms of social distinction. For example, from the 1720s onwards, tables began to be designed for a variety of purposes, such as dining, gaming, tea drinking, dressing, shaving, and writing. Accordingly, the style, form and material of each one delineated its different function. In the same way, carriages began to be designed specifically for rural, urban, and continental travel, as well as for promenading and pleasure driving. Such variation, especially in lightweight pleasure carriages, was possible due to improvements to the quality and maintenance of roads. By 1750, Turnpike Trusts maintained 13 roads connecting London to regional centres.[18] In London, the 1762 Westminster Paving Act greatly improved the condition of roads and pavements for both pedestrians and coach users, and other towns soon followed suit.[19] Carriages were made from lighter materials than before and required fewer horses to be drawn safely on these improved roads – this is why the one-horse chaise and cabriolet became popular. As road legislation was introduced ad hoc there was significant variation between carriages intended for rural and urban roads. Due to the cobbled

streets in the capital, town-carriages had to be much sturdier than lighter carriages, like the post-chaise, designed for long-distance, rural travel. Pedestrians complained about the number, size, and noise of carriages on the capital's streets. In 1710, the *Tatler* objected, 'why one man should have a half a Street to carry him at his ease, and perhaps only in the Pursuit of Pleasures'.[20] Town-carriages were more compact than those for long-distance rural travel and patents were granted for harnesses that ensured that coaches travelled in a straight line so as not to take up too much of the road.[21] The wide streets of the developing aristocratic estates in the West End attest to both the increase of carriages on London's streets and the need to appease the metropolitan pedestrian.

As well as designing for the differing conditions of English roads, coach-makers also built carriages differently for continental travel.[22] European travellers commented on the variety and quality of English carriages unavailable back home due to poor quality roads.[23] At the end of the seventeenth century, English carriage design was considered to be as good as, if not better than, that of the French or Germans and the variety and quality of English carriages became a symbol of national prestige.[24] The ownership of an English carriage abroad was a symbol of truly elite taste and wealth; the British Ambassador to Spain, Lord Grantham, was commissioning a plethora of English carriages for the Spanish court and European diplomats in the 1770s.[25] The German visitor to London, Sophie Von la Roche, noted the magnificent vehicles ready to be exported to the Governor of the West Indies, the Nawab of Arcot, and Catherine the Great from John Hatchett's workshop on Long Acre.[26] Thus ownership of such carriages in Britain meant consumers were participating in an emergent form of nationalistic consumption – eschewing the fashions for French and German coaches and championing the superiority of British manufactures.

Until the mid-eighteenth century the variety of carriage types in an English coach house would strongly resemble those in Europe, but a much larger variety of British carriages emerged after the 1750s. Import-substitution policies in the mid-eighteenth century, which aimed to protect British trade in an increasingly competitive global marketplace, bolstered the domestic manufacturing and exportation of coaches to Europe and North America. Maxine Berg and John Styles have both demonstrated that import-substitution

incentivised British manufacturers to innovate and improve existing production processes and technologies that enabled them to produce more varied, quality products.[27] It was no coincidence that coach-makers increasingly subcontracted the manufacturing of different coach parts to specialised artisans as they began to innovate, rather than imitate, foreign carriage types. As the structure of carriage bodies became more varied, other carriage components had to be adapted; coach springs, for example, differed according to height, weight, and number of wheels of the type of carriage they were intended for.[28] Due to the innovation in steel production, some earlier carriage bodies evolved into new adapted forms and hung on new types of steel springs.[29] The shallow body and fold-down hood of the two-person calash gave way to the four-seat *vis-à-vis* arrangements of landaus, landaulets, and barouches in the nineteenth century. The two-wheeled chaise, although still popular, evolved into other forms, such as the curricle, gig, and whiskey, and the four-wheel phaeton. The emergence of these owner-driven carriages marked another significant change in carriage design that continued until the advent of motorcars.

While economic policies and technological innovation account for why carriage-makers were manufacturing new carriage types, it is not clear as to why owner-driven vehicles became so popular by consumers in the second half of the eighteenth century. Gentleman raced empty four-wheel carriages at Newmarket by the 1750s. The most plausible explanation is the rise of what Paul Langford has called 'self-conscious sartorial egalitarianism'.[30] This particularly masculine phenomenon was part of the cultural shift from hegemonic codes of elite, polite masculinity based on a chivalric model to one grounded in sentimentality and sincerity. David Kuchta writes 'changes in male fashion were driven not by a social dynamic of conspicuous consumption, but by a dynamic of inconspicuous consumption, elite understatement, superior example in manly modesty'.[31] That a gentleman eschewed the affected trappings of high rank by driving his own carriage was a display of polite, manly condescension. This material egalitarianism also extended to coach decoration as private carriages from the 1770s onwards rejected the ornate gilt mouldings and pictorial painting schemes of earlier baroque and rococo coaches for plainer ornamentation, associated with the simplicity of neoclassicism. Carriages were now usually varnished

in just one colour and sometimes only decorated with the owner's crest or cipher. Of course, the material simplicity of such expensive and luxurious carriages is inherently contradictory, something not lost on later, nineteenth-century writers. In his 1837 treatise on English pleasure carriages, coach-maker William Bridges Adams' writes that the phaeton was a

> monstrous-looking vehicle and the favourite driving carriage of the Prince of Wales, afterwards George IV. The object in alluding to it here is to serve as a standard to show the great progress which a comparatively short period has developed in the art of the carriage constructor ... It was a contrivance to make an enormously high and dangerous seat for two persons, inconvenient to drive from, and at the same time to consume as much material and mix up as many unsightly and inharmonious lines as possible.[32]

Carriage design materialised changing codes of masculine expression. Adams expresses a particularly Victorian ideal of sombre, stoic manhood that was itself constructed as a push-back against conspicuous, magnificent, and, to them, 'monstrous-looking', eighteenth-century masculine material expressions. The Prince of Wales was, after all, a leading Regency dandy who embodied luxurious excess and decadence, which perhaps contributed to the undesirability of the high-perch phaeton by the 1830s. We can see the innovation of carriages working hand in hand with the evolution of elite masculinity across the eighteenth century.

An anatomy of coach consumption

Historians of elite consumer culture have focused on the coach's ability to denote elite status and wealth.[33] The prohibitive cost of purchasing and maintaining a suitably glamorous collection of coaches, a well-bred stable, and magnificent liveries made the coach, in Amanda Vickery's words, 'a universal shorthand for worldly wealth and social prestige'.[34] A year's cost of repairs, maintenance, coachman, grooms, liveries, horses, feed, farriers, stabling, harnesses, and tackle were almost always more expensive than the coaches themselves. Coach ownership was also suggestive of extensive stabling and estate buildings as well as pastureland. The Duke of Chandos's

stable account book meticulously recorded every cost of maintaining a coach on a weekly basis from 1703 to 1714, each expense was categorised under 'groom', 'coach-makers work', 'farriers work', 'hay and straw', and 'incidentals of the stable'.[35] Coaches required decorative and mechanical upkeep – maintaining mobile magnificence came with considerable costs. Minor repairs could be done in the coachyard, but often upkeep was outsourced to the coach-maker as part of the bespoke service. Earl Temple paid a total of £382 2s 4d between 1763 and 1769 on coach-makers' bills; over £224 was spent on 146 repairs on carriages and £158 on one new town-chariot. More extravagantly, between December 1734 and October 1741, Charles Spencer, the 3rd Duke of Marlborough ordered only one new coach body at a cost of £40, but spent £578 6s 3d on 1,001 orders for new harnesses, repairs, and decorative and structural alterations to eight different crested carriages.[36] While structural and decorative alterations to carriages formed the basis of these records, earlier bills of Temple's extensive coach-related expenditure between 1749 and 1753 demonstrates that he paid 24 bills to grooms and to tailors for coachmen's livery, boots, and hats.[37] Temple spent more money, more frequently, on grooms and livery than structural and decorative repairs to his four carriages.

Ownership of a coach was not an intrinsic marker of elite status, but the associated costs of maintaining one was a considerable part of its ability to signal wealth and prestige. Of course, this material communication of economic privilege had different meanings to different audiences. While the simple possession of a coach marked elites out as wealthy and privileged to the masses, other elites were discerning connoisseurs of others' carriage design and materiality. That so many spent eye-watering sums on furnishing their carriages' interiors, lining seats, and putting up curtains made from expensive, luxury textiles such as silks with lace trim reminds us that some of the most expensive elements of a carriage, the upholstered interior, could only be appreciated by those invited into the coach itself. Considering the spatiality of the carriage, as well as its materiality, it is clear its decoration was for other elites' discerning eyes, rather than the masses, despite its presence in public and outdoor spaces. The need to maintain a materially magnificent coach was particularly heightened in political, diplomatic contexts; the British Ambassador to Spain, Thomas Robinson, was alarmed when his ambassadorial

gala coach was 'shabby to a degree & I determine whether I can do anything to be merely decent at Aranjuez. You may think that I have no ambition to make a figure, at the same Time I must keep up appearances'. To appear merely decent at the Spanish court was unthinkable to Grantham. To appear shabby was unthinkable, especially when diplomatic relationships with Spain were breaking down in the 1770s, and he attempted to borrow a coach from a diplomatic rival rather than appear so. To be 'merely decent' was still unpalatable to Grantham and thankfully within a few weeks his 'new Coach-wheels – looks very well, & the harness too are well brushed up, the liveries are smart' – he was relieved that 'that I shall not look shabby'.[38] Grantham's 'audience', for want of a better word, here was other diplomats, nobles, courtiers, and royalty literate in fashion, taste, and luxury.

Jon Stobart and Mark Rothery argue that coaches, horses, and liveried servants expressed families' wealth and status because they were 'consumption bundles' – goods that were more meaningful when displayed together.[39] When travelling to East Sussex from London in his new post chaise, Grantham's brother Frederick Robinson wrote that he was 'obliged to have four horses all the way, the solidity of wheels exciting universall admiration'. Due to the quality of his new chaise, Robinson could travel the whole distance with four horses – therefore travelling much quicker than with two – making his purchase all the more satisfying.[40] This act of display and admiration was notable enough for Robinson to include in a letter to his brother overseas, and was an important experience through which Robinson *felt* his status and wealth. Here, there is a dynamism between different forms of assembled and vibrant matter: horses, vehicles, roads, and bodies that interact together in movement. This material encounter could be thought of as what Jane Bennett calls a 'mode' – a set of alliances of the human, the animate non-human, the man-made, and the natural world that form an actant assemblage.[41] No one 'mode' is totally in control, and chance and contingency make the encounter a tense one; at any point a horse could bolt, a rock could cause a wheel to splinter, a body could be thrown from the carriage. That this did not happen meant that this vibrant assemblage of actant parts provided Robinson with an embodied and emotional experience of wealth, power, privilege, and taste. The symbolic power of the coach is unquestionable, but here its experiential quality

enabled Robinson to feel, to know, and to enact his privilege and power.

Genteel men who lacked the funds to acquire or maintain a coach, especially, felt the dependency of life without private and prestigious forms of transport. The Rev. John Mulso, vicar at Sunbury-upon-Thames with a decent living and handsome parsonage attached, could not afford the luxury of a private carriage as a gentry younger son in the professions. In 1745, his horse was lame and the cost of renting a coach was 'rather too much to be born'. In a letter later that year he thanked his fellow clergyman friend Gilbert White for his loan of an old horse, describing it as a 'genteel creature' but questioned whether White 'would have the prince of wales know me by such a Horse? As He did by my lame One!' This must have been quite galling as White himself was commissioning a new carriage – despite the fact he got travel sick and tended to ride, being known affectionately amongst friends as the Hussar Parson. Mulso's maternal uncle, the Bishop of Peterborough, Salisbury, and Winchester gifted him a horse, 'tho' with its Accoutrement', Mulso complained, 'cost but twelve Guineas'. Mulso's letters to White repeatedly complain about his status as a younger son who had to enter into the clergy to 'make his own way in the world'. Hailing from old Northamptonshire lesser gentry stock, Mulso had to make social calls and perform clerical duties on horseback – confirming to him that he was no longer a gentleman. By 1757, Mulso had come to terms with his downward social mobility, signing off his letter to White forlornly that 'I am one of the little & my Concern is to keep off the Cold Hunger & Nakedness. I wish only for the Cheerfulness of middling Life'. As gentry sons, both Mulso and White would have spent their youth engaging in equestrian pursuits and riding in carriages. Mulso was the head of a household, had a decent and attractive living, and his professional status required a degree of mobility – visiting parishioners, patrons, and other benefices. How this mobility was enacted informed Mulso's sense of his social position within his parish. Although Mulso was higher up the episcopal hierarchy than White, a curate to Mulso's vicar, White's family money enabled him to purchase a coach. More so, White, unlike Mulso, was able to choose whether he travelled by horseback or by carriage and thus had greater access to the elite independence and privileged mobility of his youth. It was through such minor points of distinction that

access to forms of masculine power and prestige were made manifest and meaningful. When, through family connections, White obtained the curacy at Durley in Southampton in 1753, Mulso wrote that as he visited him when he 'glisten'd in your velvet & pwder'd your grand wig' as an Oriel College fellow, Mulso will 'wait upon the Weather-beaten Curate of Durley, in his dirty Boots & dripping Bob'.[42] Mulso clearly understood, and resented, that weather-beaten disarray was the carriageless cleric's lot.

Life without a coach could be social ruin for the fashionable elite.[43] If it was an aspiration for many men like Rev. John Mulso to own a coach, it was a necessity for more elite men. In Henry Fielding's *The Covent-Garden Journal* (1752) the coach was so enshrined in the popular imagination as a marker of elite status that he joked 'do we not daily see Instances of Men in distressed Circumstances, that is to say, who cannot keep a Coach and Six, who fly to Death as to a Refuge'.[44] A shabby, dirty, or out-dated coach could inspire social ridicule; Chandos', Temple's, and Marlborough's frequent and extensive coach expenditure speaks to an intense preoccupation with its material upkeep.[45] So great was the need to keep a magnificent coach house that even wealthy nobles could rack up considerable debts.[46] The Earl of Northampton had to mortgage one of his estates for £7,000 in August 1762 to pay debts totalling £16,000 – £2,000 of which was owed to Samuel Butler the coachbuilder of George III's Gold State Coach.[47] As a cost-saving measure, in 1722 Chandos employed a man to repair and maintain his carriages in the stables at Cannons instead of sending his coach to be fixed in Town.[48] Moralists and satirists may have perceived the carriage as a symbol of the elite's extravagance, but the elite themselves saw it as a 'prudent necessity' to maintaining a fashionable social profile.[49] In one practical sense, the emergence of the political season in London, and a less itinerant royal court after the Glorious Revolution, meant that travelling coaches were a practical necessity in transporting landed families from country seats to lavish townhouses.[50]

The frequent repairs and alterations necessary for maintaining a coach – some ledgers record up to eight entries per month over a nine-year period – helped maintain a good relationship between coach-maker and customer.[51] Over the eighteenth century, manufacturers increasingly sought to retain loyal customers by undertaking

repairs and small-scale alterations – a common practice of makers of bespoke, luxury goods. In the earlier eighteenth century, many elite households used more than one supplier for coach repairs. The Churchills used three different coach-makers between 1677 and 1708 and paid separate bills to coach-painters and harness-makers.[52] The outsourcing 'coach-maker' emerged later in the eighteenth century, although the 'full-service' coach-making workshop was still not universal by the end of the century. Earl Temple used two different coach-makers between 1763 and 1769.[53] The Earl of Egremont also paid two different coach-makers in 1774, and in 1789/90 he paid bills from coach-makers Hartley & Haukins, bit-maker William Kerr, and coach-wheeler John Wilson.[54] Failure to meet the high standards of elite, fashionable clients, especially considering that many spent small fortunes on their transport, often resulted in a termination of consumer loyalty. Lord Grantham discharged his coach-maker John Wright after two substandard commissions in the early 1770s and replaced him with the more dependable Robert Giles.[55] Grantham's coach expenditure was particularly important to him as a diplomat at the Spanish court, and his correspondence to his brother and coach-maker reveals a materially literate coach consumer commissioning a plethora of carriages for personal and professional use, as well as for European diplomats and courtiers.

Due to clients' significant financial outlay, coach-makers were often required to produce incredibly detailed, priced estimates and present designs for customers' approval or alteration.[56] Therefore, successful coach-makers, like cabinet-makers, needed to be skilled draughtsmen; probably the best example of a coach-maker's designs are Rudolph Ackermann's series of eight books *Imitations of Drawings of Modern Carriages* (1793–1802) containing designs to promote his business. Clients frequently visited the coach-makers as their carriages were being built and expected to have considerable influence on their coaches' design and finish.[57] Coach-makers did speak out, though, if they thought their clients' ideas were outdated, showing a reciprocal and often collaborative hand in the coach design between expert artisan and discerning consumer.[58] Men's correspondence illustrates their significant material knowledge of coach manufacturing and design, which they exchanged with one another. They understood carriages' mechanical and structural components such as axletrees

and springs, the changing fashions for new coach types, as well as the decorative finishes of paint, mouldings, and upholstery. Many were knowledgeable about the size and weight of the carriages and what was appropriate for different roads in town, country, and the continent. Eighteenth-century consumers of furniture acquired a significant material literacy of styles and designs through printed furniture manuals, such as Chippendale's *Gentleman and Cabinet-Maker's Director* (1754); no similar manuals for coaches emerged until Ackermann's *Imitations* in 1793 and William Felton's *A Treatise on Carriages* in 1794. Men therefore garnered this knowledge from their coach-maker and the carriages they saw on the streets.[59] Coaches were therefore both advertisements of their owners' taste and prestige and their coach-makers' designs and skill. Men certainly gleaned knowledge of the latest trends from those they saw on the streets. Grantham's brother Frederick reported to him of the new 'fashion of having no mouldings [raised iron or woodwork] on the doors'.[60]

Coach-makers also acquired commissions through word of mouth. Sir Robert Walpole wrote to Charles Delafaye to recommend his coach-maker.[61] Frederick Robinson bespoke a new post chaise from coach-maker Mr Norton because of his 'fair dealings' with his friends the Pelhams.[62] Coach-makers' advertisements hinted to their existing illustrious clientele; in Hatchett's 1783 trade card Minerva points to his premier clients the Dukes of Gloucester and Cumberland – owning a coach made by the same hands as for royalty must have carried some social prestige.[63] As coaches marked membership to an exclusive elite, the ownership of certain carriage types or styles was also important.[64] Robert Darley Waddilove, Grantham's chaplain, wrote to him in 1775 that he decided upon the design for his new chaise's body from 'one at [John] Foster's made for Mr. Greenville, it is the best seen in Long Acre.'[65] As the dirtier work was put out to specialist artisans, coach-makers' workshops often doubled as retail premises with showrooms.[66] Hatchett opened his workshop to visitors when working on opulent coaches for foreign royalty; Frederick Robinson made an outing to Hatchett's expressly to see the Nawab of Arcot's costly commission for a palanquin in December 1778.[67] Whilst visiting London in 1786, German novelist Sophie Von la Roche described her visit to Hatchett's workshop:

Mobile man: travelling in style 141

> We concluded our tour amongst a number of finished coaches, and with an inspection of some fine drawings of all kinds of vehicles ... I should have liked to have taken the drawing of a coach costing fifteen thousand guineas, made for the Nabob of Arcot, along with me; or that of the Empress of Russia, or Rumbold's, the governor of the East Indies, just to have an idea of the size and magnificence of this kind of conveyance.[68]

Von la Roche describes Hatchett's full advertising arsenal of tours around the showroom and drawings for new carriages for celebrity clients. The expansion and nature of the coach-making trade, particularly in London, demonstrates where and how elite men garnered their considerable consumer expertise and material literacy of carriages. Customers gained their significant knowledge of coach design and production from the coach-maker and their designs, new coaches on the streets, in the showroom, and later print. Both the client and the coach-maker influenced the design of carriages and contributed to the evolution of the carriage type. Both were engaged in an exchange of knowledge of production, innovation, and fashion.

Mobile magnificence

As the coach was perceived to be a symbol of elite status, newly ennobled and newly moneyed men used carriages as tools to materially assimilate into new social groups. These men's coach consumption contained a variety of consumer and material strategies as they rose up the social ranks. However, this did not always mean that all men acquired magnificent coaches. Since the 1980s, historians have hotly debated how 'open' the landed aristocracy was to newcomers. Some argue that the landed aristocracy closed its doors to the burgeoning wealthy mercantile classes through inter-marriage, primogeniture, and defensive status consumption.[69] Others questioned how desirable 'elite' status was to the upper-middling sorts, arguing that they self-consciously constructed a 'middling' social identity and culture, grounded in polite, genteel respectability, economic prudence, and religious observance.[70] Ultimately, 'elite' status was obtainable; the peerage grew from an estimated 160 families in 1688 to 267 in 1800.[71] For many, dynastic preservation trumped any snobbery

pertaining to bloodlines or breeding. If an aristocratic lifestyle exceeded a titled or landed families' income, sons and daughters of wealthy and respectable mercantile families were sought out to replenish the coffers. But for those few with a newly acquired title, acceptance within this exclusive club was difficult. Through consumption, the 'old' elite worked to defend their status by both consuming traditional luxury goods and leading the ever-changing fashions in dress, interiors, architecture, and leisure.[72] But arguably, carriages could materialise social mobility itself, with new wealth bringing new fashionable carriage types and new titles reflected in alterations to crests, coronets, and ciphers.[73]

John and Sarah Churchill, the Duke and Duchess of Marlborough, shot up the eighteenth-century social ladder. Born to an impoverished baronet in Devon, Churchill rose to become one of the most influential men in eighteenth-century Europe. On his road to power, Churchill's coaches marked his progression through the aristocratic ranks. In 1677, at the beginning of their married life and joint social and courtly career, John Churchill paid £40 for one new coach and repainting and repairing two others.[74] Gentlemen typically purchased a marital coach, but such coach expenditure was perhaps part of maintaining an appearance of status during his parents' woeful financial troubles in a ploy to obtain a wealthy heiress – which he did when he married Sarah Jennings that same year.[75] The exact date of their secret marriage is not known and the coach could have been purchased afterwards as a celebration of the union. Either way, it would have symbolised Churchill's financial security, his manly independence from his debt-ridden parents, and an ability to maintain a wife at court. The next coach purchases occurred in January 1682 and May 1684 in the years when John Churchill had been elevated to Baron Churchill of Eyemouth. With these new titles, won through Churchill's diplomatic and military prowess, a new coach was a public declaration that John Churchill had made it since his family's earlier financial struggles.

A coach-maker's bill for work done between 1701 and 1708 provides more detail about the Churchill's coaches themselves. This period of expenditure coincides with the very height of the Marlboroughs' political, diplomatic, military, and courtly success. He received the titles of Marquess of Blandford and Duke of Marlborough in December 1702 with a pension of £5,000 for his lifetime. Later,

in February 1704, Queen Anne assigned him the old royal manor of Woodstock in Oxford with land enough to procure an additional £6,000 per annum.[76] Between 1701 and 1708, the Marlboroughs ordered six new coaches. In 1701, Marlborough commissioned a new chariot 'made after the French Fashion' in Russian leather. The chariot had brass earl's coronets and ornate bullions added to the roof and was richly upholstered in velvet and studded with brass nails at a cost of £55.[77] When Marlborough received his dukedom in 1702 he soon spent £47 on a new bespoke calash,

> made of the best seasoned timber well framed from work leather work brass work with guilt nails to the inside and fine Gray cloth to lyne the inside & blew silk ossies lace around the valance & for 2 side glasses a pair of glass shings, & for serge to lyne the curtaine & for Quills for the back and sides, canvas, ticking, ... and painting of the Callash with your Graces armes & coronets Crest in the sides.[78]

Churchill's open-top calash, a new and fashionable carriage model in the early eighteenth century, emblazoned with his newly acquired ducal coronets and crest, with a more lavish interior than any of his previous coaches, connected the magnificence of the coach's material riches with its owner's newly elevated status. Marlborough's new ducal coronet was not just limited to the body of the coach. It also appeared on a new set of travelling harnesses with his cypher and coronet on the reins and pole pieces.[79]

As a courtly upstart, Marlborough's purchasing of new, magnificent coaches was an important way for him to assert his political and military prowess to the British and European courts. However, others repaired their coaches as a way to assimilate into elite society. Robert Clive, also known as 'Clive of India', was Commander-in-Chief of British India who, not without controversy, established the dominance of the East India Company in the Indian subcontinent. In 1760 it was common knowledge that Clive's considerable influence in British India had amassed him a fortune of well over one million pounds, so much so that that year's *Annual Register* reported 'he may with propriety be said to be the richest subject in the three kingdoms'.[80] Clive's name was synonymous with the excesses of the 'nabob class' – the name given to the East Indian Company men who gained huge fortunes by their brutal suppression of the Indian subcontinent – and with British society's anxieties over these men's

dangerous potential to naturalise exotic, and corrupting, luxury in Britain.[81] This reputation continued long into the nineteenth century. Thomas Macaulay's diatribe against the nabob class, particularly, attacked their conspicuous consumption of 'new' and 'luxury' goods; he wrote that 'they had sprung from obscurity, that they had acquired great wealth, that they exhibited it insolently, that they spent it extravagantly ... that their liveries outshone those of dukes, that their coaches were finer than that of the Lord Mayor'.[82] However Margot Finn and Kate Smith have argued that East India 'men and women often worked sedulously to erase or obscure the provenance of their wealth' by using their considerable purchasing power to accrue a quintessentially 'English' country residence and material culture.[83]

This is perhaps why when returning to England in 1754 from a successful military campaign in Madras and newly married to Margaret Maskelyne, Clive paid coach builder Howell Thomas £25 17s 6d for 12 repairs to his coach rather than purchasing a new one.[84] Six of these repairs were for structural maintenance to the coach and six other orders were for alterations to the coach's décor; a new coachman's seat cloth was fringed with his livery lace, the window shutters were lined with shalloon and new tassels, the interior seats were re-stuffed and re-quilted, a new Wilton carpet with silk fringe nailed to the coach floor, and the leather-and brass-work was washed, cleaned, and japanned. The most expensive entry was for 'new painting the coach on your agreement' at £8 8s. Two orders for harnesses combined practical maintenance with decorative additions of Clive's crest; 'washing cleaning and oyling a pr of harness and bridles putting on ... new engraved crests on them' and a 'very good second hand pr of harness and bridles with new ... crests'. The second-hand harness was the second most expensive order of the bill at £4 4s.[85] The cleaning, repainting, and reupholstering of the coach as well as purchasing a second-hand harness suggests that Clive's conspicuous consumption was more concerned with polite prudence than gaudy extravagance. Such practices remind us that we should be wary of aligning conspicuous consumption with extravagance; repairing and altering existing goods and procuring used goods was as, if not more, useful to Clive than purchasing new, magnificent ones.[86] Clive's bill demonstrates repairs could be as expensive as buying a new coach, and thus his choices to do so

remind us that mundane repairs could be conspicuous status-display as well as purchasing new and extravagant goods.

Repairing and altering goods was therefore not restricted to the more economically prudent middling sorts; elite men lavished money on both decorative and structural repairs to their coaches.[87] Similarly to Earl Temple and the 3rd Duke of Marlborough, wealthy and fashionable Robert Nugent, later Earl Nugent, of Gosfield Hall, Essex spent £68 7s on coach repairs, new tackle, and harnesses between 1741 and 1743.[88] Swiss-born courtier General-Major Jacob de Budé spent £45 2s 6d on repairs to his barouche between 1808 and 1810.[89] Indeed, the cost of coach maintenance was so great that men began to buy coaches that could easily adapt to changing fashions. In 1781, wealthy landowner Sir Charles Cope received an estimate from coachbuilder John Mills for 'a plain neat coach' for £101 18s, including the additional estimates for durable 'strong curtains', 'flute lining made with striped Manchester stuff to take out occasionally', and 'a platform for ditto to take off occasionally'.[90] De Budé spent £220 on a new chariot in 1813 with a coachbox and interior upholstery to 'take off occasionally'.[91] The 3rd Duke of Marlborough's coachbuilder broke up his existing coaches' bodies and rebuilt them around the original structure, as did Earl Temple's coachbuilder.[92] Magnificence was not without practicality, and coaches' elite appeal was as much about their associated costs as their material brilliance.

However, the fashion for magnificent baroque and rococo coaches waned in the later part of the eighteenth century. The fashion for plainly decorated carriages in the 1770s can be attributed to material culture reflecting the change in attitudes towards social status, with a greater emphasis on polite and elegant simplicity than ostentatious magnificence. In 1774 coachbuilder John Wright wrote to the British Ambassador, Lord Grantham in Madrid that his designs for a carriage were all 'elegance and simplicity ... but broken out lines [mouldings on the panels] are totally exploded at Paris & London & wherever a Chaste taste prevails'.[93] Grantham's brother Frederick wrote in 1778 that 'the carriages in England are not magnificent at present but very pretty & my eye is now us'd to the fashion of having no mouldings on the doors'.[94] Nowhere is this change better seen than in diplomatic coach consumption where material magnificence was a professional requirement. In 1701, John Churchill, then the Earl

of Marlborough, was sent to The Hague by William III to act as chief negotiator in forming an alliance between England, the Holy Roman Empire, and the Dutch Republic against the French – a treaty that lead to the War of Spanish Succession.[95] Before setting sail in 1701, Marlborough wasted no time in ordering alterations to his 'Great Coach'; his coachbuilder washed and cleaned the gold leaf brass, added a new fringe to the interior upholstery, added new glasses to the doors, and oiled the wheels, brakes, and coach body. Marlborough ordered his coach-maker to paint a new set of iron wheels red and add his arms and earl's coronets to them; he also ordered brass and gold leaf coronets to be added to the body and 10 new coronets to the roof.[96] Helen Jacobsen observes 'diplomatic missions used the formal entry to parade the wealth and power of the visiting nation and, from the beginning of it evolution as a marker of status, coaches were associated with diplomacy'.[97] Such a cornucopia of heraldry on Marlborough's stately coach was a material expression to the European powers of his international diplomatic and military successes that earned him his earldom and intimacy with the King.

Lord Grantham's own diplomatic coach consumption in the 1770s highlights the shift in masculine material tastes in the later part of the century. As British diplomat to Spain, Grantham was required to commission an ornate gala coach for the formal diplomatic processions into the Spanish court, and bitterly complained to Frederick of the 'clumsy unwieldy tabernacles' at these ceremonial events. Grantham resented being professionally required to pay out for such a vehicle – especially as he longed for the material simplicity of a phaeton. He described his gala coach as gaudy and 'more showy than I hoped for'.[98] David Kuchta observes that once it became fashionable for men to renounce affected manners and dress, material simplicity lost its potent, moralistic resistance to material show.[99] In fact, this new, fashionable simplicity in coach aesthetics reinforced the traditional, patriarchal social order. The owner's crest was a persistent motif in coach decoration from the seventeenth century onwards. Crests, arms, and ciphers permeated coaches' panels, harnesses, wheels, pole pieces, box seats, and coachman's liveries. In 1710, the *Tatler* lamented the lack of English sumptuary laws censoring the decoration of private coaches. Steele wrote that 'to see men, *for no reason upon earth* but that they are rich, ascend

triumphant chariots, and ride through the people, has *at the bottom nothing else but insolent transport, arising only from the distinction of fortune*'.[100] The demand for coach heraldry was so great that a coach heraldry-painter's register book contained designs for 168 clients across England between 1752 and 1755, including the Lord Mayor of London and the earls of Darnley and Sandwich.[101]

Felton wrote in 1796 that coach 'panels had better be entirely plain, than daubed as many of them are, in imitation of painting' to showcase the heraldry of the owner.[102] But as fashions changed and heraldry became more prominent on carriage panels than before, it could be argued that a plain, neat carriage with a well-painted family crest was, in a sense, a patina against the opulent carriages of the *nouveau riche*. The increased visual emphasise on the heraldic crest in carriage design is emblematic of the declining patrician social order anxieties: a wealthy merchant could purchase a coach as opulent as an earl, but no amount of gilt mouldings or Italianate painting could match the lineage and prestige of an earl's coronet and ancient arms.[103] Defensive status consumption by the established elite made it particularly difficult for newcomers to assimilate through material show.[104] Therefore, it required a variety of consumer strategies to do so effectively. At one end, Marlborough's lavish spending on coaches was a symbol of his rapid acceleration to the very top of the social pecking order. At the other, Clive's use of repairs, alterations, and second-hand goods is evidence of conspicuous coach consumption that was not necessarily magnificent.

The coach and the gendered lifecycle

Carriage decoration also signalled new marital alliances. Hastings lawyer John Collier made do without a coach for several years in the 1740s, hiring carriages or using public stagecoaches to make frequent business journeys up to London for parliamentary and court sittings. When in Town, his wife Mary Collier was reliant on the coaches of fellow Hastings gentlewomen to attend to balls and dinners. Born the son a Hastings publican, Collier's work as a lawyer, land agent to the Duke of Newcastle, and local officeholder propelled him into the landed gentry and Hastings local elite. Upon his death in 1760, his surviving children inherited significant landholdings surrounding

Hastings and he bequeathed £2,000 to his daughter Elizabeth.[105] As part of this social mobility, in 1745 the Colliers acquired a chaise and crested travelling coach – at a cost of £50 – enabling Mary to gad about Hastings and John to commute between the coast and Town on Sussex's notoriously terrible roads. John's coach consumption would have given his wife some independence and dignity to continue her sociable life while he was on his long business trips to the capital. A string of letters between John and his brother-in-law William Cranston detail the pressure Mary's family exerted on John to acquire a coach. John entrusted William with overseeing the coach's manufacturing and decoration. William was keen to have his sister's crest painted on the carriage and wrote informing John that 'in respect to the coach, it is doubtless the constant practice to quarter the wive's arms theron with the husband's and thereupon I this morning sent an epistle for that purpose to Mr Gower'. In fact, William ensured that the Cranston crest was daubed on the carriage panels well before John sent his own, newly acquired, crest to John.[106] The inclusion of the marital crest was both a sign of the Colliers' social advancements and a significant part of the Cranstons' family strategy.

The bulk of men's consumption occurred at momentous stages in the lifecycle such as reaching majority, inheriting property and titles, and, particularly, marriage.[107] For centuries, women understood men's courtship gifts and material preparations for married life as emblematic of their future wedded comfort.[108] The possession of a well-turned-out carriage was a considerable pull for prospective middling and elite wives as it signalled a man's financial independence, tasteful eye, and the couple's future prosperity. In July 1777, it was rumoured that the eligible Earl of Cholmondeley was engaged to his divorced mistress Grace Dalrymple. Society's suspicions seemed to be confirmed when the *Morning Post* reported that, 'she already sports his Lordship's coronet on her coach'.[109] Scandalised by the 'impropriety of an avowed *courtesan* sporting his arms, coronets and liveries perpetually through the town', Cholmondeley's family and friends insisted that he make her 'ride in her own carriage, attended by a suite in her own liveries'.[110] Merely being seen in another's coach could be read a sign of marital promise.

Across the eighteenth century, men were acutely aware of a coach's ability to make or break a marriage deal. The son of a baronet and

wealthy landowner, William Herrick ordered an elaborate Berlin coach to be built for his marriage to Lucy Gage signalling to her the life she could expect to lead, requesting designs to be sent ahead for his approval.[111] In the 1750s, modest Lancastrian gentleman Robert Parker offered his prospective wife and cousin, Elizabeth, 'cordial affection' in place of 'a Coach & deck[ing] you out in Pomp & Splendour', much to the displeasure of Elizabeth's family and friends.[112] Barbara Wigglesworth's disappointment is palpable in her letter to Elizabeth Barcroft in March 1800 that her future husband's 'prudence forbade his keeping a carriage'.[113] Accordingly, prospective husbands made their sweethearts enticing offers of material comfort. Despite her marriage to her poorer cousin, for Elizabeth Parker Shackleton, a happy marriage could be determined by the quality of a couple's well-kept coach. Of the newly married Mr and Mrs Wainman she wrote: '[what] a very happy couple they are. Had a Handsome Carriage, Handsome Horses, [and] Handsome Liveries'.[114] By men eschewing their preferences for riding horseback, or impractical vehicles such as chaises and chariots, the purchase of a 'coach' that could accommodate an expanding family signalled that they were ready to commit to the responsibilities and routines of married life – of calls to be made and a brood of children to be had.

Once married, the management of the stable yard and coach house was the husband's dominium and was an arena of elite masculine consumer and material expertise. Lord Grantham was solely responsible for the commissioning of carriages and paying for their maintenance, so when he died in 1786, his wife Mary asked for her brother-in-law's advice 'on the subject of the Coach I mean to keep', and for him to 'give the necessary orders to the Coachmaker'.[115] This is no surprise as elite men's obsession with outdoor sports and the paraphernalia of riding and hunting shared similar material characteristics to their vehicles. Elite men concerned themselves with all aspects of maintaining coaches, from mundane purchases such as horse feed to commissioning a plethora of carriages. This pattern of consumption fits within the historiographical consensus that men often consumed bulky, expensive, and dynastic goods as well as quotidian purchases for the household.[116]

Although women's involvement in the world of goods is often obscured in the traditional documentary sources of consumption, evidence suggests that women had minimal participation in the

Table 3.1 The receipted coach-related bills of John and Sarah Churchill

Type of bill	Number of bills	Spend	Paid by John Churchill	Paid by Sarah Churchill
New sedan chair	1	£33	0	1
Saddlers	1	£50	1	0
Sedan chair hire	2	£11 4s	0	2
Liverymen	2	£101 15s 9d	2	0
Harnesses	3	£5 16s 11d	3	0
Coachmen's wages	4	£67 9s	3	1
Farriers	5	£83 1s 1d	4	1
New coaches and repairs	7	£153 6s	6	1

commissioning and maintenance of carriages.[117] Joint domestic account books illustrate that even if a wife's marriage portion paid for the trappings of a genteel lifestyle, their husbands would pay out the bills from the saddler and coach-maker in his name.[118] The joint receipt book of John and Sarah Churchill details the gendered patterns of household accounting. Between January 1677 and November 1686, the Churchill's accumulatively spent over £500 on twenty-five coach-related bills (see Table 3.1). John paid for 19 of the 25 bills and Sarah 6. The Churchills' largest and most frequent expenditure was on new coaches, repairs, and repainting. John was responsible for paying £138 6s of the £153 6d total spend on the coaches themselves. Sarah, in April 1681, paid coach-maker John Cross £15 for a new coach, although John's absence lobbying for the end of the Duke of York's exile may account for this.[119] Both were responsible for the more everyday aspects of maintaining a bevy of coaches such as settling coachmen's wages and farriers' bills, yet Sarah's expenditure on coach maintenance was meagre in comparison to John's and any relatively lavish expenditure was confined to her own use of sedan chairs.[120] A similarly gendered use of sedan chairs can be found in a coach-maker's bill sent to Lord Cobham in 1753. While the bill contains 72 entries for repairs to coaches and harnesses, 2 entries were for repairs to 'Lady Cobham's sedan chair'.[121] John Churchill's coach bills shared a pattern of household expenditure that historians characterise as masculine as it focused

on high-status, expensive, and dynastic goods. The conventions of coverture dictated that women's economic practice was limited to smaller, less expensive goods.[122] Objects that were emblazoned with the family's arms were more often than not commissioned by men and displayed in 'masculine' spaces such as the stable yard.[123]

Although the Churchills' bills suggest that married women had little involvement in the maintenance of carriages, men's probate records demonstrate that they often bequeathed their coaches to their widows. Eighteenth-century widows had a different relationship to property than their married counterparts. Under English Common Law, married women were deemed *feme covert*. Upon entering marriage, a wife's portion and settlement became legally subsumed by her husband, and she could not enter into legal contracts, sue or be sued, or obtain credit. In economic terms, she had no legal right to her husband's property, including any of her own that she brought into the marriage. Unmarried women, those who never married, or widows, were classed as *feme sole* with legal rights to hold property and grant inheritance. Widows therefore had greater legal independence than married women and, as inheritors of their husbands' property they were legally entitled to a least a third, so had greater individual economic power than married women. Of course, the letter of the law did not always map onto practice, and much historical work has excavated how men and women negotiated the confines of coverture. Indeed, as Chapter 2 has shown, married women appear in upholsterers' ledgers alongside their husbands – a clear circumvention of coverture doctrines. Furthermore, many widows, as Amy L. Erickson observes, could receive much more than a third of their husbands' property.[124] Wealthy husbands bequeathed their widows a coach and this was an important act of patriarchal, masculine provision. Viscount Cobham left his wife a coach and coach-horses in wills dated June 1737 and June 1748.[125] A younger son of the Earl of Shelbourne, Thomas Fitzmaurice left his wife Mary, Countess of Orkney in her own right, all his 'coaches and carriages' and coach-horses upon his death in 1793.[126] Bequests of a coach and horses were not limited to aristocrats. Somerset gentleman Hodges Strachey (d. 1746) left to his wife Mary his jewels, chariot, chaise, carriage, and horses.[127] William Herrick left his wife Lucy his chaise and three good horses in a will dated 1768.[128] Similarly, Christopher Buckle left his second wife Ann, along with the household

furniture, plate, books, and linen, his coaches, chariots, and chaises including all the harnesses and coach-horses in a 1781 will.[129] If men felt compelled to bequeath coaches to their sons, they, like Sir William Palmer and James Shuttleworth Esq., left their wives their very best coach, coach-horses, and harnesses while their sons would have to make do with the rest.[130] Sometimes, the contents of the coach house was the only property a husband left his wife.[131] These men ensured their widows still had the means by which to live comfortably and maintain their position in polite society and thus formed a significant example of patriarchal masculine provision.

Widows' spending on coaches was small-scale and characterised by ad-hoc expenditure on coach maintenance. A coach-maker's account book kept between 1733 and 1741 served 60 male clients and only 4 women – all of whom were widows who made small-scale repairs to existing coaches rather than commissioning new ones.[132] One rare exception can be found in a coach-maker's bill sent to the Earl of Huntington in 1691 in which the coach-maker references 'my Lady's coach' and 'my Lord's town coach'.[133] There are also rare examples of widows bequeathing their coaches to other women; Lady Cobham left her sole executrix Henrietta Jane Speed 'her coaches and other carriages' in a will dated October 1759.[134] These bequests remind us that while men lavished money and time on buying and maintaining their coaches, they were not their sole users. As the evidence from the probate documents hints at, wives and daughters used coaches daily and the dignity of private transport was essential to maintaining their place within the sociable world.[135] Paying calls in Town during the season and travelling between country estates was the bedrock of provincial and urban women's polite sociability. The diary of teenage Ann Brydges records the almost gruelling schedule of female visiting. Between March and July 1769, she notes almost daily visits to 13 country houses across southern England.[136] Such frequent, long-distance travel must have required the use of a coach, and the regularity of such visits by her and her sisters and mother suggest a bevy of vehicles used to visit rural genteel society. Her father, uncle, and brothers, who paid almost as many visits as their female relatives, preferred to travel by horseback, not in the very expensive coaches that they themselves owned.

While a husband's coach provided a wife with some mobility and independence, unmarried men and spinsters also required the use

of a coach. Thomas and Frederick Robinson's correspondence bristles with fetishistic engagement with coaches, typical of elite men, thinly veneered as a concern with practical, masculine economy.[137] Keenly aware of their beloved unmarried sister Anne's (nicknamed Nanny), dependency on them for transport, the brothers decided in December 1778 to commission Anne a new 'strong, fit for England' post chaise and Thomas would foot the bill.[138] Anne was impatient for the coach to arrive to enable her to see Frederick, and, in June 1780, she wrote that 'I cannot help still regretting the distance there is between us, but I must rest satisfied with the Hint you give me of a Post coach & chaise and will wait with patience till that time comes'.[139] While Thomas and Frederick's coaches afford them relative freedom, single Anne remained dependent on her brothers' generosity. Stobart and Rothery's comparison of the spending habits of unmarried brother and sister Edward and Mary Leigh discovered that Mary spent significantly more on coaches, saddlery, and tackle than her brother.[140] As a wealthy, unmarried, aristocratic heiress Mary's coach expenditure mirrored that of her male contemporaries and reveals 'the true effect of landownership on an aristocratic woman'.[141] Without a husband, Mary adopted both traditionally 'masculine' and 'feminine' consumer habits out of necessity, travelling between her family estate in Warwickshire and London.[142] Thus it was the ability to own a carriage outright, usually prohibited for married women under the customs of coverture, that granted single Mary such an usual degree of independence and mobility for her sex. Thus heiresses and some unmarried aristocratic sisters could possess coaches bought with family money.

Nevertheless, bachelor younger sons, such as Frederick Robinson and Gilbert White, were privileged to have such economic independence to acquire a coach. We only have to look to less fortunate female dependents than Anne Robinson and Mary Leigh to gage the importance of private transport to forms of gendered power and agency. The diary of the spinster Gertrude Savile is full of understandable self-pity as an unmarried woman living in her widowed mother's household.[143] Gertrude's brother, Sir George Savile, gifted his mother and sister the use one of his coaches. In the late 1720s Gertrude's mother refused her the use of the coach, even choosing to transport guests and servants over Gertrude, and Sir George had to step in to arrange a formal coach booking system.

Gertrude wrote in 1729: 'the owner desiring I may have the use of the Coach. It is enough. I shall henceforward use it. This regard, the condescension ... lifting me above the dirt Mother would have me walk in, gave me much satisfaction and a little triumph'. Just as it was 'prudent economy' for Frederick Robinson to purchase a town-carriage, access to a private coach was essential to Savile's maintaining her precarious dignity as a genteel spinster paying polite calls in Town, however unlike Robinson she had no means of acquiring and keeping one herself. Infringements on women's mobility were, in Katharine Glover's words, 'not merely practical, but limited by fashion and polite protocol. In London, the idea of visiting in a state of weather-beaten dishevelment was incompatible with the expectations of polite femininity'.[144] Certainly, the Bingley sisters were horrified when Elizabeth Bennet walked into Netherfield Park's drawing room with her 'petticoat six inches deep in mud' as the Longbourne coach-horses were in use on the farm.[145] As a literary device in Samuel Richardson's *Pamela* (1740), the coach highlighted Pamela's entrapment in her closet as her jailer, Mr B., came and went in his chariot. Pamela was only able to drive out in his crested coach once they were married. Gertrude's reliance on rented carriages and public stagecoaches confirmed to her the indignity of her feminine dependence and the lowly station of an uncared-for spinster – and she complained bitterly of 'what I had spent in Chairs'.[146] The exclusivity, independence, and dignity of owning a carriage set the refined and genteel apart from the merely respectable, who depended on rented carriages and public stagecoaches. The dispute was settled by Sir George asserting his status as the legal owner of the coach with its use at his behest, not dowager Lady Savile's. Here, the contours of female autonomy and dependency are drawn on the differences concerning Lady Savile's and Gertrude's marital status and age. Both women financially relied on the heir to the baronetcy, although Lady Savile, as his widowed mother with limited spending power, clearly thought she had a greater right to the coach than his dependent, spinster sister. Gertrude Savile's battle with her mother reminds us that even 'elite' eighteenth-century women had limited access to these vehicles, and therefore to decorous modes of personal, private, and prestigious transport. Their relationship, both legal and financial, to carriages and the mobility they afforded, were precarious in ways

which they were not for their male kin, and the use and possession of such property were always in the gift of a patriarch. Gertrude's concerns over her dignified travel do not fill the pages of elite, wealthy bachelors like Robinson and White. Private carriage transport was a significant mechanism for the gendered politics of independence, authority, and mobility. The access to, and ownership and use of, a coach conformed to the grids of power that determined unmarried women's dependency and experiences.

Conclusion

Coaches demonstrated both positive and negative aspects of eighteenth-century masculinity. On one hand, a coach signalled to a prospective wife a man's commitment to the responsibilities of married life. Once married, the crested coach's dynastic association meant that it fell under the husband's jurisdiction. Men ensured that their unmarried female relatives had some mobility and independence by buying them coaches. Although the coach remained a husband's property throughout their life, many husbands ensured their widows were able to maintain their social standing by bequeathing them a coach. On the other hand, the coach was a symbol and a tool of patriarchal control, enshrined in coverture, which enabled men to control the movements of their households. Longstanding legal customs and structures determined gendered patterns of eighteenth-century elite consumption and possession and underpinned elite men's mobile independence. But possession or consumption is just one part of the coach's meaning in eighteenth-century consumption. Carriages necessitated repair and maintenance by the very nature of their use; we can read onto these consumer practices the importance of materiality in maintaining masculine identities. Maintaining elite manly mobility was as mundane as it was magnificent. But it is in these mundane practices of repairing, altering, oiling, and cleaning that we can understand eighteenth-century elite men not simply possessing elite status but maintaining it. In doing so, they regularly participated in a material process of becoming and redefining to maintain their particular forms of social prestige and economic privilege. It was this process that accounts for the

shifting construction, design, and decoration of carriages across the eighteenth century.

Notes

1 See Jo Guldi, *Roads to Power: Britain Invents the Infrastructure State* (Cambridge, MA, 2012).
2 BA. L 30/14/333/91. 'Fritz, Whitehall to Grantham' (4 May 1778).
3 See Sarah Goldsmith, *Masculinity and Danger on the Eighteenth-Century Grand Tour* (London, 2020), 111–39.
4 Amanda Vickery, *The Gentleman's Daughter: Women's Lives in Georgian Britain* (New Haven, CT and London, 1999).
5 John Gay, *Trivia, Or The Art of Walking the Streets of London* (London, 1716).
6 Ingrid H. Tague, *Women of Quality: Accepting and Contesting Ideals of Femininity in England, 1690–1760* (Woodbridge, 2002); 162–93; Amanda Vickery, *Behind Closed Doors: At Home in Georgian England* (New Haven, CT and London, 2009).
7 RA. GEO/ADD/15/8140. The fashion, until the 1770s, for painted coach panels meant that many well-known eighteenth-century painters, such as Robert Smirke and William Kent, began their artistic careers as coach-painters, see Michael Wilson, *William Kent: Architect, Designer, Painter, Gardener, 1685–1748* (London, 1984), 5.
8 Coachmaker William Felton wrote that it was widely recognised that the 'coachbuilder' was the principal figure in the network of artisans employed in the coachbuilding trades, see William Felton, *Treatise on Carriages* (London, 1794), iii.
9 Giorgio Riello, 'Strategies and Boundaries: Subcontracting and the London Trades in the Long Eighteenth Century', *Enterprise and Society* 9.2 (2009), 243–80; John Styles 'The Goldsmiths and the London Trades, 1550–1750', in David Mitchell (ed.), *Goldsmiths, Silversmiths and Bankers: Innovation and the Transfer of Skills, 1550–1750* (London, 1995), 114.
10 The Robinsons of Newby Hall in Ripon bought all their coaches in London and had them sent up in the 1770s and 1780s, see BA. L 30/16/16/1. 'M. Grantham to K. G. Robinson' (c.1786); L 30/14/333/91. 'Fritz, Whitehall to Grantham' (4 May 1778).
11 Although this geographical clustering was rare, the impracticality of transporting heavy coach parts across the city can account for this clustering, see Styles, 'Goldsmiths', 114.
12 *Locating London's Past*. 'Fire Insurance Records 1777–1786'.

13 William Felton, *A Treatise on Carriages* (London, 1796), v.
14 G. A. Thrupp, *The History of Coaches* (London, 1877), 46.
15 'Coach', Ephraim Chambers, *Cyclopædia: or, An Universal Dictionary of Arts and Sciences*, vol. 1 (Dublin, 1728). Also see Thrupp, *History of Coaches*, 48.
16 Jane Austen, *Pride and Prejudice*, (ed.) Vivian Jones (London and New York, 2003), 155.
17 BL. Add MS 61346; BL. Add MS 61348. A seventeen-year gap in the evidence suggests they could have owned many more. Shropshire Archives. 112/6/Box 64/40, 64/43, 64/387, 64/396, 64/397.
18 Road development was driven by the increased land-carriage of goods, post, and people, increased carriage ownership, and the rise of domestic tourism due to Britain's ongoing involvement in European conflicts, see Ian Ousby, *The Englishman's England: Taste, Travel and the Rise of Tourism* (Cambridge, 1990).
19 Dan Cruickshank and Neil Burton, *Life in the Georgian City* (London, 1990), 14.
20 Cruickshank and Burton, *Georgian City*, 14; Richard Steele, 'Tatler No. 144, Saturday, March 11, 1710', in Donald F. Bond (ed.), *The Tatler*, vol. 2 (Oxford, 1987), 319.
21 BL. Add MS 36123. f. 95.
22 Felton, *Treatise on Carriages*, 19.
23 RCT. RCIN 1083235. 'Sophie in London, 1786', 15. In British correspondence see BA. L 30/17/4/10. 'Grantham, Madrid to Nanny' (21 October 1771).
24 Helen Jacobsen, *Luxury and Power: The Material World of the Stuart Diplomat, 1660–1714* (Oxford, 2012), 31.
25 Ben Jackson, 'To Make a Figure in the World: Identity and Material Literacy in the Coach Consumption of British Ambassador, Lord Grantham', *Gender & History* (2022), 1–22.
26 Sophie Von la Roche, *Sophie in London, 1786: Being the Diary of Sophie v. la Roche*, trans. Clare Williams (London, 1933), 159.
27 John Styles, 'Product Innovation in Early Modern London', *Past & Present* 168 (2000), 124–69; Maxine Berg, 'Imitation to Invention: Creating Commodities in Eighteenth-Century Britain', *Economic History Review* 55.1 (2002), 1–30.
28 Felton, *Treatise on Carriages*, 88–94.
29 Chris Evans and Alun Withey, 'An Enlightenment in Steel? Innovation in the Steel Trades of Eighteenth-Century Britain', *Technology and Culture* 53.3 (2012), 533–8.
30 Paul Langford, 'The Uses of Eighteenth-Century Politeness', *Transactions of the Royal Historical Society* 12 (2002), 330.

31 David Kuchta, *The Three-Piece Suit and Modern Masculinity: England, 1550–1850* (Berkeley, CA and London, 2002), 173.
32 See Jackson, 'To Make a Figure', 13.
33 See Susan Whyman, *Sociability and Power in Late-Stuart England: The Cultural World of the Verneys, 1660–1720* (Oxford, 2002), 100; Hannah Greig, *The Beau Monde: Fashionable Society in Georgian London* (Oxford, 2012), 32–62; Jacobsen, *Luxury and Power*, 30.
34 Amanda Vickery, *The Gentleman's Daughter: Women's Lives in Georgian England* (New Haven, CT, 1998), 31–2. For examinations of hierarchical structures of early modern society see Keith Wrightson, *English Society 1580–1680*. Reprint (Abingdon, 2003), 25–47; Peter Borsay, *The English Urban Renaissance: Culture and Society in the Provincial Town, 1660–1770* (Oxford, 1989), 208–308. Much of this debate is characterised by sociologist Pierre Bourdieu's concept of the social distinctions of status-display, taste, and lifestyle constantly defending and reinforcing social hierarchies, see *Distinction: A Social Critique of the Judgement of Taste* (London, 1984). Also see Grant McCracken, *Consumption and Culture: New Approaches to the Symbolic Character of Goods* (Bloomington, IN, 1990), 31–44. Lawrence Klein disagrees with the exclusivity of polite goods and argues that the polite world of goods was more open to non-elite groups, 'Politeness for Plebes: Consumption and Social Identity in Early Eighteenth-Century England', in Ann Bermingham and John Brewer (eds), *Consumption of Culture 1600–1800: Image, Object, Text* (Abingdon, 1997), 362–82; John Styles, *The Dress of the People* (New Haven, CT, 2007). Also see Colin Campbell's critique of emulative and exclusive motivations of consumption in 'Understanding Traditional and Modern Patterns of Consumption in Eighteenth-Century England: A Character-Action Approach', in John Brewer and Roy Porter (eds), *Consumption and the World of Goods* (London, 1993), 40–57. Also see Jon Stobart and Mark Rothery's characterisation of the permeable elite in *Consumption and the Country House* (Oxford and New York, 2016), 50–1.
35 HL. mssST Vol. 86, Vol. 1.
36 HL. mssSTG Accounts Box 165; TNA. C114/60/5.
37 HL. mssST Accounts Box 144.
38 Jackson, 'To Make a Figure', 14–15
39 Stobart and Rothery, *Consumption and the Country House*, 40. They are referring to Jan de Vries' argument of a Structuralist approach to material culture in which goods exist within a system of marking difference between one another, see Jan de Vries, *The Industrious Revolution: Consumer Behaviour and the Household Economy, 1650 to the Present* (Cambridge, 2008), 31–4. This is similar to Henry

Glassie's observation in *Material Culture* (Bloomington, IN, 1999) that 'all objects are simultaneously sets of parts and parts of sets. They are texts, sets of parts to which meaning is brought by location them in context, by analyzing them as parts of sets' (47). Also see McCracken *Consumption and Culture*, 118–29; Greig, *Beau Monde*, 100–1.

40 BA. L 30/14/333/108. 'Fritz, Stanmer to Grantham' (24 June 1778).
41 Jane Bennett, *Vibrant Matter: A Political Ecology of Things* (Durham, NC, 2010).
42 JRRIL. GB 133 Eng MS 911.
43 After separating from her husband, the Duchess of Grafton begged him for a landau and liveries to maintain her social position. See Vickery, *Behind Closed Doors*, 137–43.
44 Henry Fielding, *The Covent-Garden Journal*, (ed.) Humphrey Milford (New Haven, CT, 1915) 203.
45 In a letter to MP Charles Mellish, George Shaw wrote that he was shocked to see Lord Gallway in a shabby phaeton, see Nottinghamshire University Library, Manuscripts and Special Collections. Me 2C 95. 'Letter from Mr G. Shaw to C. Mellish at Blyth' (17 June 1793).
46 Greig, *Beau Monde*, 218–19; Vickery, *Behind Closed Doors*, 124. Stobart and Rothery challenge this and argue that, in their examination of Warwickshire aristocratic families' consumerism, they spent huge sums of money on luxury goods such as coaches, horses and liveries, but it never exceeded their income. See Stobart and Rothery, *Consumption*, 23–54.
47 Oxfordshire Health Archives. W/D/129/3.
48 HL. mssST 24, vol. 1
49 Greig, *Beau Monde*, 61–2. Also see Whyman, *Sociability and Power*, 101; Jacobsen, *Luxury and Power*, 7.
50 Jacobsen, *Luxury and Power*, 1–19. The 'season' was fundamental to constructing the metropolitan elite's fashionable and political world, as well as London's built environment and the commercial expansion of its entertainment and trade industries, see Greig, *Beau Monde*, 1–32.
51 TNA. C114/60/5. Stobart and Rothery, *Consumption*, 207.
52 BL. Add MS 61346 (1677–1690); BL. Add MS 61348. Notably the Churchill's used coach-makers who were elected as Master of the Coachmaker's Company.
53 HL. mssSTG Accounts Box 145.
54 WSRO. PHA/8101; WSRO. PHA/7528.
55 BA. L 30/14/408/27. 'Waddilove, Whitehall to Grantham, Madrid' (17 February 1775).
56 LLRO. DG 9/2053. Also see BL. Add MS 38477.

160 Material masculinities

57 Felton thought that it was right that the design of the coach be subject to 'the fancy of its occupier', Felton, *Treatise on Carriages*, 75.
58 Grantham's coach-maker wrote to inform him of the latest fashions in London and Paris, see BA. L 30/14/426/1. 'Wright, London to Grantham, Madrid' (19 April 1774).
59 Public coaches were used as advertising billboards, see Maxine Berg and Helen Clifford, 'Selling Consumption in the Eighteenth Century: Advertising and the Trade Card in Britain and France', *Journal of the Social History Society* 4.2 (2007), 146.
60 BA. L 30/14/333/96. 'Fritz, Whitehall to Grantham, Madrid' (19 May 1778).
61 TNA. SP 35/23/35. 'Walpole to Charles Delafaye' (14 September 1720).
62 BA. L 30/14/333/207. 'Fritz, Whitehall to Grantham' (11 May 1779).
63 BM. 'Trade Card of Hatchett Coach & Cart Builder', c.1780. Heal,49.12. Reilo argues that Sophie von la Roche's description of Hatchett's workshop obscured the work of outsourced manufacturers and perpetuated 'the myth of the self-sufficient business' hidden behind the 'monolithic notion of the workshop', see Riello, 'Strategies and Boundaries', 255.
64 Grieg makes a similar argument that goods gained their 'fashionable' status by their owners rather than inherent material qualities, see Grieg, *Beau Monde*, 32–62.
65 BA. L 30/14/408/27. 'Waddilove, London to Grantham, Madrid' (17 February 1775).
66 Riello, 'Strategies and Boundaries', 255; Styles, 'Goldsmiths', 114. Also see Claire Walsh, 'Shop Design and the Display of Goods in Eighteenth-Century London', *Journal of Design History* 8.3 (1995), 157–76.
67 BA. L 30/14/333/150. 'Fritz, Whitehall to Grantham', 8 December 1778.
68 Von la Roche, *Sophie in London*, 159.
69 See Lawrence Stone and Jeanne C. Fawtier Stone, *An Open Elite? England 1540–1880* (Oxford, 1986), esp. 283–303.
70 See the Introduction for historiographical debates on social rank in eighteenth-century England.
71 See G. E. Mingay, *English Landed Society in the Eighteenth Century* (London, 1963), 20–6; Roy Porter, *English Society in the Eighteenth Century* (London, 1982), 70.
72 This is a long established and controversial discourse but is borne out by sociologists on conspicuous consumption and cultural capital, see Veblen's *Theory of the Leisure Class: An Economic Study of Institutions* (London, 1970); Bourdieu, *Distinction*; Georg Simmel,

'Fashion', *International Quarterly* 10.1 (1904), 130–55. For recent historical application of this sociological approach to elite spending see Greig, *Beau Monde*, 36–47; Stobart and Rothery, *Consumption*, 23–52.
73 Whyman highlights the coach's connection to sociability in *Sociability and Power*, 100.
74 BL. Add MS 61346.
75 John B. Hattendorf, 'Churchill, John, first duke of Marlborough (1650–1722), army officer and politician.' *Oxford DNB*. 23 September 2004.
76 Hattendorf, 'Churchill', np.
77 BL. Add MS 61348.
78 BL. Add MS 61348.
79 BL. Add MS 61348.
80 *The Annual Register*, vol. 3 (London, 1760).
81 Tillman W. Nechtman, *Nabobs: Empire and Identity in Eighteenth-Century Britain* (Cambridge, 2010).
82 Thomas Babington Macaulay, 'Lord Clive', in *The Historical Essays of Macaulay*, (ed.) Samuel Thurber (Boston, MA, 1892), 229–31.
83 Margot Finn and Kate Smith, 'Introduction', in Margot Finn and Kate Smith (eds), *The East India Company at Home, 1750–1850* (London, 2018), 7–10.
84 BL. Mss Eur G37/75/5.
85 BL. Mss Eur G37/75/5.
86 Burke, 'Res et Verba', 149.
87 This is argued in Chapter 2's examination of repairs to furniture. For the elite's preoccupation with refashioning existing goods see Greig, *Beau Monde*, 46–61.
88 ERO. D/DU 502/2.
89 RA. GEO/ADD/15/0861a/220.
90 BL. Add MS 38477.
91 RA. GEO/ADD/15/0861a/474.
92 TNA. C114/60/5. Also see HL. mssSTG Accounts Box 145.
93 BA. L 30/14/426/1. 'Wright, London to Grantham, Madrid' (19 April 1774).
94 BA. L 30/14/333/96. 'Fritz, Whitehall to Grantham, Madrid' (19 May 1778).
95 Hattendorf, 'Churchill', np.
96 BL. Add MS 61348.
97 Jacobsen, *Luxury and Power*, 30, 108–11.
98 Jackson, 'To Make a Figure', 11–14.
99 Kuchta, *Three-Piece Suit*, 173.

100 Steele, 'Tatler No. 144', 321. Emphasis in original.
101 BL. Add MS 12455; BL. Add MS 12456.
102 Felton, *Treatise on Carriages*, 207.
103 McCracken, *Culture and Consumption*, 31–44.
104 See Stobart and Rothery, *Consumption*, 78–94; Vickery, *Behind Closed Doors*, 133–4.
105 ESRO. SAY/2689.
106 Robert Saville, *The Letters of John Collier of Hasting, 1731–1746* (Sussex, 2016), 182, 184, 292, 295, 296.
107 Vickery, *Behind Closed Doors*, 133; Stobart and Rothery, *Consumption*, 19; Helen Clifford, *Silver in London: The Parker and Wakelin Partnership 1760–1776* (New Haven, CT, 2004), 132.
108 Vickery, *Gentleman's Daughter*, 83–105. The necessity for financial security and a respectable marital home was a pressing motivation for women accepting proposals across a century in which courtship became more autonomous and less ritualised, see Robert B. Shoemaker, *Gender in English Society 1650–1850: The Emergence of Separate Spheres?* (London, 1998), 95–6, 100. Sally Holloway's recent examination of breach of promise suits demonstrates that material preparations for marriage were not only influential in courtship practices, but could be provided as 'incontrovertible proof' of intention to marry, see Sally Holloway, *The Game of Love in Georgian England: Courtship, Emotions and Material Culture* (Oxford, 2019), 143–65. For research that stresses women's involvement in the material culture of courtship and early marriage see Diane O'Hara, *Courtship and Constraint: Rethinking the Making of Marriage in Tudor England* (Manchester, 2000), 190–235; Joanne Bailey (Begiato), *Unquiet Lives: Marriage and Marriage Breakdown in England, 1660–1800* (Cambridge, 2003), 85–109; Greig, *Beau Monde*, 39–45. Holloway, *Game of Love*, 34–43. For research that stresses men's involvement see Karen Harvey, *The Little Republic: Masculinity and Domestic Authority in Eighteenth-Century Britain* (Oxford, 2012), 102–6.
109 *Morning Post and Daily Advertiser*, 16 July 1777.
110 *Morning Post and Daily Advertiser*, 5 November 1777. Emphasis in original.
111 LLRRO. DG 9/2053.
112 LA. Acc.7886 Wallet 4, 'Robert Parker to Elizabeth Parker' n.d. For the reaction of Elizabeth's family and friends see Vickery, *Gentleman's Daughter*, 45–57; French and Rothery, *Man's Estate*, 193–4.
113 LA. DD/72/1496. 'B. Wigglesworth, Townhead, to E. Barcroft, Otley' (20 March 1800).
114 LA. DDB/81/39 (1781). Also see Vickery, *Gentleman's Daughter*, 183–94.

115 BA. L 30/16/16/1. 'M. Grantham to K. G. Robinson, Park Street [Westminster]' (c.1786).
116 Stobart and Rothery, *Consumption*, 41. Also see Margot Finn, 'Men's Things: Masculine Possession in the Consumer Revolution', *Social History* 25.2 (2000), 133–55; Harvey, *Little Republic*, 80–2, 114–20; David Hussey, 'Guns, Horses and Stylish Waistcoats? Male Consumer Activity in Late-Eighteenth- and Early-Nineteenth-Century England', in David Hussey and Margaret Ponsonby (eds), *Buying for the Home: Shopping for the Domestic from the Seventeenth Century to the Present* (Farnham, 2008), 67–9.
117 Stobart and Rothery argue that this was less about conformity to gender roles and more about different social identities, Stobart and Rothery, *Consumption*, 140–68.
118 Vickery, *Behind Closed Doors*, 106–28.
119 BL. Add MS 61346.
120 BL. Add MS 61346.
121 HL. mssSTG 'Accounts Box 144'.
122 Vickery, *Behind Closed Doors*, 278.
123 See discussion of masculine spaces and furniture in Chapter 2. For more armorial goods and elite masculinity see Kate Smith, 'Manly Objects? Gendering Armorial Porcelain Wares', in Finn and Smith (eds), *The East India Company at Home, 1757–1857*, 130. Also see Elizabeth A. Williams, 'A Gentleman's Pursuit: Eighteenth-Century Chinoiserie Silver in Britain', in Jennifer G. Germann and Heidi A. Strobel (eds), *Materializing Gender in Eighteenth Century Europe* (London, 2017), 105–19.
124 Amy L. Erickson, *Women and Property in Early Modern England* (London, 1993), 3. For more work on women's legal relationship to property see Introduction, n. 25.
125 HL. mssSTT Personal Box 16.
126 Oxfordshire History Centre. Hey IV/ii/6.
127 Somerset Heritage Centre. DD/SH/79/10/31. Other examples include: BA. FN975. 'Will of Sir John Francklin of St. Giles in the Fields' (30 October 1703); BA. HY722-3. 'Probate Will, with Copy, of John Harvey of Ickwell Bury, Esq.' (15 December 1708). BA. R6/7/1/2. 'Attested Copy of Will of Thomas, 1st Baron Trevor'. 23 December 1723; Shropshire Archives. SRO 1045/461. 'Attested Copy Will of Charles Watkin Meysey of Shakenhurst Esq.', 25 August 1773.
128 LLRRO. DG/9/2299.
129 North Yorkshire County Record Office. ZBL I/2/1/14.
130 TNA. PROB 11/372/400. Also see Derbyshire Record Office. D 779B/F 51. 'Will of James Shuttleworth of Forsett, County of York',

1772; TNA. PROB 11/569/372. 'Will of Sir Thomas Cave, Stanford Northampshire', 23 July 1719.
131 ERO. D/Q 6/3/7, 'Will, 25 January 1708, of John Cressener of Earls Colne, Esq'; Hertfordshire Archives and Local Studies. DE/AS/4275, 'Will of Philip Boteler Esq., 18 Aug 1708'.
132 TNA. C114/60/5.
133 HL, mssHA HAF Box 25 (20).
134 HL. mssSTT Personal Box 16 (12).
135 See Whyman, *Sociability and Power*, 105–7; Vickery, *Behind Closed Doors*, 14–6; Greig, *Beau Monde*, 63–98. Katharine Glover, *Elite Women and Polite Sociability in Eighteenth-Century Scotland* (Woodbridge, 2011), 145.
136 ERO. D/DRuF10.
137 Vickery, *Behind Closed Doors*, 124.
138 BA. L 30/15/54/107. 'Grantham, Madrid to Fritz' (17 December 1778); L 30/14/333/91. 'Fritz, Whitehall to Grantham' (4 May 1778); L 30/17/4/200. 'Grantham, Aranjeuz to Nanny' (4 June 1778).
139 BA. L 30/15/50/5. 'Anne, Saltram to Frederick' (27 June 1780).
140 Stobart and Rothery, *Consumption*, 143.
141 Stobart and Rothery, *Consumption*, 144.
142 Mary Leigh, as an unmarried female landowner, travelled much more than a married woman would between Town and her country estate and perhaps this accounts for her increased coach expenditure, see Stobart and Rothery, *Consumption*, 144.
143 See Vickery, *Behind Closed Doors*, 202–12.
144 Glover, *Elite Women*, 79–109.
145 Austen, *Pride and Prejudice*, 36.
146 Alan Saville (ed.), *Secret Comment: The Diaries of Gertrude Savile, 1721–1757* (Devon, 1997), 169–70.

4

Discerning consumer: possessing the self

The eighteenth-century consumer was faced with an unprecedented and dazzling array of new, luxurious, and innovatively manufactured products. In the consumer revolution's nascent marketplace of print advertising, and the English abolition of sumptuary laws, exclusive luxuries quickly became accessible necessities. This consumer culture intensely debated standards of beauty and material discernment bound up in moral panics on 'social hierarchy, public morality, military might, and economic efficiency'. These debates congregated around expressions of 'taste'.[1] Small accessories, such as snuffboxes, canes, toothpick cases, and pocket fobs, emerged in the eighteenth century as fashionable goods and were possessed by people across the social strata. Eighteenth-century writers associated these new accessories with women's, supposedly, undiscerning and irrational consumer desires for textiles and porcelain.[2] Thus British anxieties surrounding men's seemingly effeminate fashionable tastes, since the mid-seventeenth century, manifested in a succession of 'character types' such as the fop, beau, macaroni, and dandy. These characters' fashionability transgressed the rational manly ideal.[3] Likewise, the nabob manifested the anxieties over Asian products and newly acquired imperial wealth flowing into Britain. Prolific writers on luxury characterised men's ownership of 'baubles' and 'gew-gaws', such as snuffboxes, canes, toothpick cases, and fobs, as foolishly foppish; such accusations abound in printed materials but rarely appear in the manuscript archive. In *The Spectator* (1711), Addison and Steele's 'beau' were 'loaden with such a redundance of excrescencies' such as 'snuffboxes, and the like Female Ornaments'.[4] As macaroni male fashion emerged in the 1770s, an explosion of satirical plays, poems, and polemics on the 'Macaroni' appeared in the print

marketplace. The garish snuffbox, thin cane, toppling wig, and minute hat comprised the macaroni's costume in Matthew Darly's extensive series of macaroni satires throughout the 1770s.[5]

Men's consumer tastes became a cultural battleground upon which socially conservative concerns and anxieties of luxury's potentially perilous aberration of the masculine ideal were fought out. Beyond this moral panic, the discerning male consumer sought out these goods for their ingenuity and technological innovation. Accessories spoke to who you were as a consumer, and by extension who you thought you were and claimed to be in an increasingly consumer society shaped by enlightenment ideals of progress and improvement. While the line between refined discernment and vulgar extravagance could be a thin one, these goods became central to practices of all-male homosociability, gift-exchange, political reform, and emotional network building. They also spoke particularly to the personal, sensory, and embodied experiences of men and women in eighteenth-century England. To be a discerning consumer, then, required much more than a deployment of taste.

This chapter begins with exploring the gendered and social politics of who was a discerning consumer in eighteenth-century England and what constituted that discernment. It then widens its purview to a broader range of terms – 'smallness', 'ingenuity', 'novelty', 'effeminacy', and 'refinement' – associated with luxurious accessories. It considers the gendered material practices of eighteenth-century consumers to argue that male accessories were not merely objects of effeminate whimsy but of technological wonder, rational discernment, and gendered selfhood. As both eighteenth-century writers and historians have focused on the luxury debates' preoccupation with gender's interaction with social rank, this chapter then turns to thinking about the possession and theft of these objects in the *Proceedings of the Old Bailey*. Here, the chapter examines a sample of stolen snuffboxes, canes, and toothpick cases to consider how the material qualities of goods worked to materialise hierarchical distinctions of gender and rank. Turning from possession to personalisation, the chapter then works through how consumers would customise and personalise these accessories as a part of stamping a sense of self upon these examples of personal property. From possession and personalisation, the chapter concludes with an examination of exchanging and bequeathing these small things.

Discerning consumer: possessing the self 167

In examining the possession, personalisation, and exchange of these accessories, this chapter makes two central claims. First, to be a 'discerning consumer' required haptic, embodied, and material knowledge of objects' material qualities, and such knowledges and literacies underpinned the cultivation and enactment of 'good taste'. Elite consumers could differentiate themselves in a society in which an increasing number and variety of people possessed objects that were once luxuries through the material qualities of their possessions. While the chapter explores the value systems people projected onto, and projected through, their possessions – a traditional focus of the scholarship on 'taste' – I am also interested here in what it was about objects themselves that appealed to the discerning masculine consumer and denoted a refined sense of taste. In approaching 'refinement' in a more material sense, the delicacy of the thinly cast snuffbox, the finely turned cane, and the delicate toothpick accessories' material qualities emerge as both integral and agential in the construction of eighteenth-century selfhood and operation of social identities and networks.

Secondly, there was a clear relationship between personal property – moveable goods often kept about one's person – and the body. Such a connection is not new to histories of eighteenth-century materiality, but here I argue that the relationship between person, or body, and thing was integral to giving these objects their social, cultural, and emotional valency. This is most clearly seen in the personalisation of the accessories under study here, possibly due to the semi-finished nature of eighteenth-century consumer goods, and practices of bequeathing and gifting. The material qualities of these small, often handheld, accessories invited a tacit, haptic set of interactions between the thing and the person – speaking to the centrality of materiality to selfhood and identity. In recent years, scholarship has moved beyond the cultural debates on 'luxury' and 'taste' to think about material literacies and knowledges, an approach I readily adopt here as it aids the understanding of what constituted discerning material taste and how it operated in eighteenth-century life. These knowledges and literacies worked to make social identities (gendered, urban, classed, and aged) meaningful, presentable, and legible. In doing so, rational, material discernment emerges as a key way in which forms of masculine material power were understood, assessed and practised in eighteenth-century England.

Conceptualising and possessing taste

Many in the eighteenth century thought the possession and production of new, luxury goods spoke to the new, modern age's refined taste, civility, and improvement. 'Taste', then, was not a subjective set of preferences – how it is used to describe material and consumer choices today – but was a mechanism of social distinction. For the Earl of Shaftesbury, a prominent early eighteenth-century theorist of taste, in *Characteristics of Men, Manners, Opinions, Times* (1711), 'Taste or *Judgment* ... can hardly come ready form'd with us into the World ... A legitimate and just Taste can neither be begotten, made, conceiv'd, or produc'd, without the antecedent *Labour* and *Pains* of Criticism'.[6] Taste was an innate mental faculty, or sense, refined and cultivated through a polite and enlightened education and demonstrated in *men's* manners, conversation, and discerning material acquisition. Similarly, in artist Gerard Alexander's 1759 *An Essay on Taste*, a fine taste was 'neither wholly the gift of *nature*, nor wholly the effect of *art*' but acquired through critical labours. Alexander conceptualised taste as a process by which the improvement of natural, mental powers such as novelty, sublimity, beauty, imitation, harmony, ridicule, and virtue supplied people with 'finer and more delicate perceptions' of their subject.[7] Historians' examination of the rise of the 'polite and commercial' classes in the eighteenth century found that who defined and had 'taste' increasingly expanded across the period.[8] At the beginning of the century, only a narrow few defined and possessed good 'taste'. Shaftesbury thought only elite men could determine and exhibit good taste and associated manliness with a rational, stoic disregard for novelty and fashion; men's taste was, supposedly, wholly superior to the whims of women and the vulgar.[9] In practice, though, eighteenth-century men were avid and eager consumers of a host of new consumer luxuries. Joseph Addison and Richard Steele's primary aim in print was the moral improvement of urban, moneyed society through the refinement of manners and good taste. They emphasised the utility and importance of politeness as the new paradigmatic axiom of the 'post-church', 'post-court' society of the early eighteenth century.[10] Enlightenment ideals of the human mind's potential for improvement through reason informed many thinkers' definition of taste.[11] Yet

taste, politeness, and enlightenment were movements of rational improvement for a certain powerful few. 'Taste' was a contentious term throughout the long eighteenth century and satirists, polemicists, commentators, and consumers alike deployed it to signal prudent virtue and modern refinement, while bad taste evoked consumer excess and vulgar emulation.

The language of taste was an elaboration of decorum – the classical notion of appropriateness – which permeated eighteenth-century aesthetics, social judgments, and practices; street manners and salutations, clothes and silverware all had to be appropriate to age, rank, and gender.[12] In November 1750 Lord Chesterfield wrote to his natural son detailing the conditions of his allowance warning that

> there is another sort of expense that I will not allow, only because it is a silly one; I mean the fooling away your money in baubles at toy shops. Have one handsome snuff-box (if you take snuff), and one handsome sword; but then no more pretty and very useless things. ... I mean to allow you whatever is necessary, not only for the figure, but for the pleasures of a gentleman, and not to supply the profusion of a rake.

In other letters, Chesterfield reiterated that he was happy to supply his son with an allowance to furnish him with the 'pleasures of a rational being' such as lodgings, furniture, coaches, and clothes, but was adamant his money should not be frittered away on baubles and trinkets such as snuffboxes, watches, and canes.[13] Chesterfield's distinction between 'handsome' necessities and 'pretty things' is an important one. The eighteenth-century lexicon of taste defined 'handsome' as something easy to handle and elegantly dignified, whereas 'pretty' conveyed beauty without elegance or dignity. Rational discernment was not abstention for Chesterfield, although, his concern with the lavish extravagancy of *many* pretty things speaks to material restraint becoming increasingly important to eighteenth-century male consumers within the anxious climates of the luxury debates. These handsome objects were deemed useful because they denoted the rational cultivation and material acumen that set the gentleman apart from the rake and his other inferiors; the 'charms of the toyshop' were a fool's 'destruction' in Chesterfield's, and his whiggish contemporaries' minds.[14]

The expanding middling sorts' engagement, and increasing discernment, in the eighteenth-century world of goods drove the anxious debates on luxury and taste. While not necessarily tastemakers, the middling sorts increasingly became taste-followers with growing access to, and knowledge of, fashionable goods. The middling sorts often accumulated a material culture that worked to express their own value systems and identities of prudence, economy, family, and devotion rather than emulating elite tastes.[15] Much, too, has been done to question London as the leader of national fashions.[16] The provinces did not always emulate London tastes, and provisional towns' local elites and their middling neighbours were conscious that aping London manners, amusements, and fashions could erase their distinctive regional identities. As well as a growing middling and provincial engagement in the world of goods, cultural discourses of beauty, politeness, and consumerism increasingly accepted women's refined material taste.[17] In practice, male consumers called on women's considerable consumer and material expertise to assist their purchases.[18] These examples of a growing acceptance of middling, provincial, and female consumer discernment suggest that, over the course of the eighteenth century, taste was increasingly democratised.

For Shaftesbury, good taste was a quality or faculty continually in flux. Tastes for things could be good or bad, refined or vulgar, masculine or feminine, exotic or traditional. Moreover, who was in possession of good taste – and therefore who defined and influenced what constituted it – continually changed in response to national anxieties. Thus taste was not only diverse in its cultural application, but it was also a slippery concept and its meaning changed, evolved, and expanded across the eighteenth century. In Edmund Burke's 1756 essay 'On Taste' he wrote: 'it is known that the taste (whatever it is) is improved exactly as we improve our judgment, by extending our knowledge, by a steady attention to our object, and by frequent exercise'.[19] Whatever taste was, a quality, or a faculty, or a set of principles, it was meaningful to eighteenth-century people as a process of mental improvement and aesthetic refinement in an evolving and expanding consumer marketplace. If taste was therefore a process, it contained a set of practices. Shifting our focus on taste from a study of language to one of practices of (social, cultural, and material) discernment and distinction, a different picture of taste emerges.

Novelty: ingenious technological wonder and effeminate refinement

Taste was but one word in a wide vocabulary of discerning material choices. Maxine Berg's study of eighteenth-century luxury and pleasure found that consumers prized the 'ingenuity', 'novelty', and 'quality' of products when purchasing and displaying their possessions. Small luxurious goods evoked delightfully modern, technological wonder within an enlightenment culture of scientific progress and social improvement. Taking snuff, and snuffboxes themselves, could arguably express the ideologies behind the delights of luxury culture writ large. Produced as a cash crop in colonial America by enslaved peoples, snuff, ground tobacco, arrived in England in the mid-seventeenth century and became the dominant mode of tobacco consumption by the close of the eighteenth century.[20] The 1822 commemorative history of the celebrated perfumer Charles Lillie associated the variety of snuff circulating in England as exemplative of the nation's thirst for novelty. The 'quantity of different snuffs, thus distributes throughout the kingdom, novelty being quickly embraced by us in England, arose the custom and fashion of snuff-taking; and growing upon the whole nation, by degrees, it is now almost as universal here, as in any other part of Europe'.[21] As snuff-taking was a more polite and respectable mode of tobacco consumption, although not without its impolite implications of sneezing, runny noses, and dirty handkerchiefs, it garnered a fashionable status among royalty, the aristocracy, and the clergy.[22] The gendering of tobacco consumption stemmed from the differences in how and where tobacco was consumed. Pipe smoke, as William Tullett has observed, was associated with masculine, homosocial spaces, such as the coffeehouse, tavern, and dining room, whereas in heterosocial environments, like Vauxhall Gardens, the visual and olfactory invasion of masculine tobacco smoke was an affront to polite and refined heterosociability.[23] At a dinner hosted by the Duke and Duchess of Bridgewater in June 1762, guests who smoked after dinner were 'coy and disconcerted together with half a Grain of Shame & would not willingly have exhibited before the female spectators'.[24]

This new, fashionable commodity needed a new, fashionable container. Delightful novelty was not only evident in snuffboxes' contents, but was also found in their new material mediums, new

decorative details, and new processes of production. A mid-century Battersea white-ground enamel snuffbox held at the British Museum has the calendar for 1759 decorated onto the lid (see Figure 4.1). The lid's interior is inscribed with a French love song to music. These decorative features were transposed from printed pocket diaries-cum-almanacs, such as *Bell's Edition* and *The Polite Repository, or, Pocket Diary* that contained the year's new songs and fashionable dances, a list of peers and MPs, and important dates in the social and religious calendar.[25] Like small snuffboxes, pocket diaries were designed to be carried in the keeper's pocket. Both snuffboxes and pocket diaries were produced within and marketed to an increasingly competitive marketplace of goods designed around seasonality. In August 1771, Horace Walpole wrote to Lady Ossory from Paris that 'as to snuffboxes and toothpick-cases, the vintage has entirely failed this year. I have not been able to find a new one of either sort'.[26] Retailed by London enamellist Anthony Tregent, the calendar-snuffbox, as Walpole's letter neatly illustrates, is indicative of the imitation of products' design qualities and features and the tapping into existing consumer 'crazes'.[27] The snuffbox's decoration, like the ephemeral pocket diary's printed format, signals that its 'intended' function would be redundant at the dawn of a new year. Obsolescence was built into these products' design and was part of their consumer appeal. It was this profligacy that angered those anxious of the nation's taste for novel luxuries. Yet the shared decorative features of this snuffbox and pocket diaries suggests that the habitual and ritualised taking of snuff connected the snuffbox, its decoration, and it contents with its user much in same way as the diary, its format, and its written contents connected the object with its owner and the ritual of life-writing. Accordingly, the feverish writing of the self and the addictive quality of snuff encouraged return and repetitive consumption of snuffboxes and pocket diaries. For Amanda Vickery, the use of eighteenth-century printed pocket diaries as managers of time, tasks, and social relations 'asserted [that the] individual consumer was more than a mere person, but a fully fledged personage'.[28] Will Tullett charts the popularity of snuffing, as a more personal, individualised form of tobacco consumption, alongside the rise of the modern, individual self. These objects thus had an entwined relationship with the possessors' sense of self. That

Discerning consumer: possessing the self 173

Figure 4.1 BM. Battersea-Enamel Snuffbox, 1759. 7.4 × 5.3 × 3.4 cm. Museum Number: 1895,0521.11. © The Trustees of the British Museum, London

the self was dependent on things to be meaningful contravened the ideal of independent masculinity.

'Novelty' is also apparent in the snuffbox's material medium. A new ceramic production technique, Battersea enamelware was perceived to be imitative of German Meissen porcelain ware. Battersea enamel was made from soft, white-ground enamel covered in copper ground. But Battersea is most notable for its high-quality transfer printing on a large scale. Such improvement in transfer printing techniques enabled the Battersea warehouse to produce high quality and intricately printed enamelware – that was eagerly sought out by consumers. A white-ground, mid-century, Battersea-enamel snuffbox held at the British Museum has the crest of the Anti-Gallican Society transfer-printed onto its lid (see Figure 4.2). On the lid's interior, there is an engraving of a bust of Irish politician Henry Boyle. Influential tradesmen dissatisfied with the political elite's inability to fully protect and promote international British trade established the Anti-Gallican Society during the Jacobite Uprising of 1745.[29] The year 1745 was a

Figure 4.2 'Battersea-Enamel Snuffbox', c.1700–1800, 8.8 × 6.5 × 3.8 cm. The British Museum, London. Museum Number: 1895,0521.7. © The Trustees of the British Museum, London

peak moment in English writers' anxiety over elite masculine political culture. The society's declared aim was 'to discourage by precept and example, the importation and consumption of French produce and manufactures, and to encourage, on the contrary, the produce

and manufactures of Great Britain'.[30] The society raised money for prizes for new British enterprises and goods, and it widely publicised British makers. In doing so, the society sought, in Kathleen Wilson's words, to restore manly, rational patriotism and 'stave off national emasculation by keeping out French commodities and promoting British manufactures and designs'.[31] Stephen Theodore Janssen, one of the Grand Presidents of the society, manufactured enamelware toys and small goods such as watchcases, medallions, and snuffboxes at his factory at York House in Battersea. Janssen was responsible for introducing high-quality enamelware with fine transfer printing that copied the styles and materials of both French and German ceramic decorative arts – as seen with the calendar-snuffbox in Figure 4.1.

But Janssen went further to push the society's cause and manufactured Battersea goods that were emblazoned with the society's crest, such as medals for its members and supporters, tea caddies, and china plates, sauceboats, mugs, and punch bowls.[32] This associational material culture of patriotic goods appealed to men's consumer preferences. The Anti-Gallicans were also tapping into an existing marketplace of armorial ceramic objects associated with all-male societies and clubs. The crest was a way of expressing societies' distinct collective identity and rituals through the snuffbox. The British Museum holds a snuffbox with the crest of the Freemasons transfer-printed on its lid.[33] Other snuffboxes hinted less at the heraldic symbolism of the clubs, but rather at the activities that formed their collective identity, such as snuffboxes that depict Bacchus and Ceres with the inscription of 'in the night we rejoice'.[34] Elite men, as Kate Smith has argued, were particularly eager consumers of armorial chinoiserie porcelain adorned with both Chinese motifs and their family crests. The crested object had strong appeal to male consumers and was a recurring decorative feature in elite men's private consumption of silverware, coaches, rings, and interiors.[35] Yet the Anti-Gallican crest stamped objects of middling sociability such as creamware tea caddies, plates, porcelain sauceboats, punch bowls and enamelware snuffboxes – goods that borrowed design features of 'elite' goods'. They included English rococo bouquets and gilt spearhead border motifs of the interior rims of plates, sauceboats, and bowls. This paraphernalia of male sociable conviviality – dining, drinking, and smoking – that was displayed and used in both the public arena of clubs and domestic settings, formed and displayed

a collective 'middling', 'masculine' patriotism.[36] Tullett argues that, over the course of the eighteenth century, snuffing replaced smoking as the dominant mode of tobacco consumption. As snuff-taking was a more intimate and less invasive form of tobacco consumption than the more invasive forms of pipe smoke, public spaces that were once clouded in smoke were now more private and intimate.[37] Yet while this suggests that snuff created a more personal, less olfactorily social world, snuffboxes themselves both expressed a collective identity and were key tools in the practices of new forms of urban sociability. More than just displaying a politically charged masculine patriotism, the act of consuming and using the Anti-Gallican wares demonstrated that male participation in the production and consumption of ceramics could further the manly prosperity of the nation and encouraged an active masculinisation of the marketplace of supposedly 'feminine' or effeminate goods.

The Anti-Gallican Society did not promote a puritanical or ascetical ideology, it was grounded in promoting a populist, protectionist climate that promoted and rewarded British imitation and innovation of goods readily available on the continent, not the abolition of luxury goods altogether. Rather they imitated elite male societies, their social rituals, and material cultures to innovate and reinvent a new nationalistic material culture and an economic model of middling, manly British mercantilism. To imitate and thus innovate new goods, with new design details, materials, and production processes, Anti-Gallicans materialised their own calls for a reform and innovation to dominant modes of masculine material expressions, tastes, and practices.

Snuffboxes could express a middling, mercantile political ideology but what of their use in social interactions of an increasing sociable society? With new methods of consuming and containing tobacco, new social practices and rituals surrounding the snuffbox appeared. Snuff-taking was a heavily choreographed performance of social etiquette and its understanding, as Charles Lillie's advertisement in *The Spectator* in 1711 demonstrates:

> The Exercise of the Snuff-Box, according to the most fashionable Airs and Motions, in opposition to the Exercise of the Fan, will be Taught with the best plain or perfumed Snuff, at Charles Lillie's Perfumer at the Corner of Beaufort-Buildings in the Strand and Attendance given for the Benefit of the young Merchants about the

exchange for two Hours every Day at Noon, except Saturdays, at a Toy-shop near Garraway's Coffee-House. There will be likewise Taught the Ceremony of the Snuff-box, or Rules of offering Snuff to a Stranger, a Friend, or a Mistress, according to the Degrees of Familiarity or Distance; with an Explanation of the Careless, the Scornful, the Politick, and the Surly Pinch, and the Gestures proper to each of them.[38]

Many, including Emily Freidman and Will Tullett use this argument to paint snuff-taking as effeminising fashionable practice.[39] However, this perhaps over-emphasises the risk the snuffbox posed to dominant modes of masculine behaviour. The potentially satirical advert is explicitly masculinising the 'ceremony of the snuffbox' in opposition to the femininity of the fan. It specifically situates snuff and the snuffbox within the all-male spaces of the coffeehouse and the Exchange. As Claire Walsh has argued, men's shopping 'was more frequently personally pleasurable than women's' and often more concerned with 'identity building'.[40] Lillie's advertisement sought out those aspiring merchants and traders unschooled in the ways of polite society's material culture and social practices. Whether the art of taking snuff was an affectation or a requirement of polite society, the eighteenth century's obsession with 'taste' placed considerable value on the meanings behind social interactions between things and people as a marker of refined status and cultivation. Delicacy and refinement were required of both men and women when opening a delicate, small, and narrow silver, porcelain, or tortoiseshell snuffbox with fine, powdery contents that could easily spill or blow away.[41] As Chesterfield wrote, 'the very accoutrements of a man of fashion are grievous encumbrances to a vulgar man'.[42] Potentially inept haptic interactions with such trinkets could expose their possessors' vulgarity or reveal their refinement.

It was the size and scale of eighteenth-century accessories that determined the ceremony of the snuffbox and its cultural association with effeminacy. The refinement of snuff itself, the material delicacy of the snuffbox, and therefore the delicate movements required to extract snuff carefully and elegantly all contributed to charges of effeminacy. Mimi Hellman's important work on elite objects in eighteenth-century France stressed that objects with a gender-differentiated design 'elicited correct conduct and corporeal refinement, for through their very forms and functions they themselves demonstrated the basic attributes of polite cultivation'.[43] Building on Hellman, Vickery's

discussion of the emergent gendered language of eighteenth-century furniture found there was little difference between the materials and decorative styles and details of men's and women's furniture. Rather their scale and size gendered them and, in turn, produced gendered work; women's work was more delicate and compact and men's was altogether more important and substantial. She writes, 'the diminutive was a design expression of femininity'.[44] Smallness is often associated with delicacy and fragility, while largeness is most commonly coupled with strength and solidity. This thinking stemmed from, and replicated, new eighteenth-century ideas of the sexed body.[45] The historical study of gender and material culture has often reproduced this binary characterisation of feminine delicacy and masculine strength. Notably, Elizabeth Kowaleski-Wallace's influential discussion of literary female consumerism emphasised the metonymy between feminine delicacy and fragile Chinese porcelain. In her words 'like the china she holds in her lovely hands, the woman at the tea table is flawless and delicate'.[46] Smallness was associated with the forgotten, ignored, insignificant and mundane.

Particularly relevant to the snuffbox, Walvin has argued that quotidian material objects and modern cultural habits such as smoking and smoking paraphernalia owe their origins to the big, intangible institution of slavery.[47] Equally, this book argues, the everyday materiality of eighteenth-century life was a key way in which emergent modern gender systems were cemented and reproduced. It was not only the seemingly banal, inexpensive, or insubstantial that provided small things with a feminine charge in the eighteenth century, snuffboxes' material qualities and function also played a part in its effeminising potential. Samuel Johnson defined snuffboxes and similar baubles, 'gewgaws', and toys as 'showy trifles' and associated them with a lack of substance, function, and importance. Returning to some of the examples in this chapter so far, in *The Spectator* snuffboxes were redundant, superfluous 'female ornaments' that adorned a vacuous body. Chesterfield's 'rational' objects were substantial – lodgings, furniture, and coaches – whereas objects that lead to a fool's destruction, that were very pretty and useless, were small: snuffboxes, watches, and canes. Historical archaeologist James Deetz's conceptualisation of smallness extends to stuff of little monetary, or connoisseurial, worth.[48] In legal proceedings, stolen objects were often not recorded if they fell below a value

Discerning consumer: possessing the self 179

that mitigated the sentence or even reported at all. Wider early modern legal practices and customs gendered the association of smallness with insignificance as feminine. Economic and legal conventions also dictated smallness with the feminine and insignificant. 'Coverture' in English Common Law prevented married women from owning immovable property, apart from that in their dowry, independently of their husbands, and in economic practice this precluded married women from large-scale purchases of substantial, expensive goods. Probate and household inventories often obscure from the historian's view the small, moveable, often low-value goods that made up a women's *bona paraphernalia*.[49] Coverture meant that women created rich worlds of meaning in the small, moveable goods they were legally able to own. Equally, as men patrilineally bequeathed land, property, and dynastic furniture and furnishings under the particularly English practice of primogeniture, women's material worlds, although rich in affective and social meaning, were often comparatively small in monetary worth, physical scale, and quantity.[50] Refinement thus posed a problem to the discerning male consumer.

If the size and scale of goods were important to questions of men's rational discernment then so too was the use of these objects. Canes became a fashionable accoutrement of the cosmopolitan gentleman by the late seventeenth century. To many early eighteenth-century commentators, the use of a cane was an effeminate affection and exemplative of luxury's very real debilitation of the idealised male form.[51] Men's reliance on a cane certainly contravened the normative ideals of psychical strength and independence which determined eighteenth-century manliness. Polemicists were particularly critical of the affectation of carrying a cane on a string looped on a waistcoat button rather than using it to aid mobility. In the *Tatler* in 1709 Steele writes of recent, modish male infirmities such as blindness, limping, and lisping:

> the blind seem to be succeeded by the lame, and a jaunty limp is the present beauty. I think I have formerly observed, a cane is part of the dress of a prig, and always worn upon a button, for fear he should be thought to have an occasion for it, or be esteemed really, and not genteelly, a cripple ... as for our peaceable cripples, I know no foundation for their behaviour, without it may be supposed that in this warlike age, some think a cane the next honour to a wooden leg.[52]

This attack on male fashion is bound up in complex attitudes towards eighteenth-century disability, particularly mobility impairments such as 'lameness'. While eighteenth-century commentators were sympathetic to the soldier who was injured by his heroism in battle, they were less compassionate to those physically impaired from birth or by accident. The affectation of Steele's 'peaceable invalids' was therefore doubly problematic – an insult to the heroism of those injured in battle, and a dangerously ironic adoption by men of wealth and fashion of a physical impairment that many perceived to be the physiological product of low moral and social status. The affected superiority of wearing one's cane upon a button changed the perception of the walking stick from a necessity to an accessory and, in doing so, the cane became an object of affected male fashion and luxurious ornament. In Steele's eyes, 'pretty fellows' were corrupted by fashion, and, in turn, fashion disabled the male body. These modish infirmities were a part of wider criticism of urban attitudes and fashions, especially in London; as David Turner writes, the presence of disabled people on London's streets contravened its desired 'values of orderliness, decency, aesthetic refinement and polite commerce'.[53]

Eighteenth-century culture grounded the idealised male body in prescriptions of manly strength that was of reproductive, economic, social and national utility.[54] Therefore, fashionable men's affectation of bodily weakness emasculated them in the social imagination. In the *Tatler* example, this is less to do with effeminacy and oppositional gendered comparisons, but with hierarchies of manliness between men based on physical ability; men could be unmanly by virtue of their affections, but that did not make them effeminate *per se*.[55] Steele, in *The Spectator*, had diverse attitudes towards male accessories. He writes that, while foolish young men used snuffboxes and canes as 'the usual Helps to Discourse with other young Fellows', a new breed of young men had a 'Piece of Ribbon, a broken Fan, or an old Girdle, which they play with while they talk of the fair Person remember'd by each respective Token'.[56] Here snuffboxes and canes are masculine and are vehicles to encourage either rational, masculine conversation or used as roguish trophies to boast of romantic conquests.[57] Either way, the critique centres on expressions of masculinities that do not conform to the whiggish polite, manly ideal.

Nonetheless, male affectation encouraged criticisms of politeness, and its effeminising effect on men. The association between effeminacy and canes continued throughout the eighteenth century. In the *Gentleman's Magazine* in 1731 a group of fashionable young men were described as 'a Parcel of spruce powder'd Foplings with their Hair tuck'd under a Tortoiseshell Comb; their Sleeves slic'd up above their Elbows, a Gold Headed Cane in one Hand, an Agate Box in t'other, with a Nose full of Snuff, and a Head full of – Nothing'.[58] Historians of eighteenth-century politeness have argued that easy, carefree, intensely practised, but casually performed conversation was the most important characteristic of the cultivated, polite gentleman.[59] Men's conversation was the ultimate display of an elite, liberal education. If fashionable gentlemen's accoutrements were trifling affectations, then these objects were antithetical to prescriptions of seemingly easy, unrehearsed, polite conversability. For the *Gentleman's Magazine*'s fops, bedecked with snuffboxes, canes, swords, hats, fobs, and watches, their outward and material magnificence could not detract from or mask their interior void.

Not only could these fine accoutrements not hide men's lack of intelligence, they could work to expose their unpolished vulgarity. Like many of his whiggish counterparts, Chesterfield was anxious about what these supposed ornaments could expose. He wrote that

> the very accoutrements of a man of fashion are grievous encumbrances to a vulgar man. He is at a loss what to do with his hat, when it is not upon his head; his cane (if unfortunately, he wears one) is at perpetual war with every cup of tea or coffee he drinks; destroys them first, and then accompanies them in their fall.[60]

Like Steele, those who wore a cane rather than using one offended Chesterfield the most. The vulgar man's fear of his own sword, much like Steele's peaceable invalids, was a criticism of the effeminising power of luxury accessories upon long-standing ideals of male chivalry and martial heroism. Despite the similar criticisms, Chesterfield was more concerned with fashionable accoutrements as an expression of taste, and taste as the product of elite cultivation. Again, Chesterfield was less troubled about effeminacy, but he was anxious of the ever-growing multitude of fashionable accessories that men were adopting, which presented them with a plethora of

opportunities for the polite, gentlemanly mask to slip and reveal the 'unpolished diamond' beneath.

The new social practices and performances surrounding new goods were themselves a performance of one's refined manners, civility, and good taste; knowledge of fashions, etiquettes, and behaviours was a socially conservative performance of one's access to, and knowledge of, the *beau monde*. The more accoutrements a fashionable man about town wore, the greater the new performances and choreographies of elite male status he had to learn, and, more importantly, also the chances for a social encounter to go awry. Possessing a garish, outmoded, or dishevelled snuffbox, offering poor quality snuff, or offering snuff in the wrong way to the wrong person, taking snuff at the wrong time and in the wrong place, wearing a cane on your button, knocking both you and your conversing partner with your wayward cane, or breaking furniture could all lead to social ridicule and commentary. These possibilities therefore posed problems for the self-assured and cultivated, easy and refined, polite man.[61]

This anxiety surrounding the ever-expanding accoutrements can be seen in previously discussed works; the common rhetorical trope of listing male accessories (snuffboxes, canes, watches, wigs, and shoes) in *The Spectator*, the *Tatler*, *Gentleman's Magazine*, and in Chesterfield's *Letters*, suggests that it was both the newness and the proliferation of these personal accessories that created this anxiety around the effects of male fashion. Chesterfield would only supply his son with the money for 'one handsome snuff-box ... and one handsome sword' and refused to 'supply the *profusion* of a rake'.[62] Adam Smith, in *The Theory of Moral Sentiments*, was perplexed that 'lovers of toys' would 'walk about loaded with a multitude of baubles ... of which the whole utility is certainly not worth the fatigue of bearing the burden'.[63] Good taste, for these men, was as much about restraint as it was refinement. The gendered politics of novelty culture clearly had material dynamics. It is noteworthy that the Anti-Gallicans did not think the objects of male convivial sociability were innately effeminising but that their material qualities – design, decoration, and production techniques – did have the power to change the meaning of these goods. Here, questions of size, scale, quantity, and, importantly, use underpinned the politics of novelty culture in eighteenth-century England.

Possession: materialising rank

The historian's problem is how to move beyond these questions of gender, taste, and refinement, which often produce a cyclical set of conclusions. As national museum collections often preserve the extraordinary rather than the ordinary, mundane stuff of everyday life this poses a particular set of problems for a historian of material culture. To excavate the significance of these accessories for men and women beyond effeminacy, historians need to explore a more diverse selection of source materials, to which this chapter now turns. The dataset of the *Proceedings of the Old Bailey* used here was collated by a word search for 'snuff box' in all cases of theft between 1680 and 1820. In this 140-year sample there were 316 snuffboxes allegedly stolen either from someone's person or from their home. The *Proceedings*, admittedly, provides only a partial view of snuffbox ownership. The *Proceedings* were a commercial enterprise and this data sample is based only on the recorded, printed trials of noteworthy thefts. Many cases did not make it to trial and were left unreported and unprinted. The *Proceedings* are London-centric and so this data cannot make claims of snuffbox ownership on a national scale. The dataset shares similar issues to other documentary sources of material histories, such as probate inventories and wills, as it does not reveal how, where, and why these snuffboxes were acquired. Moreover, just as manufacturers' ledgers and order books rarely record the occupation, address, age, and marital status of their customers, so too are these details rarely recorded in the *Proceedings*.[64] Nonetheless, historians of material culture have demonstrated the fruitfulness of the *Proceedings* to construct a picture of London's material world.[65] The most obvious benefit is the ability of the data to demonstrate change over time (in this instance 140 years). As victims of theft had to swear to the goods when they were produced in court, they gave descriptions of their snuffbox's design and material – although not always size and colour. The mitigation of punishment based on the value of the property stolen also meant that, in most cases, the *Proceedings* recorded the value of stolen snuffboxes. Finally, the dataset reveals the spaces (the street, the tavern, the opera, the shop) and places (the fashionable West End, the Exchange) in which these snuffbox thefts took place.

The *Proceedings* sample demonstrates that snuffboxes were relatively uncommon in London between 1680 and 1710 (seven instances of theft) but grew year on year. There were nine instances of snuffbox thefts between 1710 and 1720 compared to 45 between 1811 and 1820. The evolution in the materials snuffboxes were made from stands as a testament to the innovation in British decorative arts across the long eighteenth century. While only one known material (brass) was recorded between 1680 and 1690, between 1781 and 1790, 11 different materials were recorded from traditional gold and silver to lapis lazuli and enamel. The sample includes 316 snuffboxes made from 30 different specified materials. Mother of pearl (5), tin (5), paper (12), gold (15), tortoiseshell (38), and silver (68) snuffboxes were the most frequently recorded. This illustrates a prevalence of traditional, inexpensive and new, luxurious materials in the sample and suggests men's appetite for and receptiveness to new, luxury goods.

In a sample taken from the *Proceedings* of the same period (1680–1820), 45 women had their snuffbox stolen (compared with 276 men). Only 4 women had an occupation recorded (a silversmith, a jeweller, a pub-keeper, and a shopkeeper); there was 1 unmarried woman and 4 widows. The sample included 27 snuffboxes made from 13 specified materials. The sample of female victims is therefore too small to make concrete conclusions of gendered snuffbox ownership other than two suggestive points. First, a considerably larger number of men had their snuffboxes stolen than women. A particularly gendered difference can explain why male victims dominate the sample of snuffbox thefts. Men's snuffboxes were often designed to be able to fit into the pocket of a waistcoat, and therefore easier to be pick-pocketed, whereas women's pockets were most often worn between under- and outer-garments.[66] Secondly, in both the male and female sample, gold, mother of pearl, tortoiseshell, and silver were the most popular snuffbox material, suggesting little gendering of snuffboxes' material medium. While historians have debated the gendering of snuff, it is important to remember that possession of a snuffbox does not necessarily mean that the owner was a snuffer as many were used to contain sweets, letters, and other small things.[67] None of the cases in the *Proceedings*, for men or women, mentioned whether snuff was contained inside and/or its value.

There are 48 recorded occupations within the sample of male victims in 101 trials. These 'occupations' cover the total strata of the eighteenth-century social hierarchy, from the Earl of Mansfield to a farm hand. Unsurprisingly the largest category was made up of merchants and dealers associated with the tobacco, snuff, or toy trades, such as tobacconists, silversmiths, and jewellers (24% in total). Excluding this group, 44 snuffboxes belonged to noblemen, gentlemen, professionals, merchants, and esquires – a broad mixture of men who would be categorised as the elite or the genteel and respectable upper-middling sort. There was a similar level of snuffbox ownership between this group of men and those making up the lower-middling sorts and 'mechanics'; 38 snuffboxes belonged to those who can be grouped under the occupational categories 'artisans' and 'labourers', a wide and diverse group ranging from gilder to pencil-maker, coachman to farm hand.

Snuffbox ownership in this sample was widespread across social groups relatively early in the eighteenth century. By 1720 six of the eight social groups had appeared in the sample – interestingly the two groups missing were noblemen and gentlemen – indicating that although not widespread in any significant number, ownership of snuffboxes occurred across the social divide early in the eighteenth century. By 1820, snuffbox thefts were appearing in the *Proceedings* across all social groups in greater numbers and there was parity between higher social groups – aristocrats, gentlemen, merchants and professionals (12 snuffboxes in total) – and lower social groups – artisans and mechanics (11 snuffboxes in total) in the years 1811 to 1820. While possession of a snuffbox did not necessarily mark out social distinction, the social hierarchy was delineated in snuffboxes' material form. Both higher and lower social groups recorded snuffboxes in a variety of materials but there is a noticeable, albeit unsurprising, difference. Aristocratic, gentry, and professional men were more likely to own snuffboxes made from new or expensive materials such as gold, tortoiseshell, or porcelain than artisans and mechanics whose snuffboxes were made from more traditional and inexpensive materials such as base metals, horn, and leather. One interesting exception to this is silver snuffboxes; 6 esquires, merchants and professionals owned a silver snuffbox, 4 artisans and mechanics did. Snuffboxes were owned by men and women up and down the social hierarchy; to preserve material and

social distinction they consumed snuffboxes made from luxurious and new materials to demarcate the social hierarchy. The intricately chased gold snuffbox set the upper crust apart from the plebeian snuffer. The majority of snuffbox thefts took place in spaces such as brothels and taverns, suggesting that snuffboxes were used much more in spaces of all-male sociability and conviviality.

Toothpicks were by no means new to the eighteenth century, but the period did see the emergence of the toothpick case. The rise in personal grooming in a society that prized the body beautiful highlights, as Alun Withey notes, the material bodily ephemera used in the quotidian management of the body and the self.[68] A much smaller sample of theft trials for toothpick cases is still revealing about masculine possession. Of the 23 trials between 1680 and 1820, 20 of the cases were brought by men and 3 by women. This sample is comparatively small alongside those of snuffboxes, fobs-seals, and canes in the *Proceedings*. As most of these toothpicks were valued between one and two shillings, this small sample size suggests that perhaps owners didn't press charges for property of such small value. The earliest trial to appear in the *Proceedings* was brought by the King, George I, in 1725 against Claude Anjou for breaking into St James's Palace and stealing a booty of jewels and accoutrements including a toothpick case.[69] Despite an infrequent presence in the *Proceedings*, toothpick-case ownership was widespread even in such a small sample, and included a clergyman, auctioneer, undertaker, optician, and publican as well as the King. Of the 17 known occupations, 8 were retailers with toothpick cases stolen from their shops. There were 5 recorded materials: gold (1), paper (1), ivory (2), silver (7), and tortoiseshell (2).

The sample of stolen canes and cane heads in the *Proceedings* is significantly smaller than the snuffbox dataset (316 instances of theft); 93 trials included cane thefts in the *Proceedings* between 1680 and 1820. Of these 93 thefts, 86 were male victims, 5 were women, and 2 had no name recorded. No women had their profession or marital status recorded. Due to the small sample size there is no obvious chronological narrative to the cane data, apart from that there were peaks in 1721–1730 (15 trials) and 1731–1740 (14 trials) and again in 1771–1780 (13) and 1781–1790 (11) and that there were recordings of thefts from women after 1740. There were 10 different cane head materials recorded in the sample. Gold was the

most popular material with 19 gold cane heads recorded, although 46 of the 93 stolen canes had no cane head material recorded. The material that canes themselves were made from was never recorded, although this can be attributed to the cost of gold, china, silver, or ivory cane heads compared to the wooden component. Of the five female victims, only one had a material recorded (brass). Like the *Proceedings* snuffbox sample, cane heads were made from a variety of materials that fall into both the traditional, inexpensive and new, luxurious. There were 16 different occupations/rankings of male cane owners in the sample. Esquires were the most common victims of theft (9), followed by 3 nobles – 2 baronets Sir James Brown, Sir John Thomas, and the Hon. Edward Stratford. These two social groups had gold cane heads. Most of the canes in the sample cost less than a pound with most of the canes valued between 1 and 5 shillings. Cane thefts in the *Proceedings* demonstrate that canes were objects particularly to do with demarcating distinctions in social rank. Elite men were more likely to own canes and their canes were more likely to be made from precious metals such as gold and silver.

Eighteenth-century cultural commentators associated men's new accoutrements, such as snuffboxes, canes, and toothpick cases with material luxury's power to reduce stoic, rational men into effeminate fops who fawned over the charms of the toyshop. The century's vivid social imagination, formed through an ever-increasing literary and visual print culture, certainly considered snuffboxes and canes to be a fool's destruction, very pretty but useless. This salient characterisation is perhaps why these objects have received little interrogation by historians of gender and material goods, beyond their effeminising potential. This chapter found little evidence of these objects causing a crisis in masculinity or their effeminising power. Despite the increasing egalitarianism of men's sartorial and material possessions, the *Proceedings* samples demonstrate that, in practice, men across the eighteenth century deployed snuffboxes and canes to display high social rank, or aspirations to it. However, snuffboxes, in particular, were owned across gender and class divides. Thus, to preserve material and social distinction, they consumed snuffboxes made from luxurious and new materials to demarcate the social hierarchy. Moreover, the majority of snuffbox thefts took place in spaces such as brothels and taverns. This would suggest

that snuffboxes were not embroiled in a culture of effeminacy, but in all-male sociability and conviviality.

Personalisation: stamping the self

Men also personalised their snuffboxes through engraved crests, arms, and ciphers.[70] Many of the snuffboxes that goldsmith Martha Braithwaite sold from her shop in Lombard Street in the early 1740s were bought and then engraved; she sold an agate snuffbox for £12 12s and the buyer paid £2 2s for engraving it.[71] In the famed silversmith partnership Parker and Wakelin's 'Gentleman's Ledger' between 1767 and 1770 there were five orders for alterations to existing snuffboxes, three orders for repairs, and two for new ones.[72] The snuffbox orders were made by an earl, a bishop, a foreign diplomat, gentlemen, and wealthy merchants.[73] Despite the small number of orders, the five alteration entries suggests that these elite customers bought off-the-shelf snuffboxes, but entrusted the finer detailing of alterations, mountings, and additional decorative work to Parker and Wakelin's subcontractors. These men could personalise their snuffboxes through engraving, remounting, or replacing the snuffbox paper, which suggests that these men had an attachment to their snuffboxes. Such practices of repairing and finishing question how far these elite consumers associated these goods with novelty – they are not seeking out the new year's vintage, like Horace Walpole was in Paris, but practising prudent economy. If the eighteenth century is the moment in which there was an increase in buying new goods then this complicates this picture. Certainly, this practice appears within the *Proceedings*: warehouseman William Hodge, whose snuffbox was stolen by his errand boy in 1800, declared that he knew the snuffbox worth 6s to be his as he 'had it 10 years, it is mended with a piece of putty at the top'.[74] Other ways snuffboxes were decoratively personalised were through portrait miniatures and cameo snuffboxes. These snuffboxes became increasingly popular in the later part of the eighteenth century and keen amateur artists commissioned snuffboxes decorated with their own work. In 1778, Lord Grantham had his own sketch of Venus set into a black tortoiseshell snuffbox and his portrait set into a 'transparent horn bonbonniere' by acclaimed Parisian goldsmith Pierre-François Drais.[75]

Discerning consumer: possessing the self 189

Between 1760 and 1770, 11 men placed 15 orders with Parker & Wakelin for cane head-related work such as mending cane heads, new ferrules, shortening the cane, and new, elaborately chased heads. These men reflect the elite clientele of the firm and included a Viscount, a Baronet, a MP, the Governor of Virginia, the younger sons of baronets, and a gentleman-architect.[76] Of the 13 entries, 2 repairs were to gold cane heads, 6 entries were for new cane heads, all but one being gold, 2 were for engraving cyphers to cane heads, and 3 were for alterations to 1 gold cane head and 2 new ferrules. Unsurprisingly, as these were elite customers the new cane heads were decorated with crests and ciphers. The two orders for engraving suggests that these men purchased their cane heads from another producer and left the finer details to the skilled and prestigious Parker and Wakelin.[77] A John Jones paid £5 5s in March 1767 for a 'gold cane head with chased border' and paid a further 5s to have his cypher engraved on it.[78] John Gulston, spent only 2s on having cyphers engraved on two cane heads in April 1768.[79] Personalisation of possessions was a much more prevalent practice of eighteenth-century consumption as many wares were bought in semi-finished condition. Subcontracting systems meant that at each manufacturing stage choices about the finished product could be incorporated into its production – this was as true for bespoke, luxury goods such as carriages as for more everyday purchases such as furniture. Chapter 3 considered the choice of only decorating a carriage with a heraldic crest as part of an increasingly competitive culture of status-defensive consumption as the middling ranks swelled as well as a part of family strategy. Here, I want to reflect on what it meant to stamp these objects, which, as this chapter has shown, had both a deep relationship with the possessor's sense of self and importance to new forms of sociability with personal regalia.

The personalisation of canes and snuffboxes with cyphers and crests marked them with personal meaning and denoted possession of, or pretentions to, elite status and material discernment; it also had practical purposes in marking out ownership. When Samuel Sedgwick's gold-headed cane was stolen in 1731, Sir George Caswal returned it to him, 'knowing it to be his by the likeness of the Crests'.[80] That John Williamson who pretended to be an East India Man and borrowed a watch and cane from the man he lodged with to make a 'better Appearance' at East India House in

1773 suggest that eighteenth-century Londoners considered watches and canes to be tools of appearing genteelly respectable.[81] Swiss travel writer César-François de Saussure wrote in the 1720s that all most all Englishmen 'wear small, round wigs, plain hats, and carry canes in their hands, but no swords. Their cloth and linen are of the best and finest. You will see rich merchants and gentlemen thus dressed, and sometimes even noblemen of high rank'.[82] De Saussure's commentary on Englishmen's manners and dress reveals that eighteenth-century men adopted a recognisable assemblage of accessories and accoutrements to display status – even if they lacked it.[83]

Historians have used foreign visitors' observations on English customs to discuss the emerging egalitarianism of male street manners, dress, and behaviour in the later part of the eighteenth century. Georg Forster, on return from his long travels on the continent in 1790, Paul Langford observes, 'selected one change as particularly significant, the disappearance of swords, suggesting at once the inappropriateness of displaying weapons in public and the unwisdom of flaunting gentility. Canes and umbrellas were emblems of the new, pacifist street manners'.[84] Yet this newfound egalitarianism was not without exception. In the trial of two thieves indicted for stealing the trunk of Henry Edwin Stanhope on 26 February 1783 the trunk contained a 'cane, which is very remarkable, being a loaded cane'.[85] Loaded canes were weighted with lead in one end to provide a heavy blow to an assailant. The presence of loaded canes, and canes that concealed pistols or swords, suggests that while canes and umbrellas replaced silver swords as an overt display of the new pacifist street manners, men still carried canes to defend themselves in urban streets.

Exchange: affective and social bonds

Snuff-taking and snuffboxes formed a part of eighteenth-century social encounters, social conviviality, and collective experience and identity. As tobacco was a global commodity, snuff and tobacco were closely associated with naval and military men.[86] James Johnston, an Irish Colonel in the British Army, was presented with a gold snuffbox for services rendered to Prussian forces in the Seven Years

War by the Hereditary Prince Charles of Brunswick in November 1762.[87] Lord Wallingford, later the Earl of Banbury, wrote to his mother from the military camp at Menin, Flanders in September 1793 that he had become a snuff-taker and joked that 'Banbury's Box is called for after dinner by every one of the officers'.[88] Often, luxurious and magnificent snuffboxes were given as presents for political or diplomatic service. The Marquis of Circello sent a diamond snuffbox to Richard Oglander, the British consul at Tunis, in 1817, for services rendered to the Neapolitan government.[89] Lord Robert Herries wrote to Mary Hamilton that he 'was one of the eight officers to whom the King of Naples gave a fine Snuff box as a token of approbation & gratitude', which was reported to be worth £700.[90] The British Ambassador to Madrid, Lord Grantham, gifted Count Massin a leather snuffbox during his early years in Madrid in 1775 as a strategy in forming an ambassadorial network through material gifting.[91]

The proffering of one's snuffbox in social interactions could signal all sorts of non-verbal messages – as Charles Lillie's advertisement for 'snuff-taking lessons' neatly illustrates. Men's gift-exchange expressed affective bonds between family and friends and underpinned the significance of new forms of sociability.[92] Lady Herries wrote to Mary Hamilton in 1791 detailing a package of snuff her husband had sent from London to Hamilton's father-in-law in Manchester. Some thought appears to have gone into this gift as Herries writes that 'both Mr Sackville and Herries hopes that it is to his taste but would much prefer seeing him use his own snuff', suggesting that he visit St James's Street to do so.[93] While the Hamilton exchange is indicative of conspicuous gift-exchange used to confer and mark out distinctions of status and knowledge, others illustrated emotive bonds between giver and recipient. The card inside an early nineteenth-century gold and tortoiseshell snuffbox reads 'Snuff Box given by George III to his private secretary Sir Herbert Taylor'. A later card dated 6 February 1855 reads: 'For dearest Bridges Taylor from the Godmamma of dear little Ellinora Alma one of his dear Uncle Herberts Snuff Boxes'.[94] Earl Vane wrote to his cousin the Marquess of Camden in 1818 to thank him for a gift of a snuffbox used by his grandfather.[95] In both exchanges, family history and familial affection motivated snuffbox gifting.[96] But in these instances it was not so much the design or material of the snuffbox itself but that a family member

used it that charged the snuffbox with a particular affective and emotional power.

Both eighteenth-century commentators and historians acknowledge the affective power of objects. In *The Theory of Moral Sentiments* (1759), Adam Smith wrote:

> we conceive ... a sort of gratitude for those inanimated objects, which have been the causes of great or frequent pleasure to us ... A man grows fond of a snuffbox, of a pen-knife, of a staff which he has long made use of, and conceives something like a real love and affection for them.[97]

Stephanie Downes, Sally Holloway, and Sarah Randles remind us that 'things function not as symbols of emotions, but as direct objects of them' and the emotional value of objects can be both associated with their aesthetic appeal and act independently of it.[98] Queen Charlotte considered, in a letter to the Prince of Wales, that the aesthetic quality of the gifted snuffbox stood alone as a testament of personal affection.[99] Writing to her son to thank him for his gift of a snuffbox, she reassured him that:

> I am also so Sorry that You should have given yourself so much Trouble about procuring me Snuffbox which have You so much difficulty to obtain. I shall value it not only for its beauty; but for the role of the donor who is and ever will be most dear to His, very affectionate Mother.[100]

Small material tokens and gifts like snuffboxes were particularly powerful material conduits to emotions and memory. Whilst at Oxford, Rev. James Woodforde gave away his snuffbox 'to a Particular Friend' in November 1759 and then also exchanged his 'Paper Snuff Box with Miss Nancy Rooke for one of hers by way of remembrance of her' before returning to Oxford in October 1762.[101] The affective possibilities of snuffboxes came about due to the sensory interaction between thing and user; the wear, tear, dirt, cracks, and dents in a silver snuffbox, for example, were an affective patina of personal use, of habits, spaces, places, and events.

The affective power of the snuffbox was not lost on eighteenth-century writers. In Laurence Sterne's *A Sentimental Journey Through France and Italy* (1762), Yorick exchanges his fine tortoiseshell snuffbox for an old monk's horn one and asks that 'when you take

a pinch out of it, sometimes recollect it was the peace-offering of a man who once used you unkindly'. Yorick later narrates that he 'guard[s] this box, as I would the instrumental parts of my religion, to help my mind on something better'.[102] The act of taking snuff and the snuffbox itself charged the ritual with affect and memory; as snuff itself was blended and perfumed, snuffboxes would have retained distinctive smells of unique blends the owner used. It was possible to purchase blends of perfumed snuff named after their creators, such as Sir Herbert Taylor's blend, at famed tobacconists Fribourg and Treyer in Haymarket.[103] When her brother George IV died in 1830 Princess Elizabeth received two snuffboxes, which she said would 'be taken the greatest care of, and the snuff never taken out, so dear is it to me'.[104] The 'consumption bundle' of both the snuff and the snuffbox and its associated ritual created affective meaning and memory.

Snuffboxes, through their decoration and personalisation, materialised social and emotional bonds between friends and family. They were tokens of esteem and their use, material qualities, and exchange were a conduit to affective memory. While snuffboxes were used in all-male spaces, such as the coffeehouse, and all-male groups, such as the military, this chapter will now turn to the gendering of snuffbox exchanges by examining the bequeathing of snuffboxes in probate documents. It questions the extent to which snuffboxes' association with effeminacy was born out in practices of men's and women's bequests. Due to women's legal status under English Common Law they were more likely than their male kin to inherit moveable, personal property. Women's records, writes Vickery, 'consistently reveal a more self-conscious, emotional investment in household goods, apparel, and personal effects. On the rare occasions when male testators particularlized their personal property they usually referred to tools or livestock'.[105]

It is certainly true that women's wills demonstrate that they carefully bequeathed chattels to selected friends and family; it was, after all, Bridges Taylor's female relative that gifted him his uncle's snuffbox. In 1800, Shropshire gentlewoman Barbara Glynne wrote to Mary Fletcher that a friend had left her a 'handsome silver snuff box as a token of her regard' – she believed it was the only thing her friend had not bequeathed to her husband.[106] Cornish widowed Mary Tillie of Pentillie Castle left her grandson John Tillie Coryton

'the family repeating watch and gold snuff box', and spinster Ann Hickman bequeathed her nephews a small collection of silver spoons and snuffboxes.[107] But, even in this instance of a woman bequeathing her personal property, the emotional connection was between male relatives. Yorkshire widow Mary Brathwaite made a similar bequest to her brother. She left him their engraved family silver she had inherited, including a posset cup, candlesticks, and a snuffbox that then would be passed onto his son.[108] In a will dated March 1769, the widowed Mary, Countess of Stamford left to her third son, John Grey, a ruby and diamond ring, her father's gold watch, gold and agate sleeve buttons, and a gold snuffbox.[109]

While these female testators from across the social hierarchy support Vickery's observation that, denied from public life, women 'turned to personal and household artefacts to create a world of meanings' and transit their and their families' history, men, too, bequeathed small personal effects to particular family members.[110] Isle of Wight yeoman William Williams left his silver snuffbox, along with £150, to his granddaughter Sophie Rolf.[111] Lancastrian clerk Benjamin Wright bequeathed to his wife Susanna £500, a gold snuffbox, tweezers and case, 'and all that is in it', along with her personal property before they married.[112] Shropshire apothecary Edward Philipps left his niece his linen, a trunk, and silver snuffbox.[113] London goldsmith George Braithwaite left his young son all his clothes, portraits, household plate, china and silver alongside a selection of goods from his shop including a mother of pearl 'hart snuff box' and a silver snuffbox with two additional rims.[114] To his brother, Hampstead landowner Thomas Lane left an assemblage of memorabilia, including his gold-headed cane, tortoiseshell snuffbox, and portraits of their parents.[115] Small objects that denoted lineage, family, and affection were passed on by men and women alike.

Outside of the family circle, men left tokens to their friends. Thomas Secker, the Archbishop of Canterbury, left his 'good friend' Sir Horatio Pettus £200 and his gold snuffbox.[116] Along with 10 rings given to gentlemen of his 'most intimate acquaintance', Sussex gentleman Thomas Frewen left his 'very valuable friend', Whistler Webster Esq., his shagreen snuff box studded with silver and embossed with Frewen's crest.[117] To his 'old friend' George Clark, the Hon. Richard Hill left his 'gold snuffbox adorned with a green stone and several diamonds' as well as gifting a number of rings to his male

friends and nephews.[118] Bestowing these trinkets upon their closest male friends, these men demonstrated the emotional bonds of friendship between them, symbolised in the goods each treasured. It is perhaps not surprising that these trinkets were left to men, as snuffboxes were used in contexts of male sociability. Although this survey of probate documents is small, it suggests that both men and women used small personal effects like snuffboxes to demonstrate emotional ties, family history, and friendship. Both shared similar motivations in the bequeathing of small goods.

Conclusion

To be a discerning consumer in eighteenth-century England required more than merely owning these accessories. Those studied here reveal much about what constituted tasteful discernment in the period; possessing one of these fashionable trinkets was not enough to convey the aesthetic appreciation and rational acumen that eighteenth-century consumers often wished to, when purchasing and using their possessions, and consumers were increasingly literate of the material qualities of goods. Their material choices, such as owning goods made of more expensive, exotic, or luxurious materials, or personalising semi-finished accessories with their own designs and heraldry were important practices of self-fashioning and self-expression. Indeed, not merely owning an accessory in the best taste but knowing how to use in a set of choreographed performances reveals taste to be something performed and practised as well as a quality that is symbolised and projected. Tastefulness required a haptic and embodied material knowledge. It was exactly this relationship between body and thing that often gave these objects affective meaning and enabled them to underpin social bonds.

Upon reflection of exploring what discernment was, who possessed it, how it was acquired, displayed, and exchanged, it is apparent that eighteenth-century novelty culture made it hard to be a discerning consumer. This newness (of object, material, practices, and relationships) was a significant way materiality aided gender-formation. Skilful using, holding, wearing, offering, purchasing, personalising, repairing, altering, exchanging, and bequeathing – practices this chapter has examined – were all constituent practices of the adroit operation

of tasteful discernment in eighteenth-century England. Masculine material selfhood, then, was problematic to social conservatives because it was itself emergent and more widespread than ever before. To understand novelty culture, then, we must integrate questions, concerns, and masculine material self-expression as it fundamentally underpinned the concerns with luxury. Such novelty and the new was hard to square with the pretence of masculinity of something eternal and increasingly biologically determined in the period. While historians of masculinity now often approach it as an ongoing, historically contingent process of identity formation, rather than a fixed relational category, the writers studied here promoted a masculinity that was fixed and in crisis from material deviants. Thinking about material selfhood through and with these objects we can think of gendered material selfhood as embodied, haptic, and sensory. There was a huge capacity for the display of rational discernment to go wrong. Indeed, the language and practices of tasteful consumption emerge precisely because possession or ownership of luxury goods was not enough to denote refinement in a period of increased consumption. What material your accessory was made from and how you used it were key indicators of rank, status, and prestige.

What determined goods' description as 'novel' and 'luxurious' evolved over the eighteenth century as it manufactured, through imitation and innovation, decidedly British products through increasingly sophisticated manufacturing systems. In this sense, this chapter re-emphasises much of the historical work that approaches British consumer and industrial revolutions through material culture and materiality, while thinking more explicitly about masculine materiality. In moving towards a materiality of luxury, we can better understand why these objects were associated with luxurious effeminacy, and indeed what other practices and meanings were attached to these objects. This exploration of masculine materiality here is much less interested in the confected stereotypes of the beau, fop, macaroni, and dandy of print than what constituted men's tasteful discernment, how was it acquired, what was it used for, and what processes and practices were involved in communicating discernment to others. In material practice, men and women bought, used, exchanged, designed, and personalised these accessories; in doing so they constructed,

Discerning consumer: possessing the self 197

communicated, and sometimes contested eighteenth-century gendered individual, collective, and political identities.

Notes

1 See John Styles and Amanda Vickery (eds), *Gender, Taste, and Material Culture in Britain and North America 1700–1830* (New Haven, CT, 2006). For recent work on luxury and sumptuary laws see Maria Hayward, '"Outlandish Superfluities": Luxury and Clothing in Scottish and English Sumptuary Law from the Fourteenth to the Seventeenth Century', in Giorgio Riello and Ulinka Rublack (eds), *The Right to Dress: Sumptuary Laws in a Global Perspective, c.1200–1800* (Cambridge, 2019), 96–120.
2 Robert W. Jones, *Gender and the Formation of Taste in Eighteenth-Century Britain: The Analysis of Beauty* (Cambridge, 1998), 5, 190–8. Often these anxieties bound together, such as the association of the Chinese taste with women, see Elizabeth Kowaleski-Wallace, *Consuming Subjects: Women, Shopping, and Business in the Eighteenth Century* (New York, 1997); David Porter, *The Chinese Taste in Eighteenth-Century England* (Cambridge, 2010), 8, 78–90, 133–53. For an examination of men's taste for Chinese goods see Kate Smith, 'Manly Objects: Gendering Armorial Porcelain Wares', in Margot Finn and Kate Smith (eds), *The East India Company at Home, 1757–1857* (London, 2018), 113–30.
3 There is an extensive body of work on these character types, for key examples see Philip Carter, 'An "Effeminate" or "Efficient" Nation? Masculinity and Eighteenth-Century Social Documentary', *Textual Practice* 11.3 (1997), 429–43; Linda Colley, *Britons: Forging the Nation 1707–1837* (New Haven, CT, 1992), 85–97; Philip Carter, *Men and the Emergence of Polite Society, Britain 1660–1800* (London, 2001); Valerie Steele, 'The Social and Political Significance of Macaroni Fashion', *Costume* 19.1 (1985), 94–105; G. J. Barker-Benfield, *The Culture of Sensibility: Sex and Society in Eighteenth-Century Britain* (Chicago, IL, 1992); 106–55; Miles Ogborn, 'Locating the Macaroni: Luxury, Sexuality and Vision in Vauxhall Gardens', *Textual Practice* 11.3 (1997), 445–61; Peter McNeil, 'Macaroni Masculinities', *Fashion Theory* 4.4 (2000), 373–404; Shearer West, 'The Darly Macaroni Prints and the Politics of "Private Man"', *Eighteenth-Century Life* 25.2 (2001), 170–82; Amelia F. Rauser, 'Hair, Authenticity, and the Self-Made Macaroni', *Eighteenth-Century Studies* 38.1 (2004), 101–17;

O'Driscoll, 'What Kind of Man Do the Clothes Make? Print Culture and the Meanings of Macaroni Effeminacy', in Kevin D. Murphy and Sally O'Driscoll (eds), *Studies in Ephemera: Text and Image in Eighteenth-Century Print* (Lewisburg, PA, 2013), 241–79; Peter McNeil, *Pretty Gentlemen: Macaroni Men and the Eighteenth-Century Fashion World* (New Haven, CT, 2018); Tillman W. Nechtman, *Nabobs: Empire and Identity in Eighteenth-Century Britain* (Cambridge, 2010), 148; Tillman W. Nechtman, 'A Jewel in the Crown? Indian Wealth in Domestic Britain in the Late Eighteenth Century', *Eighteenth-Century Studies* 41.1 (2007), 71–86.

4 Joseph Addison, 'No. 16, Monday, March 19, 1711', in Donald F. Bond (ed.), *The Spectator*, vol. 1 (Oxford, 1987), 71.

5 West, 'The Darly Macaroni Prints', 70–82. In 1777 *The Universal Magazine of Knowledge and Pleasure* published a satirical 'recipe' to make a 'modern fop', including 'a lofty cane, a sword with silver hilt, a ring, two watches, and a snuff-box gilt'. See 'RECEIPT to make a MODERN FOP', *Universal Magazine of Knowledge and Pleasure*, vol. 60 (1777), 377.

6 Lord Shaftesbury, *Shaftesbury: Characteristics of Men, Manners, Opinions, Times*, (ed.) Lawrence E. Klein (Cambridge, 2000). For an in-depth discussion on Shaftesbury's conceptualisation of taste in the context of early eighteenth-century cultural politics, see Lawrence E. Klein, *Shaftesbury and the Culture of Politeness: Moral Discourse and Cultural Politics in Early Eighteenth-Century England* (Cambridge, 1994).

7 Alexander Gerard, *Essay on Taste* (London, 1756), 1. Emphasis in original.

8 See Paul Langford, 'The Uses of Eighteenth-Century Politeness', *Transactions of the Royal Historical Society* 12 (2002), 311–31; R. H. Sweet, 'Topographies of Politeness', *Transactions of the Royal Historical Society* 12 (2002), 355–74; Helen Berry, 'Polite Consumption: Shopping in Eighteenth-Century England', *Transactions of the Royal Historical Society* 12 (2002), 375–94; Klein, 'Politeness and the Interpretation of the British Eighteenth Century', *Historical Journal* 45.4 (2002), 869–98; Maxine Berg and Elizabeth Eger (eds), *Luxury in the Eighteenth Century: Debates, Desires and Delectable Goods* (Basingstoke, 2002); John Styles and Amanda Vickery, 'Introduction', in John Styles and Amanda Vickery (eds), *Gender, Taste, and Material Culture in Britain and North America 1700–1830* (New Haven, CT, 2006), 1–21; Maxine Berg, *Luxury and Pleasure in Eighteenth-Century England* (Oxford, 2006), esp. 21–45, 199–246.

9 Jones, *Gender and the Formation of Taste*, 5; Styles and Vickery, 'Introduction', 16.

10 Klein, *Shaftesbury*, 9–11.
11 Langford, 'Uses of Eighteenth-Century Politeness', 312.
12 Amanda Vickery, *Behind Closed Doors: At Home in Georgian England* (New Haven, CT and London, 2009), 53.
13 Philip Dormer Stanhope, Earl of Chesterfield, *Lord Chesterfield's Letters*, (ed.) David Roberts (Oxford, 1992), 214, 131.
14 Stanhope, *Lord Chesterfield's Letters*, 132.
15 Berg, *Luxury and Pleasure*, 199–246. John Styles argues that plebeian consumers were also susceptible to the allure of luxury, John Styles, *Dress of the People: Everyday Fashion in Eighteenth-Century England* (New Haven, CT and London 2007), 181–211.
16 Peter Borsay, *The English Urban Renaissance: Culture and Society in the Provincial Town, 1660–1770* (Oxford, 1989); Peter Borsay, 'The London Connection: Cultural Diffusion and the Eighteenth-Century Provincial Town', *London Journal* 19.1 (1994), 21–3. Also see Sweet, 'Topographies of Politeness', 355–74; Dror Wahrman, 'National Society, Communal Culture', *Social History* 17 (1992); 43–72. Lawrence E. Klein, 'The Polite Town: Shifting possibilities of Urbaneness, 1660–1715', in Tim Hitchcock and Heather Shore (eds), *The Streets of London: From the Great Fire to the Great Stink* (London, 2003), 27–39. For a rebuttal of Borsay's and Wahrman's characterisation of a 'national taste' see Helen Berry, 'Promoting Taste in the Provincial Press: National and Local Culture in Eighteenth-Century Newcastle upon Tyne', *British Journal for Eighteenth-Century Studies* 25 (2002), 1–17. Birmingham's middle-classes were not so concerned with London goods, see Berg, *Luxury and Pleasure*, 230.
17 Jones, *Formation of Taste*, 37–116. Also see Helen Berry, 'Women, Consumption and Taste', in Hannah Barker and Elaine Chalus (eds), *Women's History, Britain 1700–1850* (Abingdon, 2005), 194–216.
18 Amanda Vickery, *The Gentleman's Daughter: Women's Lives in Georgian England* (New Haven, CT, 1998), 162–94; Berry, 'Polite Consumption', 381–2; Claire Walsh, 'Shops, Shopping and the Art of Decision Making in Eighteenth-Century England', in Styles and Vickery (eds), *Gender, Taste, and Material Culture*, 162–8.
19 Edmund Burke, *A Philosophical Enquiry into the Origin of Our Ideas of the Sublime and Beautiful: With an Introductory Discourse Concerning Taste; and Several Other Additions* (Cambridge, 2014), 38–9.
20 James Walvin, *Slavery in Small Things: Slavery and Modern Cultural Habits* (London, 2017), 67–8.
21 Charles Lillie, *The British Perfumer* (ed.) Colin McKenzie (London, 1822), 297.
22 Walvin, *Slavery in Small Things*, 67–8.

23 Tullett, 'The Macaroni's "Ambrosial Essences"', 6–7. Also see Will Tullett, *Smell in Eighteenth-Century England: A Social Sense* (Oxford, 2019), 139–45.
24 HL. mssHM 81640. 'Sir Edward Turner, Bath to Sir Edward Leigh' (17 June 1762).
25 Jennie Batchelor, 'Fashion and Frugality: Eighteenth-Century Pocket Books for Women', *Studies in Eighteenth-Century Culture* 32 (2003), 1–18. Amanda Vickery, 'A Self off the Shelf: Packing Identity in Eighteenth-Century England', *Eighteenth-Century Studies* 54.3 (2021), 667–86.
26 Horace Walpole, *The Yale Edition of Horace Walpole's Correspondence*, vol. 32, (ed.) W. S. Lewis (New Haven, CT, 1977), 54.
27 This is borrowing the language of Maxine Berg's 'From Imitation to Invention: Creating Commodities in Eighteenth-Century Britain', *Economic History Review* 55.1 (2002), 1–30.
28 Vickery, 'A Self off the Shelf', 682.
29 Colley, *Britons*, 88–92, 100; Kathleen Wilson, *The Sense of the People: Politics, Culture and Imperialism, 1715–1785* (Cambridge, 1998), 191.
30 Anon., *Rules and Orders of the Society, Established at London for the Encouragement of Arts, Manufactures and Commerce* (London, 1758).
31 Wilson, *Sense of the People*, 187–91. For a study comparing early modern Britain and early America see Angela McShane, 'Tobacco-Taking and Identity-Making in Early Modern Britain and North America', *Historical Journal* 65 (2022), 108–29.
32 For examples of other Anti-Gallican wares see Christie's, 'An Anti-Gallican Society Sauce-Boat' c.1760. Sale 2786, 'Asian Art', Amsterdam. 20–21 May 2008. Lot Number: 208; Christie's, 'An English Creamware Tea-Caddy', c.1760. Sale 5870, 'Christie's Interiors – Masters and Makers', South Kensington, London. 2 December 2014. Lot Number: 636.
33 BM. 'Snuffbox', Battersea Enamel, ca.1760–64. 8 × 6 × 3.3 cm. Museum Number: 1895,0521.9.
34 BM. 'Snuffbox', Horn, ca.1750–1780. 10 × 8 cm. Museum Number: 1889,0702.22.
35 Smith, 'Manly Objects', 124, 113–30.
36 For more on the material culture of men's societies see Karen Harvey, 'Barbarity in a Teacup? Punch, Domesticity and Gender in the Eighteenth Century', *Journal of Design History* 21.3 (2008), 205–21; Karen Harvey, 'Ritual Encounters: Punch Parties and Masculinity in the Eighteenth Century', *Past & Present* 214 (2012), 165–203.

37 Tullett, *Smell*, 131–53.
38 Richard Steele, 'No. 138, Wednesday, August 8, 1711', in Donald F. Bond (ed.), *The Spectator*, vol. 2 (Oxford, 1987), 46–7.
39 Emily C. Freidman, *Reading Smell in Eighteenth-Century Fiction* (Lewisburg, PA, 2016), 43; Tullett, *Smell*, 142.
40 Walsh, 'Shops, Shopping', 164. Also see David Hussey, 'Guns, Horses and Stylish Waistcoats? Male Consumer Activity and Domestic Shopping in Late-Eighteenth- and Early-Nineteenth-Century England', in David Hussey and Margaret Ponsonby (eds), *Buying for the Home: Shopping for the Domestic from the Seventeenth Century to Present* (Abingdon, 2008), 47–69; Vickery, *Behind Closed Doors*, 123–8.
41 In a letter from Paris to George Selwyn in April 1766, Horace Walpole wrote that 'hearts do not snap like a tortoise-shell snuffbox'; Walpole and Lewis, *Horace Walpole's Correspondence*, vol. 30, 219.
42 Stanhope, *Lord Chesterfield's Letters*, 163.
43 Mimi Hellman, 'Furniture, Sociability, and the Work of Leisure in Eighteenth-Century France', *Eighteenth-Century Studies* 32.4 (1999), 415–45. Also see Kate Smith, 'In Her Hands: Materializing Distinction in Georgian Britain', *Cultural and Social History* 11.4 (2014), 489–506.
44 Vickery, *Behind Closed Doors*, 287.
45 Thomas Laqueur, *Making Sex: Body and Gender from the Greeks to Freud* (Harvard, MA, 1990), 25–6.
46 Kowalski-Wallace, *Consuming Subjects*, 60.
47 Walvin, *Slavery in the Small Things*.
48 James Deetz, *In Small Things Forgotten: The Archaeology of Early American Life* (New York, 1977), 4.
49 Margaret Spufford, 'The Limitations of the Probate Inventory', in John Chartres and David Hey (eds), *English Rural Society, 1500–1800* (Cambridge, 1990), 139–74; Lena C. Orlin, 'Fictions of the Early Modern English Probate Inventory', in Henry S. Turner (ed.), *The Culture of Capital* (New York, 2002), 51–83; Giorgio Riello, '"Things Seen and Unseen": The Material Culture of Early Modern Inventories and their Representation of Domestic Interiors', in Paula Findlen (ed.), *Early Modern Things: Objects and Their Histories, 1500–1800* (Basingstoke, 2013), 125–50.
50 Berg, 'Women's Consumption', 415–34; Vickery 'Women and the World of Goods', 274–301.
51 David M. Turner, *Disability in Eighteenth-Century England: Imagining Physical Impairment* (Abingdon, 2012), 32.
52 Richard Steele, 'No. 77, Thursday, October 6, 1709', in Donald F. Bond (ed.), *The Tatler*, vol. 1 (Oxford, 1987), 525.
53 Turner, *Disability in Eighteenth-Century England*, 29–32, 82.

54 For the importance of male fertility see Alan Macfarlane, *Marriage and Love in England: Modes of Reproduction 1300–1840* (Oxford, 1986), 59–61; Helen Berry and Elizabeth A. Foyster, 'Childless Men in Early Modern England', in Helen Berry and Elizabeth Foyster (eds), *The Family in Early Modern England* (Oxford, 2007), 158–83; Jennifer Evans, '"They are Called Imperfect Men": Male Infertility and Sexual Health in Early Modern England', *Social History of Medicine* 29.2 (2016), 311–32.

55 Historians of masculinity have convincingly argued that, like 'luxury', 'effeminacy' is not ahistorical and that, across the eighteenth century, it had various meaning of weakness or excess, refinement or immaturity, see Carter, *Emergence of Polite Society*, 128–35; Cohen, *Fashioning Masculinity*, 1–12.

56 Steele, 'No. 30, Wednesday, April 4, 1711', 124.

57 However, it is important to note that the gifting of small love tokens by men was a crucial masculine role in courtship, see Sally Holloway, *The Game of Love in Georgian England: Courtship, Emotions and Material Culture* (Oxford, 2019).

58 Appleby's Journal, Sat. Aug. 28. 'Human Reason and Fops', *Gentleman's Magazine*, vol. 1. 1731 (London, 1998), 344. Emphasis in original

59 See Cohen, *Fashioning Masculinity*, 42–53. Carter, *Emergence of Polite Society*, 60–6; Jon Mee, *Conversable Worlds: Literature, Contention and Community, 1762–1830* (Oxford, 2011), 14–17.

60 Stanhope, *Lord Chesterfield's Letters*, 163, 214.

61 Wigs could pose problems for polite, gentlemanly deportment, see Susan Vincent, 'Men's Hair: Managing Appearances in the Long Eighteenth Century', in Hannah Greig, Jane Hamlett, and Leonie Hannan (eds), *Gender and Material Culture in Britain since 1600* (London, 2005), 58–67.

62 Stanhope, *Lord Chesterfield's Letters*, 214. Emphasis in original.

63 Adam Smith, *Adam Smith: The Theory of Moral Sentiments*, (ed.) Knud Haakonssen (Cambridge, 2002), 211.

64 For a more exhaustive discussion of the problems and possibilities of the *Proceedings* database see Sarah Horrell, Jane Humphries, and Ken Sneath, 'Cupidity and Crime: Consumption as Revealed by Insights from the Old Bailey Records of Thefts in the Eighteenth and Nineteenth Centuries', in Mark Casson and Nigar Hashimzade (eds), *Large Databases in Economic History: Research Methods and Case Studies* (Abingdon, 2013), 246–68; Tim Hitchcock, William J. Turkel, and Anne Helmreich, 'Rethinking Inventories in the Digital Age: The Case of the Old Bailey', *Journal of Art Historiography* 11 (2014), 1–25.

Discerning consumer: possessing the self 203

65 Beverly Lemire, *The Business of Everyday Life: Gender, Practice and Social Politics in England 1600–1900* (Manchester, 2005), 122; Styles, 'Lodging at the Old Bailey: Lodgings and Their Furnishings in Eighteenth-Century London', *Gender, Taste and Material Culture*, 61–80; Vickery, *Behind Closed Doors*, 36–9; David E. Hussey and Margaret Ponsonby, *The Single Homemaker and Material Culture in the Long Eighteenth Century* (Farnham, 2012), 165–9.
66 Barbara Burman and Ariane Fennetaux, *The Pocket: A Hidden History of Women's Lives, 1660–1900* (New Haven, CT, 2019).
67 Friedman, *Reading Smell*, 34–50; Tullett, *Smell in Eighteenth-Century England*, 131–53.
68 Alun Withey, *Technology, Self-Fashioning and Politeness in Eighteenth-Century Britain: Refined Bodies* (London, 2016), 65–90.
69 OBO (www.oldbaileyonline.org, version 9.0) April 1725. Trial of Claude Anjou (t17250407-43). (Accessed: 11 March 2024).
70 VAM. 'Snuff Box', Silver-gilt, 8.5 × 13 cm. Museum Number: M.307-1962; VAM. 'Snuff Box', Ivory with Brass Mounts, 1.4 × 8.5.6.2 cm. Museum Number: A.33-1949.
71 TNA. C105/5. A mother of pearl snuffbox was sold for £1 1s and the buyer paid 1s for engraving; another snuffbox was worth £1 5d and the purchaser bought it for £1 4s 6d.
72 The National Art Library. VAM 7.
73 There is a surprisingly small number of snuffboxes and canes in the Parker and Wakelin ledgers. Clifford in *Silver in London* observes that by the 1760s, elaborately chased cane heads were going out of fashion, but also that potentially consumers were buying snuffboxes and canes elsewhere, see Helen Clifford, *Silver in London: The Parker and Wakelin Partnership 1760–1776* (New Haven, CT, 2004), 107–8.
74 OBO (www.oldbaileyonline.org, version 8.0, accessed 3 July 2019), September 1800, trial of Thomas Russell (t18000917-126).
75 BRO. L 30/17/1/1.
76 The National Art Library. VAM 7.
77 There is no evidence in the ledger to suggest that either John Jones or John Gulston purchased a snuffbox from Parker and Wakelin.
78 The National Art Library. VAM 7.
79 The National Art Library. VAM 7.
80 OBO (www.oldbaileyonline.org, version 8.0, accessed 3 July 2019), June 1731, trial of Edward Perkins (t17310602-9).
81 OBO (www.oldbaileyonline.org, version 8.0, accessed 3 July 2019), January 1733, trial of John Williamson (t17330112-40).
82 RCT, RCIN 1128232. César-Francois de Saussure, *A Foreign View of England in the Reigns of George I and George II: The Letters of*

Monsier César de Saussure to his Family, ed. and trans. Madame Van Muyden (London, 1902), 113.
83 David Kuchta, *The Three-Piece Suit and Modern Masculinity: England, 1550–1850* (Berkeley, CA and London, 2002), 123–4.
84 Langford, 'Uses of Eighteenth-Century Politeness', 330.
85 OBO (www.oldbaileyonline.org, version 8.0, accessed 23 September 2019), February 1783, trial of THOMAS DUDFIELD HART LEVY (t17830226-3).
86 Friedman, *Reading Smell*, 37–8. Lillie writes that the British plunder of Spanish ships gave sailors many opportunities to become 'snuff proprietors', see Lillie, *British Perfumer*, 295.
87 Hertfordshire Archives and Local Studies. DE/HL/16006. 'Letter from Charles, Hereditary Prince of Brunswick to James Johnston' (17 November 1762).
88 Hampshire Archives and Local Studies. 1M44/11/45. 'Camp before Menin' (28 September 1793).
89 TNA. PRO 30/7/2. 'From Marquis Circello to Sir W Court' (6 September 1817).
90 JRRIL. GB 133 HAM/1/17/250. 'Sir Robert Herries to Mary Hamilton' (9 January 1810).
91 BA. L 30/14/408/45. 'Waddilove, Newby to Grantham, Madrid' (8 July 1775).
92 Margot Finn, 'Men's Things: Masculine Possession in the Consumer Revolution', *Social History* 25.2 (2000), 133–55.
93 JRRIL. GB 133 HAM/1/17/168. 'Lady Herries to Mary Hamilton' (8 October 1791). Finn observes that it was a common expectation of male gift-exchange to lead to reciprocal hospitality and gifts.
94 BM. 'The Parbury Plaque', Gold and Tortoiseshell, 1745. 8 × 6 × 2 cm. Museum Number: 1997,0707.1
95 Kent Heritage and Library Centre. U840/C60/2. 'Earl Vane to the Marquess of Camden' (8 April 1818).
96 Also see Rosie MacArthur, 'Kinship, Remembrance and Luxury Goods in Eighteenth Century: A Study of the Hanbury Family of Kelmarsh', *History of Retailing and Consumption* 1.2 (2015), 134–6.
97 Smith, *Adam Smith*, 110–11.
98 Stephanie Downes, Sally Holloway, and Sarah Randles, 'A Feeling for Things, Past and Present', in Stephanie Downes, Sally Holloway, and Sarah Randles (eds), *Feeling Things: Objects and Emotions through History* (Oxford, 2018), 16. For other significant work on this subject see Marius Kwint, Christopher Breward, and Jeremy Aynsley (eds), *Material Memories: Design and Evocation* (Oxford and New York 1999); Gerhard Jaritz (ed.), *Emotions and Material Culture* (Vienna,

2003); Sherry Turkle, *Evocative Objects: Things We Think With* (Cambridge, MA, 2007).
99 Objects had an emotional and aesthetic value for their owners, see Downes, Holloway, and Randles, 'A Feeling for Things', 16.
100 RA. GEO/MAIN/36415. 'Letter from Queen Charlotte to George, Prince of Wales' (21 September 1791).
101 James Woodforde, *The Diary of a Country Parson, 1758–1802*, (ed.) John Beresford, (Norwich, 1999), 2, 9.
102 Laurence Sterne, *A Sentimental Journey through Italy and France*, ed. Paul Goring (London, 2005), 21.
103 City of Westminster Archives Centre. FT.
104 Dorothy Margaret Stuart, *The Daughters of George III*, 1st pub. 1939 (London, 2016), 135.
105 Vickery, *Gentleman's Daughter*, 194.
106 JRRIL. GB 133 MAM/FL/4/1/18. 'B. Glynne to Mary Fletcher' (2 December 1800).
107 Cornwall Record Office. CY/1743; Hertfordshire Archives and Local Services. DE/AS/2083.
108 North Yorkshire County Record Office. ZBL I/1/1/293.
109 JRRIL. GB 133 EGR1/8/12/4.
110 Vickery, *Gentleman's Daughter*, 194; Finn, 'Men's Things', 144.
111 Isle of Wight Record Office. ELD87/38/1/3.
112 LA. DDX 112/62.
113 Shropshire Archives. 1045/562.
114 TNA. C105/5.
115 ESRO. SAY/2977.
116 Cheshire Archives and Library Services. DDS/432.
117 ESRO. FRE/85.
118 Shropshire Archives. 112/1/1866.

5

Gentleman sportsman: collecting trophies

Thomas Gainsborough's outdoor conversation piece of the newly married Mr and Mrs Andrews is one of his most famous works (see Figure 5.1). Essex squire Andrews, in a stance of comfortable repose, is positioned centre-left, a nod, perhaps, to his greatly expanded estate funded by his new wife's large dowry. He leans nonchalantly on the rococo bench, sporting gun casually cocked under his arm, with his loyal hunting hound obediently waiting at his feet. Andrews was a 'gentleman sportsman' – a compound of the specifically eighteenth-century legal and social identities of the landed and titled Englishman. As Ann Bermingham writes, the iconography of the Andrews' informal leisure and elegant privilege meant that 'the Andrewses can afford to be themselves'.[1] The history of early modern blood sports has centred on its exclusionary politics as the pursuit of a wealthy, landed few, yet rarely have scholars considered its elegance and gentility. Hunting's legal, political, social, and regional history has been fruitfully explored, but the identities of sportsmen has received much less attention.[2]

In eighteenth-century masculine culture, hunting's militaristic and nationalistic associations were perceived by some to be a rejection of urbane, polite masculinity.[3] In 1747, *the* advocate of polite, refined sociability, Lord Chesterfield, wrote that country sports were the preserve of 'bumpkins and boobies'.[4] But, as Lawrence Stone and Jeanne Fawtier Stone observe, there have always been plenty of English squire boobies 'but whether they were in the majority is very doubtful'.[5] Both the squire booby and the elegant gentleman sportsman were material masculinities in eighteenth-century England as either a rejection or an embrace of fashionable, urbane (often whiggish) masculine models in rural settings. Blood sports and the

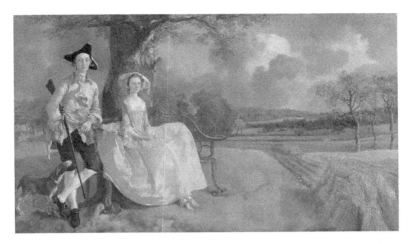

Figure 5.1 Thomas Gainsborough, *Mr and Mrs Andrews*, c.1750. Oil on Canvas, 70 × 120 cm. The National Gallery, London. Museum Number: NG6301. Reproduced courtesy of the National Gallery, London, licensed by CC. BY.

men who participated in them were embroiled in debates on luxury, gendered consumer desires, and masculine behaviour. The material construction of this masculinity reveals both continuities and changes in masculine selfhood and identification across the eighteenth century. Elegance and politeness found their way into militaristic sporting culture and were integral to the exclusionary social power that huntsmen and sportsman wielded.

To explore the gentleman sportsman as a material masculinity, this chapter draws on a range of sources from gunsmiths' trade cards and bills to probate and household inventories and surviving guns themselves. Men's diaries and correspondence were littered with brief matter-of-fact notes of what was killed, where, and when. Men's 'hunting journals', such as those belonging to Peniston Lamb, 1st Viscount Melbourne between 1796 and 1801, provide little psychological insight into attitudes to sport.[6] Game books, akin to score cards, became more popular in the mid-eighteenth century and recorded the number of different game birds shot on each day of the season.[7] While the existence of game books suggests that for men the greatest pleasure in shooting was the number of birds shot,

these books were most probably kept by gamekeepers to monitor game on the estate rather the gentleman sportsman himself.[8] Nottinghamshire country gentleman Robert Lowe's 1793–1822 pocket almanacs contained only fleeting references to the number of fish caught, some sporting-related errands – such as a reminder to purchase a gun in London – trade cards, receipts of fishing tackle manufacturers, and, curiously, a fishing fly tucked into his 1804 copy.[9] By the early nineteenth century, specialist pocket diaries emerged designed for the gentleman sportsman and his gamekeeper, such as 'The Game Book, Or Sportsman's Journal', and functioned in the same way as older game books.[10] These documents illustrate the fervour, frequency, and location of shooting, and the emerging commercialisation of sporting culture, but reveal very little of men's attitudes towards country sports, and importantly for this chapter, its materiality. Gunsmith's trade cards, gunsmith's bills, surviving guns, and country house inventories have all proved more fruitful sources in elaborating the materiality of sporting masculinities.

The gentleman sportsman's power and privilege

To examine the gentleman sportsman as a material masculinity requires a longer history. Country sports were, and to an extent still are, a bastion of elite privilege, wealth, and power because of their legal and political history. The history of hunting has always been one of class struggle. There have been English laws surrounding the right to hunt since the Norman Conquest. Royal Forests were created in the eleventh century as large, protected areas of land within which the king alone had the right to hunt. The Royal Forests continued to expand over the twelfth century, as did their legal administration under the Forest Laws, until the Magna Carta in 1215. The charter softened the increasingly punitive measures taken by the Forest Courts and returned much of the Crown's forested land to landowners. The gentry's acquisition of monastic land in the English Reformation increased both the size and power of the Tudor gentleman class.[11] Disafforestation and forest enclosure continued through to the seventeenth century and tenants' growing resentment resulted in the Western Rising between

1626 and 1632.[12] The continued disafforestation, exacerbated by the Interregnum's plunder of timber and game rendered the old Royal Forests wasteland compared to their Norman predecessors by the time of the 1671 Game Act.[13]

The change from Forest Laws to Game Acts at the end of the seventeenth century signalled the increasing limitation of royal power and privilege; as William Blackstone wrote in *Commentaries on the Laws of England* (1765), 'the forest laws established only one mighty hunter throughout the land, the game laws have raised a little Nimrod in every manor'.[14] The less itinerant royal court, and its declining political cultural, social, and fashionable influence after 1688 contributed to the growth of the country house as a symbol of wealth, power, prestige, and elite leisure. The 1671 Game Act introduced the property qualification of £100 for freeholders and £150 for leaseholders. As such, the 1671 Act had democratised hunting and shooting to gentlemen, yet retained these sporting privileges within a small, landed elite.[15] The Act's introduction attests to the increased need to regulate the expanding practice of shooting game birds such as partridges and moorfowl and prohibited hunting and shooting on Sundays and Christmas Day.[16] For most the eighteenth century, elite men were legally able to shoot one type of game or another for six months of the year. Elites were keen observers of this new sporting system. The Glorious Twelfth (12 August) and Moor Game Day (1 September) quickly became significant and ritualised dates in the rural calendar, often noted in diaries, journals, and correspondence.[17] Hunting, shooting, and fishing invitations formed a significant part of rural polite leisure, sociability, and hospitality. Invariably, gentlemen's letters contain invitations to friends and kin to hunt, shoot, or fish.[18] According to the Althorp Game Books (1787–1808) the Spencers were shooting, on average, 305 game birds each shooting season at a combination of suburban and rural sites including Althorp, Wimbledon, Brompton, Mora, Glen Beg, and Ireland, with the first day of the Spencer's shooting season typically beginning with partridge day in early September and continuing with some verve until the end of January – the Althorp 1818 'Sportsman's Journal' notes 1,057 game birds shot in just 15 days.[19] The Spencers would shoot for a quarter to a third of the shooting season, and for a third of the hunting season Earl Spencer would

have had his sporting gun in his hand. Shooting was therefore an intense and itinerant sport, which dictated the movements of elite men and their families.

In the seventeenth century, as Tom Rose has shown, hunting became a keen form of social, gendered, religious, and political exclusion.[20] Therefore the gentleman sportsman was a masculine identity rife with social tension at the beginning of the eighteenth century. The 1671 Act exacerbated tensions between and within social ranks. As the burgeoning property-owning elite's legal power expanded post-1688, anti-poaching and game laws were perceived to override the ancient, customary rights of tenants. Hunting gave a small number of landowners control over both their tenants and large areas of land dedicated to pasture and was, in the words of Stone and Fawtier Stone, 'the very socio-economic system that created and sustained the landed elite and their houses, and gave them their power and prestige'.[21] There was a long rural tradition of poaching and protest against hunting legislation, and its legal administration, and the 1671 Act, and the later, more punitive Black Act of 1723, demonstrated landowners' efforts to preserve their estates and privileges.[22]

The 1671 Act's property qualification had more ideological implications. As P. B. Munsche writes, 'many professional and commercial men had wealth enough to purchase an estate of £150, but the Act forced urban, moneyed men to concede the superiority of land over other forms of wealth – and for landed gentlemen that was the important point'.[23] In metropolitan print culture, particularly the Whig publications *The Spectator* and the *Tatler*, the 'Tory Fox-Hunter' became a synecdoche of rural, landed gentlemen's unrefined manners and traditional worldview.[24] Steele and Addison's Sir Roger de Coverley was the archetypal boorish country squire unable to talk of anything but his beloved chase. In the early eighteenth century Whig ascendency, urban moralists deployed de Coverley and other fox-hunting Tories in *The Spectator* to compare the decline of the old, Tory, landed, rural ethic with the emerging dominance of urban, commercial Whigs.[25]

While whiggish writers made claims to superior cultivation in the coffeehouse, foxhunters were seen as staunch defenders of traditional ideals of masculine behaviour. The anonymous treatise *An Essay on Hunting by a Country Squire* (1733) opened with a

vociferous attack on the 'busy, trifling effeminate Mortals' and their urbane, polite manners and behaviours. The country squire wrote:

> Perhaps there is no greater Demonstration of the Degeneracy of the present Age, than the Neglect and Contempt of this Manly Exercise. Balls and Opera's, Assemblies and Masquerades, so exhaust the Spirits of the puny Creatures over Night, that Yawning and Chocolate are the main Labours and Entertainments of the Morning ... I laugh heartily to see such delicate Smock-faced Animals, judiciously interrupting their Pinches of Snuff with dull Jokes upon *Fox-Hunters*; and foppishly declaiming against an *Art* they know no more of than they do of Greek.[26]

Private correspondence expressed a similar attitude to country life; Frederick Robinson wrote to his brother in September 1770, 'what you can have better to do all alone in London than to write to us. Yesterday we went out a hunting in the morning'.[27] Even for a fashionable gentleman like Frederick, the diversions of London could not match the delights of the chase.[28]

As well as tensions between rural, landed men and urban, moneyed men, the preservation of private property and game stoked tensions between the gentry and aristocracy. As the right to hunt game overrode the rights of property ownership itself, men were legally entitled to ride over their neighbours' land in the pursuit of game, and the only legal redress available to the landowner was to sue for trespass. In an 1810 letter from Viscount Sydney to his country neighbour squire Richard Leigh, Sydney wrote of protecting his legal property rights and used them to reinforce his social and legal superiority to his squire neighbour: 'When you first set up your Fox hounds he called upon to ask my permission for the hounds to hunt over my Estate & courses and I had not in the least difficulty in distinctly stating to him that I could provide no such consent or permission'.[29] The expanding middling sorts, increasingly attuned to animal rights in the birth of sensibility, criticised the brutality of country sports.[30] Historians, taking their cue from Blackstone's *Commentaries*, conclude that protectionist game and anti-poaching laws perpetuated a Norman feudalism that was antithetical to emerging ideas of modern, legal egalitarianism.[31] The 1671 Game Act exposed and exacerbated the tensions in rural society between landowners and tenants, mercantile and landed gentlemen and their associated modes of masculine expression.

Eighteenth-century England had a thriving gun culture. The eighteenth century introduced new forms of guns, such as coach guns to protect coach-travellers, and improved older gun types and mechanisms, such as blunderbusses used by troops on military campaigns. Historians of men's material culture have, curiously, neglected to investigate the sporting gun's central position in the material culture of elite masculinity.[32] This chapter focuses on eighteenth-century sporting guns, often called 'hunting guns' or 'fowling pieces' in the eighteenth century, which were an early form of the modern-day shotgun. The fowling piece was distinct from other firearms, such as pistols, as its primary function was for hunting rather than duelling or self-defence – it was an object of leisure. Fowling pieces had long barrels that were designed for their accuracy in firing at flying targets. More specialised sporting guns, such as duck guns, with incredibly heavy, long barrels, were designed to kill a group of waterfowl with a single shot. Increasingly, country sports were a key indicator of power and powerlessness as the early modern patriarchal order was disrupted by eighteenth-century social and economic changes. Materiality, a key process in which power and powerlessness is made manifest, is certainly at work in the gentleman sportsman's identity formation. Property and income qualifications, the commercialisation of leisure, and distinctions between tougher, provincial and urbane, metropolitan elite masculine forms all signal the relationship between the sportsman identity and its materiality. It is therefore difficult to underestimate the importance that sporting guns had for elite men as they invested considerable time in pursuing shooting and dedicated their rural calendar and movements to the sport.

The consuming sportsman

Eighteenth-century Game Laws legally restricted sporting rights and firearms ownership to landed men, and guns were therefore *de facto* elite objects. But guns were 'luxury' goods due to both their decorative design and technological complexity. Gunsmiths normally branded their work as a mark of distinction. They were often famous, not only for the decorative detailing on weapons but more often for technological innovations.[33] John Manton and

later his son Joseph are widely considered by both collectors and historians as some of the very best British gun-makers.[34] The Mantons were famous in England, and also in Europe, for their innovation of flintlock mechanisms, and Joseph Manton was described by his friend, and shooting companion, Peter Hawker, as a leading innovator of British guns.[35] Joseph Manton held the royal warrant and was gun-maker to the Prince of Wales and the Duke of York at the turn of the nineteenth century.[36] Perhaps because of this royal clientele, the Mantons also provided guns for the British aristocracy including the Earl of Egremont in 1784, 1786, and 1807, the Duke of Marlborough in 1795, Viscount Sydney in 1804, and Marquess Townshend in 1808.[37]

Often the gentleman sportsman retained a single gun-maker over time. This loyalty is similar to patronage patterns in other luxury trades such as furniture-makers, coachbuilders, and silversmiths. However, other aristocratic men were less loyal to their gunsmiths. The personal bills of George, 3rd Earl of Egremont show that between 1772 and 1806 he bought guns from five different gun-makers. These gun-makers were some of the most well-regarded and fashionable of their day; he bought from Joseph Griffin in 1772, later of the Griffin & Tow partnership, in 1779, and in 1780 he shifted allegiance to John Clark. By 1784 he changed once more to up-and-coming John Manton, again in 1797 to the Swiss-born Durs Egg, and finally returned to Manton's son Joseph in 1806.[38] These successive changes suggest that Egremont was a keen patron to up-and-coming makers and innovators, while also a patron of well-established artisans. At the apex of society, the acquisition of guns was an extension of established patterns of luxury consumerism, privileging famed and innovative manufacturers who advertised their elite patrons.

While writers on shooting across the long eighteenth century gave detailed advice on how to maintain and store guns at home, a cursory examination of gun-makers' bills suggests that aristocratic gunowners sent their guns to their gun-maker for cleaning, oiling, and repairing – these repairs often coincided with the shooting season.[39] Elite men, then, did not maintain the guns themselves, or even have them attended to by their stewards, but sent them to expert makers for maintenance and repairs. This suggests that these gentlemen recognised the intricacies of their guns, and the skills of

gunsmiths. It seems that maintaining one's own gun was not typically part of the business of elite shooting, or a requisite competence of a gentleman sportsman. Gunsmiths, like other manufacturers of luxury goods, provided low-cost maintenance and repairs to encourage consumer trust and future commissions. A cursory glance at both aristocratic and gentry wills suggests that sporting guns were passed down through the generations and, as talismans of elite masculinity, they denoted both elite men's sporting lineage and cultivated material taste. In his 1727 will, Nathaniell Thomas of Westfelton in Shropshire left his nephew Thomas Lloyd his fowling piece and his other nephew Richard his muskets and pistols.[40]

Elite male consumers did not just buy guns from British gunsmiths, as collector W. Keith Neal and his gun collection sold at Christie's in November 2000, demonstrates.[41] Of the 35 sporting guns belonging to the Earls of Aylesford at Packington Hall during the eighteenth and early nineteenth centuries there were 22 guns made by English gunsmiths, 10 of which were made by John Twigg, a revered London gun-maker, and 13 from France or Germany.[42] Neal's survey of the accounts at Packington concludes that these 10 Twigg guns were purchased at an almost obsessive rate between 1778 and 1780, with £114 15s being spent on three rifles, two shotguns, two duck guns, a double-barrelled gun, and a gun with a German barrel.[43] The combination of non-British elements makes historical sense, as many considered continental gun-makers to be far superior to British producers until the Manton partnership arrived at the end of the eighteenth century.[44] George Edie wrote that 'our English Fowling-piece has, of late years, met with so much improvement, that we may, without partiality, esteem it equal, if not superior, to any other in Europe'.[45] Even in the Packington gun collection, though, the combination of non-British gun elements with British ones was also driven by purely aesthetic and decorative considerations. A gun with an inlaid silver Indonesian barrel mounted by London gun-maker Edward Sale shows no significant signs of use and the bore of the gun itself remains unfinished.[46] The presence of both these guns in the Packington collection demonstrates the Earls' technological and aesthetic appreciation for non-British gun components as well as the improving quality of the British gunsmiths.

Country sports were the preserve of landed men and an expression of their economic and social values of rural paternalism. But for

landed men, there was an economy of guns and shooting; country sports were not pursuits divorced from commercial and urban society. Guns were expensive to both buy and maintain; they continually required repairing, oiling, and updating and a constant supply of powder. Although shooting required less land and dogs than stag, fox, and hare hunting, it still needed a gamekeeper to maintain the coveys of pheasants and partridges. Nevertheless, the associated costs of maintaining a sporting lifestyle reinforced these men's position at the apex of the social and gender hierarchy.

Gunsmiths' trade cards provide a useful insight into perceptions of the sportsman and how manufacturers appealed to this emergent consumer group. Many gunsmiths advertised their technological innovation of gun parts. William Jover, a gun-maker at 337 Oxford Street, recommended to 'The Notice of every Gentleman; his new design for gun construction that improved guns' precision and strength and was 'absolutely superior to any thing of the kind yet known'.[47] Joseph Manton's 1794 trade card provided a wealth of detail on his new patented flintlock mechanism. Guns 'on this new principle are much stronger and safer than any others ... they will throw their shot more regular and with greater Velocity'.[48] As such, these cards appealed to a masculine appreciation of complex technological innovation.[49] Similarly, other gunsmiths stressed skill and talent by invoking their impressive apprenticeships. In the cartouche of Stanton's 1763 trade card, he highlighted that he was 'Nephew & Successor to the Late Mr Turvey'.[50] Besides his name and address, John Manton's 1788 card only informed the viewer that he was the 'Late Foreman to Mr Twigg'.[51] Both Turvey and Twigg were renowned gunsmiths of the 1770s. Others deployed a language of material quality. William Henshaw's c.1800 trade card detailed the sorts of finishes available to gentleman. Their guns could be 'elegantly or plainly mounted in Gold, Silver, Steel', and, should they require it, he also sold 'portable Mahogany or Wainscot boxes, containing every useful & necessary implement for shooting'.[52] William Guy made and sold 'all sorts of Neat Fowling Pieces' and offered 'cleans & repairs after the best manner'.[53]

Many mid-eighteenth-century trade cards typically depicted their wares in elaborate and decorative rococo borders to evoke the prestige of gun ownership and sporting prowess. Maxine Berg writes that these elaborately engraved rococo designs 'suggested [the] quality

material and fine design of the goods advertised'.[54] Gunsmiths listed their illustrious royal clientele as well as flaunting their patents and innovations invoking the sort of eminent shooters that potential purchasers could join. More illustrious still was the royal warrant and those gunsmiths who held it put it in pride of place on their trade cards. Trade cards were almost always addressed to 'gentlemen'. William Henshaw's 1800 trade card invited the variety of those interested in the fowling pieces and arms he produced – 'the Nobility, Gentry, Merchants, Captains of Ships, and others' – to his shop on the Strand.[55]

As these trade cards demonstrate, sporting guns were sold alongside a variety of military firearms. Many gunsmiths manufactured guns for private gentlemen, as well as the army and the East India Company; those that did included the Board of Ordinance and East India Company crest.[56] Innovation in sporting guns was entwined with the development of the increasingly sophisticated military technology, such as firearms, essential for European imperial expansion. Watt's gunsmiths advertised their 'several excellent fowling pieces [and] also, great variety of New Invented Spring Guns, For Warehouses, Gardens, Plantations, &c.' and is a causal reminder that guns were weapons to preserve privilege and power both at home and on colonial frontiers.[57] This privilege is perhaps best demonstrated in the trade card of Bristol gunsmith William Heard. It depicts a sportsman with his loyal hunting hound and shooting spoils alongside a generic racialised other who throws down his bow and arrow and picks up the sporting gun.[58] This representation is indicative of early British colonial faith in the ability to civilise native peoples, argues Priya Satia, a confidence that quickly turned into anxiety as Native Americans' gun ownership increased over the eighteenth century.[59] But despite their shared mechanical components, the guns for use in the British Empire were not luxury items. This is an important distinction as the 'civilising' function of utilitarian guns beyond Britain was a world away from the bespoke, personalised guns used on the grouse moors of estates by elite, cultivated men. Country sports were so entrenched in a national, elite, masculine identity that when East India men were far away on colonial shores they decorated their residences with fox-hunting prints – little windows to their longed-for English arcadia.[60] Indeed, the British used tiger hunting in colonial India,

Joseph Sramek argues, to assert their dominance over the Indian population.[61]

Many trade cards echoed the association of shooting, and country sports more broadly, with martial masculinity. Some trade cards, like Stanton's, depicted a cornucopia of military arms and weaponry including canons, axes, and suits of armour.[62] Later trade cards, like those of Edward Deane, John Bennett, and John Burgon, depicted figures of both the armed military man and the sporting gentleman side by side.[63] Linda Colley suggests that hunting as an expression of masculine attributes of virility, daring, danger, honour, and activeness, increasingly became aligned with a growing sense of national identity. Blood sports were, Colley writes, 'another expression of the new patriotic, patrician machismo', with hunting dress consciously mimicking British military uniforms.[64]

Country sports were perceived to both train young men for military careers and to instil in them manly attributes of courage and bravery. In Nicholas Cox's *The Gentleman's Recreation* (1686), sport 'imflame[d] the hot Spirit of young men with roving Ambition, love of War, and seeds of Anger.'[65] The militarism of hunting was not lost on female letter writers. Lady Polwarth wrote to her sister Lady Mary Yorke in November 1775 that her husband was 'too good a Friend to the sport to destroy the Enemies of his poultry Yard by any other ways than the fair War of Hunting'.[66] The association between hunting and militarism is also evident in legal discourses. Blackstone's *Commentaries* traced the right to hunt and use arms back to the Norman feudal system in which the 'martial genius of the conquering troops who delighted in sport which, in its pursuit and slaughter, bore some resemblance to war'.[67] The right of a privileged few to bear arms was as much a way of suppressing feudal rebellion in the eleventh century as in the eighteenth. Blackstone therefore traces the right to hunt back to the inception of Englishness: of William the Conqueror, Doomsday, and later the Magna Carta. Blackstone's characterisation of hunting's legal privileges had purchase. In 1794 Viscount Torrington wrote in his diary that,

> from our cradle there is a love of field sports handed down to us from Nimrod; and confirmed by the Norman Conquest; as a right of gentry: Nor do I hope to live to see the Sans Culottes of this land laying all distinction waste and in defiance of law, and submission proclaiming what they call the rights of man.[68]

These trade cards reflect this association between the manly pursuits of both the sporting and battle field. As such, the 'gentleman sportsman' was a social, national, and, even, imperial masculine identity that encompassed elite men's social power, legal privilege, and martial honour. Accordingly, gunsmiths advertised their wares to appeal to the gentleman sportsman's consumer desires.

The association of blood sports with militarism offered men an alternative to refined, polite heterosociability. Lord Chesterfield drew a comparison between French and English hunting in a 1751 letter to his illegitimate son, who was hunting with Louis XV: 'the French manner of hunting is gentlemanlike; ours is only for bumpkins and boobies. The poor beasts are here pursued and run down by much greater beasts than themselves'.[69] Accusations of boorishness were not without foundation; Amanda Vickery has emphasised that the homosociality of English country sports posed problems for ideals of polite behaviour. Elizabeth Shackleton disapproved of the licentious behaviour and promiscuous sociability she witnessed at post-hunt meals in alehouses involving her own family and their social inferiors. Sporting parties, Vickery argues, offered gentlemen an escape from 'the burden of polite heterosociality'.[70] T. Hewson's and I. Blissett's trade cards depict a pastoral idyll in which sportsmen relaxed by a stream with thatched cottages in the background.[71] East India Colonel Patrick Duff hankered for a simple, agrarian life back home.[72] Writing to his brother from Calcutta, homesick Duff desired to source a small Scottish estate that was

> not far from a stream where I could divert myself in fine weather with fishing; to have a hill near where one might go a shooting would make it still more agreeable to my taste ... To be in the fields in fine weather, to fish, shoot & hunt; with some Books, and now and then the Company of any friends, are the only pleasures which I can hope to enjoy.[73]

Of course, this was itself tied up in a nostalgic, pastoral fantasy of a pre-industrial arcadia that was fashionable in the late eighteenth century; aristocratic estates now featured *ferme ornées* to provide elite men and women an escape from the stresses of elite lifestyles and the performance of politeness.

But other gunsmiths' trade cards in the later part of the eighteenth century show a different picture. The Watts & Co.'s and William

Gentleman sportsman: collecting trophies 219

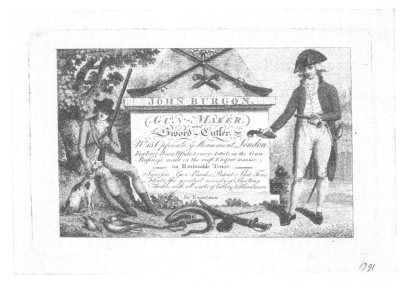

Figure 5.2 BM. 'Draft Trade Card of John Burgon, Gunsmith', c.1790. Banks,69.11. © The Trustees of the British Museum, London

Nicholson's trade cards depict sportsmen shooting in the parks of Palladian country houses. Gentility and refinement were not antithetical to the sportsman's identity and manufacturers were keen to show the sort of identity and power that the consumer could acquire through their purchase.[74] Many trade cards depict sportsmen in reclining poses of easy, calm gentility (see Figure 5.2) and echo Gainsborough's depiction of squire Andrews' elegant privilege. Hunting and shooting were an escape from polite heterosociability, but shooting was imbued with practices and prescriptions of polite homosociality, not necessarily vulgarity. Berg's work on eighteenth-century advertising and trade cards cautions that manufacturers' trade cards were not a tool of mass advertising but a form of targeted advertising to existing or potential consumers – reinforcing the exclusivity of the gentleman sportsman. Trade cards were well-executed and used new printing technologies and quality materials. Their elaborate and sophisticated design combined the 'reality' of goods and the 'fantasy' of shopping. Berg argues that trade cards were used more than just bills and letters but were consumer souvenirs.[75] As such, these

gunsmith trade cards were not just advertisements but souvenirs in the acquisition of the fantasy and identities they depicted. Gun-makers deployed the established association of country sports as a manly, militaristic, genteel, but exclusive pursuit. These trade cards confirm that the sporting gentleman was a recognised consumer identity in eighteenth-century England.

The sporting gun's materiality

Men's gun consumption fitted established patterns and practices of luxury consumerism, yet how did men interact with the design and use of these guns? Taking a sample of sporting guns both in auction sales and in private collections, this section provides a material analysis of sporting guns made by renowned gunsmiths in the later part of the long eighteenth century.[76] All of the guns were made from luxury, exotic woods such as mahogany or walnut with varying degrees of inlaid platinum, steel, iron, and silver or gold detailing to the gun handle and flintlock. These woods would match similar furniture in the home, such as mahogany tables and chairs that were rich in reddish hues and diligently varnished. The carved chequering on the butt and tang aides the shooter's grip as well as providing a decorative finish – with function and decoration working together to create material meaning. All the guns have engraved silver, platinum, or gold inlaid metalwork.

Guns were unique compared to many eighteenth-century luxury goods such as silverware, furniture, silks, chinaware, and carriages as the name of the maker regularly appeared on the product itself. Throughout the long eighteenth century, guns had their makers' name engraved, typically, on the flintlock. This is perhaps why, in the inventories examined in this chapter, they were some of the only possessions to have their maker listed. While makers' marks, particularly on silver and gold products such as watches, snuffboxes, and dinner services were commonplace, overt inscriptions of makers' names and addresses were not.[77] Consumer historians have charted the eighteenth-century emergence of product branding, which was a key part of establishing makers' reputations as skilled and consistent manufacturers; moreover, branding created an emotive connection between the producer and consumer, composed of loyalty and

memory.[78] These gun inscriptions were a visual and material indicator of quality – they signalled not only a dedicated sportsman, but also a man of means and material and technological discernment. This material inclusion signalled men's access to, and these goods' position in, a metropolitan word of technological innovation and fashionable commodities.

Throughout the eighteenth century, hunting guns had their owners' crests on the top flat. Armorial markings were out of view when the shooting gun was displayed on gun racks on a hall or study wall, but heraldic marks would be seen when out shooting and when the gun was cocked on the grouse moor. While the inclusion of armorial markings on old and new luxury goods was commonplace across the eighteenth century, the small decorative and armorial detailing on gun metalwork was one of the only ways to personalise these guns in the late eighteenth and early nineteenth century.[79] They are all of a similar size between 71 and 76 cm in length, made from, and decorated with, similar materials such as walnut and mahogany, silver and gold, and share the same technological component pieces such as bores, flintlocks, and triggers. The subjects detailed in the decorative metalwork range from conventional shooting scenes, often including hares and pheasants, to more exotic ones such as pineapple finials on two of the Manton guns or more nationalistic motifs such as Britannia's shield. It is possible that the inclusion of the owner's crest is a form of defensive status consumption; shooting was perceived as a more 'democratised', egalitarian form of country sport than hunting.[80] Therefore, a well-made, luxurious fowling piece with armorial ornamentation spoke to the gentleman sportsman's rank and status. On a more practical level, out on a grouse moor with several other guns, the crest and inlaid work would help distinguish a gun from others.

To be able to chart the changing designs in sporting guns across the long eighteenth century, it is necessary to select one category of gun to provide a chronology of design change. Duck guns were typically long-barrelled – one in the Packington collection was 117 cm long – which made them more accurate than other shooting guns to be able to kill waterfowl more efficiently.[81] While these guns had a specific function at the heart of their design they attest to the changing decorative patterns and preferences across the eighteenth century. The essential mechanical components of duck guns, such

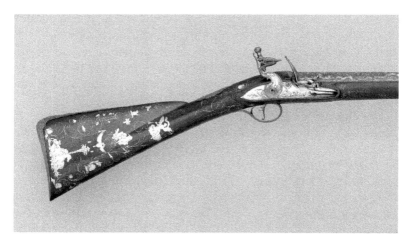

Figure 5.3 William Simpson, 'Flintlock Sporting Gun', 1738. Royal Armouries, Leeds. Object Number: xii.5843. © Royal Armouries

as flintlock and triggers, and structural elements, such as barrels, butts, and tangs, remained the same across the eighteenth century. The decorative woodcarvings and metalwork engravings, however, changed considerably. A flintlock, walnut duck gun made by Robert Sharpe c.1700 was decorated with ornate strawberry foliage work on the brass mounts and on the lock itself.[82] William Simpson of York's flintlock sporting gun made in 1738 for William Constable (see Figure 5.3) contains a rich variety of ornamentation and symbolism. Inlaid with metalwork of flora and fauna and a rococo leaf, scroll, and a variety of shellwork from snails, shells, and dolphins, the gun has classical depictions of putti, Diana, the Roman goddess of hunting, and a mythological, grotesque headed figure. The gun even sports nationalistic iconography of Britannia and a lion and unicorn on the butt of the gun. This fine, ornate metalwork is reflected in the relief shell carving by the lock. The iconographical power of gun decoration was as object that materialises nationalistic, cultural, and aesthetic trends that the gentleman sportsman sought to associate with himself.

Similarly, a steel-mounted duck gun made by James Barbar – son of the royal armourer Huguenot Louis Barbar – for Constable in Leeds c.1755 has a richly decorative scheme of scrollwork and

shellwork on the steel engraving on the lock, as well as in relief carving on the tang with an unadorned steel escutcheon.[83] Much later duck guns, such as a walnut, flintlock duck gun made by Cambridge gun-maker Samuel Evans c.1820–1830 have much more sparse ornamentation than earlier models.[84] There is no inlaid work on the lock, and the only carving work is the chequered work on the tang and grip, which, by this time, were a consistent feature of British firearms.

Guns with detailed rococo and baroque decorative metal mountings gave way by the 1780s to plainer ornamentation, with less metalwork and carving, and a much simpler ornamentation by the 1820s. This change in gun design was part of wider alterations in elite masculine materiality expressions across the period. As elite male manners and dress became more egalitarian in the closing decades of the eighteenth century, so, too, did elite male material culture. The changing ornamentation of sporting guns across the long eighteenth century was part of men's renunciation of material magnificence and ostentation but can also be attributed to wider changes in masculine leisure and behaviour. Historians have noted that reformed elite male honour culture meant that as male violence, particularly duelling, decreased across the eighteenth century, men's honour was no longer constituted through martial heroism and prowess, but rather through their polite and condescending manners.[85] Sporting guns were luxury objects that signified their owners' status as much through their decoration and ornamentation as their primary sporting function. As objects of keen masculine consumer expertise, guns were not immune from these wider changes in prescriptions and practices of eighteenth-century masculine behaviour, as game shooting's increasingly popularity was due, in part, to its status as a more pacifist, sedate, and egalitarian country sport than hunting.[86]

Weapons for the everyday, especially military weapons, existed of course but were distinguished by their 'mass-production', lack of ornamentation, and lesser gunsmithing. While many sporting-guns were used regularly, others were solely displayed as object d'art or furnishings. The guns acquired by the Constables at Burton Constable Hall in East Yorkshire show little material evidence of use. Others, like the guns of the Marquess of Rockingham at Wentworth Woodhouse show extensive use.[87] The material components and ornamental features of guns before the 1790s mirrored wider aesthetic styles

such as rococo and baroque. British gun manufacturing was influenced by continental gun manufacturing; wider global tastes and manufacturing influenced domestic gun production, which combined British and non-British components. Even as a prop in the most seemingly traditional and quintessential elite British pastime, guns' materiality points to a penchant for exotic and foreign luxuries that was not the sole preserve of female consumers. That said, gun design changed over time from the rich carving and metalwork of early eighteenth-century guns to the more sombre and sparse guns of the 1790s onwards. As luxury objects, guns were therefore not immune to changes in male fashion. The shift in expressions of elite manliness from magnificent superiority to sombre modesty was not limited to men's dress but their wider material practices and preferences. Guns were luxury consumer goods and fitted within established patterns of elite consumption. In their design, guns' decoration evolved in tandem with changing masculine codes.

Embodying the gentleman sportsman

Historians of eighteenth-century masculinity have, in recent years, studied men's embodied experience of the material, sexed body. Masculine embodiment – the ways in which cultural codes of masculinity and manliness shape the material body physically as well as its experience – has been explored, in particular, through the material body's interaction with material things. Sport was a key activity in which men across the social hierarchy experienced, interacted with, and changed their sexed bodies. Exercising, toughening, shaping, and honing the male body through boxing and cricket, carriage driving and dancing was a particular occupation of eighteenth-century men – although these forms of exercise were stratified by social rank. The anonymous squire's *An Essay on Hunting by a Country Squire* (1733) contrasted country squires' exhaustion from their 'Manly Exercise' as foxhunters with their urban contemporaries 'delicate' and 'puny' performances at balls and assemblies. Sporting treatises speak to the embodied experiences of the sportsman. Seventeenth-century manuals such as Cox's *The Gentleman's Recreation* espoused both the psychical and mental benefits of hunting as a 'Noble and Healthy Pastime'. He went on to say, '*Hunting* trains

up Youth to the use of manly Exercises in their riper Age, ... Nothing doth more recreate the Minde, strengthen the Limbs, whet the Stomach, and clear up the Spirit, when it is heavy, dull and over-cast with gloomy cares'[88] – a sentiment echoed throughout eighteenth-century hunting treatises.[89] For hunting writer John Smallman Gardiner, for the men of letters and commerce, an hour of walking or riding was incomparable to the 'state of robust, and if you will, of rude health' that hunting provided.[90]

The proliferation of sporting literature from the late seventeenth century speaks to the changing demography of early modern country sports participation. Bolstered by commercial engagement, the landed gentry grew in number and power across the eighteenth century and there was an increase in those participating in the sport. The established gentry were taught to shoot at home by either their fathers or gamekeepers and had shooting lessons at school or at military academies, alongside other gentlemanly accomplishments such as riding, fencing, and dancing for the European Grand Tour. As Sarah Goldsmith's work on danger and the eighteenth-century Grand Tour has shown, physical activity, such as fencing, gymnastics, and hunting, and the dangerous travel that the tour facilitated, were just as important to the rationale and outcomes of the Grand Tour as an elite male rite of passage as polite cultivation and aesthetic appreciation. The Grand Tour's dangerous elements, she concludes, were requisite for instilling emotional forbearance and embodying physical strength and hardiness in young elite men, significant manly attributes that underpin gentlemanliness and elite masculine identity in the period.[91] The emergence of such didactic sporting literature that covered topics, from the classical hunters of ancient Greece to the best food for different breeds of dogs, emerged to cater to the newly landed, commercial elites unschooled in the mores of the sporting field and without the training of the eighteenth-century Grand Tour.

As shown elsewhere in this book, embodied interactions with material goods, and the requisite material knowledges to do so successfully, enabled elites to both experience and defend their social privileges. George Edie's *The Art of English Shooting* (1775) provided new sportsmen with the necessary embodied and material knowledges. In Edie's work, the gentleman sportsman's use of, and interaction with, sporting guns was imbued with prescriptions of gentlemanly

politeness. Edie wrote that partridge shooting became so popular in eighteenth-century England 'on account of the cleanness, little fatigue, and more certain diversion than any other, ... [It] is generally esteemed the genteelest and best sport we have in England'. For Edie, shooting was not an escape from the genteel world, but was bound up in gentlemanly qualities of respectable appearance and manly self-control. The opportunity to display elite masculine qualities comes when the partridges rise from the woods. Edie writes this moment is 'the difference between the good and bad sportsman; the greatest coolness and composure are now necessary: when they rise, lift your gun deliberately to your shoulder.[92] This language of calmness and composure calls upon prescriptions of gentlemanly politeness and the refined performance of leisure. Ten years later, Beckford wrote that the 'perfect huntsman' shared qualities with those men of 'more brilliant situations;– such as a clear head, nice observation, quick apprehension, undaunted courage, strength of constitution, activity of body; a good ear; and a good voice'.[93]

Shooting a gun successfully was an application of embodied knowledge. To shoot well, you must have your feet firmly placed at a stance on the ground and a firm grip is required to keep the gun aimed at the moving target. The gunstock must be securely nestled into the shoulder joint, but the entire upper body must be relaxed yet composed enough to be able to take the recoil once the gun is fired. Shooting required huge upper body strength as many guns could be up to 1.5m long and incredibly heavy. The loud sound and plumes of smoke also make the shooting of the gun an olfactory and aural assault on the sportsman. On woodcock shooting, Edie described the woodcock as 'a very tender bird; and being a large mark, affords easy, pretty shooting, where a person has got the art of shooting flying tolerable well'. Throughout, Edie focuses on the cleanliness of the environs in which shooting took place; wildfowl-, fen-, and wood-shooting were, for example, 'very little practised by the gentleman sportsman, owing to the several disagreeable circumstances attending it'.[94] While a wealthy yeoman could get a bit wet and dirty, a gentleman out for a day's shooting could, and would, not. Guns, and by extension, shooting itself, were not, for Edie, exempt from prescriptions of manly politeness and refinement. The physical competence involved is akin to elite eighteenth-century French women's mastery of exquisite furniture evoked by Mimi

Hellman: 'to operate ... objects smoothly, individuals had to be intimately familiar with them [suggesting] a usage was a kind of joint performance by both person and thing'.[95] Such materiality at play here – the dynamic interaction between the material body and the material object – helped make this material masculinity meaningful and knowable. In application to shooting then, to be a good sportsman, gentlemen had to provide an easy and calm operation of a complex and, more importantly, dangerous weapon. Men's mastery of arms was part of their construction and expression of chivalric and martial but also refined masculinity. This mastery over both person and thing was aided by material knowledge. Edie gave advice on 'the knowledge of a good fowling-piece', 'the ordering and managing of a gun', gun accoutrement. The material knowledge and material upkeep of guns illustrates the tempering of what is a dangerous activity through technological material knowledge. Shooting required refinement and finesse of both body and object. For Edie, to be a successful marksman required simply a 'good gun, a cool and steady aim, and practice'.[96] But this belies the privileges and powers the sporting gentleman had to have access to: consumer and material knowledge, commercial centres, financial wealth, and the embodied qualities prescribed and practised by gentlemen, such as poise, patience, control, and decisiveness. To embody the gentleman sportsman in eighteenth-century England was thus a difficult as well as dangerous task.

The gentleman sportsman at home

Thus far, a picture emerges of the elegance and sophistication required of the gentleman sportsman. If guns were object d'art and prized as objects of curiosity and cultivation, this begs the question, where were they were stored and displayed in the domestic interior? The following discussion examines the presence of guns in country house inventories ranging across the seventeenth and eighteenth centuries. In the seventeenth century, Helmingham Hall, the Suffolk estate of the newly titled Tollemache baronets, was an archetypical material world of the seventeenth-century lesser nobility.[97] A household inventory recorded that the Great Hall bristled with heraldic objects, weaponry, and hunting paraphernalia, including a hawk's perch and

stags' and bucks' heads.[98] Sir Lionel had been deputy lieutenant of Suffolk since 1614, which potentially accounts for Helmingham's armoury, containing 35 objects concerning military armament.[99] Alongside the marble fireplace, wall and window hangings, chess and writing tables, and gilt boxes in Sir Lionel Tollemache's richly furnished 'Great Parlour', sat an array of swords and guns. The storage and display of weaponry alongside hunting equipment shows that the association between militaristic and hunting male identities was also played out in material form. The adjoining closet contained 'diverse small things', including boxes, guns, crossbow cases, quails nets, hampers, and horse bits.[100] Despite its function in the seventeenth century as a place for the family to socialise, eat, and entertain, the Great Parlour was an altogether masculine space, populated with both new, and fashionable, and old, and quintessential male, objects, which were utterly typical furnishings of a rural seat. At Helmingham, hunting trophies were displayed in the front-facing parts of the early modern country house – which often served as spaces in which estate management was conducted and servants and tenants would dine – and the hunting weapons in the more private, intimate space of the chamber. These hunting weapons, therefore, were personal objects; more than merely utilitarian tools to rid the estate of vermin and pests or to defend the moated hall, they were, instead, collected and displayed as markers of identity.

Sir Lionel's widow Elizabeth married John Maitland in 1672, who became Duke of Lauderdale later that year. At Ham House, Elizabeth's ancestral home on the bank of the Thames in Richmond, the Lauderdales set about updating the house's Jacobean H-plan to resemble mid-seventeenth-century French palaces, redecorating and refurnishing the house to suit their new titles and tastes. Inventories made in 1677, 1679, and 1683 record a similar wealth of armorial and sporting objects to Helmingham, with Ham's 'Great Hall' displaying 19 guns in 1677, 22 guns in 1679, and 20 guns in 1683. Examining the furnishing of Ham, Christopher Gilbert and Peter Thornton argue that while the uncertainty of the Interregnum, and the Lauderdales' close connection to the Restoration court could account for the overt and conspicuous display of weaponry and arms, it was much more likely that these objects were displayed formally as a conventional feature of seventeenth-century country house interior decoration.[101]

A completely new material culture at Helmingham appears in the 1708 household inventory: hot drinks equipment, delftware, glassware, and an abundance of art and decorative plasterwork and marble.[102] Helmingham changed architecturally, too, with a new suite of apartments for Lord and Lady Tollemache respectively formed from old rooms. In the 1708 inventory the hall's decorative hunting furnishings, such as the 2 bucks' and 13 stags' heads, the hawk's perch, and most of the weaponry recorded in the 1626 inventory, were replaced with family portraits and pictures in gilt frames.[103] Hunting equipment and arms comprised one-third of the hall's contents in 1626, but by 1708 the vast majority of the hall's contents were pieces of art.[104] The Tollemaches had inherited the Earldom of Dysart, and perhaps the weaponry was perceived insufficiently sophisticated furnishings for an earl; as the Tollemache property portfolio increased, some goods could have been moved between estates. However, despite the decreased material presence of hunting in the hall, hunting objects were relocated and displayed in newly created private spaces. In the 1741 household inventory, in a chamber in an apartment of private rooms for the family, now on the first storey, there was a collection of hunting paraphernalia belonging to the fourth earl's son, Lord Huntingtower. It consisted of a bridle, saddle, and horse furniture, two red pistol cases, and Kirby's *Survey of Suffolk*. In the 'red room' there was a 'large long square chest, in which are 6 green water'd stuff window curtains, 1 old green cushion, 3 guns, 1 halbert, 2 fishing rods'.[105]

The three Helmingham inventories demonstrate that changes in early modern household structure and changing perceptions and use of domestic space influenced the display and storage of hunting and shooting paraphernalia. By the 1708 and 1741 inventories at Helmingham, there was no longer an overt display of military weapons and hunting equipment in the Great Hall. The relocation of sporting equipment and trophies at Helmingham, from the Great Hall to more personal rooms, can be explained by changing attitudes to, and uses of, social space in the country house. By the seventeenth century, Mark Girouard writes, country houses' 'great halls' were used less frequently for communal dining between the family and household.[106] The seventeenth-century introduction of private dining parlours for the family, back stairs, servants' halls, and even servants' annexes attest to landed families' growing desire for privacy and a

spatial separation between the 'family' and 'household'. As the hall's function changed, so too did its decoration; arms and armours were still hung in great halls, no longer for use but as decoration, and by the eighteenth century they were often replaced by classical hunting scenes in relief plasterwork. The pacification of elites was, seemingly, complete.[107] By both the 1708 and 1741 inventories, England had recovered from the instabilies of the Civil War and had no serious land invasions from foreign powers. This internal stability, combined with the increased professionalisation of the eighteenth-century standing army after the Restoration and Glorious Revolution, decreased the need for military weaponry to be both stored and conspicuously displayed in the front-facing spaces of aristocratic and gentry country houses.[108] As such, blood sports and their paraphernalia had a much more powerful ability to indicate martial masculinity as the traditional weaponry displayed in country houses declined in importance. The introduction of *enfilade* apartments at Helmingham was also part of the re-articulation of seventeenth-century domestic space; social rooms increasingly had gendered associations based on their function which, by the mid-eighteenth century, also influenced their decoration.[109] The appearance of hunting and sporting equipment in these new gendered apartments speaks to these objects no longer being emblematic of the family's status and lineage but of the personal exploits and pleasures of the Master.

Like the Helmingham Hall inventories, a probate inventory taken upon the death of the Earl of Lichfield of Ditchley Park, Oxfordshire in 1772 records a plethora of hunting-related objects similarly located in more 'private' rooms. In a closet adjoining Lord Lichfield's library and dressing room, the inventory records a material world of polite, cultivated elite masculinity.[110] Amongst the 'apparatus for Printing and Bookbinding' and array of musical instruments there was 'A Neat fowling Piece, by Harman, Silver Mounted, & a short Barrell to Ditto, A Riffled Barrell Gun, 2 brass blunderbusses, One steel ditto, a brace of pistols, 3 swords a hanger & 2 powder flasks'.[111] The description of the 'neat' fowling piece is rare in any inventory and here it receives more description than other weaponry. Neatness connoted tasteful, unshowy, and well-executed craftsmanship, and the appraiser's description signals Lichfield's appreciation of quality craftsmanship and tasteful aesthetics.[112] That these objects were recorded in a library closet at the end of a suite of Lichfield's private

rooms and were assembled alongside technological and mechanical objects associates them with a particular kind of gendered material knowledge. Lichfield was a renowned huntsman and his love for hunting was also displayed within more communal living spaces at Ditchley; in the music room, containing only a 'German Flute', hung hunting scenes by Rubens, Irish portrait painter James Worsdale, and a landscape of the Jacobite-supporting Lichfield and his uncle shooting in their Beaufort Hunt blue frockcoats by John Wootton.[113] Like the replacement of weaponry and hunting trophies at Helmingham with artwork, at Ditchley, hunting was represented in a more aestheticised form – less the exhibition of hunting exploits and more the material display of the polite, cultivated, and political gentleman sportsman.

The probate inventory made on the death of Charles Watson-Wentworth, the Marquess of Rockingham, in 1782 at Wentworth Woodhouse records 35 sporting guns and pistols in a gun closet adjoining Lord Rockingham's antechamber on the new, expansive Palladian east front. A wealth of equestrian portraiture in the Red Drawing Room preceding the gun closet and the adjoining antechamber included many by Rockingham's famed equestrian painter protégé George Stubbs. As at Helmingham, Ham, and Ditchley, hunting and equestrian pursuits were present in the country house's material culture, not as hunting trophies and stags' heads, but as aestheticised and pacified representations of the gentleman sportsman. The eighteenth-century introduction of a gun closet into stately houses – the Spencers also built one at Althorp House in the eighteenth century – indicates the decrease of elites' personal military powers. Importantly, though, the gun closet was not a replacement armoury but more a cabinet of curiosities. The Rockingham closet contains guns from British gunsmiths such as W. Turvey, Griffin & Tow, Edward Newton, and Thomas Singleton as well as guns from Germany, France, Spain, Russia, and an Italian gun made in Pistoia, a famed Tuscan gun-producing town.[114] These continental guns could have been acquired during Rockingham's four-year Grand Tour of Geneva, Italy, Austria, Prussia, Hanover, and Brunswick.[115] Elite eighteenth-century gun owners did not always buy domestically produced guns, but would often combine European gun components, in particular barrels, that they brought back from their Grand Tour.[116] The 4th Earl of Aylesford had an older seventeenth-century

Turkish-made barrel mounted onto a contemporary gun by London gunsmith John Twigg in 1779.[117] The Turkish barrel is richly engraved with floral detailing and a foresight in the shape of a classical figure, with the butt of the gun carved with a rococo shell and carved chequering. The combined affect is a consistent decorative scheme combining European and Ottoman design elements with British craftsmanship. As Rockingham was an avid antiquarian collector of Roman coins, and a collector and patron of European and British art and sculpture, guns were as much objects of cultivated taste and material discernment as the ancient Roman sculptures and Italian masterpieces that graced Rockingham's Wentworth Woodhouse.[118]

These inventories combined indicate that sporting material culture was less likely to be kept in 'front-facing' spaces from the 1740s onwards. In a 1792 probate inventory of Houghton Hall – the Palladian pile of the earls of Orford – on the death of the bachelor third earl reveals a unique spatial attitude to hunting objects. At Houghton, the eastern block of rooms on the ground storey was given over to the display of hunting material culture and its sociable functions. Girouard notes that the use of heavier rustication on the ground story facade, rather than, as typical, the *piano noble*, indicates this floor's more 'traditional' function.[119] The entrance 'Arcade Hall' contained 'Four Staggs heads', which spoke to the current earl's sporting lineage and is similar in design and decoration to a baronial hall, with groin vaulted arches and unpainted stone walls. The adjoining 'Hunting or Sportsman's Hall' is a rare example of a room functioning specifically for the display of hunting equipment and pre- and post-hunt conviviality. Like the 'Arcade Hall', it, too, contained a stag's head as well as 'a large mahogany oval dining Table, 2 japanned frames with tray tops, a marble table on a mahog[an]y frame, a deal Table, an Easy Chair covered with leather, Thirteen Chairs with leather seats ... a Map of the County of Norfolk'. Here, new, modern luxury furnishings sat alongside old emblems of elite status. As at Helmingham, Ditchley, and Osterley, scientific instruments were recorded in the same rooms as shooting equipment; the 'Breakfast Parlour' adjoining the 'Supping Room' contained a barometer as well as a pair of gun racks, a dressing table and mahogany dining table.[120] Barometers, a seventeenth-century invention, were used to predict changes in the weather and, as hunting and shooting were always contingent on good weather conditions,

the barometer is a practical inclusion here in a room the sportsmen used before they set out for the day's diversion.[121] The sportsmen, presumably, used the dressing table, a surprising inclusion, to fix their sporting attire before or after the day's exploits. At Houghton in 1792, older, traditional sporting material culture, hunting trophies, and stags' heads sat alongside objects of politeness and science.

The Helmingham, Ham, Ditchley, Osterley, and Houghton inventories detail the sporting material culture of landed and titled men, but the changing location of hunting material culture from public, household spaces to more individual and intimate spaces also occurred in the houses of the gentry. The 1690 probate inventory of Edward Pershouse, a gentleman-lawyer of Lower Gournall in Staffordshire, recorded a fowling piece worth 13 shillings in the hall alongside a table, bible, cradle, and an array of brass and pewter goods.[122] In a 1701 probate inventory of Suffolk gentleman Henry Stebing's property, the hall contained 'two short small guns'.[123] However, in a 1728 probate inventory for Thomas Waldgrave of Thurlon Magna, Suffolk there were no guns or fowling pieces recorded in communal, public-facing rooms, but rather in individual rooms: 'two guns, two pistols, a silver hilted sword, two ditto a whip, two pairs of spurs' were found in the upstairs 'Red Chamber', and 'a gun and a brase of pistols' were located in the 'Yellow Chamber'.[124] The seventeenth-century inventories from Helmingham and Ham, and the eighteenth-century inventories at Ditchley, Wentworth Woodhouse, Osterley, and Houghton – houses of the leading men of their day – follow a similar pattern of sporting material culture remaining present in the home, but moving to more private, male associated spaces by the earlier part of the eighteenth century. This transition occurred in both the houses of the titled and the gentry.

As with the hunting material culture in the Ditchley, Osterley, and Houghton inventories, luxurious and status-displaying goods, such as mahogany furniture and objects of polite education and gendered attributes like swords and globes, were also found in the homes of the gentry. In the Smoking Room, in a 1733 probate inventory of Northill Manor, Bedfordshire, owned by wealthy gentleman Owen Thomas Bromsall, there was wainscot and walnut furniture, silver-trimmed upholstery, and a pair of globes, alongside an abundance of weaponry and hunting equipment with militia and mourning swords displayed amongst a pair of pistols, a blunderbuss, a fowling

piece, and four muskets.[125] An equally gentlemanly assemblage was recorded in a 1766 inventory of Hinwick House owned by John Orlebar Esq. His dressing room contained a 'cane couche, walnuttre Escrutore' as well as a 'brass barrell blunderbuss, a Rifle barrell Gun and powder horn, 5 Fowling Pieces, 4 pairs of Pistols, 4 old Swords with Mettle hilts, 4 old whips, ... a pewter shaving pott and plate'.[126] Sporting material culture in homes of both peers and gentlemen thus changed in similar ways. Sporting paraphernalia moved to more private and gendered domestic spaces at a similar time in the homes of the gentry and peerage. However, there does seem to be a distinction between aristocratic men's houses that had specific spaces for pre- and post-hunt conviviality, such as Walpole's Sportsman's Hall, and spaces purposefully dedicated to gun display, such as Rockingam's gun closet, and the houses of the gentry.

These select examples point to wider changes in masculine material expression in the eighteenth century. The movement of hunting goods to increasingly more private and gendered spaces in these country house inventories is linked to the 'civilising process'. Sociologists Norbert Elias and Jonah Brundage, and historians Philip Carter and Robert Shoemaker, have all argued that with new polite modes of masculine behaviour, honour and civility became less militaristic and violent.[127] This pacification can be seen in domestic material culture as portraiture replaced pikes and spears in front-facing spaces, and sporting guns, fishing rods, and horse furniture were now located within men's personal rooms. These eighteenth-century country house inventories confirm that elite masculine behaviour became increasingly pacified in the early modern period, reflected in the changing location of sporting objects in the country house and the objects displayed alongside them. While hunting and shooting were more popular and accessible to a wider variety of men in the eighteenth century than ever before, they became more ritualised forms of sport. The introduction of hunting clubs, which mimicked the eighteenth century's flowering club and society culture, the ritualisation of foxhunting, and the ritual days in the shooting calendar, such as the Glorious Twelfth and Moor Game Day, demonstrate that there was a growing emphasis on sociability and hospitality, alongside the traditional blood and slaughter.

Nevertheless, country sports still enabled men to perform long-standing cultural prescriptions of masculine martial heroism on the

sporting field. Indeed, the materialisation of martial masculinity remained in the country house across the period of these inventories, but the material objects that helped construct this martial masculinity changed. Stags' heads were replaced with sporting portraiture. Sporting guns were no longer displayed alongside pikes and spears but telescopes, globes, and barometers. Notably, at Houghton these objects were in adjacent rooms and worked to combine both Walpole's hunting lineage, scientific knowledge, and polite cultivation. In this context, sporting material culture in the country house shifted from hunting trophies to instruments of polite, gentlemanly learning – notably as hunting itself was becoming a 'science' under Hugo Meynell. Militaristic masculinity was now grounded in an intellectual and scientific material culture that showcased an appreciation and engagement in enlightened knowledge, technological innovation, maritime exploration, and global expansion.[128] Violence and refinement went hand in hand.

This objectscape of polite and enlightened science and sporting instruments may at first seem contradictory.[129] After all, enlightenment empiricism was fundamentally a democratisation of knowledge whereas blood sports were the preserve of an exclusive elite. But these objects do share similar qualities and functions; they were commercially desirable and fashionably designed, made by skilled artisans and innovators, and had both a decorative and utilitarian function within the home. Globes, telescopes, barometers, and guns had a masculine consumer appeal as objects associated with technological innovation, complex ingenuity, and gadgetry. But there remains a fundamental contradiction. Scientific instruments enabled men to engage in an exploration and appreciation of God's natural creation. Sporting guns were a symbol of, and a tool in, men's dominance over the natural order. But as this chapter has repeatedly shown, sporting culture was not antithetical to refined and polite gentlemanliness.[130] Rosalind Carr's study of duelling in enlightenment Scotland notes that writers such as Smith and Hume did not find martial violence antithetical to commercial refinement and civility. In social instances of masculine inter-personal violence in urban Scotland, Carr found that urban violence often occurred in typically polite spaces and was instigated by professional men eager to assert chivalric honour to precariously claim gentlemanly status. Martial masculinity was thus not immune from enlightenment thought or

the practices of polite society.[131] It is perhaps unsurprising that polite and enlightened violence was found in the urban spaces of London and Edinburgh. That objects of enlightened violence, such as sporting technologies and instruments, appear in the provinces speaks to the portability of politeness for the gentleman sportsman operating between urban and provincial spaces of elite leisure. Material and technological knowledge was a requirement of both the polite man of science and the gentleman sportsman, and worked together to charge this material masculinity with potent social and political power.

Despite the pacification of elite masculinity, the gentility and politeness of the 'gentleman sportsman' was still connected to Britain's military power, which, in turn, was connected to the Empire – however distant imperialism might have seemed on the grouse moor. As globes and barometers were the product of Britain's naval prowess and imperial expansion, it is unsurprising that sporting guns were displayed alongside them. Indeed, materially, the spoils of empire and exotic luxury decorated the elite sporting guns studied here.

Conclusion

Although not often discussed by historians of masculinity, the gentleman sportsman was a materially constructed and practised masculine identity in eighteenth-century England. This chapter has unearthed elite men's investment in the material culture of blood sports to forge an elite gentlemanly persona. Men's consumption of guns was bound up in luxury consumer behaviour yet was immune from the criticism of effeminacy as hunting and shooting were 'manly' pursuits and formed part of elite men's legal, political, and social privilege and power. Yet the changing design and display within the country house of elite men's sporting guns is indicative of these objects' polite status; as the masculine cultural ideal changed from chivalric honour to refined politeness, so too did men's material culture. Material objects were central to the self-fashioning and display of elite masculinity across the eighteenth century. The movement of the gun collection's location in the country house denoted changing associations between the placement of objects and the representation of power and of personal identity. Martial prowess continued to be

Gentleman sportsman: collecting trophies 237

materially important to these men in understanding their place in the eighteenth-century social order. Guns, and the paraphernalia associated with them, remained integral to the 'gentleman sportsman', but his masculinity was also demonstrated in objects of global luxury, polite science, and entertainment. Elite men materially curated a wide variety of complimentary facets of an elite 'masculine' identity. Their interaction with genteel, polite sporting material culture proves that blood sports were not an 'escape from politeness' or luxury but were entrenched in its material and consumer characteristics.

Notes

1 Ann Bermingham, *Landscape and Ideology: The English Rustic Tradition, 1740–1860* (Berkeley, CA, 1986), 29. Also see Kate Retford, *The Conversation Piece: Making Modern Art in Eighteenth-Century Britain* (New Haven, CT and London, 2017), 150–1.
2 E. P. Thompson, *Whigs and Hunters: The Origins of the Black Act* (London, 1975); P. B. Munsche, 'The Game Laws in Wiltshire 1750–1800', in J. S. Cockburn (ed.), *Crime in England: 1550–1800* (London, 1977), 212–13; P. B. Munsche, *Gentleman and Poachers: The English Game Laws, 1671–1831* (Cambridge, 1981); David C. Itzkowitz, *A Peculiar Privilege: A Social History of English Foxhunting, 1753–1885* (Brighton, 1977), 113–34; Thomas S. Hendricks, *Disputed Pleasures: Sport and Society in Preindustrial England* (Westport CT, 1991); Paul Langford, *Public Life and the Propertied Englishman, 1689–1798* (Oxford, 1991); James M. Rosenheim, *The Emergence of a Ruling Order: English Landed Society, 1650–1750* (London and New York, 1998); Emma Griffin, *Blood Sport: Hunting in Britain since 1066* (New Haven, CT, 2007), 43; Buchanan Sharp, *In Contempt of All Authority: Rural Artisans and Riot in the West of England, 1586–1660* (London, 2010); Mandy de Belin, *From the Deer to the Fox: The Hunting Transition and the Landscape, 1600–1850* (Hatfield, 2013).
3 Linda Colley, *Britons: Forging the Nation, 1707–1837* (New Haven, CT, 1992), 173–5; Amanda Vickery, *The Gentleman's Daughter: Women's Lives in Georgian England* (New Haven, CT, 1999), 213–15.
4 Philip Dormer Stanhope, Earl of Chesterfield, *Lord Chesterfield's Letters*, (ed.) David Roberts (Oxford, 1992), 232–3.
5 Lawrence Stone and Jeanne C. Fawtier Stone, *An Open Elite? England 1540–1880* (Oxford, 1986), 415.

6 BL. Add MS 83073.
7 For examples of game books see Nottinghamshire Archives. DD/E/37; Norfolk Record Office. WLP 5/1; NRS 7963, 42A3; NRS 7966, 42A3; BL. Add MS 78048.
8 The game books of the Adair baronets of Flixton Hall in Suffolk were maintained by their gamekeepers, see Suffolk Record Office. HA12/D22/1-3.
9 Nottingham Archives. DD/Sk 217, 1-6. I am grateful to Amanda Vickery for this reference.
10 BL. Add MS 78075.
11 See Raymond Grant, *The Royal Forests of England* (Wolfeboro Falls, 1991).
12 A series of rural riots by rural artisans and skilled labourers concerning the enclosure of forest lands in Dorset, Worcestershire, Gloucestershire, Wiltshire, and Leicestershire between 1626 and 1632; see Sharp, *In Contempt of All Authority*.
13 Munsche, *Gentleman and Poachers*, 14; Thompson, *Whigs and Hunters*, 119.
14 Sir William Blackstone, *Commentaries on the Laws of England in Four Books*, vol. II. (Philadelphia, 1893), 72.
15 The property qualification value stayed the same until the 1831 Act that repealed the property qualification and lowered the duty on game certificates to £3 13s 6d, see Munsche, *Gentlemen and Poachers*, 21.
16 Before the 1762 Game Act, shooting partridges and pheasants was only restricted in July and August and no season was prescribed for black game and grouse shooting.
17 BA. L 30/11/240/87. 'Mary to Amabel' (8 August 1799); LA. DBB/81/24 (1775).
18 This was certainly the case with correspondence in the Wrest Park Collection at BA. Also see the letters of Yorkshire gentry in the Spencer-Stanhope correspondence at the West Yorkshire Archives Services, Bradford.
19 BL. Add MS 78048.
20 Tom Rose, 'Hunting, Sociability, and the Politics of Inclusion and Exclusion in Early Seventeenth-Century England', in Naomi Pullin and Kathryn Woods (eds), *Negotiating Exclusion in Early Modern England, 1550-1800* (London, 2021), 161-78.
21 Stone and Fawtier Stone, *An Open Elite?*, 215.
22 See Thompson, *Whigs and Hunters*; Munsche, 'Game Laws in Wiltshire', 213-14, 223; Munsche *Gentleman and Poachers*, 28-51; Douglas Hays, 'Poaching and the Game Laws in Cannock Chase', in Douglas Hay

(ed.), *Albion's Fatal Tree: Crime and Society in Eighteenth-Century England* (New York, 1976).

23 Munsche, *Gentlemen and Poachers*, 18.

24 The boorish country squire was a popular character type throughout eighteenth-century literary culture. For example, Squire Western in Henry Fielding's *Tom Jones* (1749), George Dennison in Tobias Smollett's *Humphrey Linker* (1771), Sir Thomas Sindall in Henry Mackenzie's *The Man of the World* (1773), and Lord Merton in Frances Burney's *Evelina* (1778).

25 Lawrence E. Klein, 'Property and Politeness in the Early Eighteenth-Century Whig Moralists: The Case of *The Spectator*', in John Brewer and Susan Staves (eds), *Early Modern Conceptions of Property* (London, 1995), 224.

26 Anon., *An Essay on Hunting by a Country Squire* (London, 1733), 5–6. Emphasis in original.

27 BA. L 30/14/333/62. 'Fritz to T. Robinson' (14 September 1770). Lancashire gentleman Ralph Standish Howard's ambivalence toward metropolitan polite amusements and longing for hunting and shooting in Lancashire see Vickery, *Gentleman's Daughter*, 214.

28 This oppositional distinction between urban and rural, landed and moneyed is, doubtlessly, not universal. Langford, *Public Life*, 307–8.

29 HL. mssTD Correspondence Box 24, TD 1775. 'John Townshend, Viscount Sydney, Grosvenor Square to Richard Leigh Esq.' (May 1810).

30 This particularly affected more plebeian animal entertainments such as bullbaiting and cockfighting. See Langford, *A Polite and Commercial People: England, 1727–1783* (Oxford, 1989), 505; Vickery, *Gentleman's Daughter*, 241–2.

31 Langford, *Public Life*, 45.

32 For studies on French hunting guns see Amy Freund, 'Men and Hunting Guns in Eighteenth-Century France', in Jennifer G. Germann and Heidi A. Strobel (eds), *Materializing Gender in Eighteenth-Century Europe* (Farnham, 2016), 17–34.

33 See Maxine Berg, *Luxury and Pleasure in Eighteenth-Century Britain* (Oxford, 2006), 278.

34 W. K. Neal and D. H. L. Back. *Great British Gunmakers, 1740–1790: The History of John Twigg and the Packington Guns* (London, 1975), 45; Nigel Brown, *British Gun Makers*, vol. 1 (Shrewsbury, 2004), 76–8.

35 Peter Hawker, *To Young Sportsmen in all that Relates to Guns and Shooting* (London, 1844).

36 BM. 69.36
37 WSRO. PHA/8053; WSRO. PHA/9271; BL. Add Mss 61678; HL. Townshend Family Papers, Box 65 (5).
38 WSRO. PHA/8045; PHA/8050; PHA/8051; PHA/7962; PHA/9271.
39 Edie, *Art of Shooting*, 20; Viscount Sydney often sent his guns to John Manton in time for the shooting season, see HL. Townshend Family Papers, Box 65 (4).
40 Shropshire Archives. 484/176; Cornwall Record Office. WM/420.
41 Christie's Sale 8934.
42 Neal and Black, *Great British Gunmakers*, 34.
43 Neal and Black, *Great British Gunmakers*, 43.
44 Brown, *British Gun Makers*, 11.
45 Edie, *Art of Shooting*, 5.
46 Neal and Black, *Great British Gunmakers*, 35–6.
47 BM. Heal,69.27
48 BM. Heal,69.36
49 For more on men's technological material culture, see Amanda Vickery, *Behind Closed Doors: At Home in Georgian England* (New Haven, CT and London, 2009), 261–5.
50 BM. Heal,69.64
51 BM. D,2.2102
52 BM. D,2.2103
53 BM. Heal,69.22
54 Berg, *Luxury and Pleasure*, 274.
55 BM. D,2.2103
56 BM. Heal,69.50
57 BM. D,2.2066
58 Bristol Reference Library. 'William Heard, Gun-Maker, Trade Card'.
59 Priya Satia, *Empire of Guns: The Violent Making of the Industrial Revolution* (New York, 2018), 230–60.
60 See Margot Finn, 'Swallowfield Park, Berkshire: From Royalist Bastion to Empire Home', in Margot Finn and Kate Smith (eds), *The East India Company at Home, 1757–1857* (London, 2019), 216.
61 Joseph Sramek, '"Face Him like a Briton": Tiger Hunting, Imperialism, and British Masculinity in Colonial India, 1800–1875', *Victorian Studies* 48.4 (2006), 659–80.
62 BM. Heal,69,64
63 BM. Heal,69,16; Banks,69.5; Banks,69.11
64 Colley, *Britons*, 174.
65 For examples see Nicholas Cox, *The Gentleman's Recreation* (London, 1686).
66 BA. L 30/13/12/32. 'Amabel, Wrest to Mary' (9 November 1775).

67 Blackstone, *Commentaries*, 413–14.
68 John Byng, Viscount Torrington, *The Torrington Diaries*, (ed.) C. B. Andrews (New York, 1938), 10.
69 Stanhope, *Lord Chesterfield's Letters*, 232–3.
70 Vickery, *Gentleman's Daughter*, 214.
71 BM. Heal,69.26; Heal,69.6
72 Alistair Mutch, 'Connecting Britain and India: General Patrick Duff and Madeira', *East India Company*, 347.
73 Mutch, 'Connecting Britain and India', 347, fn.49.
74 BM. D,2.124; Banks,69.43
75 Berg, *Luxury and Pleasure*, 272–5.
76 This sample was taken from Christie's Sale 8934, 9 November 2000; Bonham's, Sale 13738. (10 November 2005).
77 Helen Clifford, *Silver in London: The Parker and Wakelin Partnership, 1760–1776* (New Haven, CT, 2004), 107–8.
78 John Styles, 'Product Innovation in Early Modern London', *Past & Present* 168 (2000); 149; Ilja Van Damme, 'From a "Knowledgeable" Salesman Toward a "Recognisable" Product? Questioning Branding Strategies before Industrialisation (Antwerp, Seventeenth to Nineteenth Centuries)', in Bert de Munck and Dries Lyna (eds), *Concepts of Value in European Material Culture, 1500–1900* (Abingdon, 2016), 75–130; Carlo Marco Belfanti, 'Branding Before the Brand: Marks, Imitations, and Counterfeits in Pre-Modern Europe', *Business History* 60.8 (2017), 1141.
79 See Elizabeth A. Williams, 'A Gentleman's Pursuit: Eighteenth-Century Chinoiserie Silver in Britain', *Materializing Gender*, 105–19.
80 Norbert Elias and Eric Dunning, *The Quest for Excitement: Sport and Leisure in the Civilizing Process* (Oxford, 1986); Richard Grassby, 'The Decline of Falconry in Early Modern England', *Past & Present* 157 (1997); 37–62.
81 Neal and Black, *Great British Gunmakers*, 169.
82 Christie's. Sale 8934, Lot Number 28.
83 Bonham's. Sale 13738. Lot Number 35.
84 Christie's. Sale 8934. Lot Number 74.
85 Donna T. Andrew, 'The Code of Honour and its Critics: The Opposition to Duelling in England, 1700–1850', *Social History* 5 (1980), 409–34; Robert B. Shoemaker, 'Male Honour and the Decline of Public Violence in Eighteenth-Century London', *Social History* 26.2 (2001), 190–208; Robert B. Shoemaker, 'The Taming of the Duel: Masculinity, Honour and Ritual Violence in London, 1660–1800', *Historical Journal* 45.3 (2002), 252–545; Philip Carter, *Men and the Emergence of Polite Society: Britain, 1660–1800* (London, 2001);

Michèle Cohen, '"Manners" Make the Man: Politeness, Chivalry, and the Construction of Masculinity, 1750–1830', *Journal of British Studies* 44.2 (2005), 312–29.
86 Jonah Stuart Brundage, 'The Pacification of Elite Lifestyles: State Formation, Elite Reproduction and the Practice of Hunting in Early Modern England', *Comparative Studies in Society and History* 58.4 (2017), 786–817, 802.
87 Neal and Black, *British Gun Makers*, 101.
88 Cox, *Gentleman's Recreation*, 2.
89 Robert Howlett, *The School of Recreation* (London, 1701); Peter Beckford, *Thoughts on Hunting* (London, 1788), 7–8.
90 John Smallman Gardiner, *Essays on Hunting* (London, 1782), vii.
91 Sarah Goldsmith, *Masculinity and Danger on the Eighteenth-Century Grand Tour* (London, 2020), 111–39.
92 George Edie, *The Art of English Shooting* (London, 1775), 14, 16.
93 Beckford, *Thoughts on Hunting*, 7.
94 Edie, *Art of English Shooting*, 21, 25.
95 Mimi Hellman, 'Furniture, Sociability, and the Work of Leisure in Eighteenth-Century France', *Eighteenth-Century Studies* 32.4 (1999), 424–34.
96 Edie, *Art of English Shooting*, 16.
97 The Tollemaches were an ancient Suffolk land-holding family and held property in the county since the thirteenth century.
98 Moira Coleman (ed.), *Household Inventories of Helmingham Hall 1597–1741* (Woodbridge, 2018), 113.
99 'TOLLEMACHE (TALMASH), Sir Lionel, 2nd Bt. (1591–1640)', in Andrew Thrush and John P. Ferris (eds), *The History of Parliament: The House of Commons 1604–1629* (Cambridge, 2010).
100 Coleman, *Household Inventories of Helmingham*, 49.
101 Christopher Gilbert and Peter Thornton, 'The Furnishing and Decoration of Ham House', *Furniture History* 16 (1980), 41.
102 This material culture of novel goods is typical of early eighteenth-century elite households; see Lorna Weatherill, *Consumer Behaviour and Material Culture in Britain, 1660–1760* (London, 1988), 147–8.
103 Coleman, *Household Inventories of Helmingham*, 113.
104 For more on how sporting art replaced hunting trophies see Stephen Deucher, *Sporting Art in Eighteenth-Century England: A Social and Political History* (New Haven, CT, 1988), 34.
105 Coleman, *Household Inventories of Helmingham*, 147, 148.
106 Mark Girouard, *Life in the English Country House: A Social and Architectural History* (New Haven, CT, 1978), 30–1.

107 Girouard, *English Country House*, 136. Also see Mark Overton et al. (eds), *Production and Consumption in English Households 1600–1750* (London, 2012), 114.
108 For discussions of the decline of militaristic gentry masculinity over the seventeenth and eighteenth century, see Karen Harvey, 'The History of Masculinity, circa 1650–1800', *Journal of British Studies* 44 (2005), 308; Alexandra Shepard, 'From Anxious Patriarchs to Polite Gentlemen? Manhood in Britain, circa 1500–1700', *Journal of British Studies* 44 (2005), 286–7; Matthew McCormack, *Embodying the Militia in Georgian England* (Oxford, 2015), 20–1. For work on the gentry's changing role in local administration over the sixteenth and seventeenth century, see Felicity Heal and Clive Holmes, *The English Gentry, 1500–1700* (London, 1994).
109 Girouard, *English Country House*, 154; Tita Chico, *Designing Women: The Dressing Room in Eighteenth-Century English Literature and Culture* (Cranbury, 2005), 67–8.
110 It details the private room of a man in the final years of his life – Lichfield was in fact only 52 when he died – as it contained 'a Neat Mahogy Invalid's Chair' and a 'Gouty Stool'.
111 T. V. Murdoch, Candace Briggs, and Laurie Lindey (eds), *Noble Households: Eighteenth-Century Inventories of Great English Houses. A Tribute to John Cornforth* (Cambridge, 2006), 156.
112 Vickery, *Behind Closed Doors*, 180.
113 Wooton's piece is most likely the 1744 landscape held by the Tate, see The Tate, London. N04679.
114 Sheffield City Archives. WWM/A/1204.
115 S. M. Farrell, 'Wentworth, Charles Watson, Second Marquess of Rockingham (1730–1782), Prime Minister'. *ODNB*. 23 September 2004.
116 Neal and Black, *Great British Gunmakers*, 99.
117 Neal and Black, *Great British Gunmakers*, 29. Plates 25–28.
118 For more on Rockingham as a collector see Viccy Coltman, *Classical Sculpture and the Culture of Collecting in Britain since 1760* (Oxford, 2009), 273–8.
119 Girouard, *English Country House*, 160–1.
120 Murdoch, *Noble Households*, 193.
121 See Nicholas Goodison, *English Barometers, 1680–1860: A History of Domestic Barometers and Their Makers* (Woodbridge, 1977).
122 John S. Roper, *Sedgley Inventories 1614–1787* (Woodsetton, 1960), 91.
123 TNA. PROB 32/42/217.
124 TNA. PROB 31/54/55.

125 James Collett-White (ed.), *Inventories of Bedfordshire Country Houses 1714–1830* (Bedford, 1995), 189.
126 Collett-White, *Bedfordshire Country Houses*, 97–8.
127 Elias and Dunning, *Quest for Excitement*; Brundage, 'Pacification of Elite Lifestyles', 802.
128 Vickery writes that the barometer was the by-product of Britain's booming maritime culture, see Vickery, *Behind Closed Doors*, 262.
129 See Alice N. Walters, 'Conversation Pieces: Science and Politeness in Eighteenth-Century England', *History of Science* 35.2 (1997), 121–54.
130 Vickery, *Behind Closed Doors*, 262.
131 Rosalind Carr, *Gender and Enlightenment Culture in Eighteenth-Century Scotland* (Edinburgh, 2014), 142–74.

Conclusion: making men

That social credit had transferred from personal character to a material one may have angered reactionary moralists, but the eighteenth-century consuming populace eagerly and dynamically engaged with this important historical transformation. This increasingly materially oriented society engaged with material goods to make sense of what it meant to be a man or a woman, and how such identities – which were radically changing in this period – were expressed. Commercialisation was a driving force in determining experiences and identities as what position you currently held in the hierarchical social order was no longer solely determined by birth. My study of the masculine dynamics of these processes has centred on five 'material masculinities' – masculine identities formed through and reliant upon materiality to be meaningful. Purposefully broad in conception and application, these material masculinities speak to the material's significance for the operation of eighteenth-century masculinities and our historiographical understanding of such identity formation and experience. This concluding chapter returns to the 'key themes' outlined in the introduction and reflects on what is gained for thinking about masculinity materially.

Gendered power

For all of the stress on politeness and refinement, eighteenth-century England remained a patriarchal society. Patriarchal authority and domination were materially practised in two ways. Firstly, objects materialised abstract values and attributes and were themselves shaped by cultural ideas and ideals of patriarchal and hegemonic

masculinity. This began in childhood, in which boys and girls had gender-differentiated toys. The design and variety of these objects rigidly enforced gendered difference. In adulthood there was furniture for 'Gentleman' and 'Ladies'. Phaetons were materially altered to suit notions of female delicacy and male strength. The dangers of coach travel and carriage driving were part of their masculine appeal. Hunting guns were ornamented with natural scenes of flora and fauna. Gentlemen used these same guns to exert their 'natural' dominion over land, property, and its resources.

Second, in less abstract terms, patriarchal power influenced men's and women's consumer, domestic, and social practices. Coverture was complex in its application and practice, but at its heart it was a patriarchal legal custom that dictated men's and women's economic activity, consumer behaviour, and material cultures. Although men and women deployed similar consumer strategies to acquire and maintain goods, men were responsible for large-scale, whole house furniture orders. Men commissioned exorbitantly expensive carriages and were responsible for domestic expenditure on their continual maintenance. Women's carriage use was often at the discretion of male heads of the household; their mobility was restricted by men's legal status as property owners. As widows, women had small-scale, ad hoc engagement in the maintenance of carriages left by their husbands, and unmarried women had little economic independence beyond the generosity of their male relatives. However, men did think it was their manly duty to provide for their wives, unmarried sisters, and widowed mothers. In men's and women's consumer practice – their material preferences and social interaction with objects – their material culture reinforced established patriarchal norms and gendered distinctions.

While cultural commentators perceived a clear delineation between men's and women's material culture and consumer behaviour, in practice men and women often had similar material preferences and consumer desires. In their consumption of furniture, they sought to acquire a respectable or decorous assemblage of goods. Consumption of mahogany was determined by men's and women's ability to spend rather than any kind of gendered association. Mahogany furniture was often one the most repaired items in upholsterers' ledgers, and this illustrates its importance within the domestic interior. The conspicuous status of mahogany furniture was so important in

denoting wealth and taste that many middling customers ordered furniture to be made of cheaper woods and finished with mahogany or stained to imitate mahogany's reddish hues. The material qualities of consumer goods, their design, materials, and aesthetic finishes, were important to the men and women studied here. In their consumer practice, men and women, on the whole, spent a similar amount of money and bought a similar amount of goods from upholsterers – although male furniture consumers often were able to spend and purchase considerably more goods than women. Indeed, while the average order sizes and spends of middling consumers were similar, men bought a greater variety of tables and chairs, in an array of styles, colours, materials, designs, and finishes, than women. Men's and women's place in the social hierarchy informed their consumer behaviours and material preferences. Middling men and women were particularly concerned with the material their furniture was made from, while more elite furniture consumers privileged design and aesthetics over material.

Despite the persistent cultural anxiety that men's ownership of trinkets and small things made them effeminate, men owned and exchanged small objects and attached personal meanings to their material tokens. Men and women both used things to express emotion, fidelity in courtship, parental affection, and bonds of kinship and friendship. However, the meanings behind men's and women's gift-exchange were often gendered; the gifts men offered, such as a fine snuffbox or an elegant carriage, showcased what they could offer (social and financial security, fidelity, and affection) and what women could expect. Women's gifts (particularly needlework) revealed equally gendered expressions of duty, virtue, and subservience. Eighteenth-century objects had multivalent gendered meanings in different contexts and spaces. Snuffboxes, for example, were used in male homosocial spaces of the coffeehouse and tavern and were ritualised objects in men's club and society culture. They were often gifted to men for their diplomatic or military service. But they were also used by men and women in courtship culture and were bequeathed by both men and women without explicitly gendered motivations.

Men's and women's objects inhibited gendered places and spaces and charged them with gendered meaning. If we return to the opening of this book, Robert Child's closet at Osterley was a microcosm of a landed gentleman's material world; it held a mahogany shaving

stand, a silver-mounted sporting gun, fishing rods, and a Dollands telescope. His wife's adjoining dressing room contained a mahogany sofa, escritoire, Wedgwood vases, and watercolours of flowers and landscapes.[1] One significant difference in men's and women's material assemblages was that objects which had particularly technological characteristics, such as carriage elements and gun's mechanical components, were the preserve of men. Men had a particular material knowledge about these kinds of goods as they were part of the construction and display of a manly rational, scientific curiosity. It is noteworthy that men used these technological objects to exert their gendered and social power.

Social distinction

In this book, social position was a powerful determiner of masculine experience in eighteenth-century England. Middling and elite men across the eighteenth century were anxious about making 'a figure' – the requirement to acquire and maintain a suitably decorous material culture that reflected their age, rank or profession, education, taste, and marital status. A shabby coach, a cracked snuffbox, an unwieldy gun, or worn furniture upholstery could undermine men's claims to gentility and material discernment. While gentlemen could acquire furniture to curate a respectable domestic interior, commission magnificent carriages, purchase pretty snuffboxes, and procure a neat fowling-piece, these goods had to be maintained to retain their ability to denote their owners' refined taste. Gentlemen used material objects as a means to construct and maintain their social hegemony.

Just as gentlemanly masculinity was a carefully calibrated equilibrium of manly strength and refined gentility, gentlemen's material assemblages had to display a prudent magnificence. The suggestion that a man lived beyond his means and ostentatiously displayed new money or rank through things undermined manly ideals; it spoke to inauthenticity and a lack of rational self-governance. Indeed, men's dependency on things to form and express polite and refined gentility could easily be perceived as an effeminate weakness. But men's material practice often undermined, contradicted, and even ignored the characterisation of goods in the popular imagination.

Conclusion: making men

When men moved up the social hierarchy, they were quick to change their material possessions accordingly. They bought new furniture and replaced ciphers with aristocratic crests on their carriages, snuffboxes, canes, and guns. Men's things were tools to assimilate into, mark allegiances to, and belong to a social group. That a conman, in 1773, stole a watch and ivory-head cane from the man in his lodging house to make 'figure' at East India House illustrates that men were fully aware that goods were a potent symbol of their place within the social hierarchy. But material magnificence was not always the most successful way to display elite rank – economic prudence was also the trait of a gentleman and men repaired and bought second-hand goods to display their husbandry of old wealth. While eighteenth-century England saw a mushrooming of new fortunes from new forms of wealth acquisition, the culture of credit could mean financial ruin. Estates were mortgaged to pay the debts to the silversmith and coachbuilder.

Some men's goods were *de facto* elite objects because of the prohibitive cost of their production and maintenance. Ownership of a coach did not itself denote wealth and status, as it was the associated cost of maintaining it, the horses, a bevy of servants, and a suitable coach house that truly evoked financial and social privilege. Elite men's objects were also exclusive because of legal customs. The property qualification of the Game Acts limited the ownership and use of firearms to landed men. Therefore, the *ownership* of things did not necessarily delineate men's position within the social hierarchy. The coach house of a 'gentleman' had a variety of carriages for town, travelling, and pleasure driving. As both a farmhand and an earl could own a snuffbox in eighteenth-century England, their snuffboxes' material qualities – not the fact of their physical ownership – materialised their social positions, as the farmhand's snuffbox was made of leather and the earl's of ivory and gold.

The material qualities of men's things produced a specifically masculine and classed interaction with them. The eighteenth century placed significant meaning on the ways in which men and women interacted and used their possessions. Phaeton driving displayed men's bravery, daring, and virility and these associations informed the gender-differentiated design of 'phaetons' and 'ladies' phaetons'. The material refinement and smallness of the snuffbox informed the social choreography of their use in spaces of polite, refined

sociability. To have an elaborate sword meant little if a gentleman did not know how to deploy it to defend his honour. To be a 'gentleman sportsman', men needed a luxurious and well-crafted fowling piece and to be expert in deploying it. As the eighteenth-century material world expanded with new technologies and production processes, new materials demanded new social choreographies. Men's interactions with goods could expose the vulgar, the unrefined, or the effeminate man.

Under English primogeniture, younger sons of the gentry and nobility were anxious and uncertain about their future financial and social stability. Younger sons fulfilled different consumer and social roles than their elder brothers and this was reflected in their material culture. In the 1780s, when younger son Frederick Robinson was dashing between London coach-makers fulfilling orders and supervising a raft of coach commissions for his elder brother, the diplomat Lord Grantham, he bought himself a second-hand town-chariot 'out of economy and prudence'.[2] Even at the apex of gender and social power, elite men had different experiences of masculinity, and this was played out in their material and consumer practice.

Material change, interaction, and experiences

Elite men's rejection of material magnificence in the later decades of the eighteenth century was not limited to their dress and accoutrements. From the 1770s onwards, elite men's superior rank and refined discernment was no longer expressed through ostentatious material show but was articulated through manly modesty and simplicity. In the closing decades of the eighteenth century, gentlemen's objects, such as guns and carriages, had increasingly plainer ornamentation. Nevertheless, this plain decoration worked to emphasise nobles' heraldic crests. An East India man could use his vast fortune to acquire a magnificent carriage richly ornamented with Italianate pictorial schemes and rococo mount work, but this material ostentation could never display the same social and economic power of an earl's neatly painted crest and coronet on an otherwise plain coach. Driving a phaeton without the full equipage of grooms and coachmen was a display of elite men's polite condescension, but both the exclusivity of these new pleasure carriages and their potential to display

gentlemanly attributes reinforced elite men's social distinction. While middling men's material culture could express aspirations and claims to respectable status, elite men used their material possessions to defend their social distinction from encroachment.

The expansion of the 'Great Male Renunciation' theory undertaken here into a wider set of material practices beyond men's sartorial choices thus positions men as drivers of design change over the period. Men's everyday material praxis – the material decisions they made over the design and material qualities to construct and express their identities – thus contributed to product innovation. The design, shape, style, and material of goods were not merely the choice of manufacturers and retailers, especially considering luxury, bespoke goods, but often chosen in tandem with the personal choices of their clients. Even goods such as accessories and furniture bought 'of the shelf' were personalised, repaired, and altered. As dominant ideals of masculinity changed over the long eighteenth century, from honour-based chivalry to polite refinement, sentimentality and stoic nineteenth-century manliness, men's possessions enabled a diverse social practice of these changing abstract cultural values and were formative in their construction. The social practice of eighteenth-century masculinity and manhood was dependent on men's material and consumer practices. Traditional masculine values and attributes of authority, self-governance, and martial honour were materialised in men's objects, but the objects that expressed these values changed. Overt material displays of militaristic masculinity changed over the course of the long eighteenth century. Landed men removed the pikes and stags' heads from their great halls and replaced them with hunting portraiture. By the end of the eighteenth century, martial prowess was expressed in a more intellectual and technological material culture of polite science.

Men across social ranks invested their money, emotions, and time in purchasing, maintaining, and using their goods. Therefore, in the eighteenth century, men's objects were powerful tools in acquiring and displaying manhood, and exhibited men's taste, cultural capital, and social status. Middling and elite men were receptive to new, luxurious, and exotic goods. These objects provided men with new opportunities to acquire and express changing masculine ideals across the period. Eighteenth-century gentlemen perceived goods to be an extension of themselves – so much so that they sent empty crested

carriages for funerals they could not attend. But the men studied in this book were not merely receptive to new goods, technologies, and materials; elite men drove changes to the design and association of goods throughout the eighteenth century. They were active agents in material change, and this was itself a part of becoming and being a man in eighteenth-century England.

For the men studied in this book, objects were central to becoming a man and maintaining manly status. Eighteenth-century things materialised moments in a men's lifecycle, formed the rhythms and marked rituals of everyday life, and carried and created both social and emotional meaning. In this context, eighteenth-century masculine materiality – boys' and men's purchase, repair, alteration, personalisation, use, exchange, and display of these goods – was an important way men made sense of themselves and acquired their masculine identities. At its core, the has book explored men's everyday material practice and, standing back from this survey of the material examined here, it is obvious that material goods and men's interaction with them formed important embodied, haptic, sensory, emotional experiences. The book has centred gendered power and social distinction in its examination of masculine materiality but material goods had multivalent and pluralistic functions in forming and experiencing masculinities in this period.

Middling and elite men used things to forge a variety of material masculinities that changed depending on their stage in the life-source, marital status, and location. Men used possessions to enact their duties as father, husband, and householder. The process of materialising masculinity in eighteenth-century England was rich and varied. Goods that were essential to the construction and expression of eighteenth-century masculinities were diverse – differing in scale, material, ornamentation, and finish. Eighteenth-century middling and elite men had a significant material literacy that they deployed in their acquisition of goods. Men were engaged in the manufacturing, ornamentation, maintenance, and alteration of their possessions. Eighteenth-century producers and manufacturers used commercial treatises, and shooting advice literature were marketed at men and provided a shared vocabulary between consumer and producer. These didactic manuals speak to the expanding interest of the commercial and mercantile classes in acquiring quality goods that denoted gentility and respectability. They also reveal how material knowledge was

Conclusion: making men 253

the preserve of a privileged few – Chippendale, after all, addressed his *Gentleman and Cabinet-Maker's Director* to 'gentlemen'. Moreover, these publications taught men not only how or what to purchase, but how to use the products. Men's mastery over objects exhibited their material knowledge and displayed manly attributes. The artful interaction between person and thing, body and object, was a means to express abstract values and attributes of refinement, gentility, bravery, daring, and authority.

This book has concentrated on gentlemen and noblemen's materiality. But it has also examined the material desires and consumer practices of many men with claims to gentility and respectability, such as gentleman merchants, professional men, and metropolitan artisans. Many of the non-landed and untitled men in this book shared, or aspired to, the material life of the gentleman. To fully understand how objects informed men's experience of, and place within, the social hierarchy of eighteenth-century England, this book has also drawn on the material culture of lower-middling men to examine the commonalities and differences in their consumer practices and material preferences. As such, this book is a history of middling and elite men and it has exposed how material objects materialised the tensions, anxieties, and distinctions in and between these social groups. Becoming a man did not begin in the schoolroom. Objects were powerful tools for the acquisition and display of manly attributes. Men used objects to forge different masculine identities in different contexts; middling and elite men bought and used furniture, accoutrements, instruments, weaponry, and vehicles to construct and exhibit a polite, gentlemanly identity, to display their social distinction through material discernment, and to demonstrate their mastery over objects in their interaction with them. Objects enabled men to practise diverse masculine identities: dutiful father and husband, polite metropolitan man, sporting gentleman, and learned man of science.

For middling and elite men London was an important metropolitan and fashionable centre. Artisans from across the country, and across Europe, came to work and sell their wares. In 1769, furniture-makers Gillows of Lancaster set up shop in Oxford Street. Famed gunsmith Joseph Manton moved from Grantham to London to begin his own business. Rudolph Ackermann moved from Saxony in 1787 to establish himself as a preeminent coach-maker in London's world

famous Long Acre. Swiss watchmakers and chasers created a community in Clerkenwell. London's premier workshops were admired across the continent by diplomats and European courtiers. Provincial local elites, with their own commercial centres, sent to London for their children's toys, furniture, accoutrements, carriages, and guns. The use and display of these goods in the provinces radiated the chic of the metropolis into the regions. This book has traced the interconnected web of the changing and evolving design of material objects and expressions and practices of gender identity through five masculine material identities. Due to the nature of museums' decorative arts collections, and the privilege of the historical record, it has traced predominantly upper-middling and elite men's material culture, and has sought to tease out the tensions within, and between, the material cultures, practices, and preferences of these social ranks. Although the work on plebeian material culture and gender is increasing in number and scope, mostly due to pioneering dress historians, much more can be done to analyse the gendering of plebeian material culture.[3] Quantitative analysis of ownership, consumption, and material qualities has enabled this book to challenge the cultural association of goods with elite identity and to examine a wide range of men's engagement in consumer society and material culture. Just as future work could use this book to compare the material cultures and practices of more plebeian men and women, much work could be done to consider the meanings of material goods in eighteenth-century Britain and the British colonial world more broadly. This book can provide a foundational point to examine men's material culture in and between colonial and global settings. This study of system has illustrated how abstract ideals of manliness and masculine attributes were materially practised in eighteenth-century England. Men used objects to enable a diverse, and often changing, social practice of cultural values, and, in doing so, their material investment and knowledge shaped the material world of eighteenth-century England.

Well over 40 years of scholarship has grappled with this book's broadest question: why did people in eighteenth-century society consume things at a rate and on a scale like never before? It has been a recurring question of eighteenth-century historiography and has been asked and explored in cultural, social, economic, and demographic terms. The history of gendered consumption and materiality

has proven one of this question's most dynamic and long-lasting subfields. My contribution to that history is that men and women sought out the tangible in a society in which identities and selfhood were 'becoming modern', and thus undergoing significant change. I might pause here and reflect on why I first became interested in such questions and histories. The completion of this book occurred at a time of transitions in my own life. In November 2023, I decided to move into my partner's two-bed flat. Moving in with my partner meant a slimming down of my own material world, discarding clothes that no longer fit or suited my sense of style, sending unread cookbooks and old Pyrex dishes to the charity shop, and parting ways with things that already existed in some form at my partner's flat. Meaningful objects from my childhood and gifts from family and friends (what I called the 'non-negotiables') made the journey with me to the new flat: my Nana's Vimto tin, my Grandad's ship-in-a-bottle, a mid-century wooden drinks trolley – the first piece of furniture I ever bought myself – was laden with all the books I've ever read since a teen. After this clear out, we agreed on how we might begin to merge our lives together in one already populated space. One question stuck with me throughout this: how can I feel like this space, inhabited and curated by another, is mine as well as theirs? 'I want it to feel like my home too, there are things I need to be here [my books, art, trinkets] to make it feel like I live here', I said. In curating and populating this new home, two already whole material lives merged. My own masculinity has been constructed and made meaningful to me through my possessions – even when at times I tried to materially obscure or elide it. I have always personally believed that the material world is a meaningful one – my own sense of self deeply tied to things – and here in this moment of (joyous) transition and flux I found tangible significance to who I am through my possessions. Not in the least, my material presence in our home asserted, powerfully and physically, my place and belonging there. That my relationship to my own masculinity and materiality is spatially and temporally specific will not surprise scholars of the material or the masculine. My attachment to things undoubtedly the consequence of renter capitalism – having never lived in the same home for more than 2 years in the last 12, my possessions are what make my current domestic space mine. Yet such an attachment to material things was also part of materialising

for myself the life of an urban, queer, millennial historian – witness the mid-century furniture, books, and William Morris designs that I considered non-negotiable in the move. While mine may be a twenty-first-century masculine materiality, the fusing together of masculinity and materiality explored in this book, as an entwined, historically contingent process, took a particular form in the eighteenth century due to manufacturing and product innovations and changes in consumer behaviour. The commercialisation of eighteenth-century British society was a transformative process within English social and economic history as more people than ever before could participate in consumer markets. Unlike the mass-consumption characteristic of nineteenth-century consumer society, the eighteenth-century consumers studied here had more opportunities to shape, design, and personalise their finished possessions. Thus, in this specific context, there was a uniquely dialectical relationship between people and their possessions.

Notes

1 Maurice Tomlin, 'The 1782 Inventory of Osterley Park', *Furniture History* 22 (1986), 177.
2 BA. L 30/14/333/91. 'Fritz, Whitehall to Grantham' (4 May 1778).
3 There is a body of work on plebeian material culture – particularly in focusing on dress and textiles. Beverly Lemire, *Fashion's Favourite: The Cotton Trade and the Consumer in Britain, 1660–1800* (Oxford, 1991); Beverly Lemire, *Dress, Culture and Commerce: The English Clothing Trade before the Factory, 1660–1800* (Basingstoke, 1997); John Styles, *The Dress of the People: Everyday Fashion in Eighteenth-Century England* (New Haven, CT, 2007); Alice Dolan, 'The Fabric of Life: Time and Textiles in an Eighteenth-Century Plebeian Home', *Home Cultures* 11.3 (2014), 353–73; Peter King, 'Pauper Inventories and the Material Lives of the Poor in the Eighteenth and Early Nineteenth Centuries', in Tim Hitchcock, Peter King, and Pamela Sharpe (eds), *Chronicling Poverty: The Voices and Strategies of the English Poor, 1640–1840* (Basingstoke, 1997), 155–91; Joseph Harley, 'Consumption and Poverty in the Homes of the English Poor, c.1670–1834', *Social History* 43.1 (2017), 81–104.

Select bibliography

Select manuscript primary sources

Bedfordshire Archives

L 30 Wrest Park [Lucas] Manuscripts
FN975. 'Will of Sir John Francklin of St. Giles in the Fields' (30 October 1703)
HY722–3. 'Probate Will, with Copy, of John Harvey of Ickwell Bury, Esq.' (15 December 1708)
R6/7/1/2. 'Attested Copy of Will of Thomas, 1st Baron Trevor' (23 December 1723)
W351A. 'Will of Sir Wm. Palmer of Clerkenwell, kt.' (30 May 1679)

British Library

Add MS 12455. 'Herald Painter's Register Book, c.1752–1755'
Add MS 12456. 'Herald Painter's Register Book, c.1738–1740'
Add MS 36123. Hardwicke Papers
Add MS 61346. Blenheim Papers
Add MS 61348. Blenheim Paper
Add MS 78048. Althorp Papers
Add MS 83073. Lamb Papers
Add Mss 61678. Vol. DLXXVIII 'Accounts and Vouchers of later Dukes of Marlborough and their families; 1728–1822'
Mss Eur G37/75/5 'The Clive Collection. Bills, Receipted Bills and Receipts' (16 August 1750–4 July 1759)

Cheshire Archives and Library Services

DDS/432. 'Letter of Probate by Thomas Archbishop of Canterbury, with Copy of Will Attached' (17 May 1766)

258 *Select bibliography*

City of Westminster Archives Centre

FT. Fribourg and Treyer Papers

Cornwall Record Office

CY/1743. 'Probate of Will of Mart Tillie, Pentillie Castle, Widow' (7 October 1798)
WM/420. 'Probate Burthogge Mayow of Bray, Esq.' (6 September 1742)

Dorset History Centre

D/WLC/C26. 'Accounts Rendered by Thomas Angier to Edward Weld Sr.' (4 May 1761)

East Sussex Record Office

SAY/2977. 'Original Will of Thomas Lane of Hampstead, Middlesex' (4 June 1799)
FRE/85. 'Probate of the Will (6 November 1746) of Thomas Frewen'

Essex Record Office

D/DruF10. 'Anon., A Diary of a Young Girl' (1769–1776)
D/DU 502/2. 'Copies of Bills Rendered to Robert and Anne Nugent (widow of John Knight) of Gosfield Hall' (1740–1744)
D/Q 6/3/7. 'Will, 25 January 1708, of John Cressener of Earls Colne, Esq.'

Hampshire Archives and Local Studies

1M44/110/1–128. 'Letters from Lord Wallingford (later 8th Earl of Banbury) to his mother. Written from the Low Countries while on Campaign' (1793–1794)

Hertfordshire Archives and Local Studies

DE/AS/4275. 'Will of Philip Boteler Esq.' (18 August 1708)
DE/HL/16006. 'Letter from Charles, Hereditary Prince of Brunswick to James Johnston; Sent with a Gold Snuff Box' (17 November 1762)
DE/AS/2083. 'Probate Copy of Will of Ann Hickman, Spinster' (30 May 1755)

Select bibliography 259

The Huntington Library, San Marino CA

mssHA. Hastings Family Papers
mssHM. Leigh Family Papers
mssTD. Townshend Family Papers
msssTG. Grenville Family Papers
msssTT. Temple Family Papers

Isle of Wight Record Office

ELD87/38/1/3. 'Will with Probate of William Williams, Yeoman of P. Arreton I.W' (2 April 1808)

The John Rylands Library, Manchester

GB 133 EGR1/8/12/4. Grey (Stamford) of Dunham Massey Papers
GB 133 HAM/1/17, 18, 20. Mary Hamilton Papers
GB 133 HAM/2/3–4. Mary Hamilton Papers
GB 133 MAM/Fl. 7. 'The Fletcher-Tooth Collection' (c.1760–1898)

Kent History and Library Centre

U951/F24/1–69. 'Diaries of Fanny C. Knatchbull' (1804–1870)

Lancashire Archives

Acc.7886 Wallet 4, 'Robert Parker to Elizabeth Parker' (n.d.)
DD/72/1496. 'B. Wigglesworth, Townhead, to E. Barcroft, Otley' (20 March 1800)
DDB/81/17–39 'Elizabeth Shackleton's Diary' (1772–1781)
DDX 112/62. 'Copy of Will of Benjamin Wright of Poulton, Clerk' (n.d. ?1796)

Leicester, Loughborough, and Rutland Record Office

DG 9/2053. 'Estimates & Specifications by Edward Harlee, Coachbuilder, the Strand, London for a Coach to be Built for William Herrick, esq.'
DG/9/2299. 'Probate Copy Will of William Herrick, esq, Beaumanor' (Probate copy: 28 June 1774. Original will: April 1768)

The London Archives

ACC/0426/001. 'Ledger of Merchant' (1763–1772)

The National Archives, Kew

C105/5. 'BRAITHWAITE v TAYLOR: Accounts of Administrator of Martha Braithwaite and Inventories (Goldsmith's shop goods etc)' (c.1746)
C107/109, 'Upholsterer's Order-Books' (1771–1795)
C114/60/5. 'Coachmaker's Account Books' (1733–1740)
PRO 30/7/2. 'Despatches and Correspondence of Andrew Snape Douglas, British Charge d'Affares, Naples 1816–1822'
PROB 32/42/217. 'Stebing, Henry, gent., Brandeston, Suffolk Inventory' (26 June 1701)
PROB 31/54/55. 'Thomas Waldegrave, esq. of Thurlon Magna Other Great Thursden, Suffolk. Probate Inventory' (January 1728)
SP 36/6/152–5. 'Inventions. Petitions. Petitions addressed to the King for letters patent under the Great Seal' (May 1727)

Norfolk Record Office

NRS 7963, 42A3. 'Game Book' (1782–1795)
NRS 7966, 42A3. 'Game Book' (1796–1806)
WLP 5/1. 'Game Book Wolterton (1800–1831)

North Yorkshire County Record Office

ZBL I/1/1/293. 'Attested Copy of Will of Mary Braithwaite of Catterick, Widow of Richard, late of Burneshead, Esq.' (31 December 1736)
ZBL I/2/1/14. 'Copy Will of Christopher Buckle of Burgh, Surrey, Esq.' (4 March 1781)

Nottingham University Library, Manuscripts and Special Collections

Me 2C 82–102. 'General Correspondence of Charles Mellish' (1777–1796)

Nottinghamshire Archives

DD/E/37. 'Game Books' (1780–1911)
DD/Sk 217, 1–6. 'Robert Lowe's Pocket Diaries' (1793–1822)
DD/FJ/11/1/4/52. 'R. Morrison to John Hewett' (20 February 1779)

Oxford Health Archive

W/D/129/3, 'Abstract of George Henry Cavendish's Title to the Manors of Eastborne Wilson or Burton and Jevington' (December 1812)

Select bibliography 261

Plymouth and West Devon Record Office
1259 Parker of Saltram, Earls of Morley. Correspondence

The Royal Archive, Windsor
GEO/ADD/15/0457–0861 'Papers of General Jacob de Budé' (1811)
GEO/MAIN/36415. 'Letters and Correspondence of Queen Charlotte' (1770–1818)
GEO/MAIN/8960–29209. 'George IV's Privy Purse Accounts for Music, His Majesty's Private Band, Guns, Fishing Tackle, Toys, Telescopes, Opera Glasses, Billiard Cues etc.' (1784–1830)

Sheffield City Archives
WWM/A/1204. 'An Inventory made in September 1782 of all the Household Goods, Plate, Pictures, Statues and Furniture which were in the late Charles Marquis of Rockingham's Capital Messuage or Mansion called Wentworth' (24 May 1782)

Shropshire Archives
1045/562. 'Probate Copy Will of Edward Philipps of Church Stretton, Apothecary' (17 April 1739)
112/1/1866. 'Will of Richard Hill of Hawkestone' (1725–1726)
112/6/Box 64/1–494. Attingham Collection
484/176. 'Probate Copy of Will of Nathaniell Thomas of Westfelton Gent.' (18 September 1727)

Somerset Heritage Centre
DD/SH/79/10/31. 'Inventory taken at Sutton Court' (27 December 1746)

Suffolk Record Office
HA12/D22/1–3. 'Game Book' (1775–1850)

University of Southampton, Special Collections
PP/D/3. Palmerston Papers

Warwickshire Country Record Office
CR 1368 Vols. 1–3. 'Calendar of Mordaunt Letters'

Select bibliography

West Sussex Record Office
PHA/7528–9271. Petworth House Archive

Printed primary sources

Anon. *An Essay on Hunting by a Country Squire* (London, 1733)
Anon. *The Annual Register*, vol. 3 (London, 1760)
Anon. *Fishing and Hunting* (London, ?1720)
Anon. *The Gentleman's Magazine*, vol. 1. 1731 (London, 1998)
Anon. *The Lady's Magazine; Or, Entertaining Companion for the Fair Sex, Appropriated solely to their Use and Amusement* (London, 1789)
Anon. 'RECEIPT to make a MODERN FOP', *Universal Magazine of Knowledge and Pleasure*, vol. 60 (1777)
Anon. *Rules and Orders of the Society, Established at London for the Encouragement of Arts, Manufactures and Commerce* (London, 1758)
Anon. *The Young Gentleman and Lady Instructed in such Principles of Politeness, Prudence, and Virtue*, ii (London, 1747)
Austen, Jane, *Jane Austen's Letters*, (ed.) Deirdre Le Faye (Oxford, 1995)
Beckford, Peter. *Thoughts on Hunting* (London, 1781)
Blackstone, *Sir William. Commentaries on the Laws of England in Four Books*, vol. 1 (Philadelphia, PA, 1893)
Blackwell, Henry. *The English Fencing-Master* (London, 1702)
Bond, Donald F. (ed.). *The Spectator*, vol. 1 (Oxford, 1987)
Bond, Donald F. (ed.). *The Spectator*, vol. 2 (Oxford, 1987)
Bond, Donald F. (ed.). *Tatler*, vol. 2 (Oxford, 1987)
Brown, John. *An Estimate of the Manners and Principles of the Times*, vol. 1 (London, 1757/8)
Burney, Francis. *Evelina*, (ed.) Edward A. Bloom (Oxford, 2008)
Byng, John, Viscount Torrington. *The Torrington Diaries*, ed. C. B. Andrews (New York, 1938)
Carter, Elizabeth. *Letters from Mrs. Elizabeth Carter to Mrs. Montagu between the Years 1755 and 1800*, vol. 2 (London, 1817)
Carter, Elizabeth. *A Series of Letters between Mrs. Elizabeth Carter and Miss Catherine Talbot*, (ed.) Montagu Pennington (London, 1809)
Chambers, Ephraim. *Cyclopædia: Or, An Universal Dictionary of Arts and Sciences*, vol. 1 (Dublin, 1728)
Chippendale, Thomas. *The Gentleman and Cabinet-Maker's Director* (London, 1762)
Coleman, Moira (ed.). *Household Inventories of Helmingham Hall 1597–1741* (Woodbridge, 2018)
Coleridge, Samuel T. *Collected Letters of Samuel Taylor Coleridge*, vol. 2, (ed.) Earle L. Griggs (Oxford, 2000)

Collett-White, James (ed.). *Inventories of Bedfordshire Country Houses 1714–1830* (Bedford, 1995)
Cox, Nicholas. *The Gentleman's Recreation* (London, 1686)
de Saussure, César-Francois. *A Foreign View of England in the Reigns of George I and George II: The Letters of Monsier César de Saussure to his Family*, ed. and trans. Madame Van Muyden (London, 1902)
Delany, Mary. *The Autobiography and Correspondence of Mrs. Delany*, vol. 2, (ed.) Sarah Chauncey Woolsey (Boston, MA, 1879)
Edie, George. *The Art of English Shooting* (London, 1775)
Exeter Flying Post, 11 May 1815
Felton, William. *A Treatise on Carriages* (London, 1796)
Fielding, Henry. *The Covent-Garden Journal*, vol. 1, ed. Humphrey Milford (New Haven, CT, 1915)
Gardiner, John Smallman. *The Art and Pleasures of Hare-Hunting. In Six Letters to a Person of Quality* (London, 1750)
Gilbert, Christopher and Peter Thornton. 'The Furnishing and Decoration of Ham House', *Furniture History* 16 (1980), 1–194
Hamilton, Alexander. *A Treatise on the Management of Female Complaints, and of Children in Early Infancy* (Edinburgh, 1792)
Hawker, Peter. *To Young Sportsmen in all that Relates to Guns and Shooting* (London, 1844)
Hepplewhite, Alice. *The Cabinet-Maker and Upholsterer's Guide* (London, 1788)
Hull Advertiser and Exchange Gazette, 8 May 1813
Hull Advertiser and Exchange Gazette, 21 September 1811
Ince, William and John Mayhew. *The Universal System of Household Furniture* (London, 1762)
Ipswich Journal, 8 May 1802
Ipswich Journal, 20 November 1802
Isham, Zacheus. *A Sermon Preached before the Right Honourable The Lord Mayor of London, The Aldermen, and Governours of the Hospitals of London; at St. Bridget's Church. On Wednesday in Easter Week, MDCC* (London, 1700)
Johnson, Samuel. *Rambler* 34 (14 July 1750)
Johnson, Samuel. *A Dictionary of the English Language: A Digital Edition of the 1755 Classic by Samuel Johnson*, ed. Brandi Besalke. Last modified 25 June 2013.
Knox, Vicesimus. *Essays, Moral and Literary* (London, 1782)
Lillie, Charles and Colin McKenzie (eds). *The British Perfumer* (London, 1822)
Locke, John. *Some Thoughts Concerning Education*, (eds) John W. Yolton and Jean S. Yolton (Oxford, 1989)

Macaulay, Thomas Babington, *The Historical Essays of Macaulay*, ed. Samuel Thurber (Boston, MA, 1892)
Montagu, Elizabeth. *The Letters of Mrs. E. Montagu, With Some of the Letters of Her Correspondence*, vol. 1, (ed.) Matthew Montagu (London, 1809)
Morning Post and Daily Advertiser, 16 July 1777
Morning Post and Daily Advertiser, 5 November 1777
Murdoch, T. V., Candace Briggs, and Laurie Lindey (eds). *Noble Households: Eighteenth-Century Inventories of Great English Houses. A Tribute to John Cornforth* (Cambridge, 2006)
Norfolk Chronicle, 12 February 1814
North, Roger. *The Autobiography of the Hon. Roger North*, ed. Augustus Jessop (London, 1887)
Roper, John S. *Sedgley Inventories 1614–1787* (Woodsetton, Worcestershire, 1960)
Rousseau, Jean Jacques, *Emile, or, On Education: Includes Emile and Sophie, or, The Solitaries*, ed. and trans. Christopher Kelly, trans. Allan Bloom (Hanover NH, 2010)
Sheraton, Thomas. *Appendix to the Cabinet-Maker and Upholsterer's Drawing Book* (London, 1793)
Sheraton, Thomas. *The Cabinet Dictionary* (London, 1803)
Sheraton, Thomas. *The Cabinet-Maker and Upholsterer's Drawing Book* (London, 1791)
Smith, Adam. *Adam Smith: The Theory of Moral Sentiments*, ed. Knud Haakonssen (Cambridge, 2002)
Stanhope, Philip Dormer, Earl of Chesterfield. *Lord Chesterfield's Letters* ed. David Roberts (Oxford, 1992)
Suffolk Chronicle; or Weekly General Advertiser & County Express, 15 December 1810
Suffolk Chronicle; or Weekly General Advertiser & County Express, 19 September 1812
Thrupp, G. A. *The History of Coaches* (London, 1877)
Tomlin, Maurice. 'The 1782 Inventory of Osterley Park', *Furniture History* 22 (1986), 107–34
Von la Roche, Sophie. *Sophie in London, 1786: Being the Diary of Sophie v. la Roche*, trans. Clare Williams (London, 1933)
Wakefield, Roger. *Wakefield's Merchant and Tradesman's General Directory for London, Westminster, Borough of Southwark* (London, 1993)
Walpole, Horace. *The Yale Edition of Horace Walpole's Correspondence*, vol. 19, (ed.) W. S. Lewis (New Haven, CT, 1977)
Walpole, Horace. *The Yale Edition of Horace Walpole's Correspondence*, vol. 30, (ed.) W. S. Lewis (New Haven, CT, 1977)

Select bibliography

Walpole, Horace. *The Yale Edition of Horace Walpole's Correspondence*, vol. 32, (ed.) W. S. Lewis (New Haven, CT, 1977)
Wilson, Ralph. *A Full and Impartial Account of all the Robberies Committed by John Hawkins, George Sympson (lately executed for Robbing the Bristol Mails) and their Companions*, 3rd ed. (London, 1722)
Wollstonecraft, Mary. *Wollstonecraft: A Vindication of the Rights of Man and a Vindication of the Rights of Woman and Hints*, ed. Sylvana Tomaselli (Cambridge, 1995)
Woodforde, James. *The Diary of a Country Parson, 1758–1802*, (ed.) John Beresford (Norwich, 1999)

Online primary sources

Tim Hitchcock, Robert Shoemaker, Sharon Howard, and Jamie McLaughlin, et al., *London Lives, 1690–1800* (www.londonlives.org version 2.0), last accessed 8 September 2020
Tim Hitchcock, Robert Shoemaker, Clive Emsley, Sharon Howard, and Jamie McLaughlin, et al., *The Old Bailey Proceedings Online, 1674–1913* (www.oldbaileyonline.org version 8.0), last accessed 8 September 2020
Locating London's Past (www.locatinglondon.org, version 1.0, 17 December 2011), last accessed 8 September 2020

Secondary sources

Abrams, Lynn and Elizabeth Ewan (eds). *Nine Centuries of Man: Manhood and Masculinities in Scottish History* (Edinburgh, 2017)
Amussen, Susan D. 'The Contradictions of Patriarchy in Early Modern England', *Gender & History* 30.2 (2018), 343–53
Anderson, Jennifer L. *Mahogany: The Costs of Luxury in Early America* (Cambridge MA, 2012)
Appadurai, Arjun (ed.). *The Social Life of Things: Commodities in Cultural Perspective* (Cambridge, 1988)
Ariès, Philippe, *Centuries of Childhood: A Social History of Family Life*, trans. Robert Baldick (London, 1962)
Arnold, John and Sean Brady (eds). *What is Masculinity? Historical Dynamics from Antiquity to the Contemporary World* (Basingstoke, 2013)
Bailey (Begiato), Joanne. 'Favoured or Oppressed? Married Women, Property and "Coverture" in England, 1660–1800', *Continuity and Change* 17.3 (2002), 351–72
Bailey (Begiato), Joanne. *Parenting in England 1760–1830: Emotion, Identity, and Generation* (Oxford, 2012)

Bailey (Begiato), Joanne. *Unquiet Lives: Marriage and Marriage Breakdown in England, 1660–1800* (Cambridge, 2003)
Barclay, Katie. *Love, Intimacy and Power: Marriage and Patriarchy in Scotland, 1650–1850* (Manchester, 2011)
Barclay, Katie. *Men on Trial: Performing Emotion, Embodiment and Identity in Ireland, 1800–45* (Manchester, 2018)
Barker, Hannah. 'Soul, Purse and Family: Middling and Lower-Class Masculinity in Eighteenth-Century Manchester', *Social History* 33.1 (2008), 12–35
Barker, Hannah. *Family and Business During the Industrial Revolution* (Oxford, 2017)
Barker, Hannah. *The Business of Women: Female Enterprise and Urban Development in Northern England 1760–1830* (Oxford, 2006)
Barker, Hannah and Elaine Chalus (eds). *Gender in Eighteenth-Century England: Roles, Representations and Responsibilities* (London, 1997)
Barker, Hannah and Elaine Chalus (eds). *Women's History: Britain, 1700–1850: An Introduction* (London and New York, 2005)
Barry, Jonathon and Christopher Brooks (eds). *The Middling Sort of People: Culture, Society and Politics in England, 1550–1800* (Basingstoke, 1994)
Batchelor, Jennie. 'Fashion and Frugality: Eighteenth-Century Pocket Books for Women', *Studies in Eighteenth-Century Culture* 32 (2003), 1–18
Batchelor, Jennie and Cora Kaplin (eds). *Women and Material Culture, 1660–1830* (London and New York, 2009)
Beard, Geoffrey. *Upholsterers and Interior Furnishing in England, 1530–1840* (New Haven, CT, 1997)
Begiato (Bailey), Joanne. 'Between Poise and Power: Embodied Manliness in Eighteenth- and Nineteenth-Century Culture', *Transactions of the Royal Historical Society* 26 (2016), 125–47
Begiato, Joanne. *Manliness in Britain: Bodies, Emotion and Material Culture* (Manchester, 2020)
Bennett, Jane. *Vibrant Matter: A Political Ecology of Things* (Durham, NC, 2010)
Bennett, J. M. 'Feminism and History', *Gender and History* 1.3 (1989), 251–72
Berg, Maxine. 'From Imitation to Invention: Creating Commodities in Eighteenth-Century Britain', *Economic History Review* 55 (2002), 1–30.
Berg, Maxine. 'In Pursuit of Luxury: Global History and British Consumer Goods in the Eighteenth Century', *Past & Present* 182 (2004), 85–142
Berg, Maxine. 'Women's Consumption and the Industrial Classes of Eighteenth-Century England', *Journal of Social History* 30.2 (1996), 415–34
Berg, Maxine. *Luxury and Pleasure in Eighteenth-Century Britain* (Oxford, 2005)

Select bibliography

Berg, Maxine and Helen Clifford (eds). *Consumers and Luxury: Consumer Culture in Europe 1650–1850* (Manchester, 1999)
Berg, Maxine and Helen Clifford, 'Selling Consumption in the Eighteenth Century: Advertising and the Trade Card in Britain and France', *Journal of the Social History Society* 4.2 (2007), 145–70.
Berg, Maxine and Elizabeth Eger (eds). *Luxury in the Eighteenth Century: Debates, Desires and Delectable Goods* (Basingstoke, 2002)
Berg, Maxine et al. (eds). *Goods from the East, 1600–1800: Trading Eurasia* (Basingstoke, 2015)
Bermingham, Ann. *Landscape and Ideology: The English Rustic Tradition, 1740–1860* (Berkeley, CA, 1986)
Berry, Helen. 'Polite Consumption: Shopping in Eighteenth-Century England', *Transactions of the Royal Historical Society* 12 (2002), 375–94
Berry, Helen. 'Promoting Taste in the Provincial Press: National and Local Culture in Eighteenth-Century Newcastle upon Tyne', *Journal for Eighteenth-Century Studies* 25 (2002), 1–17
Berry, Helen. 'Rethinking Politeness in Eighteenth-Century England: Moll King's Coffee House and the Significance of "Flash Talk"', *Transactions of the Royal Historical Society* 11 (2001), 65–81
Berry, Helen and Elizabeth A. Foyster. *The Family in Early Modern England* (Cambridge, 2008)
Blondé, Bruno et al. (eds). *Fashioning Old and New: Changing Consumer Patterns in Western Europe (1650–1900)* (Turnhout, 2009)
Borsay, Peter. *The English Urban Renaissance: Culture and Society in the Provincial Town, 1660–1770* (Oxford, 1989)
Bourdieu, Pierre. *Masculine Domination* (Palo Alto, CA, 2001)
Bowett, Adam. 'The English Mahogany Trade 1700–1793' (Unpublished PhD Thesis, Brunel University, 1996)
Braddick, Michael and John Walter (eds). *Negotiating Power in Early Modern Society: Order, Hierarchy and Subordination in Britain and Ireland* (Cambridge, 2001)
Brandow-Faller, Megan (ed.). *Childhood by Design: Toys and the Material Culture of Childhood, 1700–Present* (London, 2018)
Brewer, John and Roy Porter (eds). *Consumption and the World of Goods* (London, 1993)
Brown, Nigel. *British Gun Makers*, vol. 1 (Shrewsbury, 2004)
Brundage, Jonah Stuart. 'The Pacification of Elite Lifestyles: State Formation, Elite Reproduction and the Practice of Hunting in Early Modern England', *Comparative Studies in Society and History* 58.4 (2017), 786–817
Buck, Anne. *Clothes and the Child: A Handbook of Children's Dress in England 1500–1900* (Marlborough, 1996)
Buck, Anne. *Dress in Eighteenth-Century England* (London, 1979)

Burman, Barbara and Ariane Fennetaux. *The Artful Pocket: A Social History of an Everyday Object in Eighteenth- and Nineteenth-Century Britain* (Abingdon, 2013)

Burman, Barbara and Ariane Fennetaux. *The Pocket: A Hidden History of Women's Lives, 1660–1900* (New Haven, CT, 2019)

Calvert, Karin. *Children in the House: The Material Culture of Early Childhood, 1600–1900* (Boston, MA, 1992)

Campbell, Colin. *The Romantic Ethic and the Spirit of Modern Consumerism* (Oxford, 1987)

Cannadine, David. *The Rise and Fall of Class in Britain* (New York 1999)

Cannon, John. *Aristocratic Century: The Peerage in Eighteenth-Century England* (Cambridge, 1984)

Capp, Bernard. '"Jesus Wept" But Did the Englishman? Masculinity and Emotion in Early Modern England' *Past & Present* 224 (2014), 75–108

Carr, Rosalind. *Gender and Enlightenment Culture in Eighteenth-Century Scotland* (Edinburgh, 2014)

Carr, Rosalind. 'A Polite and Enlightened London?', *Historical Journal* 59.2 (2016), 623–34

Carter, Philip. 'An "Effeminate" or "Efficient" Nation? Masculinity and Eighteenth-Century Social Documentary', *Textual Practice* 11.3 (1997), 429–43

Carter, Philip. *Men and the Emergence of Polite Society, Britain 1660–1800* (London, 2001)

Christie, Christopher. *The British Country House in the Eighteenth Century* (Manchester, 2000)

Clark, J. C. D. *English Society, 1688–1832: Ideology, Social Structure, and Political Practice During the Ancien Régime* (Cambridge, 1985)

Clifford, Helen. 'Concepts of Invention, Identity and Imitation in the London and Provincial Metal-Working Trades, 1750–1800', *Journal of Design History* 12.3 (1999), 241–55

Clifford, Helen. *Silver in London: The Parker and Wakelin Partnership 1760–1776* (New Haven, CT, 2004)

Cohen, Michèle, *Changing Pedagogies for Children in Eighteenth-Century England* (Suffolk, 2023)

Cohen, Michèle. '"A Little Learning"? The Curriculum and the Construction of Gender Difference in the Long Eighteenth Century', *Journal of Eighteenth-Century Studies* 29.3 (2006), 321–35

Cohen, Michèle. '"Manners" Make the Man: Politeness, Chivalry, and the Construction of Masculinity, 1750–1830', *Journal of British Studies* 44.2 (2005), 312–29

Cohen, Michèle. *Fashioning Masculinity: National Identity and Language in the Eighteenth Century* (London, 1996)

Colley, Linda. *Britons: Forging the Nation 1707–1837* (New Haven, CT and London 1992)
Connell, R. W. and James W. Messerschmidt. 'Hegemonic Masculinity: Rethinking the Concept', *Gender and Society* 19.6 (2005), 649–85
Connell, R. W. *The Men and the Boys* (Cambridge, 2000)
Connell, R. W. *Masculinities* (Cambridge, 1996)
Corfield, P. J. 'Dress for Deference and Dissent: Hats and the Decline of Hat Honour', *Costume* 23 (1989), 64–79
Corfield, P. J. *Power and the Professions in Britain, 1700–1850* (London, 1995)
Dabhoiwala, Faramerz. *The Origins of Sex: A History of the First Sexual Revolution* (London, 2012)
David, D. S. and R. Brannon (eds). *Theorizing Masculinities* (Thousand Oaks, CA, 1994)
Davidoff, Leonore and Catherine Hall. *Family Fortunes: Men and Women of the English Middle Class, 1780–1850* (Chicago, IL, 1987)
de Grazia, Victoria and Ellen Furlough (eds). *The Sex of Things: Gender and Consumption in Historical Perspective* (Berkeley, CA, 1996)
de Mause, Lloyd (ed.). *The History of Childhood* (New York, 1974)
de Munck, Bert and Dries Lyna (eds). *Concepts of Value in European Material Culture, 1500–1900* (Abingdon, 2016)
de Vries, Jan. *The Industrious Revolution: Consumer Behaviour and the Household Economy, 1650 to the Present* (Cambridge, 2008)
Deetz, James. *In Small Things Forgotten: An Archaeology of Early American Life* (Garden City, NY, 1977)
Dixon, Thomas. *Weeping Britannia: Portrait of a Nation in Tears* (Oxford, 2015)
Donald, Moira and Linda Hurcombe (eds). *Gender and Material Culture in Historical Perspective* (London, 2000)
Douglas, Mary and Baron Isherwood. *The World of Goods: Towards an Anthropology of Consumption* (London, 1979)
Downes, Stephanie, Sally Holloway, and Sarah Randles (eds). *Feeling Things: Objects and Emotions through History* (Oxford, 2018)
Duberman, M. B., M. Vicinus, and G. Chauncey (eds). *Hidden from History: Reclaiming the Gay and Lesbian Past* (Harmondsworth, 1989)
Dyer, Serena. *Material Lives: Women Makers and Consumer Cultures in Eighteenth-Century England* (London, 2021)
Dyer Serena and Chloe Wigston Smith (eds). *Material Literacy in Eighteenth-Century Britain* (Oxford, 2021)
Earle, Peter. *The Making of the English Middle Class: Business, Society, and Family Life in London, 1660–1730* (Berkeley, CA, 1989)
Edwards, Clive D. *Eighteenth-Century Furniture* (Manchester, 1996)

Elias, Norbert and Eric Dunning. *The Quest for Excitement: Sport and Leisure in the Civilizing Process* (Oxford, 1986)
Ellis, Markman, Matthew Mauger, and Richard Coulton. *Empire of Tea: The Asian Leaf that Conquered the World* (London, 2015)
Erickson, Amy Louise. 'Mistresses and Marriage: Or, a Short History of the Mrs', *History Workshop Journal* 78 (2014), 39–57.
Erickson, Amy Louise. *Women and Property in Early Modern England* (London, 1993)
Evans, Jennifer. '"They Are Called Imperfect Men": Male Infertility and Sexual Health in Early Modern England', *Social History of Medicine* 29.2 (2016), 311–32
Fass, Paula S. (ed.). *The Routledge History of Childhood in the Western World* (Abingdon, 2013)
Fennetaux, Ariane, Amelie Junqua, and Sophia Vassat (Eds). *The Afterlife of Used Things: Recycling in the Long Eighteenth Century* (Basingstoke, 2014)
Festa, Lynn. 'Personal Effects: Wigs and Possessive Individualism in the Long Eighteenth Century', *Eighteenth-Century Life* 29.2 (2005), 47–90
Findlen, Paula (ed.). *Early Modern Things: Objects and Their Histories, 1500–1800* (New York 2012)
Finn, Margot. 'Men's Things: Masculine Possession in the Consumer Revolution', *Social History* 25.2 (2000), 133–55
Finn, Margot. 'Women, Consumption and Coverture, c.1760–1860', *Historical Journal* 39.3 (1996), 703–22
Finn, Margot. *The Character of Credit: Personal Debt in English Culture, c.1740–1914* (Cambridge, 2003)
Finn, Margot and Kate Smith (eds). *The East India Company at Home, 1750–1850* (London, 2018)
Flather, Amanda. *Gender and Space in Early Modern England* (Woodbridge, 2007)
Fletcher, Anthony. *Gender, Sex, and Subordination in England, 1500–1800* (New Haven, CT, 1995)
Fletcher, Anthony. *Growing Up in England: The Experience of Childhood, 1600–1914* (New Haven, CT, 2008)
Fontaine, Laurence (ed.). *Alternative Exchanges: Second-Hand Circulations from the Sixteenth Century to the Present* (New York, 2008)
Foyster, Elizabeth A. 'Creating a Veil of Silence: Politeness and Marital Violence in the English Household', *Transactions of the Royal Historical Society* 12 (2002), 395–415
Foyster, Elizabeth A. *Manhood in Early Modern England: Honour, Sex, and Marriage* (London, 1999)
Foyster, Elizabeth A. and James Marten (eds). *A Cultural History of Childhood and Family in the Age of Enlightenment* (London, 2010)

Select bibliography 271

Freidman, Emily C. *Reading Smell in Eighteenth-Century Fiction* (Lewisburg, PA, 2016)
French, Henry and Mark Rothery. 'Male Anxiety and Younger Sons of the Gentry', *Historical Journal* 62.4 (2019), 967–96
French, Henry and Mark Rothery. *Man's Estate: Landed Gentry Masculinities, 1660–1900* (Oxford, 2012)
French, Henry and Mark Rothery. 'Upon Your Entry into the World: Masculine Values and the Threshold of Adulthood among Landed Elites in England 1680–1800', *Social History* 33.4 (2008), 402–22
Germann, Jennifer G. and Heidi A. Strobel (eds). *Materializing Gender in Eighteenth-Century Europe* (London, 2017)
Gerritsen, Anne and Giorgio Riello (eds). *The Global Lives of Things: The Material Culture of Connection in the Early Modern World* (London, 2016)
Girouard, Mark. *Life in the English Country House: A Social and Architectural History* (New Haven, CT, 1978)
Girouard, Mark, John Cornforth, and Dana Arnold (eds). *The Georgian Country House: Architecture, Landscape and Society* (Stroud, 1998)
Glassie, Henry. *Material Culture* (Bloomington, IN, 1999)
Glover, Katharine. *Elite Women and Polite Sociability in Eighteenth-Century Scotland* (Woodbridge, 2011)
Goggin, Maureen Daly and Beth Fowkes Tobin (eds). *Material Women, 1750–1950: Consuming Desires and Collecting Practices* (Farnham, 2009)
Goggin, Maureen Daly and Beth Fowkes Tobin (eds). *Women and the Material Culture of Needlework, 1750–1950* (Farnham, 2009)
Goggin, Maureen Daly and Beth Fowkes Tobin (eds). *Women and Things, 1750–1950: Gendered Material Strategies* (Farnham, 2009)
Goldsmith, Sarah. 'Dogs, Servants and Masculinities: Writing about Danger on the European Grand Tour', *Journal for Eighteenth-Century Studies* 40.1 (2017), 3–21
Goldsmith, Sarah. *Masculinity and Danger on the Eighteenth-Century Grand Tour* (London, 2020)
Goodman, Dena and Kathryn Norberg (eds). *Furnishing the Eighteenth Century: What Can Furniture Tell Us about the European and American Past?* (New York and Abingdon, 2007)
Gowing, Laura. *Gender Relations in Early Modern England* (London, 2012)
Greig, Hannah. *The Beau Monde: Fashionable Society in Georgian London* (Oxford, 2012)
Grenby, M. O. *Children's Literature* (Edinburgh, 2008)
Grieg, Hannah, Jane Hamlett, and Leonie Hannan (eds). *Gender and Material Culture in Britain since 1600* (London, 2016)
Griffin, Emma. *England's Revelry: A History of Popular Sports and Pastimes, 1660–1830* (Oxford, 2005)

Griffiths, Paul. *Youth and Authority: Formative Experiences in England 1560–1640* (Oxford, 1996)
Hamling, Tara and Catherine Richardson (eds). *Everyday Objects: Medieval and Early Modern Material Culture and its Meanings* (Farnham, 2010)
Hamling, Tara and Catherine Richardson. *A Day at Home in Early Modern England: Material Culture and Domestic Life, 1500–1700* (New Haven, CT, 2017)
Harvey, Karen (ed.). *History and Material Culture: A Student's Guide to Approaching Alternative Sources* (London and New York, 2009)
Harvey, Karen. 'Barbarity in a Teacup? Punch, Domesticity and Gender in the Eighteenth Century', *Journal of Design History* 21.3 (2008), 205–21
Harvey, Karen. 'The History of Masculinity, circa 1650–1800', *Journal of British Studies* 44.2 (2005), 296–311
Harvey, Karen. *The Little Republic: Masculinity and Domestic Authority in Eighteenth-Century Britain* (Oxford, 2012)
Harvey, Karen. 'Men of Parts: Masculine Embodiment and the Male Leg in Eighteenth-Century England', *Journal of British Studies* 54.4 (2015), 797–821
Harvey, Karen. 'Ritual Encounters: Punch Parties and Masculinity in the Eighteenth Century', *Past & Present* 214 (2012), 165–203
Harvey, Karen. 'The Substance of Sexual Difference: Change and Persistence in Eighteenth-Century Representations of the Body', *Gender and History* 14.2 (2002), 202–23
Harvey, Karen and Alexandra Shepard, 'What Have Historians Done with Masculinity? Reflections on Five Centuries of British History, circa 1500–1950', *Journal of British Studies* 44.2 (2005), 274–80
Hay, Douglas (ed.). *Albion's Fatal Tree: Crime and Society in Eighteenth-Century England* (New York, 1976)
Heal, Felicity and Clive Holmes. *The Gentry in England and Wales, 1500–1700* (London, 1994)
Hellman, Mimi. 'Furniture, Sociability, and the Work of Leisure in Eighteenth-Century France', *Eighteenth-Century Studies* 32.4 (1999), 415–45
Herman, Bernard L. *The Stolen House* (Charlottesville, VA, 1992)
Hitchcock, Tim and Michèle Cohen (eds). *English Masculinities, 1660–1830* (London, 1999)
Holloway, Sally. *The Game of Love in Georgian England: Courtship, Emotions and Material Culture* (Oxford, 2019)
Houlbrook, Matt, Katie Jones, and Ben Mechen (eds). *Men and Masculinities in Modern Britain: A History for the Present* (Manchester, 2024).
Hudson, Pat. *The Industrial Revolution* (London, 1992)
Hunt, Margaret R. *The Middling Sort: Commerce, Gender, and the Family in England, 1680–1780* (Berkeley, CA, 1996)

Hussey, David and Margaret Ponsonby (eds). *Buying for Home: Shopping for the Domestic from the Seventeenth Century to the Present* (Abingdon, 2008)
Hussey, David and Margaret Ponsonby. *The Single Homemaker and Material Culture in the Long Eighteenth Century* (Farnham, 2012)
Isherwood, Baron and Mary Douglas (eds). *The World of Goods: Towards an Anthropology of Consumption* (London, 1979)
Itzkowitz, David C. *A Peculiar Privilege: A Social History of Foxhunting, 1753–1885* (Brighton, 1977)
Jackson, Ben. 'To Make a Figure in the World: Identity and Material Literacy in the 1770s Coach Consumption of British Ambassador, Lord Grantham' *Gender & History* (early view).
Jackson, Ben, 'The Thrill of the Chaise: Gendering the Phaeton in Eighteenth-Century Literary and Satirical Culture, c.1760–1820', in Jennifer Buckley and Montana Davies-Shuck (eds), *Character and Caricature, 1660–1820* (London, 2024), 170–97.
Jacobsen, Helen. *Luxury and Power: The Material World of the Stuart Diplomat, 1660–1714* (Oxford, 2012)
Jardine, Lisa. *Worldly Goods: A New History of the Renaissance* (London, 1996)
Jung, Sandro. 'Illustrated Pocket Diaries and the Commodification of Culture', *Eighteenth-Century Life* 37.2 (2013), 53–84
Kirkham, Pat. *The London Furniture Trade 1700–1870* (London, 1988)
Klein, Lawrence E. *Shaftesbury and the Culture of Politeness: Moral Discourse and Cultural Politics in Early Eighteenth-Century England* (Cambridge, 1994)
Kowaleski-Wallace, Elizabeth. *Consuming Subjects: Women, Shopping, and Business in the Eighteenth Century* (New York, 1997)
Kuchta, David. *The Three-Piece Suit and Modern Masculinity: England, 1550–1850* (Berkeley, CA and London, 2002)
Kwass, Michael. 'Big Hair: A Wig History of Consumption in Eighteenth-Century France', *American Historical Review* 111.3 (2006), 631–59
Kwint, Marius, Christopher Breward, and Jeremy Aynsley (eds). *Material Memories: Design and Evocation* (Oxford and New York, 1999)
Langford, Paul. 'The Uses of Eighteenth-Century Politeness', *Transactions of the Royal Historical Society* 12 (2002), 311–31
Langford, Paul. *A Polite and Commercial People: England, 1727–1783* (Oxford, 1989)
Langford, Paul. *Public Life and the Propertied Englishman, 1689–1798* (Oxford, 1991)
Laqueur, Thomas. *Making Sex: Body and Gender from the Greeks to Freud* (Cambridge, MA, 1990)

Latour, Bruno. *Reassembling the Social: An Introduction to Actor–Network–Theory* (Oxford, 2005)
Lemire, Beverly. *The Business of Everyday Life: Gender, Practice and Social Politics in England 1600–1900* (Manchester, 2005)
Lemire, Beverly. *Dress, Culture and Commerce: The English Clothing Trade before the Factory, 1660–1800* (Basingstoke, 1997)
Lemire, Beverley. '"Men of the World": British Mariners, Consumer Practice, and Material Culture in an Era of Global Trade, c.1660–1800', *Journal of British Studies* 54.2 (2015), 288–319
Lemire, Beverly. 'A Question of Trousers: Seafarers, Masculinity and Empire in the Shaping of British Male Dress, c.1600–1800', *Cultural and Social History* 13.1 (2016), 1–22
Lipsedge, Karen. *Domestic Space in Eighteenth-Century British Novels* (Basingstoke, 2012)
Longfellow, Erica. 'Public, Private, and the Household in Early Seventeenth-Century England' *Journal of British Studies* 45.2 (2006), 313–34
Lubbock, Jules. *The Tyranny of Taste: The Politics of Architecture and Design in Britain 1550–1960* (New Haven, CT, 1995)
MacArthur, Rosie. 'Kinship, Remembrance and Luxury Goods in Eighteenth Century: A Study of the Hanbury Family of Kelmarsh', *History of Retailing and Consumption* 1.2 (2015), 125–39
Macfarlane, Alan. *Marriage and Love in England, 1300–1840* (Oxford, 1986)
McCormack, Matthew. 'Boots, Material Culture and Georgian Masculinities', *Social History* 42.4 (2017), 461–79
McCormack, Matthew. *Embodying the Militia in Georgian England* (Oxford, 2015)
McCormack, Matthew. *The Independent Man: Citizenship and Gender Politics in Georgian England* (Manchester, 2005)
McCracken, Grant. *Consumption and Culture: New Approaches to the Symbolic Character of Goods* (Bloomington, IN, 1990)
McKendrick, Neil, John Brewer, and J. H. Plumb (eds). *The Birth of a Consumer Society: The Commercialisation of Eighteenth-Century Britain* (Bloomington, IN, 1982)
McNeil, Peter. *Pretty Gentlemen: Macaroni Men and the Eighteenth-Century Fashion World* (New Haven, CT, 2018)
Miller, Amy. *Dressed to Kill: British Naval Uniform, Masculinity and Contemporary Fashions, 1748–1857* (London, 2007)
Miller, Daniel (ed.). *Materiality* (Durham, NC and London, 2005)
Muir, Rory. *Gentlemen of Uncertain Fortune: How Younger Sons Made Their Way in Jane Austen's England* (New Haven, CT, 2019)

Müller, Anja. *Framing Childhood in Eighteenth-Century Periodicals and Print, 1689–1789* (Farnham, 2009)
Munsche, P. B. *Gentleman and Poachers: The English Game Laws, 1671–1831* (Cambridge, 1981)
Neal, W. Keith and D. H. L. Black. *Great British Gunmakers, 1740–1790: The History of John Twigg and the Packington Guns* (London, 1975)
Nechtman, Tillman W. *Nabobs: Empire and Identity in Eighteenth-Century Britain* (Cambridge, 2010)
Newton, Hannah. *The Sick Child in Early Modern England, 1580–1720* (Oxford, 2012)
Ogborn, Miles. 'Locating the Macaroni: Luxury, Sexuality and Vision in Vauxhall Gardens', *Textual Practice* 11.3 (1997), 445–61
Overton, Mark et al. (eds). *Production and Consumption in English Households 1600–1750* (London, 2012)
Parker, Rozsika. *The Subversive Stitch: Embroidery and the Making of the Feminine* (Chatham, 1984)
Pennell, Sara. 'Consumption and Consumerism in Early Modern England', *Historical Journal* 42 (1999), 549–64
Perkins, H. J. *The Origins of Modern English Society, 1780–1880* (London, 1969)
Pointon, Marcia. *Hanging the Head: Portraiture and Self-Formation in Eighteenth-Century* (New Haven, CT, 1993)
Pollock, Linda. *Forgotten Children: Parent–Child Relations from 1500 to 1900* (Cambridge, 1983)
Pollock, Linda. *A Lasting Relationship: Parents and Children over Three Centuries* (London, 1987)
Ponsonby, Margaret. *Stories from Home: English Domestic Interiors, 1750–1850* (Farnham, 2007)
Porter, David. *The Chinese Taste in Eighteenth-Century England* (Cambridge, 2014)
Porter, Roy. *English Society in the Eighteenth Century* (London, 1982)
Powell, Margaret K. and Joseph Roach. 'Big Hair', *Eighteenth-Century Studies* 38.1 (2004), 79–99
Prown, Jules David. *Art as Evidence: Writings on Art and Material Culture* (New Haven, CT, 2001)
Rappaport, Erika. *A Thirst for Empire: How Tea Shaped the Modern World* (Princeton, NJ, 2017)
Rauser, Amelia F. 'Hair, Authenticity, and the Self-Made Macaroni', *Eighteenth-Century Studies* 38.1 (2004), 101–17
Reinke-Williams, Tim. 'Manhood and Masculinity in Early Modern England', *History Compass* 12.9 (2014), 685–93

Retford, Kate. *The Art of Domestic Life: Family Portraiture in Eighteenth-Century England* (New Haven, CT, 2006)
Retford, Kate. *The Conversation Piece: Making Modern Art in Eighteenth-Century Britain* (New Haven, CT, 2017)
Riello, Giorgio, Anne Gerritsen, and Zoltán Biedermann (eds). *Global Gifts: The Material Culutre of Diplomacy in Early Modern Eurasia* (Cambridge, 2018)
Riello, Giorgio. 'Strategies and Boundaries: Subcontracting and the London Trades in the Long Eighteenth Century', *Enterprise and Society* 9.2 (2009), 243–80
Roche, Daniel. *A History of Everyday Things: The Birth of Consumption in France, 1600–1800* (Cambridge, 2004)
Satia, Priya. *Empire of Guns: The Violent Making of the Industrial Revolution* (New York, 2018)
Schwoerer, Lois G. *Gun Culture in Early Modern England* (Charlottesville, VA, 2016)
Scott, Joan W. 'Gender: A Useful Category of Historical Analysis', *American Historical Review* 91.5 (1986), 1053–75
Shepard, Alexandra. *Accounting for Oneself: Worth, Status, and the Social Order in Early Modern England* (Oxford, 2015)
Shepard, Alexandra. 'Crediting Women in the Early Modern English Economy', *History Workshop Journal* 79.1 (2015), 1–24
Shepard, Alexandra. 'From Anxious Patriarchs to Refined Gentlemen? Manhood in Britain, circa 1500–1700', *Journal of British Studies* 44.2 (2005), 281–95
Shepard, Alexandra. *The Meanings of Manhood in Early Modern England* (Oxford, 2006)
Shimbo, Akiko. *Furniture-Makers and Consumers in England 1754–1850: Design as Interaction* (Abingdon, 2015)
Shoemaker, Robert B. *Gender in English Society 1650–1850: The Emergence of Separate Spheres?* (London, 1998)
Shoemaker, Robert B. 'Male Honour and the Decline of Public Violence in Eighteenth-Century London', *Social History* 26.2 (2001), 190–208
Shoemaker, Robert B. 'The Taming of the Duel: Masculinity, Honour and Ritual Violence in London, 1660–1800', *Historical Journal* 45.3 (2002), 525–45.
Smail, John. *The Origins of Middle-Class Culture: Halifax, Yorkshire 1660–1780* (Ithaca, NY, 1994)
Smith, Kate. 'Amidst Things: New Histories of Commodities, Capital and Consumption', *Historical Journal* 61.3 (2018), 841–61
Smith, Kate. 'In Her Hands: Materializing Distinction in Georgian Britain', *Cultural and Social History* 11.4 (2014), 489–506

Select bibliography

Smith, Kate. *Material Goods, Moving Hands: Perceiving Production in England, 1700–1830* (Manchester and New York, 2014)
Staves, Susan. *Married Women's Separate Property in England, 1660–1833* (Cambridge, MA, 1990)
Steele, Valerie. 'The Social and Political Significance of Macaroni Fashion', *Costume* 19.1 (1985), 94–105
Stobart, Jon (ed.). *Travel and the Country House: Cultures, Critiques and Consumption in the Long Eighteenth Century* (Manchester, 2017)
Stobart, Jon and Andrew Hann (eds). *The Country House: Material Culture and Consumption* (Swindon, 2016)
Stobart, Jon and Mark Rothery. *Consumption and the Country House* (Oxford and New York, 2016)
Stobart, Jon and Ilja Van Damme (eds). *Fashioning Old and New: Changing Consumer Patterns in Western Europe (1650–1900)* (Turnhout, 2009)
Stobart, Jon and Ilya Van Damme (eds). *Modernity and the Second-Hand Trade: European Consumption Culture and Practices, 1700–1900* (Basingstoke, 2010)
Stone, Lawrence. *The Family, Sex and Marriage in England 1500–1800* (London, 1977)
Stone, Lawrence and Jeanne C. Fawtier Stone. *An Open Elite? England 1540–1880* (Oxford, 1986)
Stretton, Tim. *Women Waging Law in Elizabethan England* (Cambridge, 1998)
Styles, John and Amanda Vickery (eds). *Gender Taste and Material Culture in Britain and North America, 1700–1830* (New Haven, CT, 2005)
Styles, John. 'Product Innovation in Early Modern London', *Past & Present* 168 (2002), 124–69
Styles, John. *The Dress of the People; Everyday Fashion in Eighteenth-Century England* (New Haven, CT, 2007)
Sweet, R. H. 'Topographies of Politeness', *Transactions of the Royal Historical Society* 12 (2002), 355–74
Tague, Ingrid H. *Women of Quality: Attesting and Contesting Femininity in England, 1690–1760* (Woodbridge, 2002)
Thompson, E. P. *Whigs and Hunters: The Origins of the Black Act* (London, 1975)
Tosh, John. *A Man's Place: Masculinity and the Middle-Class Home in Victorian England* (New Haven, CT, 1999)
Tosh, John. *Manliness and Masculinity in Nineteenth-Century Britain: Essays on Gender, Family, and Empire* (London, 2004)
Tosh, John. 'What Should Historians do with Masculinity? Reflections on Nineteenth-Century Britain', *History Workshop Journal* 38 (1994), 179–202

Tosh, John and Michael Roper (eds). *Manful Assertions: Masculinities in Britain since 1880* (New York, 1991)
Trentmann, Frank. 'Materiality in the Future of History: Things, Practices, and Politics', *Journal of British Studies* 48 (2009), 283–307
Trentmann, Frank (ed.). *The Oxford Handbook of the History of Consumption* (Oxford and New York, 2012)
Tullett, William. *Smell in Eighteenth-Century England: A Social Sense* (Oxford, 2019)
Turkle, Sherry. *Evocative Objects: Things We Think With* (Cambridge, MA, 2007)
Turner, David M. *Disability in Eighteenth-Century England: Imagining Physical Impairment* (Abingdon, 2012)
Ugolini, Laura. *Men and Menswear: Sartorial Consumption in Britain, 1880–1939* (Aldershot, 2007)
Veblen, Thorstein. *The Theory of the Leisure Class*. Reprint (Boston, MA, 1973)
Vickery, Amanda. *Behind Closed Doors: At Home in Georgian England* (New Haven, CT and London, 2009)
Vickery, Amanda. *The Gentleman's Daughter: Women's Lives in Georgian England* (New Haven, CT and London, 1998)
Vickery, Amanda. 'Golden Age to Separate Spheres? A Review of the Categories and Chronology of English Women's History', *Historical Journal* 36.2 (1993), 383–414
Walsh, Claire. 'Shop Design and the Display of Goods in Eighteenth-Century London', *Journal of Design History* 8.3 (1995), 157–76
Walvin, James. *Slavery in Small Things: Slavery and Modern Cultural Habits* (London, 2017)
Weatherill, Lorna. 'A Possession of One's Own: Women and Consumer Behaviour in England 1660–1740', *Journal of British Studies* 25.2 (1986), 131–56
Weatherill, Lorna. *Consumer Behaviour and Material Culture in Britain, 1660–1760* (London, 1988)
Welch, Evelyn. *Shopping in the Renaissance: Consumer Cultures in Italy, 1400–1600* (New Haven, CT, 2005)
White, Jonathon. 'Luxury and Labour: Ideas of Labouring-Class Consumption in Eighteenth-Century England' (Unpublished PhD Thesis, University of Warwick, 2001)
Whittle, Jane and Elizabeth Griffiths. *Consumption and Gender in the Early Seventeenth-Century Household: The World of Alice le Strange* (Oxford, 2012)
Whyman, Susan E. *Sociability and Power in Late-Stuart England: The Cultural World of the Verneys, 1660–1720* (Oxford, 2002)

Williamson, Gillian. *Gentleman's Magazine: British Masculinity in the 'Gentleman's Magazine', 1731–1815* (Basingstoke, 2016)

Wilson, Kathleen. *The Sense of the People: Politics, Culture and Imperialism in England, 1715–1785* (Cambridge, 1998)

Withey, Alun. 'Shaving and Masculinity in Eighteenth-Century Britain', *Journal for Eighteenth-Century Studies* 36.2 (2012), 225–43

Wrightson, Keith. *English Society 1580–1680*. Reprint (Abingdon, 2003)

Index

accessories 165–97
 affective power of 190–5
 gifting of
 diplomatic 190–1
 gendered 190–6
 proliferation of 181–2
 personalisation of 188–90
 smallness of 177–9
 use of 167, 179
 vulgarity and 177, 181
 see also canes; snuffboxes; toothpick cases
Addison, Joseph 165, 168, 210
aesthetic styles
 baroque 14, 133, 145, 223–4
 neoclassicism 14, 133
 rococo 14, 18, 88, 133, 145, 175, 206, 215, 222–4, 232, 250
Alexander, Gerard 168
Anti-Gallican Society 17, 173, 175–6
Ashley-Cooper, Anthony, 3rd Earl of Shaftesbury 168, 170
Austen, Jane 63
 Pride and Prejudice 131, 154

beau 13, 165, 196
Bennett, Jane 136
Berg, Maxine 102, 132, 171, 215, 219
boyhood 3, 4, 20, 34–5, 38, 43, 45, 47–8, 50, 68–9

boys
 activity and 55
 clothing
 breeches 12, 35, 42–3, 45, 50
 petticoats 38, 40, 41–3, 45–7
 skeleton suits 40, 43
 wigs 43–5
 preference for 40
 see also boyhood; breeching; children; gifting; guns; parents; toys
breeching 35, 38, 40, 42–3, 45, 48
Breward, Christopher 14
Brown, James (cabinet-maker) 16, 80, 84–8
 see also upholsterers
Brown, John (cleric) 12
Brown, John (tea dealer) 10
Brydges, Ann 152
Brydges, Henry, 2nd Duke of Chandos 134–5, 138
budgeting 83, 96, 98, 99, 102–3, 109, 112, 115, 117
Burke, Edmund 170
Byng, John, 5th Viscount Torrington 56–7, 217

canes 9, 17, 21, 165–6, 169
 disability and 180
 effeminacy and 180–1

gendered possession of 186–7
the male body and 179
materials of 187
smallness of 178
see also accessories
carpet 1, 99, 114
carriages 12, 14, 16, 17, 246, 248, 249, 250, 254
 changing design of 18, 133–4, 156
 connoisseurship of 135
 conspicuous consumption of 128–9, 133–4, 144–5, 147
 continental 132
 courtship and 148–9
 designs for 139
 diplomacy and 135–6, 145–6
 embodiment and 136–7
 gendered consumption of carriages by men
 bachelors 152–3
 middling men 137–8, 147
 gendered consumption of carriages by women
 married women 142–3, 150–1
 spinsters 152–5
 widows 152, 153–5
 gendered lifecycle and 147–55
 gold state coach 129, 138
 heraldry 146–8, 251–2
 historiography of 128
 inconspicuous consumption of 129, 144–5, 146
 life without 127, 138, 148
 magnificence of 128, 132, 134, 135, 138, 141, 143–4
 maintenance 135–6
 manufacturing of 129–34
 marriage and 147, 155
 material literacy of 139–40
 ownership of multiple 131–2
 politeness and 128
 repairs to 135–6, 138–9, 155
 second-hand 147, 250
 social mobility and 12, 137, 141–2
 typologies
 calash 133, 143
 chaise 131, 132, 133, 136, 140, 148, 149, 151, 152, 153
 chariot 127, 128, 131, 135, 143, 145, 147, 149, 151, 152, 154
 phaeton 10, 57, 133, 143, 146
 visiting and 152, 154
 see also mobility; travel
Carter, Elizabeth 63–5
Carter, Philip 234
Child, Robert 1–2
childhood
 innocence and 49–50
 gendered 33, 48, 68
 see also boys; children; education; girls; parents; toys
children
 as consumers 33
 elite 36, 38, 40, 54
 gendered education of 32, 34–5, 36, 52–3, 60, 64, 68–9
 middling 51, 55, 58
 plebeian 36
 see also boys; childhood; education; girls; parents; toys
Chippendale, Thomas 16, 96, 99, 105, 140, 253
 see also furniture
Churchill, Charles, 3rd Duke of Marlborough 135, 145
Churchill, John, 1st Duke of Marlborough 131, 142–3, 145–6, 147, 150–1
Churchill, Sarah, Duchess of Marlborough 142–3, 150–1
Clark, Leatitia 61
clergymen 86, 87, 137, 171, 186
Clive, Robert 143–4

coach-makers 128, 132, 134, 135,
 138, 139, 142, 146, 150,
 250
 accounts 152
 advertising 140–41
 business practices 140
 role in innovation 141
Cohen, Michèle 34, 52, 54
Collier, John and Mary 147–8
colonies 171, 216, 254
commercialisation 2, 6, 8, 10, 12,
 16
 of childhood 33, 36, 59
 of leisure 212
 social order and 128, 245
 of sporting culture 208
Connell, Raewyn 4–6
consumer society 2, 3, 4, 10, 22, 166
 nineteenth-century 256
consumer strategies 8, 19, 82, 89,
 112, 115, 117–18, 147
 gendered 80, 83, 246
consumption
 categories of 18
 domestic 3, 15, 81
 dynastic 2, 81, 83, 93, 149,
 151, 155, 179
 gendered 19, 21, 59, 81–2, 148,
 182, 236, 252
 history of 11–14
 patriotic 175–6
 politics of 13, 66, 81, 155, 166,
 176, 182
 source material for 81–4
 see also consumer society;
 consumer strategies
coverture 8
 evidentiary problems of 88
 mobility and 16, 153, 155
 smallness and 179
 women's economic practice
 151, 246
 women's emotions and goods 179
 see also credit
credit 88, 128, 151, 245, 249
cricket 56–8, 64, 224

dancing 52–3, 224
discernment 21, 103, 118, 135,
 179, 195–6, 232
 carriages and 135
 guns and 221
 household furniture and 135
 materiality of 167, 250
 middling sorts and 170
 politics of 166
 rationality and 2, 166, 167, 167
 size and scale and 179
 status and 189, 248, 253
 women's 170
 see also distinction; luxury;
 novelty; refinement; taste
distinction
 age and 34, 65–6
 gendered 33, 35, 64, 66, 98,
 166, 212
 politeness and 17
 social 2, 8, 12, 16, 108, 131,
 137–8, 147, 166, 168,
 170, 185–7, 191, 234
domestic
 account books 150
 comfort 118
 interiors 20, 83–4, 107, 109,
 112, 113, 246, 248
 display of sporting objects in
 227–36
 life 5, 15, 58, 64
 history of 80–3
 material culture 112, 116, 117
 men's authority in 129, 246
 responsibilities 15
 space 100, 175, 255
 values 35
 see also consumption; furniture;
 householder
Edie, George 17, 214, 225–7
education 53, 248
 conversation and 181
 educational treatises 32, 34, 35,
 54, 64
 gendered 34, 52, 60, 64, 68
 the grand tour and 53

Index

taste and 168
toys for 37
effeminacy 13, 21, 66, 103, 127, 166, 177, 180–1, 183, 188, 193, 196
embodiment 6, 15, 18, 34, 52, 68, 136–7, 166, 167, 195, 196, 224–7, 252
emotions
 masculinity and 6, 15, 16, 20, 81, 225, 251
 objects and 18, 19, 83, 108, 136, 166–7, 191–5, 220, 252
evidence
 approach to 19, 183
 preservation of 11
 women's absence in 149
exercise 52, 64, 211, 224–5

Family Fortunes 5, 63
 see also separate spheres
fashion (and fashionable, fashionability) 1, 4, 11, 13–14, 16, 83, 88, 95, 101, 104, 118, 137–8, 140, 145, 154, 228
 childhood and 33, 40, 43, 48, 59–60, 66
 French 92, 132, 143
 goods and 99, 103, 165, 179, 213
 knowledge of 141, 170
 London and 253
 men and 82, 96, 133, 146, 165, 168, 180–3, 221, 224
 snuff and 171–2, 177
 social status and 107, 108, 131, 142, 170
 textiles and 111–12
fathers
 childcare 42, 49
 bonding with sons 56
 gifting and 43, 194
 pride 42

Felton, William 130, 140, 147
fencing 37, 52–4, 225
Ferguson, Adam 13
Finn, Margot 81, 88, 144
Flügel, J. C. 13–14
fops 13, 165, 181, 187, 196
furniture
 chairs
 design of 95–8
 mahogany 85, 96, 97
 specific functions 96–7
 colour of 96, 105, 106, 107, 117
 gendered language of 94–5, 178
 manuals 95, 96, 98, 99, 100, 140
 Chippendale, Thomas 96, 99, 105, 140
 Hepplewhite, Alice. 96
 Ince, William and John Mayhew 96
 Sheraton, Thomas 95, 96, 99, 100, 103
 regulatory power of 111
 repairs to 107–15
 beds 114–15
 chairs 110, 111, 113
 gender dynamics of 108, 113, 115
 motivations for 108, 111, 112, 115
 tables 110–11
 second-hand consumption of 115–17
 shape of 84, 94, 96, 106–7, 117
 size of 100
 sofas 1, 114, 248
 tables
 gaming 94, 111, 131
 mahogany 93–6, 100, 102, 110, 115
 multi-purpose 94, 122 n.38
 Pembroke 93–5, 105
 trades 102
 wooden
 bamboo 97, 101, 103, 105
 deal 98, 101, 102, 103, 105, 232

rosewood 101, 103, 104
tulipwood 104, 105
wainscot 98, 101, 102–3, 104, 105, 233
 see also domestic interiors; mahogany

Gainsborough, Thomas 206, 219
game laws 4, 209–10, 212
games 33, 36–7, 45, 57, 64
gender history 4–5
gentility 11, 33, 55, 57, 58, 63, 118, 128, 137, 141, 150, 152, 154, 185, 190, 206, 219, 220, 226, 236, 248, 252, 253
gifts
 carriages as 153, 155
 children and 38, 43, 54, 55, 63
 courtship and 59, 148
 diplomatic 191
 dynastic 191
 emotion and 192
 gendered 247
 gift-exchange 166, 167
 horses as 137
 masculinity and 191, 194–5
 snuff as 191
 snuffboxes as 191–2
girls
 curriculum 34
 clothing 48, 65
 needlework 37, 54, 58–9
 passivity 32, 58–60, 68
 workboxes 58
Goldsmith, Sarah 53, 225
grand tour
 collecting and 231
 danger and 52
 domestic versions 127
 rite of passage 53, 126
 sport and 225
'great male renunciation' 13–14, 18, 251
Greig, Hannah 99–100, 107
Griffin, Ben 6

guns (and firearms, fowling piece, sporting gun) 1, 12, 14, 16, 19, 206, 208, 210
 children and 51
 consumption of 212–15
 design of 18, 220–4
 display of 227–36
 duck guns 212, 214, 221–3
 English gun culture 212
 embodied knowledge of 224–7
 empire and 236, 216
 luxury and 212
 politeness and 17, 21, 219, 223, 225–6, 230
gunsmiths
 branding 212, 220
 trade cards 207, 208, 215–20

handsome 169
haptic 10, 17, 19, 167, 177, 195, 196, 252
Harley, Joseph 11
Harvey, Karen 81, 124 n.91
Hatchett, John 130, 132, 140–1
Helmingham Hall 227–33
heraldic decoration 249–51
 canes 189
 carriages 18, 134, 142–4, 146–8, 155
 guns 221
 snuffboxes 173, 175, 188–9
Hogarth, William 48–51, 63, 111
honour 9, 34, 57, 217–18, 223, 235, 236, 250, 251
household
 children in 37, 51, 55, 58, 60
 consumption 20, 81–118, 149–50
 elite 139
 history of 80, 229–30
 inventories 21, 179, 207, 227, 229
 men's position in 3, 7–8
 women and 58, 60, 153, 193–5
 see also domestic; family; householder

Index

hunting 17, 21, 53–5, 149, 206–12, 215–19, 221–5, 227–36

imports 11, 12, 98, 132
independence
 boys' 32, 34, 43, 69
 men's 9, 16, 102, 137, 142, 155, 179
 women's 91, 148, 151–5, 246

Klein, Lawrence E. 13
Kuchta, David 133, 146

Lee, George Henry, 3rd Earl of Lichfield 230–1
leisure 4, 51, 91, 94, 142, 206, 209, 212, 223, 226, 236, 250
lifecycle 7, 33, 37, 147–8, 252
Littleton, Thomas 10
Locke, John 35, 50, 52, 66
London 136, 140, 145, 236
 academies in 51
 consumption in 45, 191, 208, 253–4
 cricket clubs 56
 fashion in 145, 170, 180
 manufacturers 20, 84, 87, 107, 129–30, 141, 172, 183, 194, 214, 232
 the season 138
 sociability in 154, 211
 thefts in 184
 travel in 126–7
 travel to 147, 153
 urban legislation 127, 131
luxury 165, 166, 167
 debates 169–70
 delights of 171
 effeminacy 181, 187
 male body and 179
 materiality of 196
 men's appetite for 184
 modernity and 168

macaronis 13, 165–6, 196
mahogany 98–107
 desirability of 98, 102
 elite consumers of 99
 furniture 88
 gendering of 98–101, 117
 imitations of 96
 imports of 11, 98
 middling consumers of 10, 16, 97
 puzzle cabinet 36
 repairing 107, 109–11
 second-hand consumption of 115–16
 shaving stand 1, 93
 see also furniture
Manton, John and Joseph 212–14, 215, 221, 253
marriage 55, 65, 129, 141, 142, 148–9, 151
masculinity
 autonomy and 42, 44, 127, 128
 authority and 5, 9, 34–5, 42, 44, 65, 69, 81, 155, 245, 251, 253
 hegemonic 5–6, 8, 133, 245
 patriarchy and 5, 8, 15, 68, 81, 127, 128, 151–2, 155, 245–6
 emotions and 15, 16, 18, 19
 see also boys; effeminacy; embodiment; emotions; fathers; honour; material knowledge; materiality; mobility; politeness; power; rationality; taste; technology
material knowledge 9, 21, 167, 195, 225
 men's 9, 10, 139, 227, 231, 248, 252–3
 women's 3
material literacy 3, 6, 9, 10, 14, 19, 59, 82, 96, 117, 118, 127, 129, 136, 139–41, 167, 195, 252

material masculinities 3–4, 6, 20, 81, 118, 207–8, 227, 236
materiality 7–8, 10–11, 17–21, 128, 178, 195, 212
 domestic 80–2, 118
 feminine 3
 gendered lifecycle and 33
 guns and 208, 220–4
 luxury and 196
 masculine 3, 4, 6, 7, 9, 11, 14, 15, 17, 155, 196, 227, 245, 252–6
 personal property and 167
 transport and 127–8, 135
Miller, Daniel 7
mobility 1, 7, 12, 126–8
 gendered 16, 127
 social distinction and 21
 see also carriages
Mulso, Rev. John 137–8

novelty 18, 21, 166, 168, 171, 173, 182, 188, 195–6

parents
 attitude to children's gender 35, 40
 breeching and 42–5, 48
 consumption 33
 educational thought and 35
 investment in children 33
 relationship with children 33, 247
Parker & Wakelin 189
politeness 13, 17, 141, 168, 180, 245
 boys and 34
 men and 13, 14, 21, 53, 133, 145, 152, 180–2, 250–1, 253
 objects of 110, 114, 177
 sociability and 98, 111, 171, 249
 women and 49, 128, 152, 154, 170
 see also carriages; effeminacy; sport

power
 gendered 15, 20, 128, 153, 245–8
 grids of 8, 155
 patriarchal 8, 246
 social 2, 3, 15, 51, 128, 207, 218
Proceedings of the Old Bailey 11, 12, 21, 166, 178, 183–8
product innovation 10, 11, 129, 251, 256
profession (and professionals, the professions) 43, 47, 84, 85, 86, 137, 139, 145–6, 185, 186, 210, 235, 248, 253

rationality 59, 65–6, 166, 167, 168, 169, 175, 178, 179, 180, 187, 195, 248
refinement 2, 10, 17, 127, 166–70, 177, 179, 180, 182–3, 196, 219, 226, 227, 235, 245, 249, 251, 253
 intellectual 53
respectability 10, 11, 81, 102, 103, 107, 112, 117–18, 141–2, 154, 171, 185, 190, 226, 246, 248, 251, 252–3
Retford, Kate 35
Riello, Giorgio 18
Robinson, Elizabeth 34
Robinson family
 Robinson, Anne 153
 Robinson, Frederick 57, 126, 136–7, 140, 153–4, 211, 250
 Robinson, Thomas, 2nd Baron Grantham 53, 132, 135–6, 139, 140, 145–6, 149, 188, 191, 250
 Robinson, Thomas, 3rd Baron Grantham 51, 56, 57
Rousseau, Jean-Jacques 32, 35, 37, 59–60

Index

royal family 36, 38, 51, 55, 60, 63, 140, 171
George I 186
George III 36, 129, 138, 191
Prince Regent (later George IV) 66, 134, 192–3
Princess Elizabeth 193
Queen Charlotte 192
royal warrant 1, 213, 216

Savile, Gertrude 153–5
science 1, 171, 232–3, 235–7
semi-finished goods 95, 167, 189, 195
sexual difference 40, 178, 224
sexuality 5, 37, 66
shooting 1, 17, 44, 45, 51, 53, 56, 207–36
Smith, Adam 182, 192
Smith, Kate 144, 175
snuff
 dominance of 176
 effeminacy and 177
 respectability and 171
 see also tobacco
snuffboxes
 Anti-Gallican 173–6
 calendar snuffboxes 172
 collective identity and 175–6
 effeminacy and 177
 gendered possession of 184
 increased ownership of 184
 materials of 184–6
 obsolescence and 172
 social interactions and 176
 social rank and 185
 see also accessories; novelty; luxury; refinement; snuff; tobacco
social mobility 12, 16, 137, 142
sociability 4, 13, 80, 92, 94, 98, 110–11, 128, 152, 166, 171, 175–6, 182, 186, 188, 189, 191, 195, 206, 209, 218, 219, 234, 249–50

The Spectator 17, 165, 176, 178, 180, 182, 210
Spencer, George, 2nd Earl Spencer 209
sport
 advice literature 217, 224–7
 class tension and 208–12
 domestic interior and 227–36
 effeminacy and 211, 236
 exercise and 211, 224–5
 history of English 208
 itineracy of 210
 luxury and 207, 212–14, 216, 220–1, 223, 224, 236
 militaristic associations of 206, 207, 220, 228, 234, 235
 politeness and 207, 209, 211, 218–19, 223, 225–6, 230, 231, 233–7
Stanhope, Philip Dormer, 4th Earl of Chesterfield 52, 53, 169, 177, 181–2, 206, 218
Stobart, Jon 81, 104, 136, 153
Styles, John 11, 132

taste
 the body and 167
 conceptualisations of 168, 170, 178
 democratisation of 170
 knowledge and 167, 195
 language of 169, 170
 materiality and 167
 moral panics concerning 165–6
 selfhood and 167
 see also consumption; discernment; effeminacy; luxury; novelty; rationality
The Tatler 132, 146, 179–80, 182, 210
technology
 discernment of 21, 212, 214, 221
 gender and 248, 251

innovation of 11, 133, 177, 212, 221, 235
manufacturing 118, 133, 182, 215, 250
material knowledge of 227, 231, 236
military 216
wonder of 166, 171
Temple, Earl 135, 139, 145
tobacco 11, 190
　dealers 185, 193
　gendered consumption of 171
　see also snuff
Tollemache, Lionel, 3rd Earl of Dysart 227–9
　see also Helmingham Hall
toothpick cases 21, 165, 166, 172, 186, 187
　see also accessories
toys
　diversity of 64–6
　for boys 51–8
　for girls 37, 58–63, 65
　markers of manhood 65–6
　size of 68
　teething toys 38–9
　without gendered association 36–7
　see also boys; childhood; children; education; girls

travel
　horseback 127, 137, 149, 152
　sedan chairs 126, 127, 150
　transport revolution 126
　walking 126, 154, 182
　see also carriages; mobility
Tullett, William 171–2, 176–7

upholsterers 80, 86, 104, 151, 246
　clientele of 86–9
　historical evidence of 83
　trade cards 88, 98, 101
　see also furniture

Vickery, Amanda 42, 58, 81–2, 89, 94, 100, 104, 134, 172, 177, 193–4, 218
Von la Roche, Sophie 132, 140–1

Walpole, George, 3rd Earl of Orford 232
Watson-Wentworth, Charles, 2nd Marquess of Rockingham 223, 231–2
Woodforde, Rev. James 192
Wright, John 139, 145, 160 n.58
Wyndham, George O'Brien, 3rd Earl of Egremont Earl of 139, 213